# ON ART

# ON ART by

Edited with an

 HORIZON PRESS

# MARSDEN HARTLEY

Introduction and notes by GAIL R. SCOTT

NEW YORK

To my parents

# Contents

# Illustrations

# Acknowledgements

This work has been made possible by a generous grant from the National Endowment for the Humanities, and I would like to express gratitude to the staff members with whom I dealt over a period of four years for their help and encouragement.

Yale University has granted me permission to publish Hartley's writings, and I want to extend particular thanks to Dr. Donald Gallup, former Curator of The Collection of American Literature at the Beinecke Rare Book and Manuscript Library, and his successor, Dr. David E. Schoonover, as well as the Library staff, for their help in facilitating my research there.

I wish to thank the following editors and publishers for permission to reprint essays: Dorothy Norman, editor of *Twice a Year* ("Memling Portraits," "Thinking of Gaston Lachaise," "Mary with the Child—of Leonardo"); Doubleday and Co., Inc. ("291—and the Brass Bowl"); and the Cincinnati Contemporary Arts Center ("Pictures"). Grateful acknowledgement is made to W. W. Norton in whose *American Caravan* (1934) versions of "Farewell, Charles" and "Albert Pinkham Ryder" appeared; and to *The Nation* ("Dissertation on Modern Painting"); *Creative Art* ("Art—and the Personal Life"); and The Arts Club of Chicago ("The MOUNTAIN and the RECONSTRUCTION") where these articles were originally published. Georgia O'Keeffe kindly granted permission to reprint from exhibition catalogues from Alfred Stieglitz's Intimate and American Place galleries and to quote from material in the Stieglitz Archive at the Beinecke Library.

Special acknowledgement is due the many individuals who had a part in this work. The late Norma Berger, whose dedication to her uncle's work as a writer and painter spanned a long life, gave her full enthusiasm to this project and cooperated in every way. Dr. William Innes Homer of the University of Delaware acted as consultant to the project and made valuable suggestions at many points along the way. Barbara Haskell, Curator at the Whitney Museum of Ameri-

can Art, cooperated in the collection of illustrated material. Leon Tebbetts, Dorothy Norman, Earl Loran, Kenneth Rexroth, and Mrs. Ursula Moore (Arnold Rönnebeck's daughter) all responded graciously to interviews and inquiries. Staff members at the San Francisco and Washington offices of the Archives of American Art also provided helpful assistance. Nancy Laleau's care in typing a difficult manuscript is greatly appreciated. A special note of gratitude goes to my publisher, Ben Raeburn, for his guiding role in the evolution of this edition.

I want especially to recognize Aileen and William Hillman who first introduced me to Hartley's work and whose devotion to the idea of this project has been a constant support. I am indebted to Christopher Wagstaff who initially shared with me his discovery of the Hartley material at Yale and later collaborated in selecting the poetry. My deepest gratitude is to my husband, Stanley J. Scott, whose encouragement and sound editorial advice were invaluable contributions to every phase of the project. Finally to my son, Ryder Allan Scott, go many thanks for his patience and understanding.

# Preface

Marsden Hartley's reputation as a writer has until now been based primarily on his 1921 collection of essays, *Adventures in the Arts,* a handful of published articles on the work of fellow artists, and a few statements on his own painting which appeared in various journals and exhibition catalogues during his life. As a poet he is known largely by the posthumous *Selected Poems* (1945); verses printed in *Poetry, The Little Review,* and *Contact;* an early book *Twenty-five Poems* (1923); and two later ones, *Androscoggin* (1940) and *Sea Burial* (1941). These published works, however, constitute only a fraction of Hartley's writings.

At his death a trunkful of manuscripts was left among his personal effects, which, thanks to the devoted efforts of his niece and literary executrix, Norma Berger, were eventually organized and placed on deposit at Yale University's Beinecke Rare Book and Manuscript Library. Of the extant manuscripts (some were apparently lost or destroyed by Hartley) there are over three hundred essays on a wide range of topics and some six hundred poems. Many were collected and arranged by Hartley into groups for books he hoped to publish. These manuscripts constitute a wealth of art and literary criticism and poetic output, much of it written in the last decade of his life, thus paralleling the most distinguished period of his career when he had gained full mastery as a painter.

Though now acclaimed as one of the leading figures in twentieth-century American art, Hartley began only in the last two years or so of his life to achieve recognition and success. For a time even after his death his painting received relatively meager critical attention, while his talents as an essayist and poet were usually mentioned by scholars and critics incidentally and only as they explicated or expanded upon his status as a painter. The aim of this edition is to adjust these imbalances by making public for the first time the full extent of Hartley's literary achievement.

In the process of this work the value of his writings as testimony to

the amplitude of his creative stature became increasingly clear. Hartley emerged as a writer of exceptional, unconventional ability, an able spokesman for his own esthetic ideas as well as an acutely sensitive critic whose appraisal of the art of his time is characterized by insight, sympathy, and wit. Moreover, the quality of his poetic gifts came to light. The poetry, like the painting, stands alone as an independent expressive medium which parallels and occasionally relates to specific paintings.

The present volume encompasses the full scope of his writings on art. The majority of the essays appear in print here for the first time; those few previously published are included with the kind permission of earlier publishers. A second volume, now in preparation, will contain Hartley's memoirs and writings on the other arts—literature, dance, music and theater—and a third volume will present a comprehensive view of his poetry, beginning with the early verse, proceeding through a highly experimental stage in the 1920s, and continuing into the mature poems of the last decade of his life. *Selected Poems* culled much of its contents from the two previous volumes, *Androscoggin* and *Sea Burial*, but it largely overlooked historically important poems which marked Hartley's emergence as a poet and placed his work in the context of twentieth-century American poetry.

The range and size of Hartley's literary oeuvre is extraordinary given the fact that writing was subordinate to his career as a painter. Furthermore, though he intermittently sought publication, he was not a professional writer, nor was he much given to revising his prose. As a result he would sometimes repeat vignettes, ideas, or anecdotes in different contexts. Every effort has been made in this volume and the subsequent one of his prose to present a complete picture of his writings while avoiding repetition. The selection is based on criteria which will best serve both Hartley and the reader. Essays that deal with the central artistic concerns of his career have been chosen according to the degree to which they reveal Hartley's unique esthetic sensibility. Those on vaudeville, the circus, travel vignettes, and reminiscences have been selected for their lively appeal and the information they contain about Hartley's life and thought.

As a self-taught and intuitive writer, without formal training (a subject discussed more fully in the Introduction), Hartley evolved a prose style with its own flavor and marked by certain idiosyncracies

which subsequently presented minor editorial problems. His writing will stand on the vital quality of his message, and since to some extent his unconventional use of the language is endemic to that message, the general policy in this volume has been to preserve the freshness and spontaneity of his style. Despite his violations of common English usage—comma splices, run-on sentences, and odd paragraph structuring—little attempt has been made to alter them, except in instances where the sense might otherwise be lost. As a general rule spelling and punctuation have been silently adjusted where needed; any word changes or grammatical corrections are indicated in brackets. One of Hartley's stylistic peculiarities was his liberal use of dashes, sometimes in place of commas or periods, sometimes for no apparent reason. This problem was especially acute in transcribing from holograph manuscripts where these marks are subject to different interpretations. And in Hartley's own typescripts, the dash is less common than one might expect after reading the manuscripts, a fact which led me to the conclusion that wherever a small dash appears in his handwriting, he would probably have typed a comma. One inexplicable habit which has been corrected was his occasional use of a semicolon to close the last sentence in a paragraph.

Certain words from the original holographs have defied deciphering. In some cases they appear in brackets as [illegible word]; in others, a probable word or correction followed by a question mark appears in brackets. Certain spelling oddities remain, such as the archaic form "extasy," and some British spellings like "-our" and "-re" as endings. He often used the lower case for the adjectival form of proper nouns (irish, proustian, greek, etc.), but since he was not consistent in this usage, the common practice of capitalization has been standardized throughout. He also usually placed quotation marks inside end-punctuation, but this too has been conformed to the standard set by the Chicago *Manual of Style*. Hartley rarely inserted accent marks on foreign language words; for clarity these have been added. Since he ordinarily put the titles of books and works of art in quotation marks, rather than indicating italics (a practice more common in his day), this habit has been retained; where he forgot them, they have been added for consistency. Wherever Hartley's original holograph or typescript exists, it has been used rather than a previously published version. In instances

where no original manuscript exists to compare to a published version, the essay has been printed here as it first appeared, with only an occasional correction. Every selection has been printed in full.

# Introduction

*The painter as writer*

The painter who, like Marsden Hartley, is also a gifted writer, is a special phenomenon in the history of art. Double manifestations of talent are highly idiosyncratic and the interconnections between the forms often difficult to define. In some instances—William Blake's illuminated books of poetry, or Dante Gabriel Rossetti's canvases inscribed with lines of poetry—the two forms, each enhancing the meaning of the other, contribute to one total effect. In other cases artists fundamentally centered in one medium have made inroads into another with varying degrees of commitment and success. Michelangelo started writing his sonnets and madrigals as a special form of correspondence in the convention of Renaissance Italy, but grew from this amateur level into an accomplished poet. In the twentieth century writers like D. H. Lawrence and Henry Miller, and painters like Paul Klee, John Marin, Robert Smithson, Ad Reinhardt, and others, have made forays into another form, but for them the alternate expressive medium was limited in scope and subordinate to the primary field of activity.

Marsden Hartley's case is a unique example of this phenomenon. Although he never combined poetry and painting in a single object, he did work in both metiers simultaneously throughout most of his life with intense energy and dedication, and the literary and critical quality of his writings was extraordinarily high.

The attitude of scholars toward the artist with dual talents has been adversely affected by the modern tendency toward intellectual specialization and resistance to holistic analysis. One finds books of literary criticism dealing with the texts of Blake's poetry, and art history monographs explaining his visual imagery without commenting on the poetic content. The result, as Northrop Frye observes, is that Blake is often "chopped by his critics into as many

---

Notes for this section appear on page 55.

pieces as Osiris," and the solution he recommends is "to identify
blinkered vision with directed vision by trying to expose oneself to
the whole impact of Blake at once."[1] The multiform works of an
artist—whether they take shape as poetry, painting or essays—stem
from the same source in individual creative imagination and are
informed by one consciousness. Though an approach to Blake is not
precisely the same for Hartley, still the point remains that to
understand an artist's achievement one needs "to expose oneself to
the whole impact" of his art at once. One must consider the *fabric* of
his life work and not be "blinkered" by the effort to distinguish the
warp from the weft. Only then is it possible to see the various
components in relation to the whole.

Hartley's contribution to American art of the twentieth century
has been measured almost solely in terms of his painting. This
lopsided scholarly estimation is due in part to a conventional attitude
of suspicion toward any artist so prodigious and proficient in two
fields, and in part to the monumental problems Hartley faced in
winning recognition and support for even one career. That so little of
what he wrote ever saw the light of publication during his lifetime
fostered the mistaken impression either that he was not a "serious"
writer, or that his writings were merely secondary to his paintings.
It is true that the paintings were the primary objects of his creative
energy, and that the majority of his essays are concerned with art,
serving to elucidate the esthetics of his painting. That he did not
publish more, however, is not a sign of a lack of serious intent and
should not affect our judgment of the quality of the material. The
reasons for the slow recognition of his writing are basically circum-
stantial. In his lifetime Hartley was never able to attract a solid
buying public for his paintings, let alone find lucrative outlets for his
essays and poems. He did try sporadically to place his writings to
supplement his income, and was at times successful. Although he
occasionally had editorial help from friends like Marianne Moore,
Alfred Stieglitz, and Edward Dahlberg, Hartley was basically an
intuitive writer, and had little patience to refine his manuscripts.

Although the sheer volume of his output demonstrates that he was
not a "Sunday writer," the question remains: why *did* he write as
much as he did? Why was he not satisfied with an occasional
statement of esthetic intent, or an appraisal of another artist's work?
Some argue that Hartley wrote to fill a void in his lonely existence;

there is some limited validity to such an argument. Certainly he
often secluded himself in remote regions of New England, the
Southwest, Mexico, and Europe, from where he pictured himself in
letters as writing to fill up the long, silent evenings. He was well
aware of his introverted nature and struggled with it most of his life.
In a letter to a friend he once described himself in a typically vivid
image: ". . . . does a natural introvert ever live anywhere but in
himself, and is it not in the end basically primitive to go into the
forest and gather sustaining substances for another, perhaps less
provisional day, and like the squirrels par example, I push all the
nuts into my cheeks and finding room for no more, rush back to the
hole in the tree and take them all out, & say what pretty shells &
what pretty meats."[2]

However, the solitude that at times caused Hartley anguish gave
him a special vantage point of which he was also aware. On several
occasions he likened himself—partly because of his prominent nose
and piercing eyes—to the eagle, and in a poem written in the late
1920s, points with acute self-perception to that unique privilege:

> The eagle wants no friends,
> employs his thoughts to other ends
> he has his circles to inscribe
> twelve thousand feet from where
> the fishes comb the sea,
> he finds his solace in unscathed
> immensity,
> where eagles think, there is no need
> of being lonesome—
> In isolation
> is a deep revealing sense
> of home.[3]

Like the eagle, he lived alone and, like the eagle, found "solace in
unscathed/immensity"; from this visionary standpoint he could
employ "his thoughts thoughts to other ends." Despite a tendency to
introversion, Hartley recognized the largeness of his vision and
sought to give it form, not alone in his paintings, but also in words—
words primarily about the work of other artists and writers. [He        ✓
wrote some six or eight direct statements about his own art, most of
them in connection with exhibitions, but the focus of his essays is

generally *outward*, toward the art, literature, and people that comprised his milieu, so much so that it is impossible to say that Hartley was writing only for personal satisfaction. The fact is, the activities that comprised the subject matter of his writings *were* his personal life, the donnée of his existence.

As demonstrated in biographical accounts of his career,[4] Hartley's life was fraught with difficulties: unending financial struggles, a restless discontent with nearly all of the many places where he lived, ill health, tragedy and loss. The triumphs and periods of peace seem rare and fleeting. Under the stress of such conditions the question becomes even more acute: what accounts for the prodigious creative effort of this man—his perseverance against such odds, his dedication to painting and writing? For a normal individual, such adversity would obviously render impossible the level of artistic productivity Hartley attained. Thus far his life has been presented largely in terms of the usual circumstantial evidence: his travels, his friends, dealers, fellow artists and writers, and his struggle for subsistence, as well as information in his long, loquacious letters. These letters tend to shift between high moments of pride or faith in some new turning point, and low points of depression (sometimes verging on suicidal thoughts), cynical defiance, and self-pity. Both letters and biographies support a rather bleak picture of his life and character, but one gets a wholly different portrait of the man and his work from his essays, and to an even greater degree from his poems. Both reveal many of the same ideas and feelings expressed in his letters, but far less self-consciously. The essays are more outer-directed in intent and naturally more literary and objective than the letters. With the background of historical biography at least minimally established, the intent of this Introduction is to trace the outlines of a spiritual biography. In examining Hartley's essays within a generally chronological framework, we will pinpoint the development of key themes and issues that characterized his thought and impelled the production of his art.

## An experiential esthetic

Hartley's career as an artist can be approached by identifying the two poles of his nature—imagination and intellect—between which he seems to have vacilated, relying on one, then on the other as his

chief esthetic guidepost. This basic dichotomy is also manifest in his writing, both private and public. His constant impulsion to write and the high level of introspective searching revealed in his essays expose his inner development to a kind of public scrutiny which few visual artists endure. Such are the risks for the painter with a verbal acuity equal to Hartley's. That there were contradictions in his thought is not surprising; his esthetics were not formulated in a philosophically structured way, but grew organically, like a semi-cultivated garden, from roots reaching deep into the soil of his experience. His self-contradiction typifies the Emersonian proverb "Consistency is the hobgoblin of little minds," and illuminates Hartley's belief that art, like life, must never be allowed to "coagulate in the soul." Furthermore, rather than intensifying the problems of research, contradictory statements may be viewed as part of an ongoing process to which the reader is witness, whereby the artist takes a perhaps extreme position in order to wrench himself free from an outgrown state of mind.

There emerges from his writings an effort to forge a resolution to this conflict between the imaginative and intellectual forces of consciousness, a resolution inherent in his fundamental belief that "life itself"—experience—is the source of creative consciousness and action. Imagination and intellect may constitute the dialectic that runs through his essays, but time and again he returns to this experiential base as the only reliable means of achieving valid artistic expression. His essays point to the fallibility of both extremes: the precarious position of the imaginative artist who has no grip on concrete fact, and the sterility and deadening effect of a purely theoretical art, yet he realized the value in both approaches and never completely eschewed either one. In the balance he doubtless identified more with the visionary's life of the imagination, but he came eventually to see its limitations and sought to compensate for it, in both painting and prose, in what he called intellectual clarity, the ability to observe concrete reality. Hartley perceived that only a fixed reliance on "life itself" would release the truly creative potential in either the imagination or the intellect.

In 1940, when he was sixty-three—an age when most individuals start to retreat into their memories and many artists glide on their reputations—Hartley wrote to his niece, ". . . to live is to keep the 'center of activity' open so that life can pour in and through one's

nature—imbibing the pure substance which is the leaven of artistic expression."[5] He was constantly alive to all that life offers—from a comic vaudeville act to a glacial boulder to a mystic's song, and his writings reverberate with his passion for living every event to its full. To him life and art were not set over against each other, with art becoming some kind of metaphorical mirror or symbolic reduction of life. He said of Toulouse-Lautrec, "Life was all one thing to him, an artistic experience, and he had no choice but to live all of it"; and of John James Audubon, "Audubon and his work were one, he lived his work, and in his work he will live." Similar passages indicate Hartley's firm conviction that concrete experience is the ultimate factor generating the creative process, and this experiential standpoint is the unifying element in his esthetics.

Hartley was caught up in a dilemma that occupied a generation of artists and thinkers who were responsible for the shift from the nineteenth-century polarity of romanticism and naturalism, to twentieth-century modernism, in which a new spirit began to predominate. Hartley's part in this shift is a small but significant contributing factor in a movement that took many forms in America and abroad because what he attempted to express creatively in paint and poetry he also managed with insight and perspicacity to articulate in discursive essays. These essays will take their place with the critical and philosophical literature of the first half of this century whose purpose has been to explain the shift to modernism.

The individual path towards modernism that Hartley pursued places him squarely in the framework of a distinctly American historical tradition. As ordinarily defined the term *experience* refers to our observation of, or participation in an event. For centuries western philosophical systems have tended to categorize existence in terms of thought and its physical counterpart. But it will be seen that Hartley's use of the term is rooted in the American philosophical traditions of Transcendentalism and Pragmatism, in which experience implies a total life orientation, one that cannot be conceptually separated into opposing factors: physical and mental, secular and spiritual, objective and subjective.

In his autobiography, *Somehow a Past*, and in the foreword to his 1921 collection of essays *Adventures in the Arts*, Hartley points to some of the formative influences on his thinking as a young man, notably Emerson's *Essays* (1841) and "the work of the Brothers James,

Will and Henry."[6] Mention of these three central figures in the development of nineteenth- and early twentieth-century American art and thought, is significant; there is in the respective philosophies of Transcendentalism and Pragmatism, and in the novels and critical writings of Henry James, a continuity of belief in the primacy of experience, and for all three, experience is conceived in terms of what can be immediately cognized or actualized.

It was Emerson who, dissatisfied with the static forms of religion into which even the Unitarian church of his background and ministry had fallen, sought to vitalize the thought and art of his time by demonstrating in such essays as *Nature* (1836), *Self-Reliance* (1841), and *The Over-Soul* (1841), that the ideal or transcendental is really one with the immediate and practical. As another pragmatist, John Dewey, wrote of Emerson, "his ideas are not fixed upon any Reality that is beyond or behind or in any way apart, and hence they do not have to be bent. They are versions of the Here and Now, and flow freely. The reputed transcendental growth of an overweening Beyond and Away, Emerson, jealous for spiritual democracy, finds to be the possession of the unquestionable Present."[7]

And later, William James would further clarify this idea of the present actuality of all experience in his *Essays in Radical Empiricism* (1905-07): ". . . the instant field of the Present is at all times what I call 'pure' experience."[8] The phrases "life as idea" and "life itself," repeated many times in Hartley's essays, suggest one of the central postulates of James's philosophy: that experience cannot be split into exclusive and differentiated entities called idea and object, thing and thought, subjective and objective. Rather, says James. "Thought and reality are made of one and the same stuff, which is the stuff of experience in general."[9]

Hartley was attempting in his essays to work out exactly how the modern artist could achieve this same workable co-ordination between the elements of epistemological dualism by starting with experience itself, because in fact, experience includes both the so-called subjective and objective. In his Preface to *The American* the other of "the Brothers James"—Henry—provides an illuminating image which helps to explain this concept of the relationship between experience, concrete fact, and imagination. "The balloon of experience," he says, "is in fact of course tied to the earth, and under that necessity we swing, thanks to a rope of remarkable length, in the

more or less commodious car of the imagination; but it is by the rope
we know where we are, and from the moment that cable is cut we are
at large and unrelated."[10] Hartley perceived the dangers in the lives
of such highly imaginative artists as Albert Pinkham Ryder and
Francis Thompson (much as he loved them) who cut the cable and
lived a tenuous, "unrelated" existence afloat in the "car of the
imagination." Like Henry James, Hartley claimed value in being
able to rise on imaginative wings to get a better view of life below,
but also like James, he wanted to be sure the balloon of experience
was anchored to the fact, even if by a very long cable. In James's view
of fiction (he himself draws an analogy in *The Art of Fiction* between
the novel and painting), the only question to ask of a work of art is,
"is it valid, in a word, is it genuine, is it sincere, the result of some
direct impression or perception of life?"[11] These same questions as to
the validity, sincerity, authenticity, and direct attachment to life, are
queries that underlie virtually every essay Hartley wrote.

Concomitant to the whole issue of imagination vs. intellect was
another major concern which he voiced in his writings (both private
and public) and also bore directly on his role as a painter: the
problem of the self. Realizing early in his career that an essential
ingredient to artistic achievement is the renunciation of self, of the
private psyche, he wrote to Stieglitz in 1911 identifying this problem
and stating his own aim in relation to it:

> I believe until a man has given up himself he has given up nothing—all
> his knowledge of accepted esthetics are of no avail until he has stepped
> aside from them and given up himself—himself only through the eyes of
> himself. What a problem everlasting then is it not? A lifetime of
> breathless endeavor to be the thing and *do* the thing of his being—So easy
> to travel along with claques and crowds, voicing vociferously the great
> discoveries of each—How ineffably difficult, voicing the soul of one
> man—alone to himself and—then to whoever else hears—. . . . So do I
> live and work—striving for but one thing to live as close to the thing as I
> can get—and express myself from that however feebly.[12]

Indeed, it would prove to be "a problem everlasting," which
would have to be hewn out step by step in Hartley's work as a painter
and poet. Through the years it remained one of his highest ideals and
a key measure by which he judged the artists and writers who were

the subjects of his writings. Furthermore it will be seen that in giving up self, Hartley liberated his sense of the imagination from egocentric emotional constraints impinging on him from his roots in nineteenth-century Romanticism.

### *"Life as background"* (1900-1912)

His creative will—his intense desire "to be the thing and *do* the thing of his being," and "to live as close to the thing" as he could—can be seen as the motivating power behind his impulse to write as well as to paint. But though he had the will to create, he did not at first have the wherewithal to become a writer. Having attended art school in Cleveland and New York between 1898 and 1904 he was well prepared to become a painter, but completely untrained in writing skills. His family background was not in the least intellectually oriented. He had had only a grammar school education, leaving school at the age of fourteen to work, before starting art school some four years later. In the 1911 letter to Stieglitz mentioned above, Hartley had claimed, "I have not esthetics as background—I have only life as background."[13] His development as a writer bears out this statement; he was forced, through lack of any educational nurturing, to rely largely upon experience and instinct to guide him in the self-styled program of intellectual cultivation which he pursued from his teenage years, when his art teacher Nina Waldeck first introduced him to Emerson's *Essays*. Through the years he read what interested him, delving into philosophy, mysticism, esthetics, literature—including poetry, fiction, and memoirs. While the broad, eclectic scope of his interests may appear unsystematic, he was nonetheless guided by a native intelligence, and not by institutional standards.

Being self-taught as a writer was in some ways an asset. Free from academic preoccupations or the expectations of commercial publishers, Hartley's writing is enriched by novel and perceptive interpretations, fresh insights, and an idiosyncratic prose style. The fact that he was both painter and poet was a more significant factor in the development of his prose—both in quality and style—than the books he read or his informal education. Though he was naturally affected by the currents of thought in his time, he always pursued an independent view. As one observer points out, Hartley's role as

painter/critic meant that "few of his essays carry the baggage of other critics' observations."[14] He wrote spontaneously, not in response to any professional demand, and always from the intuitively sympathetic standpoint of a comrade artist (even if he happened to disapprove of a particular artistic phenomenon).

His work as a poet had a strong influence on his prose. His essays are best described as *evocative*. Though they rarely follow a discursive line of argument, they ring with a poetic truth, as the language moves from image to image, or from one intuited idea to another, often with minimal or eliptical connections, so that what emerges is an over-all *sense* of a painter's work, a poet's verse, or a certain landscape, rather than a formal account. The fascination and power of the essays emerge from their value in serving Hartley as a vehicle by which he could work out the relevant problems in his painting, and for this reason his prose often has an adventurous, living quality. The themes he wrote about were in harmony with his poetic nature: the visionary and mystical; primitivism; tragedy and immortality— elusive themes, more fittingly expressed by the poetic mentality than by rigorous theory.

Hartley claimed to have begun writing after being complimented on his manner of speaking. Both critics and acquaintances observed this connection between his conversation and the informal quality of his writing.[15] His lifelone friend, Arnold Rönnebeck recalled some years after his death that Hartley "could not help *writing or speaking quite informally*; *he spoke in STYLE*. He always spoke in style. That New England, Emersonian style never left him even in conversation . . ."[16] The resemblance between Hartley's style of writing and that of Emerson is also manifest in their use of epigrammatic statements. Their essays are marked by brilliantly intuited insights strung together between longer, densely packed passages, so searching and venturesome that they are sometimes syntactically awkward. His preference for the convention of relaxed, eloquent exchange of ideas possible through letters, and his aversion to the telephone also link Hartley to the New England tradition of letter and journal writing carried on by Emerson, Emily Dickinson, Thoreau and Bronson Alcott. His voluminous correspondence records his thoughts on matters of immediate import to his activities, much of it containing in germinal form ideas later wrought out more fully in his essays.

The catalyst that transformed Hartley from an amateur to a professional writer was his first adventure in Europe (1912–15), coupled with his fortunate association with Alfred Stieglitz, his Photo-Secession Galleries (known fondly as "291" for its address on Fifth Avenue), and its historic periodical *Camera Work*. Stieglitz's role in promoting Hartley's painting career is widely known and thoroughly documented.[17] Less known is the major part that Stieglitz played in supporting Hartley's burgeoning talents as a literary spokesman of the arts. Stieglitz acted as a sounding board, replying with energy and enthusiasm to Hartley's long letters from Europe describing his impressions of all that he encountered in art circles. Very quickly, however, Hartley's letters evolved—no doubt with Stieglitz's active encouragement—into formal declarations about his own art vis-à-vis that of the modernism he had come into contact with on the Continent. Published as forewords to catalogues accompanying his exhibitions at 291 and elsewhere in 1914, 1915, and 1916, they were subsequently reprinted in *Camera Work*. Later, Stieglitz was responsible for helping Hartley publish his first collection of essays *Adventures in the Arts* in 1921. Still later, in the 1930s, despite a growing rift between them, Stieglitz continued to provide an outlet for his writing by printing other catalogue essays Hartley wrote for exhibitions of his own painting as well as for those of other 291 artists, including Georgia O'Keeffe, Charles Demuth, John Marin and George Grosz.

As Hartley's involvement with the Stieglitz-291 nexus deepened and his experience in European modernism widened, he was amazed to find, as he observed in one early essay, that "poetry is one piece with life, not the result of stuffy studios, and excessively ornate library corners, where books crowd out the quality of people and things,"[18] and that poetry and art were the everyday topics of conversation at the restaurants and café terraces that he and his colleagues frequented. It is natural that his prose and poetry evolved out of this experiential context, and his urge to write arose spontaneously from a desire to record what he saw in museums and galleries and what he heard discussed at those gatherings. Those writings, which "are of one piece with life" serve a self-revelatory, autobiographical function in a way that his actual autobiography is unable to. Hartley the man and artist is interwoven in the fabric of words about artists, poets, and others whose lives and works touched his

own; his comments about artists whom he admired or even those he criticized, reflect his own esthetics, and out of the context of those words we glean a composite self-portrait.

*Empirical discovery of modernism (1914–1916)*

From the start and at crucial points throughout his career, Hartley's writing served as the proving ground on which to thresh out elements that comprised his identity as an artist. His first public statement—the 1914 catalogue preface which accompanied his painting exhibition at 291—is bursting with ideas that he would later elaborate. It states in part:

> The intention of the pictures separately and collectively is to state a personal conviction—to express a purely personal approach. It has nothing whatsoever to do with the prevailing modes and tendencies— cliques and groups of the day. . . . . True modes of art are derived from modes of individuals understanding life. The idea of modernity is but a new attachment to things universal.

Some art historians have viewed this statement and others from these early years as merely, in the words of one critic, "Hartley's lack of candor about his work and the inspiration motivating him [which] in this instance is in keeping with his denials of various influences on his work. Like so many artists, he often wanted to preserve a sense of mystery about the subjects and the sources of his works."[19] Interpreting Hartley's statement thus has validity if taken by itself in its limited historical context. But viewed from the broader perspective of his thought, it becomes evident that what he is affirming in these catalogue forewords, is that beyond artistic influence, beyond purely formal concerns in painting, the artist's real business is personal discovery of a truly original form of expression not dependent on "styles and prevailing modes," nor even on one's given cultural background. In a letter to Stieglitz from this same period in Paris, Hartley put it this way, "I have discovered my essential self here, but this has been due to nothing or no one but myself—the sources that have helped me to my newest means of expression are without geography—It is universal in essence."[20] This is not to say that his experience with the art movements of the day did not have an

important effect on his thought and painting; he later acknowledged his debt to "all these isms" which "had their inestimable value and clarified the mind and the scene of all superfluous emotionalism" ("Art—and the Personal Life"). But his assertion here is that "life itself" is the primary and "universal" source of creative vision, a source more profoundly generative than the exigencies of style which are experiments in the *means* of expression and represent merely the surface aspect of a deeper purpose and attachment to experience itself.

The thrust of European modernism was, above all, toward solutions to formal problems first posed by Manet and the Impressionists. These Hartley and many of his American contemporaries—Demuth, Marin, Weber—assimilated in a gratuitous, almost cavalier manner. But at the same time there was a growing awareness on the part of some American artists that formal solutions were not enough, so that in 1914 Hartley could assert with startling conviction in this manifesto that form is not the essence of a work of art, but that "true modes of art are derived from modes of individuals understanding life." Form arises naturally when the artist grasps the heart of the experience from which his work emerges. In Hartley's painting objects in nature are not copied in a mimetic fashion; the structure of the situation as experienced by the artist is given statement in the structure of the painting. It is precisely in this awareness that he could make the claim that his pictures have nothing to do with prevailing modes.

Hartley's early statements belong to a wider stream of the American tradition. The early American limner painters worked empirically as itinerant portrait artists; in their rural isolation they had no formal training, no method to draw from but their experience as sign craftsmen. In the nineteenth century Fitz Hugh Lane typifies another kind of empiricism. Except for his early experience as a printmaker he was self-taught, and his was basically a primitive vision. Winslow Homer, despite exposure in Europe to the art of Manet, Courbet, and possibly Japanese prints, seems to have developed largely from indigenous beginnings and training as a lithographic illustrator. His discovery of an American proto-impressionist idiom appears to parallel, rather than follow the work of his European contemporaries.[21]

Hartley belongs to this empirical tradition, but unlike his colonial

and nineteenth-century predecessors, his orientation did not stem from isolation, naiveté, or training as a craftsman. It derived from his conscious awareness (based partly on his reading of Emerson and "the Brothers James") of the role of experience as a guiding force in his creative endeavor, an awareness which eventually became clear in a lifetime of writing about art. He confronted the intellectual and theoretical breakthroughs in Europe with the conviction that an artist acquires originality through first-hand knowledge of other art forms, through experimentation and involvement, and he is then in the position to break barriers and claim new territory. This is not to imply that the empirical method in art is an exclusively American phenomenon. Hartley's heroes, the men and women of "original vision" whom he admired, were European and American, and the one characteristic they shared was their pioneer spirit.

Related to the issue of originality is the notion of the artist as visionary, expressed for the first time in this 1914 statement, in which Hartley says that the paintings in the exhibition have only *visionary* motives and that "the delight which exists in ordinary moments is his [the artist's] ecstasy. In the art of the ordinary there is the sense of devotion. In the art of the specialist there is the sense of habit. It is devotion which is closest to creation. Boehme was a devotional ordinary—Cézanne and Rousseau also. A real visionary believes what he sees. The present exhibition is the work of one who sees—who believes in what is seen—and to whom every picture is a portrait of that something seen." For Hartley the visionary is not only one who merely imagines objects in some transcendent realm, but is able to see in the ordinary facts of experience the "living essence" or "spirit substance in all things," to take the raw facts of experience and act creatively on them. Through his imaginative faculties the artist or poet selects, orders, and intensifies these facts, and communicates something of their "spirit substance," their value or universal meaning, through the work of art.

*Beyond subject matter*

When Hartley stated in his 1914 manifesto, "It is the artist's business to select forms suitable to his own specialized experience, forms which express naturally the emotions he personally desires to present, leaving conjectures and discussions to take care of them-

selves. They add nothing to art," he was arguing for the autonomy of
the work of art. Though a painting might derive from "specialized
experience" and personal emotions, once realized on canvas it
achieved, for Hartley, a status of self-determination "leaving conjec-
ture and discussions to take care of themselves." The implications of
this remark widened into greater significance two years later at his
next exhibition at 291 in April 1916, of a group of paintings he had
executed during the previous two years while living in Berlin, then
in the throes of World War I. These canvases—with their abstract
motifs of German military insignia and emblems—have been the
subject of considerable discussion ever since that time, as has the
terse comment Hartley wrote to accompany them: "The forms are
only those I have observed casually from day to day. There is no
hidden symbolism whatsoever in them. . . ." This seemingly auda-
cious remark was apparently necessary to counteract the virulent
anti-German sentiment of the time. Throughout his life, Hartley
was adamantly apolitical and naturally eschewed any "conjectures"
that the military emblems he painted were symbolic of pro-German
feelings. Critics have demonstrated convincingly that some of the
forms obviously relate to the young German officer, Karl von
Freyburg, to whom Hartley had been strongly attracted and whose
death in action in October 1914 had been a severe blow. [22]

While these circumstantial facts would seem to contradict
Hartley's disclaimer of "hidden symbolism," there is a more far-
reaching purport in his words. They correspond with his earlier
assertion that art must derive from "specialized experience" includ-
ing emotional involvements. To New York art audiences of 1916
abstract art was still largely anathema. Charles Caffin, critic for the
*New York American* and one of the few supporters of the 291 artists,
put his finger on the crux of the issue when he commented that
Hartley: "tells us that he has expressed only what he has seen. . . .
The motive of these is scarcely what has been seen, unless it be in the
mind's eye." [23] Like so many other artists and writers—both in
American and Europe—Hartley was operating from the radically
new standpoint of an art which no longer bore the burden of copying
external reality. They accepted images in the "mind's eye" as equally
valid in a work of art as forms of the natural world. Among Hartley's
miscellaneous notes is a page of excerpts from a letter written by
Gustave Flaubert to Louise Colet in 1852, which Hartley himself

must have translated from the French.[24] The letter prophesies the coming of a "pure Art" which would exist by its own internal strength. "In such an art," Flaubert writes, "the finest books are those which have the least subject matter. The more closely the expression approximates the thought, the more beautiful the book is." Flaubert saw this as the future etherealization of art—a conclusion with which Hartley would not agree. But what obviously impressed him in Flaubert's comment was the possibility of an art freed from the constraints of subject matter, an art that could approximate thought as readily as things.

William James's radical empiricism confirms Hartley's claim. In James's view knowledge is not comprised of two separate entities, percept and concept; experience includes both idea and object, what we see in the physical world and what we know in the mind; ". . . knowledge of sensible realities thus comes to life inside the tissue of experience. It is *made*; and by relations that unroll themselves in time."[25] The idea of a thing and the thing itself cannot be separated; they are relational aspects of one broader context: experience itself. The thought (idea, essence) of a physical object unfolds or is made in the process of one's experience of it. Ideas are as "real" as objects; they are but varying densities of the same experience. To Hartley, the forms that comprise a work of art were just as real whether they arose from observed phenomena, from an idea, or from feeling. He was simply refusing to allow his paintings to become mere symbolic reductions of events or things. He later stated that "symbolism can never quite be evaded in any work of art because every form and movement that we make symbolizes a condition in ourselves" ("Dissertation on Modern Painting," 1921). He wanted an art that corresponds in *quality* to things "seen casually from day to day," not limited to a symbolic interpretation of specific subject matter.

### Spokesman for the hermit radicals (1915–1921)

In seven short years Hartley became a well-published author. By 1921 he had seventeen essays and a dozen or so poems in print. That was to be the most intense period of public acceptance he would enjoy as a writer. With his perceptive, often eloquent articles on the art and literature of the day, he gained entry into the "little magazines" that were beginning to burgeon: *Seven Arts, Touchstone,*

*Poetry*, *The Little Review*, and *Contact*; as well into some of the prestigious, established weeklies and professional journals: *The Dial*, *New Republic*, *The Nation*, and *Art and Archaeology*. His essays appeared alongside those of prominent men of letters, some of whom he knew personally: Van Wyck Brooks, Waldo Frank, Hart Crane, Paul Rosenfeld, and William Carlos Williams. As painter, poet, and critic, Hartley was active on three fronts in what *Seven Arts* proclaimed as a blossoming American renascence in the arts. When *Seven Arts* first appeared in November 1916, its editorial called on American writers to submit poetry and fiction that were an expression of natural life, and critical writing "which it is hoped will be no less creative . . . [whose] aim will be to give vistas and meanings rather than a monthly survey or review; to interpret rather than catalog."[26] Hartley, Rosenfeld, Frank, and other writers on the periphery of the Stieglitz circle, were a special breed, given to appreciative, impressionistic criticism, writing about painting, literature, and music from within the art experience.

For a time, especially during these pre-war years, this kind of criticism flourished and Hartley was able to collect his essays into book form. *Adventures in the Arts* (issued in 1921 by Charles Boni—of Boni and Liveright—a friend of Stieglitz) remained the only book of prose Hartley saw published, and has been until now the primary means by which he is known as an essayist.[27]

The major theme uniting the diverse articles of *Adventures in the Arts* is Hartley's admiration for the "hermit radicals" in art, literature, and the theater (the three sections into which the volume is divided), those individuals whose gift of original vision sets them apart from society. Whitman, Cézanne, Ryder, Francis Thompson, Emily Dickinson, and Adelaide Crapsey, the acrobat and vaudeville entertainer, were all solitary visionaries of this type. Cézanne and Whitman are seen in one chapter as supreme examples of the hermit radical type, as "the gateway for our modern esthetic development, the prophets of the new time. They are most of all, the primitives of the way they have begun, they have voiced most of all the imperative need of essential personalism, of direct expression out of direct experience."[28]

Some though not all of the men and women discussed in the book are of a romantic, even mystical nature, whom Hartley affectionately called "our imaginatives," who created their experience in art

essentially from an interior frame of reference, or from mystical sources, rather than from a perception of objective forms of reality; it is they, he insisted, who were the pioneers of an indigenous American art. Hartley's predilection toward this area of experience accounts for the affinity he felt for artists of a mystical inclination. From an early point in his career he had been fascinated with mysticism. He loved the paintings of Ryder, the poetry of Blake and John Donne, Francis Thompson, and W. B. Yeats, among others; at various points in his life he read the philosophy of Jacob Boehme, Plotinus, and Paracelsus, as well as the works of such Christian mystics as Richard Rolle, St. John of the Cross, and St. Thérèse of Lisieux. He was impressed by the different ways in which each of these figures lived out his or her personal vision, but he was also troubled by the sufferings in the lives of Ryder and Thompson, among others, who seemed to have little practical ability to deal with the mundane world.

### The shift toward the outside (1919–1928)

Certain passages in *Adventures in the Arts* and other more contemporary essays published in this volume, suggest this growing ambivalence in Hartley's attitude toward the imaginative consciousness and the place of the visionary artist in a predominantly mechanistic and intellectual age. Of Thompson he wrote: "he has scaled the white rainbow of the night, and sits in radiant company among the first planetary strummers of song," and went on to observe, with an undertone of regret:

Poetry has passed into scientific discovery. Intellectual passions are the vogue, earth is coming into its own, for there is no more heaven in the mind. We are showing our humanities now, and the soul must wait a little, and remain speechless in some dull corner of the universe. . . . We are learning to think now, so poetry has come to calculation. Rhapsody and passion are romantic, and we are not romantic. The last Rhapsodist was Francis Thompson, and in the sense of lyrical fervour, the last great poet was Francis Thompson.[29]

The momentum behind the shift in his thought around 1919 can be traced in part to his association with Robert McAlmon, William

Carlos Williams, and other writers in the vanguard of American
poetry. Hartley met McAlmon in 1919 at a poetry reading in Los
Angeles, while visiting his friend Carl Sprinchorn who lived nearby
in La Cañada. He had already read some of McAlmon's verses
published in *Poetry* the year before, and was immediately drawn to
this vibrant young aviator/poet. When they met again in New York
the next year he introduced McAlmon to Williams, and from that
friendship evolved the founding of *Contact* magazine. The inaugural
issue, appearing in December 1920, contained a statement of intent
which McAlmon helped to write, while Hartley contributed two
poems and also suggested including excerpts of letters written by his
late friend, the painter Rex Slinkard to his fiancée. The editorial in
that first issue (like that of *Seven Arts* three years before) stressed the
need for an indigenous literature, arising from direct experience and
dependent on local forms of expression. The message was that
without the life impulse poetry is merely flat and intellectually
contrived.

The contact with McAlmon and Williams, as well as with the
New York Dadaists clustered around the Société Anonyme, accen-
tuated Hartley's shift away from the romantic preoccupations of his
youth and "toward the outside." The Afterword to *Adventures in the
Arts*, entitled "The Importance of Being 'Dada' " stated that he was
Dadaist only because it approximated a "scientific principle in
experience," and that on the "hobby horse" of Dadaism he would
"ride away . . . out into the world of intricate common experience;
out into the arena with those who know what the element of life itself
is. How can anything to which I am not related have any bearing
upon me as an artist?"[30] Hartley's encounter with Dadaism was
brief, but it served to strengthen his assumption that we must relieve
art of "its infliction of the big 'A' "—take away the preciousness that
has traditionally surrounded it, and find instead authentic artistic
expression in "the world . . . of common experience."

After publication of *Adventures in the Arts*, there was a sudden
hiatus in his prose writing, and between 1921 and 1927 only a
handful of articles—none of any great distinction—appeared in
print. He did manage, however, to have his first book of poetry,
*Twenty-five Poems*, published in 1923 by McAlmon who, having by
this time married Bryher, a wealthy British heiress and poetess, was
able to start his own publishing company in Paris and thereby

support the poetry and fiction of a number of young or neglected American authors, among them Gertrude Stein and Hemingway. The drop in publication of Hartley's work was due in part to his extended residence abroad (1921–1929, with only intermittent visits home), first in Berlin and later in southern France where he was separated from his contacts with American journals. What enabled him to make this second major sojourn in Europe was the 1921 auction of his unsold paintings and, in 1925, an arrangement set up by his friend William Bullitt whereby a "syndicate" of business associates granted him a yearly stipend through 1929 in return for a certain number of paintings. These two financial sources allowed him the freedom to live, travel and work abroad, replacing somewhat the need for yearly exhibitions of his paintings, the sales from which had rarely netted him adequate income.

The decade of the twenties is often viewed as an interim period of stasis in Hartley's work, of fewer exhibitions and published writings, and of paintings that never quite came off. To all external appearances such was indeed the case. But there was a great deal going on beneath the surface, the signs of which are revealed most poignantly in his unpublished essays and letters during these years. His compulsion to write never ceased, though there were a few comparatively slack years. Much of what he did write during this period has disappeared—either lost or destroyed. And by 1930 when he had finished his next collection of essays, *Varied Patterns*, the Depression had set in, and he faced the difficulty of marketing his book.

### *The process of self-identification*

The individual articles comprising *Varied Patterns*, taken together with two key statements about his own art, written and published in 1928—"Art—and the Personal Life," and "The MOUNTAIN and the RECONSTRUCTION"—demonstrate that more than ever he was grappling with tough issues that would have a profound impact on his development as an artist. They reveal his effort to face up squarely to the implications of his writing and to actualize in practice as a painter the ideal he had been prescribing in his prose for some years.

The central problem he confronted at this time was the necessity

for self-identification in an art world fraught with what he called inauthentic "personalism." He was troubled, even disgusted, by the hypocrisy he saw as rampant in the art scene in Paris. In his view the great pre-war giants—Picasso, Braque, Derain, Vlaminck—were resting on their laurels, imitating themselves and being imitated by a younger generation, all of whom capitulated to a lucrative commercialism. Describing the situation to his friend Rebecca Strand in a letter of 1929, he noted that Europe "is a cemetery of forgotten ideals esthetically speaking & the artists have given up the ghost—at very satisfactory prices."[31]

Hartley's harsh judgment of what he saw as the static decline into repetition among the cubists is no less unorthodox and startling than his indictment of surrealism, which he described as literary theatricism and a cerebral hoax. "Are they experienced truths?" he asks in his essay on surrealist painter Max Ernst. Underlying his iconoclastic evaluation of these two sacred institutions of twentieth-century art was his skepticism about excessive manifestations of personality, about the glorification of inwardness and subjectivity for its own sake. His letters voice what he expressed less directly in the essays but which is nonetheless fundamental to them. Furthermore these letters, though characterized at times by complaint, reveal his internal struggle with the concept of self, a struggle that found expression in critical writings about his contemporaries. Together these show the process by which he eventually extricated himself from the morass of subjectivity.

He blamed his early reliance on imagination for his current problems, and rejected Blake's injunction to "put off intellect and put on imagination" as an unsound doctrine (a theme he developed in "Art—and the Personal Life"). He gradually began to feel he was "shaking himself out of the mummy case of the imagination" and learning to see through its "guises and disguises," as he told Stieglitz in a letter, adding that he wanted a "whole new basis of experience—to escape the illusion and see the reality."[32] What he needed, he felt, was to clarify his perception, to have a mathematician's grasp of fact, "to get pure form into myself."[33]

Hartley's interest in the work of George Santayana is indicative of his shift toward greater objectivity. He quoted in letters to both Rebecca Strand and Stieglitz a passage from *Skepticism and Animal*

*Faith* which stated precisely his own aim: "To distinguish that fine edge of truth from the might of the imagination." Though he sought freedom from the "might of the imagination" to which he had felt bound in his youth, he realized that intellectuality was not the right direction either. He saw the dead end of intellectuality in surrealism and wanted no part of it. He found confirmation of his anti-intellectual feelings in another author he was immersed in at the time, Miguel Unamuno whose *Essays and Soliloquies* had recently been translated into English. As he wrote in letters, Hartley was attracted to the Spaniard's intense conviction that his poetry and philosophy stemmed from his passionate desire to *live* and that art cannot be separated from that life impulse. More specific, however, was Hartley's appreciation of Unamuno's disdain for intellectual affectation, as indicated in his essay "The Spanish Christ" (which Hartley indeed read and referred to), where Unamuno uses St. Paul's categories of the carnal (psychical or intellectual) man and the spiritual (pneumatical) man to point out the limitations of the intellect. Science, he claims, can satisfy our logical need to know the truth, but it can never satisfy the needs of our heart or our hunger for immortality. The spiritual man—the dreamer and mystic—speaks the language of the heart.[34]

Although Hartley disclaimed the inward-turning subjectivity of the romantic imagination, he was still holding to its mystical element. It was the mystics who pointed the way for him in his process of self-identification, because in order for the mystic to achieve a state of clarification and oneness with the infinite, he must relinquish a degree of mortal ego. Hartley in fact hinted at a parallel between the mystic and the artist in his essay in *Varied Patterns* on St. Thérèse of Lisieux whose *L'Histoire d'une Ame* he read in 1925, and further pointed to this connection in a letter which declared, "It is the radiant shine of the mystics I seem to enjoy. The[y] actually take on the light they believe in just as I feel Fra Angelico did in his painting."[35]

He was discovering that the way out of a self-absorbed state of mind was not necessarily to reject the imagination (he told Rebecca Strand, "I have escaped from its influence, if not precisely from its meaning"[36]), but to develop a healthy skepticism toward its trap of egocentricity. Nor did he find the way out through espousing the intellectual path "which," he said in the same letter, "alas is only very

roughly indicated in my mental equipment." The way out of this dilemma for him lay in a reaffirmation of his old faith in "life itself." In a mood of despondency about ever attaining stability he wrote another friend "I want to be life and not myself, and how is one all tinged with questioning and tinged with mystic longings and relations ever to get out of the dull bondage. Not having recourse to the superficialities & the flat hypocrisies of the social life, I get no sustenance from them. I don't want to be condemned to spectatorship. I want to be released by it." All that was wanted, he claimed, was "just a wholesome supply of magnanimous life."[37] To be "condemned to spectatorship" meant to be separated from life by intellectualism; he merely wanted to be released from the bondage of inwardness by a greater degree of objective clarity and precision.

Like his earlier essays, *Varied Patterns* reveals a profound orientation to experience as the factor identifying the artists he admired. Similarly, the absence of it marked those he disapproved of. Toulouse-Lautrec lived a life that does not stem "from cowardice or superimposed principles [but] from the vital element itself, which is, in the end, just life." Masaccio and Piero della Francesca were able to paint religious scenes and divine figures that were believable because they were portrayed with a sense of their actual, living humanity. By contrast, the work of Ingres derived from dogma, not life. "One longs," he says of Ingres, "for a least touch of the simple impulse of life," instead of which one gets "paid models in antique poses."

More than anyone, however, it was Cézanne who pointed Hartley in the direction that would thrust his art and writing to its fullest potential in the years to come. In a lecture some years later he aptly summarized the impact of Cézanne's work upon his own. Paraphrasing Cézanne's famous remark, "I want to paint that thing which exists between me and the object," Hartley said, "I want to paint the livingness of appearances, and to understand this livingness calls for deep study not only of painting but of all the qualities of life."[38] Hartley attempted during his residence in Aix-en-Provence, to follow Cézanne's injunction to live close to nature. In the surrounding countryside, he drew and painted from nature, experiencing every aspect of its form and character, especially Mont Ste. Victoire, the mountain made famous by Cézanne. In "The MOUNTAIN and the RECONSTRUCTION," a poetic recapitulation of all that Cézanne meant to him, he says to his "angelic pup" (the dog he then

owned and adored), "we are going to live with this mountain." By this process of immersion in the object, the "complete experience of the thing," Hartley began to turn outward, away from the self of the interior realm of the imagination and to anchor his "balloon of experience" more securely in the observable facts of nature. At one point he quoted Santayana's comment on Lucretius: "The greatest thing about this genius is its power of losing itself in its object, its impersonality. We seem to be reading not the poetry of a poet about things, but the poetry of things themselves. That things have their Poetry, not because of what we make them symbols of, but because of their own moment of life, is what Lucretius proves once for all to mankind."[39] Unlike the surrealists, Hartley was not interested in painting images that have significance only by means of a personal symbolism; that is why he had eschewed symbolism in his earlier work. Things have their own poetry, their own moment in life, which it is the artist's job to discover, not contrive.

### Rediscovering America and the imagination (1929–1935)

The year 1929 rocked the world economically, and it signalled in Hartley's life a number of important changes. In January of 1928 he returned to the United States for nine months, on the occasion of the exhibition of his painting at the Arts Club of Chicago, (for which "The MOUNTAIN and the RECONSTRUCTION" served as the catalogue statement), and when he returned to Europe in August, everything that he had been striving for in his writing and painting came more clearly into focus. As he explained to Rebecca Strand, "I had to come back once more to find out how barren Europe is of ideas—of belief in art—or even of spiritual prospect."[40] This realization was voiced in the essays he wrote that year for *Varied Patterns*.

The pressure to return to the United States had been mounting from all sides. He had profited by his time alone at Aix but was thoroughly disgusted with Europe in general; moreover, the stipend from William Bullit and associates had come to an end at this point; and disapproving remarks were echoing across the Atlantic from critics and friends alike. Henry McBride, Stieglitz, Rosenfeld and Frank all felt that Hartley had wandered too far and too long from home territory. Frank expressed indirectly Hartley's predicament in *The Rediscovery of America* (1929) which might well have influenced Hartley's thinking on the subject. In discussing the issue of Ameri-

cans in Europe, Frank observed: "The American who has really lived in Europe—and this means, who has partaken of its life with Europeans—to save his life must return to his own place. For he will have learned, if the gift of life is in him, . . . that he must *give* to have it. . . . There he took: here only he may create what the world, including Europe, can receive. If he does less, he will not have lived in Europe; he will have died there."[41] Frank's assumption that the expatriate American artist who does not return home will have died in Europe certainly did not hold true for writers like Gertrude Stein, T. S. Eliot, and Ezra Pound (whose incarceration at St. Elizabeth's Hospital in Washington was hardly a return home), but it might well have been true of Hartley as a visual artist.

In March of 1930 he did come back and began at once to immerse himself in things American, as if to shed the dead skin of an effete Europe. During 1930 and early 1931 he saw exhibitions of and wrote chiefly about Americans: Eakins, Homer, Ryder, John Singleton Copley, William Harnett, Mark Tobey, American primitive painters, and others. In these, and in other essays from the late 1930s, he addressed specifically American issues: what it means to be an American artist; whether there *is* an American art; regionalism, American scene painting, the sense of place in American art; and the question of realism.

As a painter, Hartley's rediscovery of America was not won immediately and would be further interrupted by one last trip abroad (to Mexico on a Guggenheim Fellowship, 1932–33, followed straightaway by a year and a half in Germany). The summer of 1930, meanwhile, he spent in Franconia, New Hampshire, seeking to get at the heart of New England landscape, but it was a disaster. The region was crawling with tourists, "scenery hounds" he called them, who "look by the mile and see but an instant and have no wish to look deeper."[42] Having failed to touch his native chord in the typical American scene, he tried, in the summer of 1931, to find it in an atypical spot, remote from the hordes of tourists. He went to Gloucester on Massachusetts' Cape Ann, but not to paint the charming, picturesque harbor scenes that attracted a regular summer art colony. He went inland to a forsaken site called Dogtown Common, distinguished only by huge glacial boulders, broken fences and scrubby plants. He liked this place because it was nature, alone, stark and wild, like the Wuthering Heights region of his ancestry. He felt it was good to be painting these rocks that had stood

for eons, and quoted three lines from T. S. Eliot's poem *Ash Wednesday* (1930) on the back of one the canvases:

> Teach us to care and not to care
> Teach us to sit still
> Even among these rocks

which, he explained in a letter, signified his own need to sit still long enough to come to terms with himself and his life situation. Not being picturesquely attractive, Dogtown offered him this opportunity for reconstruction. It would not appeal to the "fake modernists" and was unrelated to "cults and tricks and movements," as he told Stieglitz,"[43] referring no doubt to the contemporaneous craze for American scene painting. Here he discovered his roots and began to define for himself the meaning of place, not as a result of portraying the physical characteristics of this geographical location, but as a consequence of what the experience of the place did to activate his consciousness.[44] It was a total experience, the complete immersion in the subject, that Cézanne's example had taught him. Dogtown represented for him "a place of psychic clarity," and he prophesied correctly, "it speaks well for my esthetic and spiritual future."[45]

Hartley's year in Mexico was generally a negative experience, clouded by the gloom of Hart Crane's suicide (on the return voyage from his Guggenheim Fellowship year in Mexico), and chronic ill health. The only redeeming forces he found there were the pure bred Indians. Both the Spaniard and the mestizo lacked the essential integrity and beauty which belonged, in his view, to these ancient people. Typically, his best moments were spent in the museums of Mexico City and the outlying temples where he studied the Aztec and Mayan ruins and artifacts. As his earlier essays on the American Indians (in *Adventures in the Arts* and a series in *Art and Archaeology*) had pointed out, the Indians' sense of integrity, as people and as artisans, stemmed from the unity of their art and their way of life, no affectation in the making of objects, no imposed esthetic theory. It was against such esthetic integrity that he would later judge such artists as Jacob Epstein and Paul Gauguin who, in his view, as sophisticated Europeans, tried ineffectually to affect the primitive in their art forms. Hartley had no patience with such spurious means of expression.

His stay in Mexico provided an unexpected opportunity in another area, which had significant implications for the future. He had access to a friend's library which specialized in mysticism and the occult. There he again delved into this favorite subject and vowed in letters to return to his earlier mystical paintings. He attributed "this release back to imagination" to the sixteenth-century physician and alchemist, Paracelsus,[46] whose writings, characterized by a unique blend of mysticism and esoteric science, influenced another of Hartley's beloved mystics, Jacob Boehme. Though it is not certain which of Paracelsus's works Hartley read, there are, among the papers in his estate, notes containing a list of terms employed by Paracelsus which help elucidate exactly how this "release" was won: first is the key term "Imaginatio" which is defined as,

The plastic power of the soul, produced by active consciousness, desire, will.

then "ADECH":

The inner (spiritual) man, lord of thought and imagination, forming subjectively all things in his mind, which the exterior (material) man may objectively reproduce.
Either of these two acts according to his nature, the invisible in an invisible, and the visible one in a visible manner, but both act correspondingly. The outer man may act what the inner man thinks, but thinking is acting in the sphere of thought, and the products of thought are transcendently substantial, even if they are not thrown into objectivity on the material plane.[47]

For Hartley to realize that the imagination is not merely an uncontrollable flight of fantasy, but the result of an active conscious will, and that these products of thought have their own substantiality, was undoubtedly precisely the handle he had been groping for to enable him to release the "plastic power" of the imagination.

From Mexico he went directly north, to cool his soul from the burning heat of the southland. He spent the summer of 1933 in Hamburg, writing about his exploits in this German port city and its environs, and about his experience in Mexico—vignettes that would later form part of his autobiography. In September he decided to

spend some time in the Bavarian Alps before returning home, feeling, as he told a friend in a letter, that he must "live with" a few Alps, face them every day and have them "enlarge his vision and spirit."[48] Accordingly he stayed in a boarding house in Partenkirchen from September through February of 1934, painting and continuing his reading of the mystics, particularly Plotinus, Ruysbroeck, and Richard Rolle. It was a period of serenity and clarity. He quoted several times an aphorism of Ruysbroeck—"Perfect stillness, perfect fecundity" because it seemed to describe his own state of thought. He felt that in achieving the quality of exactitude in his painting, he had been especially helped by Plotinus because, as he explained, he "refined my sense of essence so much that I am able to see right down to the last detail."[49]

Hartley's productivity during this last sojourn aboard (1932—35) seems to have centered largely on his painting. However, while in Germany, he read Gertrude Stein's *Autobiography of Alice B. Toklas* and was inspired to begin work on his own life story, *Somehow a Past* which would occupy his attention intermittently for some time to come. But after his return home in 1934 the dam of uncertainty and tentativeness in his writing and painting broke, and a floodtide of creativity flowed forth during the last nine years of his life. Though there were still times of struggle and discouragement, the works took on something of a life of their own, a quality of stature and *presence*. His letters during these years are full of reports of writing in progress—collections of essays and poems, revisions and regroupings—and of prospective publishers. Though most of the book publication schemes came to nothing, several important essays (on Ryder, Demuth, Marin, O'Keeffe, Gaston Lachaise, among others) and two small collections of poetry *(Androscoggin* and *Sea Burial)* appeared in print. Taken as a whole the writing of this final decade of his life reveals a process of coalescing in which the themes that had occupied him from the beginning came together in natural resolution.

### Governing the imagination

One step in this resolution appears in two quotations from Gerard de Nerval that form the epigraph to a collection of poems called *Tangent Decisions* he was writing at this time:

How is it—I said to myself
that I can possibly have lived
so long outside nature, without
identifying myself with her?
All things live, all things have
motion, all things correspond.
The majestic rays emanating from
myself to others, traverse without
obstacle, the infinite chain of related things.

and

I want to govern my dreams, instead
of endure them. [50]

In Hartley's experience the lessons of Cézanne, Dogtown Common, the Bavarian Alps, were proving that complete understanding of nature was the artist's way of governing his dreams, of taming the wild fancies of the imagination by means of what he called (taking his cue from Nerval) the "faculty of identification," which is nothing less than clarity of perception.

It was at this juncture that he wrote his long descriptive article on his beloved Ryder, published in the 1936 *New Caravan*, in which he depicted the deplorable conditions of Ryder's poverty, mentioning also Vachel Lindsay's tragic decline and suicide in 1931—circumstances pointing to the "sad lot of the poor fool who believes that vision is everything and fact to be ignored." Ryder, in Hartley's view, enclosed himself in the kingdom of his imagination and "was at once its humble ruler, as well as its loyal servant." As a consequence he, like other visionaries (St. Francis of Assisi, Jacob Boehme, Richard Rolle, are the ones named) was oblivious or immune to the suffering incurred by poverty. "When the head is among the stars the feet hardly recognize the rocks that drew the blood from them." Cherishing the sacredness of the vision, such individuals are unwilling to compromise it, however merciless the outcome. Hartley was somewhat in awe of this kind of indomitable integrity—of Ryder's being "prepared to perish for his ideas," and "brave enough to invite, and most exacting of all, to endure" such a life, but beneath his respect and admiration is a solemn note of empirical awareness that

the artist who could govern the imagination by keeping his feet grounded in the facts of experience would not need to suffer the miseries wrought by total subjectivity. As an artist, Hartley would rather cultivate the governing of dreams than have to endure them.

He continued to champion the cause of visionary artists, express-ing a growing conviction that the imaginative element, if it coincides with a thorough understanding of experience, is indispensable to the creative process. Writing of the painting of Milton Avery in "The Persistence of the Imagination" (a title which in itself suggests that the imagination will endure despite opposing cross-currents,) he alluded to the quality of Avery's work as "a strange magic in the sudden appearance of things, knowing that things may become something else before one's very eyes and that something else is just as true to the things as what they are before the something happened." Things seen through the imagination are just as real, have just as much validity, as before the transfiguring of the imaginative process.

### "Sources of revelation"

Years later Wallace Stevens, in *The Necessary Angel* (1942) de-scribed precisely what Hartley could convey only roughly. Stevens saw an analogy between poetry and painting in their mutual derivation in a "constructive faculty, that derives its energy more from the imagination than the sensibility."[51] He replaced sensibility (which he linked to the nineteenth-century notion of feeling or inspiration) with this "constructive faculty" which is "not dependent on the vicissitudes of the sensibility. . . . The poet does his job by virtue of an effort of the mind. In doing so, he is in rapport with the painter, who does his job, with respect to the problems of form and color, which confront him incessantly . . . by imagination or by the miraculous kind of reason that the imagination sometimes pro-motes." This process involves "not simply delectations of the senses" but "the labor of calculation."[52] Stevens referred directly to paintings in the Museum of Modern Art which acquire in time a "mystical esthetic," a "prodigious search of appearance, as if to find a way of saying and of establishing that all things, whether below or above the appearance, are one" and the artists of the twentieth century helped create a new reality in which those things above and below the

appearance can be joined.[53] Stevens saw painting and poetry as compensating in a modern era of disbelief, for religion, and the imagination as a power comparable to faith. He gave "vatic" stature to the poet and "orphic" power to the painter in fulfilling, if perhaps unconsciously at times, their roles in this new faith.

Though Hartley may never have read much of Stevens (other than occasional poems), his "faculty of identification" is comparable to Stevens's "constructive faculty" which, like the exact description of nature, entails "a labor of calculation." Both men affirmed the "mystical" nature of the power of the imagination as well as the substantiality of the things of the imagination. Further, Stevens's belief that the artist/poet was the priest in a new era of faith, coincides with the innermost conviction Hartley had held from his earliest years, and hinted at sporadically in his writing: that art was for him the only faith he could have. In the last decade of his life he realized with increasing sureness that without necessarily embracing Christian dogma, the artist could live out a religious sense through creative expression. In his 1936 word portrait of Georgia O'Keeffe, he identified her—in terms that anticipate Stevens's "orphic" role for the painter—as a "mystic of her own sort," adding that "artists and religionists are never far apart, they go to the sources of revelation for what they choose to experience and what they report is the degree of their experiences. Intellect wishes to arrange—intuition wishes to accept." The essay speaks of her work as "transfiguration." In the ram's skull painting, for instance, it is "as if the bone, divested of its physical usages—had suddenly learned of its own esoteric significance, had discovered the meaning of its own integration through the process of disintegration, ascending to the sphere of its own reality."

## The quality of absolutism

Leonardo da Vinci was for Hartley the paradigm of all that he had been striving to attain in his years of self-renunciation and clarification of vision. Leonardo figures repeatedly in his late prose because he had, in Hartley's estimation, achieved the perfect balance between those polar tendencies that had characterized Hartley's own thought. Leonardo "arranged his intellectual and spiritual relativities in order in the manner of a logician . . . he did not trust

the intellect more than the intuition, he did not indulge in debauch-
eries of the body or the heart . . . he was the see-er supreme" ("The
Element of Absolutism in the Drawings of Leonardo").

Sometime in the late '30s Hartley read Paul Valéry's "Introduc-
tion to the Method of Leonardo da Vinci" in which he defined his
method of analyzing the Renaissance genius as the construction of a
psychological model, representing our capacity to understand him,
not as a mere cataloguing of biographical data ("no mistresses, no
creditors, no anecdotes nor adventures").[54] In Valéry's terms the
genius encompasses an almost "inconceivable universality," a com-
plete comprehension of the relationship of all things to the whole: "It
is not his dear *person* which he raises to this high degree, since he has
renounced his personality by making it the object of his thought, and
has given the place of *subject* to that unqualifiable *I*, which has no
name and history, which is neither more tangible nor less real than
the center of gravity of a ring or of a planetary system—but which
results from the whole, whatever that whole may be."[55]

The quality of artistic ego that Valéry here describes, Hartley
called Leonardo's "absolutism." "His creatures," Hartley writes,
"are of the flesh, but the flesh does not dictate their existence in his
vision, he sees them all as ideas, as symbolic representations of the
whole thing, as absolutist consummation of one thing." In Hartley's
estimation Leonardo (and, to a degree, Rembrandt, Roger de la
Fresnaye, Lipchitz and others he wrote about in these years) had
achieved a level of selflessness which enabled him to become—like
Emerson's "transparent eyeball"—the lens through which nature's
true appearances shine. The truly great artist becomes the agent
through which all things are related to the universal whole. One
particular phrase from Valéry that echoes through Hartley's late
essays seems to have been for him the ultimate resolution to the
problem of artistic personality: "There is no act of genius that is not
less than an act of being." For Hartley, artistic expression—the "act
of genius"—cannot be separated from being, from life as such. The
artist who is grounded in and understands experience thoroughly is
working from an absolutist standpoint.

Hartley's commentary on Leonardo serves to explain how mysti-
cism relates to the problem of artistic personality. In a 1934 letter to
Stieglitz, he related a mystical experience he had undergone in the
Bavarian Alps the year before, likening it to St. Augustine's

"mystery of opening."[56] In another context he again described this experience: "Something whisked me away, completely enfolded me. I felt myself becoming everything—continuity, measure, surcease. I had become nothing and in that instant I saw myself perfectly—out of myself, and when I returned I heard myself saying to myself— wasn't it wonderful, now we can begin again."[57] Is not the mystical experience an effort to renounce one's self in order to achieve union with the whole? For the mystic, that experience itself is enough. This is where Hartley differed from the traditional mystic. As an artist the whole impulse of his being was "toward the outside," toward expression in the work of art of the events and objects which had found experiential meaning in his life. Yet he found value in the mystic's way. When, in his moment of mystical revelation he "had become nothing," he paradoxically saw himself clearly and "felt himself becoming everything." He learned that by annihilating himself in the subject, he became aware of all things in relation to the whole.

Moreover, he came to see that there is no actual loss for the artist in losing himself in the work of art. He discovered over the course of his life that it is through the creative process that one achieves immortality which consists not so much in leaving behind significant objects signed with his name, as in the fact that creativity itself is a constant rebirth, a timeless searching and experimentation. He once told a friend "The one significant essential of life, is to know what it is that gives one life," which for him was writing and painting. And he added," . . . the 'going onward' is all that matters, and the dead moments in one's life through trying to be a unit in any society or social concept are terrifying really."[58]

Death to Hartley was a "hardening of the spiritual arteries,"[59] whereas life was "a matter of fluidic experience and must in no way be permitted to congeal and coagulate in the soul."[60] His only allegiance was to this life-principle, to the life-flow that allowed him the "going onward." The value of Hartley's writings inheres in their manifestation of a mind that fiercely refused to be categorized, refused to conform to any mold, esthetic or social, or to be tied to geographical place. His was a mind that rejected the extremes of intellectual affection and imaginative introspection alike; a mind that found meaning and definition in the flow of experience, rather than in structures and organizational patterns imposed by convention.

*The moral function of art*

The same principle determined what we may loosely call his "critical method." To apply the ordinary connotations of the term "criticism" to his essays is to misunderstand his motive in writing them. His was *participatory* criticism, a coming together of consciousness and an art object, and the sympathetic expression of that conjunction through his own creative intelligence. His comments on a given work, rather than being simply subjective interpretation, become an active ingredient, a leavening force in the experience made possible by the work of art.

He called his essays "not criticisms, but merely rhythmical reactions in words."[61] His superb gift for thorough immersion in the mood, language rhythms, and visual imagery of the artists and authors he wrote about conveys his observations about their art through language that in itself generates the qualities he attempts to explain. He could assume the "voice" of a writer, as when he wrote on Emily Dickinson, Djuna Barnes, or Gertrude Stein, and he could trace in words the conscious effect a painter's work had on his psyche, as in his word portrait of Georgia O'Keeffe, and his essays on Mark Tobey and Milton Avery. Of O'Keeffe, for instance, he wrote that she had

> come almost if not completely to the border-line between finity and infinity—there are flames that scorch—there are forms that freeze—there are vapours that rise like the hissing steam of ardent admissions seeking to escape from their own density. . . . There are the flame tones—almost savage reds to verify the flesh—greys of whatever hue that seek to modify them of too much animal assertion—there are disconsolate hues of ash-like resignation, all of which typify the surging passion of a nature seeking by expression first of all to satisfy herself—and in the end perhaps to satisfy those agencies of sensation and emotion that pursue and demand deliverance.

Hartley here communicates the tonal quality and sensuous effect of an O'Keeffe painting by means of a series of images which, though not literally descriptive, are poetically parallel to her imagery. The phrases "forms that freeze," "flames that scorch," "disconsolate hues of ash-like resignation," suggest the expressive power of her color and form. Such passages of startling lyrical beauty evoke simultane-

ously a portrait-like image of the artist and a verbal transcription of
the painting. It was an impassioned criticism. That it has not been
more fully acknowledged is no doubt due to the state of criticism in
the last half century. As Sherman Paul notes in his introduction to
the 1966 edition of Paul Rosenfeld's
*Port of New York:*

> Criticism is but another mirror of our response to life: intellectual,
> discriminating, precise, it is also curiously impersonal, dry, beggarly.
> Turning on itself . . . it anatomizes the work. . . . For at least three
> decades we have been afraid to show our passion in criticism or to push
> on to the moral of our esthetic experience.[62]

Hartley was unafraid of showing his passion in writing: unafraid of
speaking out against the frail hypocrisy, inauthenticity, and affecta-
tions he observed in art and literature. He gave sympathetic, fervent
appraisal of genuine expression. It is precisely the *"moral"* of his
esthetic experience that is the heart of this edition and defines
Marsden Hartley's place in the history of American art and letters—
a quality that has been recognized by a few who knew him and by
others acquainted with his work. Kenneth Rexroth, for instance,
who had contact with Hartley in New York in the early 1920s, pays
tribute to him in *An Autobiographical Novel.* Speaking of him as both a
painter and a human being (in Hartley's scheme, the two could not in
fact be separated), Rexroth writes:

> I believe his influence was a moral and spiritual one, rather than literary
> or physical. . . . That is exactly the moral quality that his personality
> gave off like a perfume—the true magnanimity which belongs only to the
> great.[63]

In fulfilling a moral function, art moves beyond esthetics. Poetry
is not simply word games, nor is painting simply image making. In
*Four Quartets,* T. S. Eliot says "The poetry does not matter." In a
broader American tradition dating back to Puritan poetry, on
through Emerson, Thoreau, Emily Dickinson and Whitman, there
appears a similar notion that art as such does not matter—or rather
that it matters only as it serves a function (what we have identified in
Hartley as the moral function) which transcends mere esthetics.
This idea is at the core of Hartley's late writing. In "Pictures" (1941)

he confesses that theoretical painting has no meaning for him, nor does subject matter in itself. All that matters is that it is painted "with the whole of [the artist's] manhood." And in the final pages of his autobiography, in describing Rembrandt's *Night Watch*, he asks: "Has picture ever held quite as much of one thing—the idea that life itself is above all human machination . . . life as it essentially is, or should be—life knowing no sense of inconsistency . . . no religion, no philosophy, no superficial esthetic. You forget that it is an object of art—it becomes a symbol, ample and separate, of all that direct living is meant to be." The moral poet or painter, then, is not interested in making an esthetic object but in giving substance to some *felt* aspect of "direct living," so that the viewer in turn forgets about the art object in participating in that larger experience that constitutes the real meaning of a work of art.

Hartley's writing thus ended where it had begun: with "life itself," in affirmation of Eliot's statement of truth from the Little Gidding section of *Four Quartets:*

> We shall not cease from exploration
> And the end of all our exploring
> Will be to arrive at where we started
> And to know the place for the first time.

Between his end and his beginning were the years of searching: seeking resolution to the problem of the romantic imagination in an age of intellectual skepticism. The process was a ceaseless testing of everything against empirical fact. Literally he found his end in his beginning in his native New England landscape with its granite, fir trees, its mountains and people. Figuratively he found it it his passionate dedication to what he so aptly names its "hermit radical" tradition: the radical reliance on simple experience as well as artistic integrity. These were signs of the life-force that impelled his expressive power as painter, poet and essayist.

# Notes: Introduction

[1]Northrop Frye, ed. Introduction, *Blake: A Collection of Critical Essays* (Englewood Cliffs, N. J.: Prentice Hall, 1966, p. 126.

[2]Letter to Adelaide Kuntz, April 4, 1932, Archives of American Art, Smithsonian Institution, Washington, D. C. (hereafter AAA).

[3]Unpublished poetry manuscript, "Bach for Breakfast," Hartley/Berger Archive, Yale University Collection of American Literature, Beinecke Rare Book and Manuscript Library (here after YCAL).

[4]Barbara Haskell, *Marsden Hartley* (New York: New York University Press and Whitney Museum of American Art, 1980); and Elizabeth McCausland, *Marsden Hartley* (Minneapolis, Minn.: University of Minnesota Press, 1952).

[5]Letter to Norma Berger, April 15, 1940, YCAL.

[6]Hartley, *Adventures in the Arts* (New York: Boni and Liveright Inc., 1921; facsimile reprint New York: Hacker Books, 1972), p. 9 (hereafter *Adventures*).

[7]John Dewey, "Characters and Events" in *Emerson: A Collection of Critical Essays*, ed. Milton Konvintz and Stephen Whichar (Englewood Cliffs, N.J.: Prentice Hall, 1962), p. 28.

[8]William James, *Essays in Radical Empiricism* and *A Pluralistic Universe* (New York: E. P. Dutton and Co., Inc., 1971), p. 15.

[9]Ibid., p. 113.

[10]Henry James, Preface to *The American* (New York: Charles Scribner's Sons, 1907), p. 43.

[11]Henry James, Preface to *Portrait of a Lady* (New York: Charles Scribner's Sons, 1908), p. 47.

[12]Letter to Alfred Stieglitz, June 1911, YCAL, Steiglitz Archive.

[13]Ibid.

[14]Robert Burlingame, *Marsden Hartley: A Study of his Life and Creative Achievement* (Dissertation: Brown University, Providence, Rhode Island, 1953), p. 123.

[15]Paul Rosenfeld, for instance, in his review of *Adventures in the Arts*, wrote that the prose read like "a fine, elegant talk as one strolled along Fifth Avenue with Hartley, visiting some galleries, stopping in a vaudeville show, hearing some casual observations on modern art." See "Paint and Circuses," *Bookman* 54 (December 1921), pp. 385–88.

[16]Arnold Rönnebeck to Leon Tebbetts, n.d., YCAL.

[17]See Haskell, *Marsden Hartley*, as well as William Innes Homer, *Alfred Stieglitz and the American Avant-Garde* (Boston: New York Graphic Society, 1977).

[18]*Adventures*, p. 195.

[19]Gail Levin, "Hidden Symbolism in Marsden Hartley's Military Pictures." *Arts Magazine* 54 (October 1979), pp. 154–58.

[20]Letter to Stieglitz, February 1913, Paris, YCAL, Stieglitz Archive.

[21]See Barbara Novak, *American Painting of the Nineteenth Century* (New York: Praeger Publishers, 1969), pp. 165–73.

[22]Among others: Levin, *Arts Magazine*, p. 155; Haskell, p. 54; Henry McBride in his review in the *New York Sun*, reprinted in *Camera Work*, no. 48 (October 1916), pp. 58–59.

[23]Charles Caffin in his review of Hartley's exhibition, reprinted in *Camera Work* 48 (October 1916), pp. 59–60.

[24]Unpublished notes, YCAL, Hartley/Berger Archive. Hartley probably used the edition of Flaubert's letters, *Correspondance* (Paris: L. Conard, 1926–33).

[25]W. James, p. 22.

[26]*Seven Arts*, 1 (November 1916), p. 5.

[27]*Adventures in the Arts* has not been included in the present volume, nor excerpted, partially out of respect for its integrity and partially because Hartley's essays after 1921 deal with the same basic issues and many of the same figures (Ryder, O'Keeffe, George Fuller).

[28]*Adventures*, p. 36.

[29]Ibid., pp. 219–20.

[30]Ibid., p. 251.

[31]Letter to Rebecca Strand, March 27, 1929, AAA.

[32]Letter to Stieglitz, November 19, 1926, YCAL, Stieglitz Archive.

[33]Letter to Rebecca Strand, September 1929, Aix, AAA.

[34]Miguel Unamuno, "The Spanish Christ" in *Essays and Soliloquies*, trans., J. E. Crawford Flitch (New York: Alfred A. Knopf, 1925), pp. 76–81.

[35]Letter to Rebecca Strand, September 1929, Aix, AAA.

[36]Letter to Rebecca Strand, November 19, 1929, AAA.

[37]Letter to Adelaide Kuntz, September 22, 1929, AAA.

[38]"The Meaning of Painting," unpublished essay, YCAL, Hartley/Berger Archive.

[39]Quoted in Santayana's essay "Three Philosophical Poets: Lucretius, Dante and Goethe," given as a series of six lectures at Columbia University in 1910 and later published in various collected editions of his works.

[40]Letter to Rebecca Strand, March 27, 1929, AAA.

[41]Waldo Frank, *The Rediscovery of America* (New York: Charles Scribner's Sons, 1929), p. 5.

[42]Letter to Stieglitz, August 8, 1930, YCAL, Stieglitz Archive.

[43]Letter to Stieglitz, August 12, 1931, YCAL, Stieglitz Archive.

[44]See Gail R. Scott, "Marsden Hartley at Dogtown Common," *Arts Magazine* 54 (October 1979), pp. 159–65.

[45]Letter to Rebecca Strand, November 27, 1931, AAA.

[46]Letter to Adelaide Kuntz, July 23, 1932, Cuernevaca, AAA.

[47]Unpublished notes, YCAL, Hartley/Berger Archive.

[48]Letter to Adelaide Kuntz, July 12, 1933, AAA.

[49]Letter to Adelaide Kuntz, December 22, 1933, Partenkirchen, AAA.

[50]Unpublished poetry manuscript, YCAL, Hartley/Wells Archive.

[51]Wallace Stevens, "The Relations between Poetry and Painting," in *The Necessary Angel* (New York, 1942; Vintage Books, 1951), p. 164.

[52]Ibid., p. 165.

[53]Ibid., pp. 173–74.

[54]Paul Valéry, "Introduction to the Method of Leonardo da Vinci," in *Variety*, trans. by Malcolm Cowley (New York: Harcourt, Brace, and Co., 1927), p. 220.

[55]Ibid., p. 216.

[56]Letter to Alfred Stieglitz, November 20, 1934, Gloucester, Mass., YCAL, Stieglitz Archive.

[57]*Cleophas and His Own*, unpublished manuscript, YCAL, Hartley/Berger Archive (see volume II).

[58]Letter to Adelaide Kuntz, September 7, 1933, AAA.

[59]Letter to Rebecca Strand, January 6, 1929, Paris, AAA.

[60]Letter to Rebecca Strand, n.d., n.p., AAA.

[61]Letter to Kenneth Hayes Miller, June 10, 1920, AAA.

[62]Sherman Paul, ed., Introduction to *Port of New York* by Paul Rosenfeld (1924; reprinted Urbana, Ill.: University of Illinois Press, 1966), p. xxxvii.

[63]Kenneth Rexroth, *An Autobiographical Novel* (Garden City, N.Y.: Doubleday and Co., Inc., 1966), pp. 205–06.

# PART I

# HARTLEY ON HARTLEY AND THE STIEGLITZ CIRCLE (1914-1941)

*Gathered here together for the first time are virtually all Hartley's public statements on his own painting, and a selection of articles on Stieglitz's 291 gallery and some of its artists. Most were first published in brochures for exhibitions either there or at Stieglitz's subsequent exhibition spaces, The Intimate Gallery and An American Place, or at other institutions. "Dissertation on Modern Painting," "Art—and the Personal Life" and "Farewell, Charles" appeared first as magazine publications.*

*Paradoxically in his first public declaration on art in 1914 he points out the uselessness of all such catalogue forewords if taken merely as esthetic theory. They should reveal instead the artist's personal discovery demonstrated primarily in the paintings. He thus sets the stage for much of the writing that follows. Hartley was to write voluminously on art and other matters but never to formulate a systematic theory of esthetics. His writings are indeed records of intuitive discovery—especially those statements here in Part I most intimately related to his own painting by virtue of being written for a specific exhibition. For us they act as historical guideposts at crucial points in his career: three forewords in the two-year period 1914–1916 which marks the high point in his emergence as an important painter; three from the twenties, "Dissertation on Modern Painting" (1921), "Art—and the Personal Life" (1928), and "The MOUNTAIN and the RECONSTRUCTION" (1928) which record his struggles in reconciling the intellect and the imagination in the creative process; and three from the late period, "Outline in Portraiture of Self" (1936), "On the Subject of Nativeness—a Return to Maine" (1937), and "Pictures" (1941) from the height of his powers as a painter.*

*The piece on John Marin (1928) marks the beginning of a decade of writing about his colleagues from the 291 circle and reveal Hartley the art critic and appreciative observer at his best. The Marin essay, ringing with enthusiastic praise, was, as Sheldon Reich points out, too much for a critic like Lloyd Goodrich, who, in his review of the exhibition pointed a finger at what he saw as Hartley's exaggerated claims. He argued that if Hartley thought Marin captured the fundamental structure of mountains, waves, and houses, then Hartley was ignorant of such structures.[1] But Hartley, going against the grain of the growing popularity of American scene painting, was in total sympathy with Marin's efforts to express formal structure not in traditional terms of physical mass or representational likeness, but by means of the fluid interplay of translucent planes of color and light. The perspective of time has*

---

[1]Reich, *John Marin: A Catalogue Rainsonné and A Stylistic Analysis* (Tuscon: University of Arizona Press, 1970), p. 179.

*vindicated Hartley's generous and insightful remarks about Marin's achieve-*
*ment.*

*In a letter to Stieglitz Hartley commented that he wanted the Marin piece "to have as much the character and quality of a Marin picture—to be a word drawing with as much the same kind of strokes as his own" (letter to Stieglitz, July 23, 1928, YCAL). This notion of a portrait in prose evolved in the 1930s into a series of "Outlines in Portraiture." "Farewell, Charles," "Georgie O'Keeffe" and "An Outline in Portraiture of Self" are verbal characterizations of these two commrades, and of himself. Though stylistically different they were written within a few months of each other (1935–36). The Demuth essay, first in the series, was written as a eulogy for his friend who had died in October, 1935. It relies more than the other two "portraits" on a biographical context to depict the artist's character and the nature of his painting. In doing so Hartley also skilfully portrays for us larger scenes: the atmosphere of the artists congregating in Paris cafés before World War I, or the initial gatherings of the Provincetown Players in 1915 and '16. Demuth is seen with affectionate regard through the eyes of a friend.*

*O'Keeffe, on the other hand, with whom Hartley did not have such a close personal relationship, is seen through her work. The essay, which served as a foreward to an exhibition brochure, is a sensitive verbal evocation of the tonal quality and sensorial effect of her painting. He uses pictorial word images which, though not literally descriptive, are poetically parallel to the type of imagery one finds in her work.*

*The self-portrait is subtitled "From Letters Never Sent," which was a group of essays he was writing at the time in the form of letters addressed to friends, artists, or writers to whom he wished to pay tribute or express a particular affinity or share a cherished idea. With the exception of "Outline in Portraiture of Self" which was also a catalogue statement, the entire series is in volume II.*

*The two statements about 291 are separated by twenty years. "What is 291?" was written, as the dateline indicates, from Berlin in 1914. From there Hartley gave an international perspective on the significance of that little room on lower Fifth Avenue. "291—and the Brass Bowl" was his contribution to* America and Alfred Stieglitz: A Collective Portrait *(1934). Though written during a period of increasing strain between him and Stieglitz, it nevertheless traces with great feeling his personal connection to and assessment of Stieglitz and his pioneering work.*

# 1914 Catalogue Statement, 291
## (Photo-Secession Galleries)

"I do not doubt that interiors have their interiors—and exteriors have their exteriors, and that the eyesight has another eyesight and the hearing another hearing and the voice another voice"—Walt Whitman

"Put off intellect and put on imagination. The imagination is the man."—Wm. Blake

The purpose of this foreword is to state merely the uselessness in art of forewords—of theses. It is to state that in the present exhibition there is nothing in the way of a theory of art of esthetics or of science to offer. The intention of the pictures separately and collectively is to state a personal conviction—to express a purely personal approach. It has nothing whatsoever to do with the prevailing modes and tendencies—cliques and groups of the day. It has not intellectual motives—only visionary ones. It is not to be expounded. It is not a riddle. It is a discovery; but it does not purport to be the last great discovery in the scientific phase of esthetics. Its only idea and ideal is life itself, sensations and emotions drawn out of great and simple things. There is an inner substance, an inner content in all things— an interior in an interior, an exterior to an exterior—and there are forms for the expression of them. It is the artist's business to select forms suitable to his own specialized experience, forms which express naturally the emotions he personally desires to present, leaving conjectures and discussions to take care of themselves. They add nothing to art. Art creates itself out of the spirit substance in all things. There are signs and symbols for ideas of the spirit or soul as there are signs and symbols for ideas of the mind. For the former they are distinct and separate as for the latter they are distinct and separate. A picture is but a given space where things of moment which happen to the painter occur. The essential of a real picture is that the things which occur in it occur to him in his peculiarly personal fashion. It is essential that they occur to him directly from

his experience, and not suggested to him by way of prevailing modes. True modes of art are derived from modes of individuals understanding life. The idea of modernity is but a new attachment to things universal—a fresh relationship to the courses of the sun and to the living swing of the earth—a new fire of affection for the living essence present everywhere. The new wonder of the moment. The Creator never loses his sense of wonder—he is continually in the state of simple amaze. The delight which exists in ordinary moments is his ecstasy. In the art of the ordinary there is the sense of devotion. In the art of the specialist there is the sense of habit. It is devotion which is closest to creation. Boehme was a devotional ordinary— Cézanne and Rousseau also. A real visionary believes what he sees. The present exhibition is the work of one who sees—who believes in what is seen—and to whom every picture is as a portrait of that something seen.

# What is 291?

*(1915)*

Gertrude Stein once asked me that question. I told her as best I could, but I do not remember telling her adequately. Since that [time] she has learned herself more of its character and personality, for it has served her in quite a similar way [as] it has served so many of us who but for its interests and faith might have continued unnoticed way out of time. When I think of what America has been with "291" I am thinking how strange it would have been without it.

It stands unique—by itself. There is nothing anywhere—not in
Europe even—that is the equivalent of it. In Germany here there is,
of course, the Blaue Reiter which has for its object quite the same
end, otherwise there is nothing—not London, not Paris—and I am
definitely certain not any other public beside the American in
general or the New Yorker in particular knows of such an institution
if this it may be called—as "291."

It is difficult to know what the insider can say of "291," for if he
speak at all he is in danger of being—carefully putting it—over
interested. We know how often it has been denounced as ridiculous,
how for long it was considered by some as merely a pose—a kind of
esthetic affectation. It can now be seen after lapses of time and
experience and direct contact with it that it no longer appears to any
one as that ridiculous, and that, through a fairer increase of tolerance
and understanding many who once denounced are now paying
tribute more creditably. How it has dispensed with and made absurd
that feeble notion of the old gallery and dealer, by exposing at once
those who have appeared over its horizon as showing if not
completely, at least fragmentary signs of genuineness of talent or it
might be genius, and in nearly every instance, how fair has been its
eyesight, its judgment and how unfailing its desire to be so. It has
been and still is a kind of many headed creature standing firm for
every variety of truth and every variety of expression of the same. It
has insisted since its birth and to its end is certain to insist on that one
essential, the tabooed "sincerity." It has paid severe toll for this ideal,
precisely as any ideal pays heavily for the pursuance of its desires,
but it has survived all vicissitude, and the survival is splendid. It has
come of age and has shown intelligence from the day of its birth. It
has doubtless committed many of the so-called errors of youth and
frailty, but if there have been errors there has been likewise life and
earnestness in them. I do not as I say know what any one can say
about "291." Those who know it with real intimacy speak seldomly
about it actually, though often of it, naturally. It is gratifying enough
that there is now at least some degree of spiritual sustenance
achieved in the full faith of those who know it well on that side of the
ocean and of the pleasure that is expressed in the knowledge of its
work on this side. It is known in all quarters as a factor in the
development of modern art; it has literally contributed to the
vigorous growth of that. It has served the ideal and served it without
qualification other than the one of earnestness of purpose. Those

who have not known it intimately or well have from time to time with delight indulged in petty blasphemy or in a fiercer scorn with here and there an incredible contempt. It may be this has all been justified just as the praises of it are with certainty more justified. It has served its purpose wherever and when it has been priviledged to do so, and regretted when it has been denied. It has created and fulfilled its unique and specialized function, that of bringing to the view fairly and without ostent and as completely as conditions have allowed, the artistic searchings of individuals and through its generosity and faith has brought freely before a fairly curious public, the work of artists in various fields of expression who have by reason of this originality for long been excommunicated from the main body both in America and in Europe.

I should like to have intimated more adequately just what "291" means, has meant all along its career and will continue as long as it survives. If I have even insinuated even so vaguely what it has meant to the insider who has found it to be his artistic savior, I shall perhaps have said something of it. It can only, I think, be really intimated what this number has meant to that place in the universe. It can be said, however, that there will always be a strange and invaluable significance in this "291." It has in any event served the mystical purpose of establishing fair values in place of unfair; of pure appreciation in place of contempt, and with regard to itself especially, a genuine faith in place of suspicion too long alert and attentive. It has too well proved at this time its purpose and its efficiency and its readiness to serve where it finds service possible, has long since become one of the little miracles of our day. A pure instrument is certainly sure to give forth pure sound, so has this instrument of "291" kept itself as pure as possible that it might thereby give out pure expression. I think never has a body of individuals—large or small—kept its head more clear, or its hands and feet freer of the fetter of personal gain or group malice than has this "291" body. It has come well of age and its maturity is gratifying. Certainly to the insider and certainly it will sooner or later certify itself in the minds of everyone who has had or will have even so great or even so slight an interest in progressive modern tendencies toward individual expression. This is certainly what "291" is.

Berlin, July 4, 1914

# A Word

*(1916)*

Personal quality, separate, related to nothing so much as to itself, is a something coming to us with real freshness, not traversing a variety of fashionable formulas, but relying only upon itself. The artist adds something minor or major more by understanding his own medium to expression, than by his understanding of the medium or methods of those utterly divergent from him. Characteristics are readily imitable; substances never; likeness cannot be actuality. Pictural notions have been supplanted by problem, expression by research. Artistry is valued only by intellectualism with which it has not much in common. A fixed loathing of the imaginative has taken place: a continual searching for, or hatred of, subject-matter is habitual, as if presence or absence of subject were a criterion, or, from the technical point of view, as if the Cézannesque touch, for instance, were the key to the esthetic of our time, or the method of Picasso the clew to modernity.

I am wondering why the autographic is so negligible, why the individual has ceased to register himself—what relates to him, what the problematic for itself counts. I wonder if the individual psychology of El Greco, Giotto and the bushmen had nothing to do with their idea of life, of nature, of that which is essential—whether the struggle in El Greco and Cézanne, for example, had not more to do in creating their peculiar individual esthetic than any ideas they may have had as to the pictural problem. It is this specialized personal signature which certainly attracts us to a picture—the autographic aspect or the dictographic. That which is expressed in a drawing or a painting is certain to tell who is its creator. Who will not, or cannot, find that quality in those extraordinary and unexcelled watercolors of Cézanne, will find nothing whatsoever anywhere. There is not a trace anywhere in them of struggle to problem: they are expression itself. He has expressed, as he himself has said, what was his one ambition—that which exists between him and his subject. Every painter must traverse for himself that distance from Paris to Aix or

66

from Venice to Toledo. Expression is for one knowing its own pivot. Every expressor relates solely to himself—that is the concern of the individualist.

It will be seen that my personal wishes lie in the strictly pictural notion, having observed much to this idea in the kinetic and the kaleidoscopic principles. Objects are incidents: an apple does not for long remain an apple if one has the concept. Anything is therefore pictural; it remains only to be observed and considered. All expression is illustration—of something.

# 1916 Catalogue Statement, 291 (Photo-Secession Galleries)

The pictures in this present exhibition are the work of the past two years. The entire series forming my first one-man show in Europe which took place in Europe last October. These pictures were to have been shown in these galleries as previously announced in February, but owing to blockades, war difficulties, etcetera, they have only just arrived. The Germanic group is but part of a series which I had contemplated of movements in various areas of war activity from which I was prevented, owing to the difficulties of travel. The forms are only those which I have observed casually from day to day. There is no hidden symbolism whatsoever in them; there is no slight intention of that anywhere. Things under observation, just pictures of any day, any hour. I have expressed only what I have seen. They are merely consultations of the eye—in no sense problem; my notion of the purely pictural.

# Dissertation on Modern Painting

*(1921)*

It is for everyone to comprehend the significance of art who wishes so to do. Art is not a mystery, never has been, and never will be. It is one with the laws of nature and of science. Art is the exact personal appreciation of a thing seen, heard, or felt in terms of itself. To copy life is merely to become the photographer of life, and so it is we have the multitude in imitation of itself—one in the undeniable position of copying another one, without reference to the synthetic value of imitation. It is the privilege of the artist then to reform his own sensations and ideas to correspond acording to a system he has evolved, with the sensation drawn out of life itself. It is a matter of direct contact which we have to consider. There can be no other means of approach. To illustrate externals means nothing, because the camera is the supremely edifying master of that. It means nothing whatsoever for a painter to proceed with ever so great a degree of conventional flash and brilliancy to give sensations which nature or the mechanical eye of the camera can much better produce. The thing must be brought clearly to the surface in terms of itself, without cast or shade of the application of extraneous ideas. That should be, and is, it seems to me, the special and peculiar office of modern art: to arrive at a species of purism, native to ourselves in our own concentrated period, to produce the newness or the "nowness" of individual experience. The progress of the modernist is therefore a slow and painstaking one, because he has little of actual precedent for his modern premise. It must be remembered that modern art is, in its present so-called ultra state, not twenty years old, and it must likewise readily be observed that it has accomplished a vast deal in its incredibly prodigious youthfulness.

Art in itself is never old or new. It began with the first morning. That the eye trained accurately to observe its essence is of such recent existence, may be the real object of surprise. All the great races had a mission to perform. They had race psychology to perfect, and, therefore, art with them was allied with all the elements of symbolism. Symbolism can never quite be evaded in any

work of art because every form and movement that we make symbolizes a condition in ourselves.

We derive our peculiar art psychology from definite sources, and it is in the comprehension of these sources, and not in the imitation of them, that we gain the power necessary for the kind of art we as moderns wish to create. We are intrigued into the consideration of newer qualities in experience, which may or may not be eternally valuable, yet may hold contemporary distinction. We must think ourselves into the Egyptian consciousness in order to understand the importance of art to the Egyptians, and we must likewise perform the same function as regards our own appreciation of art, the art of our modern time.

It will be found that there is a greater interest in this newer type of pristine severity than in the more theatric and dramatic tendencies of the romanticists. It is [in] no way to disparge a romanticism as fostered by Delacroix, but we are finding a perhaps greater degree of satisfaction in the almost flawless exactitudes of an artist like Ingres, whose influence in his time was doubtless considered (certainly was considered by Delacroix and his entourage) detrimental in its coldness and its seeming severity and lifelessness. Art is not a comfortable or an emotional issue. It is a stimulating intellectual one. We have learned that Ingres was not cold, but clear and durable as crystal, and we in our day are made to admire the indescribable loveliness of steel and glass for the strength and unadorned splendor they contain in themselves, devoid of the excessively ornate incrustation of art as applied by the Orientals and by the artists of the Renaissance. With them it was worship of ornamentation. Surfaces were made to carry heavy burdens of irrelevant beauty. Today we have admiration for the unadorned surface itself. We have a timely appreciation for the mechanistic brilliance and precision of this era; we care for the perfect line and mass, the unornamented plasticity of workable objects, such as the dynamo and the steam drill, as well as the cool and satisfying distinction which electricity contains.

We may say then that in matters of experience generally all progress is a plunging toward discovery. With amazing yet typical rapacity the world of Europe, that is, the major part of it, has turned to art for its speedy salvation, and the revival of modern painting alone in Europe is, while utterly characteristic, nevertheless startling in its reality. The peoples of Europe know through the experience of a majestic background the importance to racial

development of the development of art. They are perfectly aware that the only solution of their civic problem is to come through the redirection of public interest toward matters of taste and cultivation. For it is through art and art alone that peoples survive through the centuries. Their arts have been their most important historical records.

The question on the lips of the rest of the world is naturally: Why is there no art in America? There is already a well-defined indication that America may one day possess a literature of its own. We need not depend entirely upon our own private exotics such as Emerson, Poe, and Whitman, who, it can be said, would never have sprung from any other soil. The last few years have shown that America has a type of poetry all its own, a poetry that is as peculiar to it as the Acropolis to Athens. There is an indication that the art of painting is quite conspicuously on the ascendant in America. Of these two arts in our own country much more indeed can be said than can be said for music and for the drama, in which we seem but for a small and slowly emerging group to be practically negligible as creators. It is because we have not yet learned the practical importance of true artistic sensibility among us. Yet there is possibly more hope for the arts of painting and poetry because they are the last to be bought and sold as valuable merchandise. It is in this, possibly, that their salvation lies, as it is in freedom that all things find perfection, in freedom that all functions find their truest gifts for expression.

## Art—and the Personal Life

*(1928)*

As soon as a real artist finds out what art is, the more is he likely to feel the need of keeping silent about it, and about himself in connection with it. There is almost, these days, a kind of *petit scandale* in the thought of allying oneself with anything of a professional

nature. And it is at this point that I shrink a little from asserting myself with regard to professional aspects of art. And here the quality of confession must break through. I have joined, once and for all, the ranks of the intellectual experimentalists. I can hardly bear the sound of the words "expressionism," "emotionalism," "personality," and such, because they imply the wish to express personal life, and I prefer to have no personal life. Personal art for me is a matter of spiritual indelicacy. Persons of refined feeling should keep themselves out of their painting, and this means, of course, that the accusation made in the form of a querulous statement to me recently "that you are a perfectionist," is in the main true.

I am interested then only in the problem of painting, of how to make a better painting according to certain laws that are inherent in the making of a good picture—and not at all in private extraversions or introversions of specific individuals. That is for me the inherent error in a work of art. I learned this bit of wisdom from a principle of William Blake's which I discovered early and followed far too assiduously the first half of my esthetic life, and from which I have happily released myself—and this axiom was: "Put off intellect and put on imagination; the imagination is the man." From this doctrinal assertion evolved the theoretical axiom that you don't see a thing until you look away from it—which was an excellent truism as long as the principles of the imaginative life were believed in and followed. I no longer believe in the imagination. I rose one certain day—and the whole thing had become changed. I had changed old clothes for new ones, and I couldn't bear the sight of the old garments. And when a painting is evolved from imaginative principles I am strongly inclined to turn away because I have greater faith that intellectual clarity is better and more entertaining than imaginative wisdom or emotional richness. I believe in the theoretical aspects of painting because I believe it produces better painting, and I think I can say I have been a fair exponent of the imaginative idea.

I have come to the conclusion that it is better to have two colors in right relation to each other than to have a vast confusion of emotional exuberance in the guise of ecstatic fullness or poetical revelation—both of which qualities have, generally speaking, long since become second rate experience. I had rather be intellectually right than emotionally exuberant, and I could say this of any other aspect of my personal experience.

I have lived the life of the imagination, but at too great an expense.

I do not admire the irrationality of the imaginative life. I have, if I may say so, made the intellectual grade. I have made the complete return to nature, and nature is as we all know, primarily an intellectual idea. I am satisfied that painting also is like nature, an intellectual idea, and that the laws of nature as presented to the mind through the eye—and the eye is the painter's first and last vehicle—are the means of transport to the real mode of thought: the only legitimate source of esthetic experience for the intelligent painter.

All the isms from impressionism down to the present moment have had their inestimable value and have clarified the mind and the scene of all superfluous emotionalism; and the eye that turns toward nature today receives far finer and more significant reactions than previously when romanticism and the imaginative or poetic principles were the means and ways of expression.

I am not at all sure that the time isn't entirely out of joint for the so-called art of painting, and I am certain that very few persons, comparatively speaking, have achieved the real experience of the eye either as spectator or performer. Modern art must of necessity remain in the state of experimental research if it is to have any significance at all. Painters must paint for their own edification and pleasure, and what they have to say, not what they are impelled to feel, is what will interest those who are interested in them. The thought of the time is the emotion of the time.

I personally am indebted to Segantini the impressionist, not Segantini the symbolist, for what I have learned in times past of the mountain and a given way to express it—just as it was Ryder who accentuated my already tormented imagination. Cubism taught me much and the principle of Pissarro, furthered by Seurat, taught me more. These with Cézanne are the great logicians of color. No one will ever paint like Cézanne, for example—because no one will ever have his peculiar visual gifts; or to put it less dogmatically, will any one ever appear again with so peculiar and almost unbelievable a faculty for dividing color sensations and making logical realizations of them? Has any one ever placed his color more reasonably with more of a sense of time and measure than he? I think not, and he furnishes for the enthusiast of today, new reasons for research into the realm of color for itself.

It is not the idiosyncrasy of an artist that creates the working

formula, it is the rational reasoning in him that furnishes the material to build on. Red, for example, is a color that almost any ordinary eye is familiar with—but in general when an ordinary painter sees it he sees it as isolated experience—with the result that his presentation of red lives its life alone, where it is placed, because it has not been modified to the tones around it—and modification is as good a name as any for the true art of painting color as we think of it today. Even Cézanne was not always sure of pure red, and there are two pictures of his I think of, where something could have been done to put the single hue in its place—the art for which he was otherwise so gifted. Real color is in a condition of neglect at the present time because monochrome has been the fashion for the last fifteen or twenty years—even the superb colorist Matisse was for a time affected by it. Cubism is largely responsible for this because it is primarily derived from sculptural concepts and found little need for color in itself. When a group feeling is revived once again, such as held sway among the impressionists, color will come into its logical own. And it is timely enough to see that for purposes of outdoor painting, impressionism is in need of revival.

Yet I cannot but return to the previous theme which represents my conversion from emotional to intellectual notions; and my feeling is: of what use is a painting which does not realize its esthetical problem? Underlying all sensible works of art, there must be somewhere in evidence the particular problem understood. It was so with those artists of the great past who had the intellectual knowledge of structure upon which to place their emotions. It is this structural beauty that makes the old painting valuable. And so it becomes to me—a problem. I would rather be sure that I had placed two colors in true relationship to each other than to have exposed a wealth of emotionalism gone wrong in the name of richness of personal expression. For this reason I believe that it is more significant to keep one's painting in a condition of severe experimentalism than to become a quick success by means of cheap repetition.

The real artists have always been interested in this problem, and you felt it strongly in the work of da Vinci, Piero della Francesca, Courbet, Pissarro, Seurat and Cézanne. Art is not a matter of slavery to the emotions—or even a matter of slavery to nature—or to the esthetic principles. It is a tempered and happy union of them all.

# The MOUNTAIN and the RECONSTRUCTION

*(1928)*

"Being lies at a greater depth than individuality—this truth China has demonstrated for all times."

"Chinese and Japanese painters are Yogis. They regard nature, not from the outside, but they become absorbed in it like mystics become absorbed in God. In the process they get beyond their humanity and become one with the spirit of nature."

—Keyserling

I had come to the end of the botched pattern.
I could not see the fabric for the tatters.

I found that vastly important decisions were necessary,
and the chief of them was, there must be a change of pattern,
there must be a change of thread, and of the shuttle as well.
"Change all"—I said—everything—EVERYTHING!
change the moyen, the form, the substance, even.
And I began to rise from the debris of the old,
the worn, and the riddled.

I stepped out of all this ancient litter,
stepped over on to new, clean ground.
"Here is where we shall build,"—I said,
Here is where we shall live,—
and the "WE"—were my body and mind and spirit,
and my dog.
"There is no need to change the dog," I said—
"He is perfect, and will remain so"—
And I talked further with these entities, saying
"Even he will help, this dog of ours,
His candour, his gaiety, his sincerity, even his
Boredom will help"—

74

I awoke one morning with a new beat in my heart,
And I said, "it's a go—we've risen—
We shall go out now, and set up a new house for ourselves,
For ourselves—and the dog.⟧

It was late in spring, and I remember one nightingale
remained long—long after the departure of the other
nightingales,
And it was the spring of Provence, and of the
    RECONSTRUCTION
Before the Mountain, after the almonds had ceased
their blooming, and there were many magpies darting
like cooled daggers through the shot silver
of the olive boughs.
The squirrels and the rabbits were there,
The cypress of Lebanon, also—
And—The MOUNTAIN—and it was
A new Mountain to ourselves, and the dog,
and it was a very noble one.
Lights poured from it in the passing of the day—
Calm fires warmed its shadows, and there was the quality
of revelation contained in it, revelation
for the body, the mind, and the spirit—
and the dog, not knowing or needing to know
of these things, was not aware of them,
and was therefore not troubled by them.

⟦"Come, my angelic pup," I said—"come and see,
we are going to live with this mountain, all of us,
as long—as there is time,"
and I took him up in my arms and rubbed his stomach
for him—"I cannot follow the words," he said,
"but these deeds benefit and comfort;"
and in among the pines soothfully swaying,
the oaks, beyond the cypress of Lebanon,
the sweet old man appeared in vision—
a man who had evolved some of the clearest principles
for himself, a new metaphysic—a new logic—
a new, inviolable conviction, a new law for the artist        *Cezanne*
with ambitions toward truth, a belief in real

appearances, and a desire toward expression, without
the HYPOCRISIES.

> L'art est une harmonie paralèlle à la nature.
> La nature est plus en profondeur qu'en surface.
> La couleur est biologique.
> La couleur est vivante, rend seul les choses vivante.
> Les couleurs sont le chair éclatante des idées,
> et de Dieu.
> La transparence du mystère.
> L'irisation du lois—

and a host of equally vivid deductions like sequences
of music, chromatics of the spirit evolved through
metaphysical application for the benefit of the eye
alone, giving off resonant reverberations like the bells
of sheep and goats at nightfall on the way to the fold,
as the calm of noble verdure reclaimed the stillnesses
again.

"TO ANNIHILATE MYSELF IN THE SUBJECT
    —to become ONE
with it"—this was the purpose of the sweet old man
consumed with humility and sincerity, who wandered away
from the scene of our infantile assertions and of our
egotistic despairs.
"I shall die, PAINTING"—and he died,
PAINTING.

La Transparance du mystère.

My friend, who spent his boyhood in the forest
of the Chateau Noir, and in the presence of
The MOUNTAIN—recalls that while he indulged
the fancies of his childhood, he saw in among the trees,
fragments of colour soiled rags, discarded among the leaves
on the ground—mouchoirs of revelation.
My friend is thirty now.

The Blanchisseuse, who is nearer fifty, remarked
as she stirred the coals in the hooded chimney
of an autumn evening—

"I used to see him painting around us here—often—
He was always very nice, very serious, and spoke but little.
He gave a picture of Sainte Victoire to one
of our neighbors, but he did not sign it.
"It does not matter now," I said—
"Il est connu."

The sages would say of him—he has understood,
he has become.
For even that which was not finished, was in the state
of perfection, for the condition of its RELATION
was perfect.
L'irigation du loir
La transparence du mystère—

---

This is not meant to be a legend, or a poetic effusion—it is intended merely as an association of fates, physical, intellectual, and spiritual, an association of entities in close relation with each other. Its chief reason for being is the quality of confession contained in it. [Hartley's footnote]

*New York, February 12th, 1928*

# The Recent Paintings of John Marin

*(1928)*

It was four years since I had seen the work of John Marin, the painter in water colours, and one recent day when several others and myself were to pick up Marin at his house in Jersey to go further on to a dinner and later to Elizabeth to see Micky Walker show his punch in

the armory there, Marin said, as we were about to start, "would you like to see some of the new pictures before we go?" "Most certainly," I said, "you know, Marin, what I think of your work," and we went up stairs to the studio, and the thick sheets of paper were brought forth one after another, and arranged sequentially in a working frame.

I had seen casual pictures in Room 303, or the Intimate Gallery, and I said to myself then, Marin is going deeper, there is even a solemnity coming forth, a gravity of wash, a new plastic intensity, a kind of sharper dimensional breadth of emotion is taking place, a new sureness of touch, a different emotional fulness.

Most painters in this medium always consider the fact that water is the main source of strength, and you find artists like Whistler, Sargent, and MacKnight even, who have had special ability in this form of expression are frequently occupied with the wash as merely liquid substance, and you will find that Winslow Homer and John Marin have found that there is a substance to be achieved in spite of this idea.

Marin never trifles with water colour. He is never concerned with its limitations though he knows them all too admirably.

He knows there is also a striking type of vigour and solidity to be achieved, and these most recent works of his prove that Marin has discovered like Carlos Chavez the best of the newest composers of modern music, that if two notes will express the idea, it is better to discard a third, or if one note will express the same, it is more intelligent to leave out the second.

A rigid economic sense marks the work of Marin in these new compositions. He introduces wherever necessary, inevitable touches of realism to indicate the idea, and avoids all extraneous modulations that border on mere descriptiveness. He produces by chaste movement and harmony the requisite completeness of sensation. He is all for having his punctuations right, he is all for the well defined, simply constructed sentence, so to say.

Marin's local scene is by choice, New England, or more specifically, Maine and New Hampshire, or, still more specifically the sea and the mountains. It would be superficial to say that he knows the sea best, because he is not a historian of the sea, he is not in this sense the historian of anything.

Marin is not a teller of tales, in no sense as in the manner of

Burchfield the Ohio water-colourist whose chief virtue is his gift for story, and he is therefore one of the few American painters who is not primarily an illustrator, and it is so easy in water-colour painting to become one. Marin is not a "sketch-artist" as I am determined to call those who have the sometimes valuable faculty of producing the appearance of place the moment they sit down to it. It is this very gift that accounts for the vapidity of so much general painting both in Europe and America. It is not even a passion to portray, that obsesses the touring painter, it is not the lighter gift of copying which was so much the quality in the water-colour painting of Sargent, whose faculty in this field knew no bounds, the search for "theatre" in a simple scene, and in whose pictures so much of real esthetic profundity is lacking.

Marin has no wish to tell an anecdote, no life's little ironies, such as besets Mr. Burchfield in all that he does, and no one will ever be able to say that this artist is engrossed in his medium. He is not thinking of the inner depth, as the Chinese always were, he is carried away with his narrative idea, and this is legitimate enough.

Marin attaches by virtue of his spiritual intentions to the Chinese principles as has been evidenced long ago in the work of his past. Marin cares first and last for the wash, and how to get the maximum expression out of it. And it must not be forgotten that he began life as an architectural draughtsman, and that his earlier etchings of the Madeleine and like subjects in Paris show that if he was not perhaps as dramatically graphic as Meryon was with his Paris, he at least knows the meaning of architectural construction, and applies the principle to every wash he lays down.

He is vitally concerned with the single movement, the ultimate rhythm that will state the esthetic premise clearly, reasonably, and with inevitable dignity.

Marin's wave is a wave, his house is a house, his sail is a sail, his tree is a tree, his rock a rock. He has even sacrificed, I have come to remark, a superabundance of dainty tones that characterizes his earlier pictures, his Tyrol series to recall.

He seems to confine himself almost to the iridescent neutralities of tone because he finds an even deeper sense of plastic strength in them, and one sees that as the years advance Marin is absorbed in hues and tonalities that lean somewhat poignantly toward sombreness, in no sense melancholic in their quality however, a marked

desire to keep more to the essentials of structure than to degrees of superficial flamboyance.

And the pictures have come to look more like mineralogical fragments in a geological collection with their textures of tarnished metal, facets of crystal, achrous [achromatic?] substances, and by this very selectiveness have come to look still more like nature, because they represent natural substances more naturally.

The earth has body, the sea has body, the sail has strength, the island remains fixed in the sea, and the houses are set on their islands where generations of islanders have lived, moved, and had their peculiar beings.

When Marin goes to the mountains, he knows with the instinct of a naturalist, his timbers, and the solid masses of his mountains, he senses their intellectual "granite-ness," he is not interested or absorbed in any way with mere topography. He has seen and felt his masses more than once, and if he could not completely satisfy the mind of an Agassiz, a Linneaus, or an Audubon, it would naturally be because their purpose was strictly scientific, and yet he would not fail to please them considerably, because like the Chinese he is informed of the botany and the geology that typifies his scene, the ultimate "nature" of the subject he intends to render, before he begins. He is thoroughly "au courant" with his prescribed land-scape, and how many painters who practice painting daily can boast as much?

Marin has experienced his subjects with depth, insight and feeling, he has painted them a thousand times, before he has painted them once, he has a universal comprehension of his essential detail, and it is this acute sense of selection in Marin, apart from his deeper researches in the power of a wash, that makes the new work of this artist, to one like myself, who had not seen his progress from year to year, seem like a prodigious ascension in revelatory achievement.

Marin is very much farther up in the language of the medium than anyone I know or have ever heard of.

I should like to see, for purposes of historical value, an exhibition of water-colour from Turner on to Marin. It would unfold marvellous surprise I am certain. I should like to see the flamboyant and watery Turner juxtaposed with Marin, with Whistler, who has come to be almost a kind of Chaminade in the world of modern painting, with Sargent the excellent illustrator, with MacKnight, Burchfield,

Homer, with the earlier Marin, and to begin the exhibit, I should like to see a room filled with Poussin, Claude, Barye, Delacroix, Daumier, and Cézanne, as a beginning offset, and I should ask for a room of earlier Chinese. I am sure Marin himself would like to see it, and I am still surer than Marin himself would be bold enough to admit, that he would find himself thoroughly at home among the great, very much at the expense of those Anglo-Saxon names that head the list in water-colour accomplishment, as given above.

John Marin is behind no one in his comprehension and accomplishment in his medium. He will unquestionably rank ninety-nine and nine tenths in his understanding of the given language he has all his life wished to speak. He has brought his medium to very genuine heights, has pushed it further than any modern I can possibly think of. He has allied himself with the Chinese, the greatest masters of all in water-colour expression, and he has added a deep full resonant American note to the American painting of the present, and of the future.

# 291—and the Brass Bowl

*(1934)*

The entrance of Seumas O'Sheel, the then young Irish poet, into my friendship's circle, O'Sheel full of fire for the Irish revolution of the time, all for going to Ireland and becoming as he said a real Irishman and not a Christopher Street one, gave shape to the course of my whole life.

O'Sheel said, do you know Alfred Stieglitz—he has a little gallery at 291 Fifth Avenue—he might be interested—let's go up and see him, and we went up the next morning.

291 Fifth Avenue was an old brownstone house of the "elegant" period, and had been left like so many of its kind to fate and circumstance, and had been taken over by various kinds of business enterprises.

At the foot of the iron staircase leading to the upper floors of 291 was a small showcase with a photograph in it, the name "PHOTO-SECESSION" and a gold disk between the words. The photograph was of a great celebrity, I don't remember now whether it was of Maeterlinck, of Duse, of Rodin; one of them it certainly was, but it was a photograph made to look like and to have the quality of a painting, and that was the fashion of that epoch, as we have since too well learned, the trend being now of course toward "pure" photography and nothing but, the presiding genius of which is still Alfred Stieglitz, who even at his advanced age holds the field to himself, and who certainly has not been excelled by anyone.

O'Sheel ushered me eventually into a small room on the top floor of that building that opened out from the elevator, it too a tiny affair, allowing never more than three or four to ascend at one time.

A shelf followed round the walls of this room, and below were curtains of dark green burlap, behind which many mysteries were hidden, things having to do with the progress of photography in those days.

In the center of this small room was a square platform, also hung with burlap, and in the center of this was a huge brass bowl.

I didn't know the meaning of brass bowls any more than I do now, but I suspect it was a late reflex from the recently departed eighteen-nineties, and the spirit of James McNeill Whistler seemed to come up out of this bowl like a singular wraith. The bowl, as I say, meant nothing much to me, as the paintings of Whistler never meant much of anything, though I learned later to enjoy the realistic etchings of the Thames series, these meaning more than the whispery effects of the Venice ones.

I was eventually presented to the presiding spirit of this unusual place, namely Alfred Stieglitz with his appearance of much cultivated experience in many things of the world, and of some of them in particular.

Since a photographer never had to fulfill the idea of conventional

appearances as the artist and poet are supposed to have done, the photographer could always look like a human being, and therefore Alfred Stieglitz looked like a very human being, and it was through this and this alone that he made his indelible impression upon me.

Under the nimbus of voluminous gray hair there was a warm light and a fair understanding of all things, and anyone who entered this special place, entered it to be understood, if that was in any way allowed, and the special condition for this was the sincerity of the visitor himself.

I am certain that I never confused the presiding spirit of this place, for I had no talents for such things, so I was taken literally on my face value, and I had some sort of an impressing face, for all that was in me was on its surface trying to find a basis of unification with the outside and what was and still is earnestly under.

I was taken in therefore to the meaning of this place, and O'Sheel said to Stieglitz that I had come down from Maine with a set of paintings seen by no one outside of the the brothers Prendergast, Glackens and Davies, upon which these men had set some sort of artistic approval.

Stieglitz, about whom there was a deal of glamour without trace of esthetic fakery, of which there was a great deal at that time, remarked that if I wanted to send the pictures there, he would look at them.

A morning in this room with the brass bowl was revealing, for a smart array of stylish personages appeared and stood about, for there was no place to sit except on the edges of the brass bowl and few there were who felt courage enough to disturb this very awesome symbol, so they mostly stood, and the more nervous stood first on one foot and then the other.

I was, of course, impressed by the people, for I had never seen quite so many stylish ones. I soon learned also that many of them could be seen on Fifth Avenue of a morning, for it was the fashion to walk and be seen walking then, and if you wished to learn who was who, and to see the casual international face, you walked too, and the walking seemed to lead, curiously enough, to this small and, of itself, not too interesting room. Certainly it was not the room, but what went on in it that mattered, just as a stage feels so empty when the play is absent. The room was, however, full when the little shows were centered in it. So much seemed to be happening.

Stieglitz said to me, the pictures having arrived, if you will leave

them a few days we can then tell you what we think of them—come in three or four days later, and we will then know. This was done, and the remark then was, I don't know any more what I think of these pictures than I did at first, but if you would like it we will give you an exhibition, and you can have it in two weeks from now. I have no money and no frames, I said. We will supply the frames, was the reply, and the exhibition was far more speedily realized than I could have hoped for, and was my initiation into over twenty years of most remarkable experience, I certainly having the right to call it unique, for here was one man who believed in another man over a space of more than twenty years, and the matter of sincerity was never questioned on either side.

The ensuing weeks were employed sensing this new place, a place which has maintained its physical and spiritual existence for more than forty years, and has been a remarkable, surely a remarkable factor in American art experience.

A sort of hallway between the small room and a large room at the rear was also used for exhibition, and in the rear room all the private talking seemed to be done, and it took me a time to find my place in this room, for it was strewn with fragments of fabrics and wall papers which I learned were the working paraphernalia of the decorating establishment of Stephen B. Lawrence, who had always to rummage around for his materials among a lot of artists, who sat around the drum stove which warmed all of them from the winter's chill.

There was likewise a Parisian tone pervading this place.

We began to hear names like Matisse, Picasso, Cézanne, Rousseau, and Manolo, this last name never heard before, and still none too well known outside immediate circles, and it was from all this fresh influx that I personally was to receive new ideas and new education.

There was life in all these new things, there was excitement, there were healthy revolt, investigation, discovery, and an utterly new world opened out of it all. A new enchantment and satisfaction was to come.

There was, therefore, intense excitement of a visual character in this little room from day to day, and the world flocked in to see what it was all about, to hear a possible explanation of it from someone, or to be intellectually and emotionally dumfounded. Certainly some were to be harassed and annoyed.

The critics came and had begun to laugh and deride.

The brass bowl was being filled with other reverberations, far less whispery than the previous ones, and it was not so long after that the brass bowl disappeared entirely and with it the early softnesses of Marin's watercolors, for he too had been overcome—indeed, Marin was among the first in this country to be affected by the new harmonic and the new dissonances.

Drawings and small paintings by Matisse made their first appearance in New York in this room. Matisse's sculpture appeared likewise, also the smaller and, as I recall, only watercolor pictures of Cézanne, then also the abstractions of Picasso, and the small but very forceful sculptures of Manolo.

It must have been more or less at this juncture that Stieglitz recalled to me, only the other day, my pointing to a Picasso abstraction and saying, this is the way it will go from now on, only an instinctive reaction certainly.

Max Weber had returned with a full understanding of the principles of Cézanne and of cubism. I was ushered into this group as a kind of new hope, with an application of impressionism imbibed through Segantini. Somewhere about this time or later, Mrs. Mary Knoblauch appeared as an old friend of Gertrude Stein, with a heap of manuscript saying, I don't understand anything of all this, I wish someone would look at it and see if he or she can—and some of the now well known portraits of Gertrude's such as "One, One, One" of Picasso were printed in *Camera Work*.

One other day a young lady walked in with a roll of charcoal drawings of a friend of hers who was, she said, teaching drawing in the schools of Texas, this friend having been a pupil of Arthur Dow at Columbia. There was no name on these drawings, and there has never been a name on any of the paintings that have followed, for this artist believes also, as I do, that if there is any personal quality, that in itself will be signature enough, and we have seen a sequence of unsigned pictures over a given space of years permeated with an almost violent purity of spirit. The name of Georgia O'Keeffe was spoken eventually, and soon learned by all of us. It was some time after that this woman herself appeared in our midst, who, according to some persistent voices, has become the leading woman painter perhaps of the world, full of utterly embedded femininity.

There was much talk pro and con about my pictures in this little room, mostly con, I seem to remember, with the dissensions coming

largely from the Parisian element. I had no voice in the matter, for I was not a talking person. I only knew I had had some kind of definite experience with nature, the nature of my own native land. I could only tell at what I had been looking and from whom my release had come. Steichen's remark to Stieglitz then was, I don't see, Stieglitz, what you see in those pictures, why you bother about them or him, there is nothing there.

Stieglitz replied, I don't think so, though you may be right—I don't think so—something makes me think something is happening.

New values, as I have said before, have been established, and with the old ones the brass bowl and all that went with it disappeared with a morning wind.

291 had to become a thing of the past, physically speaking, for the building was to be torn down. It was without doubt Mitchell Kennerley who later made it possible for Stieglitz to take room 303 in the Anderson Galleries building. The little room downtown had brought the best there was to light in the world of photography. The whole impetus and interest then seemed to go over to painting and the development of what appeared to be some new American personalities.

Mr. Thomas Craven,[1] in his latest book, would have the world now believe that Mr. Stieglitz has done more evil than good, and that some of us esthetic "snobs" have "gone to the dogs" because of our interest in eclectic notions. We are now placed among the snobs, those awful people, and we are expected to take an interest in the true meaning of art which is "social," as if art was ever meant to be anything else when properly understood, there being no such thing as unsocial art, art being distinctly for anybody who cares to be interested in it, and how really happy must those people be who do not care for it at all, after all the quibbling. Quibbling must, however, be left to the quibblers Stieglitz will tell you, and he has said it a thousand times, that the 291 idea was never meant to be anything but an experiment, "laboratory" is his favorite word; a

---

[1]Craven in *Modern Art* (New York: Simon and Schuster, 1934), showed his true colors as a reactionary critic by calling Stieglitz "a Hoboken Jew without knowledge of, or interest in, the historical American background" and "was hardly equipped for the leadership of a genuine American expression. Furthermore he claimed that none of Stieglitz' artists were "American in flavor"; they perform "in a vacuum of ambiguous spiritualism" (p. 312).

laboratory where several individuals have been allowed to display their virtues and their defects.

Despite whatever derogatory criticism, and it is the pet mania of certain cynics to destroy annually American values to the American people, this little harmless room of 291 will never be shaken out of its significances. It meant well then, and it means well today. It did a work that was never done before, and one that is not likely to be done again, for the same degree of integrity and faith in one person will not be so readily found. All that one group was able to do was done by the spirit of 291, for that group was never but a single spirit and a single voice. It was never allowed to be broken in upon by a touch of hypocrisy, and the thing that happened was found to be a high and strictly pure American value, and an American contribution to American cultivation. The purpose of Alfred Stieglitz and the famous little room 291 through which I was permitted to enter and pass onward to a given realization which I am still engaged in completing, is as genuine today as it was twenty-five years ago, when we all entered into its trust and were given credence.

If this room ceases to mean anything any longer to an outer and different world, it is because this world is essentially indifferent to the kind of thing it meant and still means.

Something has been done that will never be denied its rightful heritage, which can be no more or less than the admiration of the few who understand and who have admiration and respect to offer.

This little room has become to some of us, then, and it is not too much to say, an enormous room—enormous, I say again, if only because it let a few personalities develop in the way they were believed in, and find the way to develop of themselves.

# George Grosz at An American Place

*(1935)*

A hue and cry will probably go up when it has been spread on the air that An American Place is about to take to itself a new artist, of all things a satirist, and again of all things an artist of such international fame.

To offset this amazement, the air will be cooled somewhat by the information that a show of George Grosz' work has been under consideration in this gallery for the past three years—the time of its presentation for one reason or another not having been found feasible until now.

A simpler explanation might be made that in the midst of sobriety, and there is plenty of room for that these days—there is always the need of an about-face slant on things—and that it is time someone came along to shake American complacence and give it a chance to see if it has wit enough to see the joke on itself by means of skilful satirization.

All great satirists have done this for their specific eras—Goya—Daumier—Gavarni—Lautrec—to mention only a few who have left priceless comments on social absurdities—and but for their sharp criticisms the world would be far poorer than it is.

George Grosz takes the place in the scheme of the former 291 now developed into An American Place, after a lapse of twenty-odd years, of that brilliant Mexican satirist Marius de Zayas—certainly a worthy successor of the great Mexican satirist Posado—in the reign of Porfirio Diaz—who contributed so much to the success of 291—who set all tongues wagging in that period by his merciless onslaughts on notables of that time, and no person, alas of prominence was spared—and almost no person who did not have it in his or her heart to have this delightful imposter jailed for his powers of disturbing the peace.

That Goya-like rapier, charged with acidity which burned into the very skin of social conduct was peculiarly repeated in the gifts of de Zayas—and he left many a proud soul afraid of its own shadow in the fashionable beginnings of this century.

George Grosz now comes along with much the same intensified vision—but with a something perhaps less intellectual, something more animalistic in its attack, for Grosz is not a compiler of society manners, he is a compiler of common weaknesses in every day man and woman, by means of hyper-sophistication resulting from complete civilization common, or once was, to the average European mind. All this has been expressed by Grosz through his amazing genius for penetrating objectivity which becomes photographic the instant is it set to functioning; taking in the whole human comedy at a glance with the skill of a surgeon at an operating table—opening up with professional nicety the state secrets of the well worn body of human society, making instantaneous sport of that life as seen with biting genius and calligraphic brillance.

The inner circle of art appreciators is of course long since familiar with the work of this man, for despite his youth, and he is in his first forties—he has had a long and brilliant career—and we have been informed by a series of small books such as "Gott Mit Uns," a castigating satire on the evils of military rule—published when he was a citizen of his native country, and now a willing exile because of his hatred of present régimes. I have known George Grosz personally over a period of fifteen years—when a certain crew of us saw what in the nineteen-twenties has now become a historical fact—the fall of several Roman empires in Berlin. It is in this book to which I refer that a scathingly bitter condemnation of Prussian dominance is to be found—likewise this now so famous and at once equally infamous "Ecce Homo," an amazing piece of sardonic cruelty of vision as well as a remarkable piece of bookmaking in the former matchless German fashion, and it is for this book and for his fearful cartoon of more recent date called "Halt's Maul" (Shut your mouth), a cartoon of Christ on the cross with a gas mask on his face—that Grosz would certainly have been shot against the wall—if he had remained. Grosz is, however, as is well known, the most outstanding draughtsman of the first half of this century and is by all odds the worthy successor to the great names already mentioned above— outdoing the gifted Gulbrannson who was likewise the most outstanding figure in the world of cartoon presentation in his epoch also, Grosz has already influenced the graphic world in the same way and with the same intensity that Aubrey Beardsley did in his time in the decorative world.

This sort of gifted analysis of human frailty does not appear often in a century, and it is given therefore to a man like Grosz to force the very vitals of life to the surface—never for a moment straining the quality of mercy.

His genius for third degree observation is almost uncanny. Nothing escapes, so merciless in his perception, so vitriolic, shooting down so to speak, his victims with sure marksmanship—leaving them standing—befuddled in their own embarrassment.

The foreign eye is bound to see another place, another people with almost unerring vision and it is for our amusement that we are to see ourselves as others see us without too much of compromise.

If Grosz is perhaps kinder in these American satires than he was in his scalpel-like incisions into the coarse flesh-crust of obtuse and vulgar humanity as he knew it in Berlin—depicting the despised "spiesser," the "menschen-fresser" types of which Berlin was then so full and which he was born to hate—there is doubtless a reason, for Grosz likes us, he entertains the hope of being one of us and all of our droll behaviour is to him fresh with vital energy.

If for any reason he should ever come to hate us—the fates attend our misery then, but this is hardly likely.

Whether Grosz can function with the same vitriolic hate as formerly remains to be seen, for that was the power behind his satirical throne of action as artist. Meanwhile Grosz is giving us his versions of New York in much the same manner which de Zayas gave his twenty-five years ago—and the difference is not in the degree of intelligence but in the kind of response to that intelligence.

Grosz himself is the kindest, gentlest of beings, as was de Zayas also—but they both have the same gift for sneering in respectable fashion at the comic touches inherent in human behavior.

# Farewell, Charles

<div align="right">

*(1935)*

</div>

## A Number of Deaths—and Life. A Foreword

A number of deaths,[1] following each other like so many birds in a triangle going south, lured to other skies and other waters with other air and other nourishment in them, like so many birds, swimming into the sundown, hastening, ere the gate should close, leaving them at a foolish portal.

They are over the edge of their chromatic selvages now, and we hear the sound of their voices, which they themselves no longer can hear.

They have left behind them their own life, which we weave into clothes that warm us, shut off too much harsh blowing of wind, and these clothes shelter us against too much north of earth's decisions.

## A Portrait Outline of Charles Demuth

No one wants to see death stalking in the wake of his friends as persistently as I have been obliged to do of late.

I don't recover from these episodes as quickly as some are inclined to do, accepting them as plain facts of life, and I am still wanting the vibrant companionship of those who have brought either richness or fun, or both, into my life.[2] Charles is only just gone, and our private airs still resound with wave-length sharpness of his so recent presence.

Charles has only just gone, rest his winsome bones. I will proceed to the period of twenty-three years ago, the place is Paris, the time is nineteen-twelve-thirteen, and the hour of first meeting a certain déjeuner at the Restaurant Thomas, on the Boulevard Montparnasse.

---

[1]Hartley is probably also referring to the death of Gaston Lachaise who died at the age of 53 in this same year, 1935.          CRANE?

[2]The *New Caravan* version has "being" for "life."

Restaurant Thomas was a particularly nice one, and Madame Thomas herself very handsome, seated at the typical high desk where the patronne may see everything, understand everything, with an air of gravity and at the same time a fine sense of humour, for you have to have humour I should say to run a restaurant.

Yvonne, a pretty daughter, then a young girl assisting her with the service, and there is Père Thomas, a tall man with the usual pallor of chefs whose lives are spent in culinary confinement, and in this case a basement, coming up for air, tall, pale, gentle, with the troubled look of a chef who labours underground to provide good things for the multitude, and the fare was very good.

Restaurant Thomas was always crowded at both meals, and if it was spring, summer, or fall, one ate outside on the terrace, and the chief diversion then was counting the funerals that passed by on their way to the Cimitière Montparnasse—petit bourgeoisie en route to their last rest, by the side perhaps, of Baudelaire—or the well-to-do brass merchant, or the purveyor of oeufs et fromage, or whatever—the corpse covered with dark cloth rented for the purpose, sometimes very grand—with full regalia, sometimes pathetically moving, with, in the case of the costly funerals, many elaborate bead wreaths or even real flowers, and in the case of the poor ones, one wreath or even no wreath at all, and with the rich or the somehow famous, a long line of mourners walking in double file at the rear of the cortege, or in the case of the poor, a scant two or three to inform that someone had a care for the lonely dead, and if you were sentimental you felt you ought to get up and add one more to the poor cortege, O so pathetic they often were.

You could hardly have your déjeuner without its funeral at the hors d'oeuvres, or the fromage.

You would see nearly every day too, a singular little, very pale, delicate man with dark eyes and dark hair, a large ring on his forefinger and a black cane, walking with his mother, and this would be of course sensitive, dreaming little Eugene Zak. You would likewise see a small, very slender, also very pale and dark little woman who always seemed to be in the deepest of mourning, and she was mourning very heavily then for her Poland, and this would of course be Helena Bosnanska, a very highly cultivated woman of aristocratic birth, who knew all the great people of her country intimately, and many of the great ones of France, who for years

taught at the Grande Chaumière and painted people with a curiously whispery sort of pointillism of her own invention, the result chiefly of weak eyes, living in an amazing atelier of the old style, full of spiritually imbued debris as so often gathers in the ateliers of the dreamy type, and there she lived for many years with her pets, and I remember chiefly a cage full of white mice.[1]

Seated like myself with regularity at the Restaurant Thomas, for I seldom ate elsewhere in that period, was Arnold Rönnebeck—who at that time became a friend and has remained so all these years, he having a flair for Americans then, and since the Hitler regime has become one himself.

There was now and then the little corn blonde Alice Miriam,[2] who if she had a time off from vocalizing with de Reske, might give herself a special treat of a meal with us at Thomas', as a release from climbing six flights of stairs to do her own cooking in a room which looked out over the prison on Boulevard St. Jacques, a little way down from the Lion de Belfort.

There was somtimes Lee Simonson, then studying painting, and so with all this a sort of family air pervaded the place.

At all events, at a certain déjeuner, the restaurant was crowded, and for the purpose of regaling Charles's memory as if he were here, and how do we know he isn't, for I am sure all my friends are around a corner somewhere, and so my sense of mourning for physical losses never lasts very long, which is of course very nice and pleasant.

I shall recall to Charles, perhaps more to give a setting for his own entrance, several other figures later, I shall recall to him the day he ambled up to our table, and because of a hip infirmity he had invented a special sort of ambling walk which was so expressive of him, there being one place left at the table at which we all sat, asking if he might sit with us, the request being granted without further thought.

It wasn't long before Charles made us particularly aware of him by a quaint, incisive sort of wit with an ultra sophisticated, post-

---

[1]A number of unpublished MSS in the YCAL concern these people, Eugene Zak and Helen Bosanska.

[2]Rönnebeck's fiancée, who was then studying opera in Paris. (See volume II, "Letters Never Sent" to Alice Miriam.)

eighteen-ninety touch to it, for I always felt that Charles's special
personal tone had been formed with this period, the murmur of
imagined deaths of superior trifles clinging to his very sensitive
hands, and a wistful comprehension of what many a too tender soul
has called infectious sin, alas how harmless and sentimental it all
was.

Charles will recall as I proceed, for he always got a kick out of
them, two figures that came to life with a sort of Beardsleyesque
persistence, two figures out of Edinburgh appearing up over the
edge of the curb at odd intervals, one of them ostensibly a man,
disturbingly stylized if you cared that way, a kind of Fleurs du Mal
silhouette, with his velvet jacket, black of course, and his white lace
cuffs falling over long white hands to which many untouchable
thoughts of night seemed to be clinging, and a cascade of immaculate
silk edged with lace down the front of the shirt, velvet coat flaring at
the waist, large dark ring on forefinger with a black cane of Empire
style to complete the drawing—evidences of much powder about the
face, hours spent doubtless at manicure, and was there not even a
light touch of rouge upon the lips, the eyes large, hollow, searching
after nothing, which gives eyes the saddest of all looks, and indeed he
might have invoked another story from that other singular being of
an earlier period, Jean Lorrain to add more lustre to his Monsieur de
Phocas notions.

All this très exagéré of course, but life was like that then, and it all
seemed to be a part of the day's run, and brings up an amusing and
funny Paris, accentuated all the more acutely by the manner of the
young cubists who were over-dressing in the other extreme à la
Londres, with white spats on all occasions and an air of great
importance whisking about them, their style of dress quite all wrong
of course for no Frenchman can wear English clothes for he can
never walk like an Englishman.[1]

Accompanying this Phocas figure known to us as Stuart Hill of
Edinburgh, another extreme came into view, and the opposite of
course, of masculine virility, the very manly George Banks, whose
fate was to look so singularly like the author of the Ballad of Reading
Gaol, that she was soon to be impeded with his name, and titled
Oscar Wilde la Seconde.

---

[1]A note in Hartley's hand is inserted here in the original: "I speak particularly of
Metzinger and Delaunay as they were then."

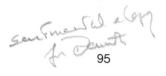

What Banks occupied herself with I really never knew, she too from Edinburgh, but I seem to recall now that it was journalism, she always in stout tailor made, for she was large, quite horsey in appearance, large featured, with something of the stride of the paddock about her.

These two ultra designs were often seen together, Hill of course the subject of much gay banter if he walked alone as he sometimes did on the boulevards, or if they were together, I suspect it was something of a pact between them to stagger the Quartier by their highly affected and outré appearance.

Charles, dressed always in the right degree of good taste, English taste of course, carrying his cane elegantly and for service, not for show, as he always had the need of a cane, coming to our table as I have said, we all saying yes of course, and there was immediately much quaint banter afloat, interspersed with veiled sous entendus, all of it fun, and I remember saying to Charles after the meal was over, I think you had better come and sit with us all the time, and so it was Charles became known to me over the space of the ensuing twenty-three years, giving now the touch of immortality to the many little bits of fun and droll waggery.

Charles was, as we all now know, a fine painter, he had a true painter's cultivation, he had a real feeling for esthetic values even if he thought of them a little preciously perhaps, he was nevertheless a true artist, and with all that a gay playmate.

Charles, like so many of us, became part of a certain epoch in phase of art history in America, beginning with that remarkable and never repeated summer at Provincetown where the "Province-towns"[1] began their first memorable attempt at little theatre movement which was to produce one famous playwright, Eugene O'Neill, and several known actors the chief among them in fame being Ann Harding, whom I see now so clearly appearing at the MacDougall Street theatre, and being given the part of the young girl from the prairies in one of Susan Glaspell's plays, very beautiful she was with her corn-coloured hair and the freshness of the open air about her.

---

[1]The *New Caravan* version reads here "Provincetown Players". Two other Mss. describe this same period: "The Great Provincetown Summer" (unpublished Ms, YCAL, Hartley/Berger Archive); and his autobiography, "Somehow a Past" (volume II).

Many names were created that summer, which have since held their respective meanings, such as Eugene O'Neill, George Cram Cook, Susan Glaspell, whose story of the transformation of Cook into a Greek will be found very delicately told in a book called "The Road to the Temple."

There was likewise the vigorous, handsome, volatile, tender, affectionate John Reed now of perpetual fame, a kind of "doomed to sociability" person, yet enjoying his doom hugely, given to the innocent pursuit of high purposes, now an idol of the first Soviet regime, who after his death there in Russia received full military honours with burial in the Kremlin at Moscow, an honour which he was certainly never playing for as he was in no sense that kind of person.

The rest of us that summer were living side by side, Eugene across the street from Jack's house living in a fish-house with another of those figures who has since gone over to unseen investigations, dear old Terry Carlin—insatiable searcher after deeper knowledge, accumulator of incredible experiences, from flop-house luxury on the Thames Embankment where he remembers seeing more than once the perhaps strangest of all [seekers after] inviolable truths and at what bitter expense, the author of "The Hound of Heaven"— Francis Thompson, Terry always alive to whatever it was, and how clearly I see his granite[1] profile against the ruffled sea as he sat hour on hour in the doorway of Gene's fish-house, ruminating over what indescribable pasts, stroking the surfaces of life with a prophet's tenderness, gnawed too persistently with hungers rich in emotions, thoughts, and the wiser way of knowing things, earned at what terrible cost.

There were the others all vital and vibrating—Mary Heaton Vorse who is now telling her records of the past in a volume entitled "Footnote to Folly"—there are Neith and Hutchins Hapgood, who with Susan and Mary, and perhaps Gene, still maintain properties in Provincetown, and I seem to gather, leave it mostly in the middle of the season to its esthetic quackeries.

There was Hippolyte Havel as cook in the house of Jack Reed where I was a summer guest, Jack having just returned from his memorable interviews with Pancho Villa in Mexico.

---

[1]The *New Caravan* version reads "his gnarled profile".

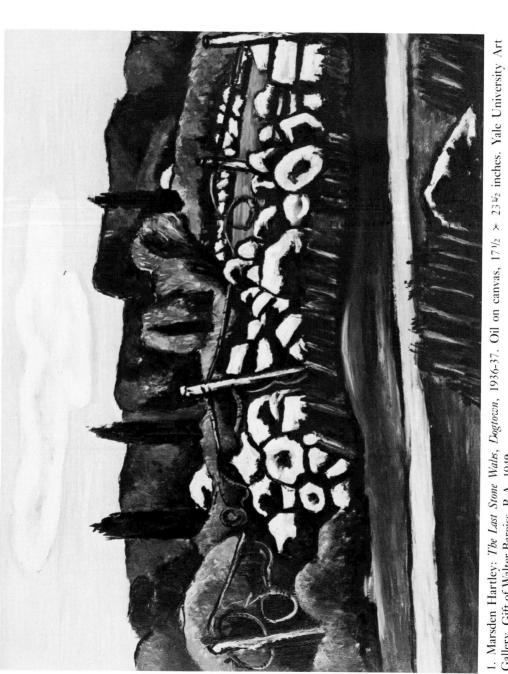

1. Marsden Hartley: *The Last Stone Walls, Dogtown*, 1936-37. Oil on canvas, 17½ × 23½ inches. Yale University Art Gallery, Gift of Walter Bareiss, B.A. 1940

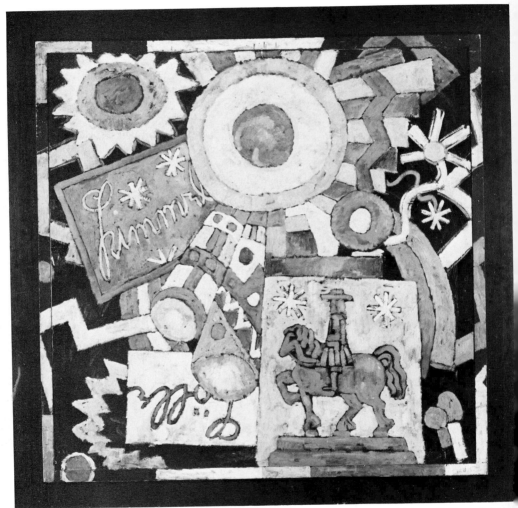

2. Marsden Hartley: *Himmel*, 1915. Oil on canvas, 49½ × 48⅝ inches. Nelson Gallery-Atkins Museum, Kansas City, Missouri. (Gift of the Friends of Art)

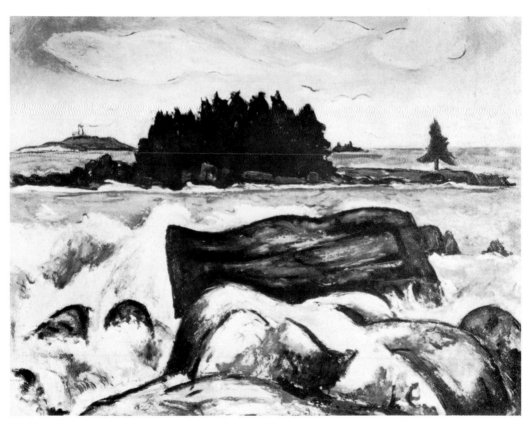

3. Marsden Hartley: *Fox Island, Georgetown, Maine*, c. 1937-38. Oil on board, 22 × 28 inches. Addison Gallery of American Art, Phillips Academy, Andover, Massachusetts

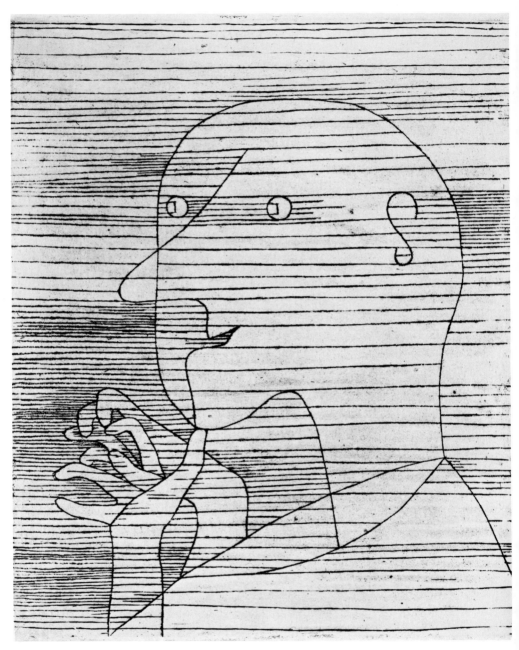

4. Paul Klee: *Old Man Figuring*, 1929. Etching, 22¹/₈ × 17¹/₄ inches. Museum of Modern Art, New York. Purchase

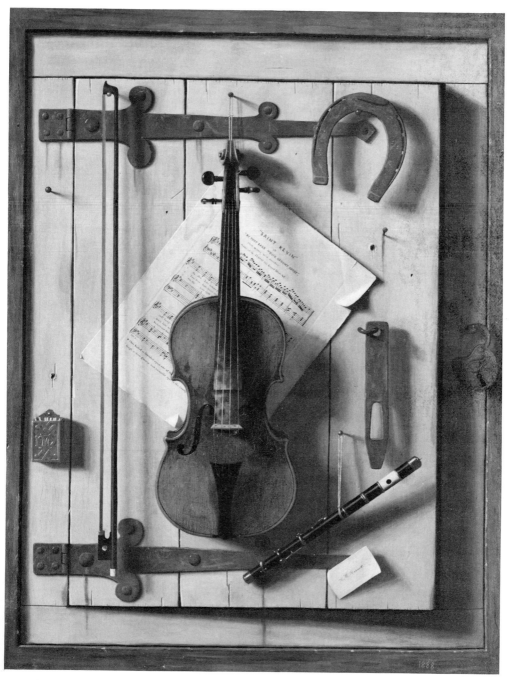

5. William M. Harnett: *Still Life—Violin and Music*, 1888. Oil on canvas, 40 × 30 inches. Metropolitan Museum of Art, Catherine Lorillard Wolfe Fund, 1963. The Catherine Lorillard Wolfe Collection

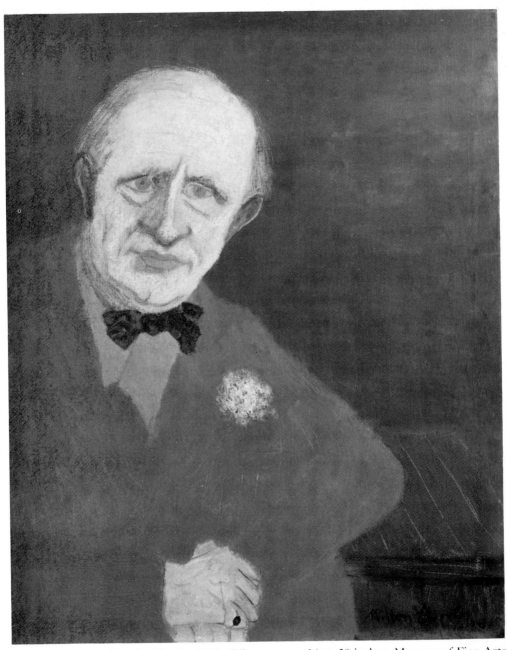

6. Milton Avery: *Marsden Hartley*, 1943. Oil on canvas, 36 × 28 inches. Museum of Fine Arts, Boston

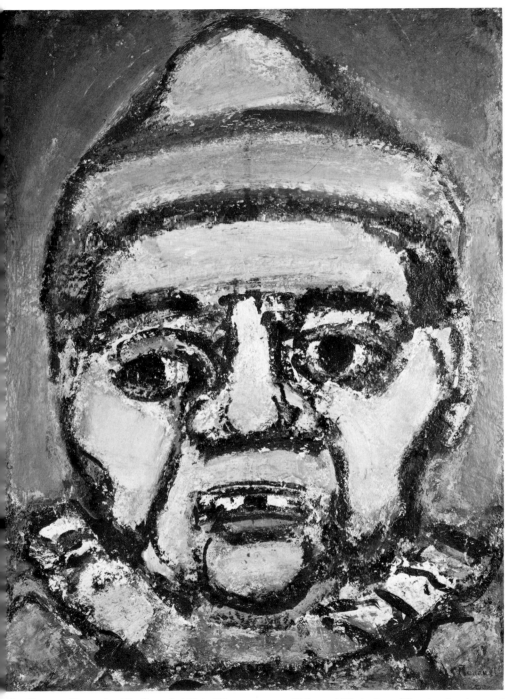

7. Georges Rouault: *The Dwarf*, 1936. Oil on canvas, 27½ × 19¾ inches. The Art Institute of Chicago

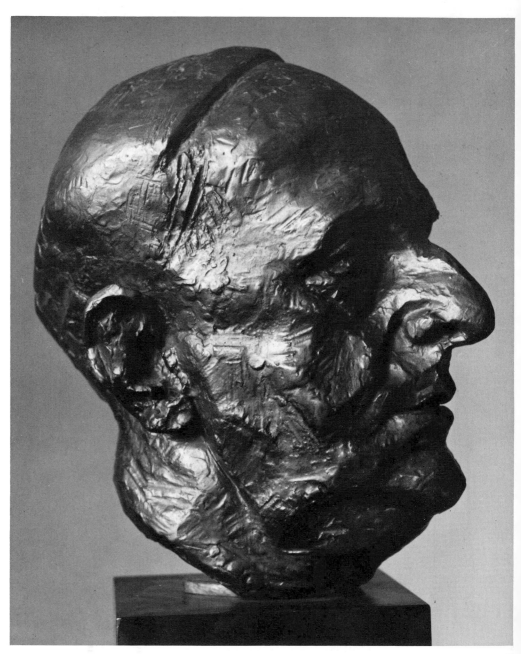

8. Jacques Lipchitz: *Portrait of Marsden Hartley*, 1942. Bronze, h. 15 inches. University of Minnesota Art Gallery. Bequest of Hudson Walker from The Ione and Hudson Walker Collection

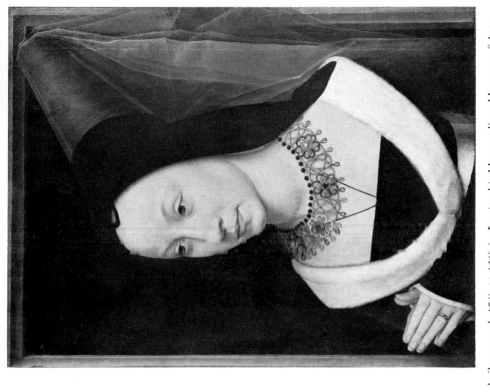

9. Hans Memling: *Tommaso and Maria Portinari*, c. 1475. Tempera and oil on wood, 17⅜ × 13¾ inches (each). Metropolitan Museum of Art. Bequest of Benjamin Altman, 1913

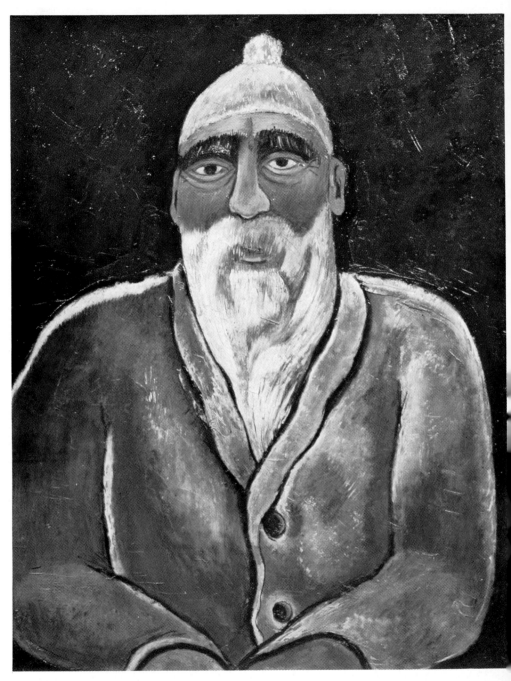

10. Marsden Hartley: *Portrait of Albert Pinkham Ryder*, 1938-39. Oil on board, 28½ × 22¼ inches. Mr. and Mrs. Milton Lowenthal, New York City

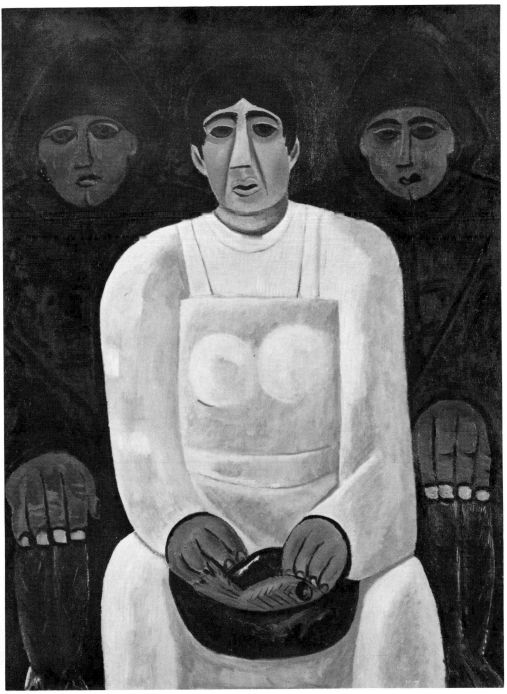

11. Marsden Hartley: *The Lost Felice*, 1939. Oil on canvas, 40 × 30 inches. Los Angeles County Museum of Art. Mr. and Mrs. William Preston Harrison Collection

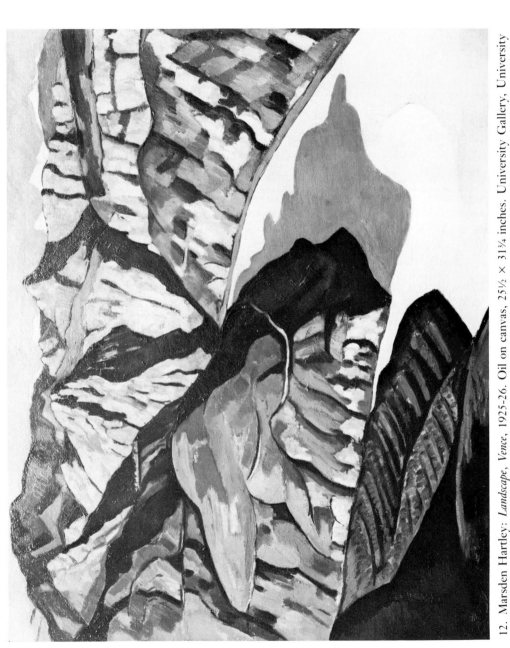

12. Marsden Hartley: *Landscape, Vence*, 1925-26. Oil on canvas, 25½ × 31¼ inches. University Gallery, University of Minnesota, Minneapolis. Bequest of Hudson Walker from the Ione and Hudson Walker Collection

There was the gifted journalist Louise Bryant[1] of whom we hear
little at this juncture—all of us living "up along" and Carl Sprinchorn
and a number of others living "down along" at the other end of the
town.

The summer was really huge in import, and huge in various
satisfaction.

Charles in the midst of all this, especially in the evening or the long
night sessions when after the various kinds of "office hours" peculiar
to us all [were over] playtime was likewise a big business,
and as I see it now, an excellent good time was had by all—all of it
provocative of hilarity and tiger-like stalkings after amusement.

There was the customary inflowing at Mary's down along, or at
Jack's up along, and in between this area Hutchins, or Hutch, and
Jig (Cook) could be found interminably talking about the universe
which never ended, and they would be talking about it now quite
likely, if they were together—and as it wore some of us down so, if
we saw Hutch and Jig coming up along, Demuth and myself would
say—let's scoot, here come Hutch and Jig talking about the universe,
and it always seemed so odd that they could find so much of it to talk
about, and nobody knows if they ever came to perfect and definite
conclusions, couldn't have—for they were always talking about it.

So it was—in and out of Mary's, in and out of Jack's, in and out of
Susan's, in and out of Gene's fish-house, and suddenly it was
decided there was to be and must be a little theatre, and as Mary
owned a dock with a fish-house on it, it was duly decided this was to
be the theatre, and from that little [era] emanated the now so prolific
little theatre movement.[2] I give all this surrounding atmosphere in
various ways, because I am always conscious of them when I think of
Charles, because Charles was a special figure in these scenes and he
would enjoy having himself set out against all that background.

Charles liked being in on these parties, those tiger-like stalkings
after amusement down the courses of the night, he liked being swept
into atmospheres and getting his own funny kick out of them, and
they were big ideas and issues for Charles, bringing some of the best
of his work out of him, and I am sure he gave them far-reaching

---

[1]Hartley added the handwritten footnote: "Louise Bryant has since died."
[2]The word "era" was inserted in the *New Caravan* version but the rest of the
sentence (added by hand in the typescript) was omitted.

importance by virtue of the fact that his imagination was essentially of the spiral variety.

Charles was doing somewhere about this time the series of witty water colours of acrobats, sailors in wild pursuit, ladies in quest of submarine favours, motives which I always felt ended too soon, as they brought so much of the fun out of him, and from these he veered over to Henry James's "Turn of the Screw," which fine drawings did as much probably as any of his efforts to establish him in his place in the prevailing art history of America.

It was in that other famous nineteen-twenty period in Paris, when the crowd from the Dôme, having had some difference with Père Jambon of that historic institution, moved across the street and gave the Rotonde its much sought-for prestige, and it was on the terrace of the Rotonde that another phase of bohemian history was created.

Charles loved Paris, the Paris which had always given him so much unalloyed satisfaction, and it certainly had quality then, which we now hear is irrevocably lost.

Charles seemed always, in a way, to suffer his thrills, he seemed sort of lashed with extasies then pacified, he seemed to sort of tremble at the approach of them, succumb to the magic of their reality, and like so many intensive natures regret their departure into the realms of memory, setting about to recapture in the imagination their appreciable beauty, to be made good use of in some form or other.

The picture of Charles turns now to a moment in an upper room of the Hotel Lutetia on Raspail, finding Charles looking out of a given and what has always seemed to me that remarkable dormer window which afforded one of the most amazing views of Paris to be had anywhere on the Left Bank, and this room and window therefore, always sought by him.

It was a visual operatic Paris that one beheld, and I can never fathom just how this angle was obtained, but you had to a striking degree, all that Paris had to offer, or most all.

You had, firstly, St. Sulpice, you had Notre Dame, you had the Pantheon, and to top it all off with a kind of Persian mythic quality, you had Sacre Coeur, which though in itself one [of] the ugliest of modern Art Nouveau structures, transforms itself by that peculiar dovelike tonality in the atmosphere which at all times hovers over Paris into a kind of Franco Taj Mahal, a temple of love, suspended

arklike after the flood of terrible decisions of the seething emotional world upon the dry ground of the Butte, a sensuous triumph, gateway of voluptuous dreams, mecca for the distraught and the fallen, fortress for the defense of a convincing idea, tomb of a maligned princess, taking on at times if the light were too high, the crude look of a palace of exclusive debaucheries, it seldom seemed to be what it actually is, a sanctuary of the Christ principle, and was again the favourite refuge of the femmes de la rue, chiefly, probably, because of its glamorous and softening effect on the jaded spirit seeking solace from the boulevards below. ] *description* !

Charles is at the right of this amazing dormer window, I at the left, and the disheartening news has been revealed, he saying to me, and I recall it so well—O well, I've seen it all—I've done it all, and the throat thickened with the sense of sudden revealment—Charles learns that he is really ill, and that he must go home.

Summer was on the way to being over, he booked passage home to begin the scientific experiments with the now so famous insulin treatments, being one of the first patients, and as he was the inheritor of its virtues, for it let him live fifteen years longer than he assumed he could, he was also inheritor of its dangerous variations, for he never knew when he would be overtaken with those violent and terrifying collapses, due chiefly to neglect in punctuality of regime.

Charles had a flare for the frivolities, but they had to be of elegant tone, a little precious in their import, swift in their results, he spent hours chasing phantoms of an aristocratic nature, and was often overcome by the highly defined appearance of things, they must come let's say, adhering to the note in their quality as Truffes de Perigord, or—costly to his imagination, he thought of things as interesting only by the degree of excitement they held for them, to get his own kick out of them. He was a bit Proustian in this, he liked fragile gossip, he liked the flare of à la mode emotions, he liked superficialities, but with the difference that being a serious person, he understood the vast implications of the little secrets of life, he rubbed his hands so to speak, if he came close enough to the thin surfaces of them—he was not strictly speaking, flaneur, but he liked the picture of life which such a position offered.

Charles's home life in Lancaster, Pa. will give you the solid background of his rich simplicity.

His mother must be brought into the picture with tender regard,

for she is one of those fine old householders in a small Pennsylvania town, so fastidious about the order of her home that she does everything herself as part of the noble rites of existence.

She went, formerly at least, with the manner of a lady who can trust no servant for qualities, to buy her own provender, she would be at the Mennonite market among the earliest, never later than six in the morning, because she wanted the dew on those fresh greens, she bought this or that of her special Mennonite, for these are the people of this region, those sternly simple people dressed in the long black garb of the cult, as if each were the special bishop of his parish, and the greens were so precious looking they seemed more like corsages than edibles, and a basket of them would have set a chef of the Cordon Bleu to gloating with culinary glee over them.

In the midst of this rich domestic milieu Charles was reared, and when he was at home he liked it thoroughly, as when he was abroad he liked the usual variations of such character.

He spent, because he had a talent for decoration, much of his time making the quaint and typical brick house on King Street, behind which the so typical church stands that forms one of the best of his subjects in his larger paintings, into all but a de luxe affair inside, and though I did not see it after the renovation, report records its charm and the exactitude of detail, for the kind of the house that it is. It belongs to the era of shell flowers, wax fruit, painted velvet, bead-encrusted antimacassars, and the usual complement of horsehair, bell pulls, opaque glass, silver lustre, and all the lavish profusion of accessory of such periods.

*Hands*

We of the intimate crew are all familiar with the patrician hands of Charles, they were Chinese in character, the fingers long and slender, belonging to that species of hands that though they live the life of every other sort of hands, living a life occupied with common things, seem to be living a life of their own, and I am thinking there of hands such as those of Georgia O'Keeffe, Robert Locher, Zasu Pitts, the family of amazing hands as it were, the incredibly wistful hands of Zasu Pitts which we all know, before they became subjected to trade values.

Charles's hands were unusual, and some of us will miss them, how the Chinese would have feted them, even Charles's whole appear-

ance was at times permeated with oriental stillness, until it woke to express a world unlike all that, and became for the moment, average.

Charles had respect for the sentimental, he believed he had been true to the Cynara of his perceptions, he liked nacreous whisperings such as are to be found in the delicate work of that other hypersensitive Charles, in the English esthetic world Charles Conder, whose deepest wonder brought forth nothing heavier than a fan, or fine touches on silk.

It takes time to tell all of what one knows of an intimate, and I have been happily that, in this case for a period of twenty-three years—and the purpose here has been only to outline some of the outstanding traits and tricks of one who liked to be admired, and certainly, himself, enjoyed and admired avidly; he had a capacity for admiration as well as friendship, he believed in friends and was amply supplied with them, a nice old-fashioned quality that survives, regardless of the whims and trends of life.

As for his works of art, they attest to themselves, they are always in the best of taste, conscious of good tradition, a perhaps too concrete insistence upon the elements of refinement and grace, delicate to the last, chiefly flower pieces, because they were within range of his later failing energies, he never could abide the vulgarities in the world of flower painting produced by a powerful painter like Courbet, who has no trace of feeling for them at all.

Charles never made a bad picture, and he made a lot of very good ones, and if many of his pictures were frail in substance they were true in import, essentially decorative, fastidious in line, harmonious, possibly to excess.

He knew the laws of picture making, and that is something that not all painters know.

He was no cheap arriviste, he was no intense eclectic, so there is no strain in his product.

The transition from the earlier, superiorly illustrative subjects to the later, cubistically evolved realistic pictures, is all one thing, and there is, therefore, a natural sequence in his product.

Charles loved the language of paint with the fervour of an ardent linguist, and this side of his work alone is thoroughly achieved.

We see of late that he has inherited, like O'Keeffe, a following of copyists, but that will disturb no one, for the difference is acutely evident.

I would say, that all in all, Charles had a good time being himself,

he probably sweated copious romantic tears to get at the vital incisive values of his experience like so many other idealists, but he did not have to descend to the miseries for the revelation of his powers.

Something like a master of the comic insinuation which lies within and behind so much average experience, always the living material of the fool or the saint at our disposal, Charles traversed the all in all thin area of esthetic experience with a firm step, and he left footprints here and there which have long since been measured and found of the proper size.

# Georgia O'Keeffe
# A Second Outline in Portraiture

*(1936)*

The following episode long since familiar to some—perhaps more in the inner circle than outside it—will for the purposes at hand, bear repeating.

During the season of nineteen-fifteen—a little lively woman[1] appeared at [the] two-ninety-one room which has long since established certain values in American art, with a roll of charcoal drawings that had been sent her, with the express condition that they were not to be shown to anyone.

The little lively woman's argument was—that having looked at the drawings, deriving singular sensations and experiences from them, and felt that despite their author's admonitions these drawings should be shown to someone closer to these ideas than she could lay

---

[1]Anita Pollitzer [Hartley's footnote].

claim to be—that is to say—she felt they must have consideration from someone more actually related to esthetic interests, and so she brought them to that unusual little room—two-ninety-one.

That room was full of curious and lively action those days—for it was making known to this country a number of artists now too familiar to speak of—except to say that these artists were Matisse—Rodin—Picasso—Rousseau—Manolo—John Marin—Max Weber—A. Walkowitz—Gertrude Stein—myself, and others.

Exactly the same condition arose when Mrs. Mary Knoblauch appeared with heaps of manuscripts of Gertrude Stein with the plea that someone look at them as she was not sure just what they were all about and yet she knew they were all about something that mattered

Did these drawings that were brought by the lively little woman have esthetic value—or did they, strictly speaking, have any value at all.

It was the custom at that period for certain artists to gather daily in that special room—and as in the case of all other products brought there—the drawings were considered and discussed.

Most of them found that the drawings had merit—they were sure that a very definite personality had produced them—sure, first of all that a woman had done them—and those of a psycho-analytical turn of mind said things that mattered very much to them—but of not much consequence to anyone else—for artists are not usually concerned with subterranean reasons.

All that mattered was that the drawings had merit—it was a woman who rose up out of the drawings of a singularly violent integrity—and the woman is she who is now known as Georgia O'Keeffe.

In the two decades that have passed since then we have seen the drama unfold with such uncompromising earnestness and sincerity, of a personality disrobing itself so to speak to the gaze of the world much in the manner of that peculiar translucent literary work known as Amiel's Journal,[1] never once considering, for any trivial reason, its relation to any other entity than itself, never once swerving from its documentary persistence, not for any common egotistic reasons—

---

[1]*The Private Journal of Henri Frederic Amiel*, trans. by VanWyck Brooks and Charles Van Wyck Brooks. (New York: The MacMillan Co., 1935), which Hartley read in the late '30s.

but solely for the sake of getting down in esthetic form, all the involved or simple states of being of a separate and intensified relationship.

The history of Georgia O'Keeffe is a unique one—she was born and raised on a Wisconsin farm—in a small settlement known by the attractive name of Sun Prairie—Hungarian revolutionary stock on the maternal side—the maternal grandfather having held the position of aide-de-camp to Louis Kossuth of well known Hungarian revolutionary fame. The strain on the father's side being, of course of Irish origin—no small order in the hereditary sense—to bring together into plausible harmony, tempers of such curiously varying qualities.[1]

The story transfers itself for family reasons to Virginia—and from Virginia the journey outward leads the way to the Art Students' League—into the classes of Luis Mora and William Chase—odd esthetic background of many a student of that period, myself included, for I had the same teachers, but the true angle of O'Keeffe's esthetic development begins at what would seem to be a more rational source—in the classes of Arthur Dow and his assistants at Columbia University—which also, if I am not mistaken includes Max Weber in his earliest training experience.

For pecuniary reasons Georgia O'Keeffe found herself eventually teaching in the University of Virginia—and later on in a similar institution in Texas—and it is from this period that the drawings come.

The rest is a development that we all know. The pilgrimage toward the Golgotha of deliverance through expression, down through the valley of disarming shadows—and up over the sun-clipped heights of spiritual investigation.

From the first the element of mystical sensation appears—and it is not difficult to think of O'Keeffe as a mystic of her own sort—passionately seeking direct relation to what is unquestionably, to her, the true force of nature from which source and this alone—she is to draw forth her specific deliverance.

---

[1] Since writing the above—I have received further documents from O'Keeffe as to her ancestral background which are very important. Her maternal grandmother was of Dutch origin—dating back to sixteen hundred and thirty-eight—making her one of the first Dutch settlers in America [Hartley's footnote].

There are paintings in the stacks of an earlier period that would provoke devotees of arcane research into proving that O'Keeffe had come almost if not completely to the border-line between finity and infinity—there are flames that scorch—there are forms that freeze—there are vapours that rise like the hissing steam of ardent admissions seeking to escape from their own density—then the passionate struggle subsides for a spell, and nature in her simplest appearance is consorted with—and we find numbers of canvases and drawings that seek only to inscribe the arc of concrete sensation and experience—and I am thinking of course of the many smaller essays in flowers and fine shapes from the intricate vegetable world.

There are mysteries from the garden—there are austerities from the forest—there are conversations with shell-curves—and other seeming trivia of the visible world. The vision expands and there are floral figures of enormous size, so huge that they shut out the sky above them—shut out even the morning that opens them—shut out all consciousness of a common world that wearies of its own realities—they become like gates almost that are to close behind a spirit seeking the higher relation known and spoken so freely of by the earlier spiritual romantics, the Christian mystics, they become like corridors of fire and silence through which the spirit must pass to attain its own special and lasting peace—in order to escape imprisonment in a world of defined limitations.

There is the sense also that eternal judgment is not far off in some of these essays, there are blacks that are so black that the peril of annihilation becomes immanent—there are whites so acutely adjusted to their own speechlessness that they seem almost to talk in a prescribed monotone known only to themselves.

There are the flame tones—almost savage reds to verify the flesh—greys of whatever hue that seek to modify them of too much animal assertion—there are disconsolate hues of ash-like resignation, all of which typify the surging passion of a nature seeking by expression first of all to satisfy herself—and in the end perhaps to satisfy those agencies of sensation and emotion that pursue and demand deliverance.

When I once wrote to Stieglitz from Florence in a state of siege among those incredible splendours in the art world there—that of all the artists I had seen—Fra Angelico was the one that would most satisfy this woman artist—for of all that great array of beauty there,

this holy brother had achieved more completely the quality of purity than any other in the whole range of that remarkable endeavor of the renaissance period—and the term "pure" is used here without reference to sentimental or moralistic values.

The term "pure" means in this special sense—the quality of a thing or a thought when it has been released from all irrelevant influences.

Many times I have had the feeling that in some of O'Keeffe's pictures, that by virtue of their subconscious intensity they reach almost over a disastrous horizon, a Blake-like reaching into other spaces, the difference being that Blake by virtue of his ecstatic religious extravagance through Swedenborgian verifications, seeks to establish a clear view of what to him is undeniably heaven—when in a person like O'Keeffe the struggle is always toward a glorification of the visible essences and semblances of earth, or, to employ a fine phrase of Cocteau's "Enfants Terribles"—"the privileges of beauty are enormous—it affects even those who have no experience of it."

There are always a certain number of persons who see grandeur in everything—and are not quite able to state what this grandeur is.

O'Keeffe lays no claim to intellectualism. She frets herself in no way with philosophical or esthetic theories—it is hardly likely she knows one premise from another. She is satisfied that appearance tells everything and that the eye is a better vehicle of truth for picture purposes than the mind can ever be.

O'Keeffe is a highly developed intuitive and she would heartily agree with those pundits who believe that instinct and intuition are all there is to be considered, she—to turn, the Cocteau phrase a little—is satisfied to think of the enormity of the sense of beauty and of its privileges as common property among those who desire to achieve dignified consideration of it. Artists and religionists are never very far apart, they go to the sources of revelation for what they choose to experience and what they report is the degree of their experiences. Intellect wishes to arrange—intuition wishes to accept.

Take the new ram-skull picture in the present exhibition—it is— or so it seems to me—a transfiguration—as if the bone, divested of its physical usages—had suddenly learned of its own esoteric significance, had discovered the meaning of its own integration through the processes of disintegration, ascending to the sphere of its own

reality, in the presence of skies that are not troubled, being accustomed to superior spectacles—and of hills that are ready to receive.

There is, they say, an amazingly moving phenomenon takes place—I do not know if always—in the period of cremation of the human body—when at a given pitch of heat the body is seen actually to rise in the air above its bier before dissolving into ashes. Something of this sort seems to appear to me in the apotheosis of this animal skull attended by a single flower as if to perform the final sealing approval of the august function.

There is nothing forbidding or gruesome in this new essay of this transmigration of bone—and it has, I think a much calmer sense of the same idea that was expressed in the several other ox- and horse-skull pictures where the spirit of death is always present, and the swerve of last earthly rites is being depicted. This brings me to consider the newest phase of O'Keeffe's development, and like all other pictures these new ones also portray the journey of her own inner states of being.

O'Keeffe has known the meaning of death of late and having returned with valiance to the meaning of life—there comes to the surface a confidence that comforts, first of all herself—secondly those who are interested in her as person and artist, greater confidence in the sun and the earth, these new pictures give the feeling that personalisms have vanished—self has been denied—there is the new image living its own life irrespective almost of the person who performed it.

No struggle now, and pictures without ego assertion are always inclined to be satisfying.

You may think of O'Keeffe's pictures as but a further attempt at psychic calligraphy—you may call them image without body—spirit without encumbrance. You may like the new small arrangement of horse-shoe and turkey feather. They may have no meaning at all to you—O'Keeffe like many another significant artist has run the gamut of unqualified praise and qualified condemnation—but she remains the same as always—just what she is, a woman, having a woman's interests, a woman's ardours in pursuit of the sense of beauty—a woman's need of getting at her own notion of truths—she is never struggling for man-power or man equality—she has no need

of such irrelevant ambitions—she has never made a cult of her own intensified intuitions—she is even free from the laudations that have been lavishly heaped upon her—she is a woman, utterly free.

It is enough, then, merely to expect any serious artist to go one step further and of this the clear evidence is here. O'Keeffe never has questioned the condition of delight—it is for her like her daily meal—or a walk in the world, alone. There is seldom a time when she is not aware of her privilege—and the relation to the beauty of appearances is as natural to her as the training of an athlete is to his final demonstrations.

The desire here has been to render something like an outline in portraiture, of Georgia O'Keeffe the woman, as I have known her over a space of two decades—there being no need to go further into esthetic discussions for as regards O'Keeffe's pictures—she has long since proven herself—and the matter of her place is settled.

# An Outline in Portraiture of Self
# From Letters Never Sent

*(1936)*

Dear Aurelie Cheronne:[1]

You, dear Madame, have been for long revered by me, as I must by now surely, have made clear to you, in and out of our twenty years' friendship, and if I address you this winter morning, when the frenzied pressure of ice makes every emotion and thought interior,

---

[1]Little is known about this woman, except that Hartley met her in France before World War I.

having remarked in recent years the enviable journey of yourself into illustrious solitude, where you as a young woman conjured so victoriously among the aspects of your singular fancies, I am inclined to congratulate you, profoundly.

We have talked of these things often by the hard sea, or within the walls of anguished buildings, and I have so often been regaled by the sense of astute perception which has all along been so typical of you, among the finer categories of experience. We have, you remember, talked so much of the livingness of experience, of the aliveness of this or that one among our acquaintance, we have seen now and then a too sensitive one shudder a little, then retire to some subterranean crypt of super-conscious disillusionment, we have seen others pick up and go on, take to themselves new face and feature and become quite something else, something more than even they had anticipated, receiving thereby praise from the clear principle of life which always hopes for increased scope and sudden blossoming in all of us, becoming quite something else, I say, than even they themselves anticipated, precisely because life is always gratified at change of face and feature, leaving behind those who do not remark this, and sooner or later, do not recognize us at all, which is by way of being a new kind of compliment to life itself.

We have talked and thought of people, of things, of ideas, and because we have had what almost seems now in view of these oblique times, a belated respect for pictures, and we have transferred our interest from the problem of pictures to the personage of them, pictures being paintings of course, since being as we are, we are obliged to consider them as one of the real aspects of our experience, and yet, sometimes it comes, how much more alive life is if we do not think of pictures at all. You have been persistent as to the significance of art being placed in the feelings more than in the thought, that of course being romanticism, which notion is never far from human needs, and toward which there is a distinct leaning to revival, and if you have looked upon the incredible "Night Watch," you have been certain of how much more feelings have to do with pictures than thoughts merely for themselves.

Fine pictures are, after all, are they not, something like images of the true architecture of being, else how could they rise to the heights they do in the said "Night Watch," or in the unfinished "Adoration of the Magi" of Leonardo in the Uffizi, already seeming to sing of the

harmonies that have not quite reached fruition there, realities rising above mere thoughts or dialectic adherences, into the realm where everything is alive because it lives out perfectly the dictations of clarified human sense.

There will always be in every field of thought the conflict between fact and the imagination, of intellect and intuition, the objectivists will always accuse the dreamer of building swallow nests in the stone mouths of their objectivist giants.

Some are born subjective, abstruse—some the reverse of it, and whomever is born whichever way can only keep to form, we inevitably obeying our own polarity in all cases.

The question of sentimentality arises, and you say—everyone is born sentimental, it is the umbilical twitch that makes it so, everyone dies sentimental, because he is caring profoundly about even the cessation of physical life.

It is sentimental to care about anything, inevitable—that in order to live at all one must care about something. Even raw facts, wearying of their own solidity crave a touch of visionary glamour, even they are therefore sentimental.

Art as experience, simple enough—you like it or you don't like it, but human nature is helpless, for the search for beauty in some form or other is the most mechanical function that can be thought of, and as natural as digging potatoes in October.

You are, however, most right when you say it is bad taste or no taste at all to like something herdwise, witness the recent and almost leprous enthusiasm for the dead Van Gogh, whose livingness, so abject in his time, ceases to revile the multitude swarming to its presence via the dress-shops, with no other motive than helpless curiosity which does them no good save to learn of the dull predicament of the artist, the element of pity often making art and artists so attractive and fashionable, and who now that his broken filaments have been flayed before intemperate winds, return to their cold spaces again, and "ici repose" on a moss-worn stone gleams once more amid faint shifts of casual sun.

You recall too, I am sure how our contemporary, also a woman of the north remarked to me a few years ago, gliding her glistening hands over the arms of her huge gold chair, relic of the great auction-room fetish, saying—"Aren't you glad you were born in the nineteenth century"—and I, returning, for the moment confused for

it sounded like glib afternoon tea snacks in words, "I must think it over," and—having thought it over, the answer was obviously "yes," if only for the simple truth that I have my roots there.

And I began to think of the White Horse Legend of Yorkshire, or was it more precisely Cheshire, that was tossed over to me on the saltstrewn rocks of New England, and of the same geographic heritage of Richard Rolle and his undying song-fervours to his beloved Yhesu, and the much too living Bröntes, binding awful truths together with their herbaceous sentiments and frozen ecstasies, and at my child's elbow, the warm diffidences of Emerson and Thoreau nudging me to consciousness, I felt secure enough.

All that is coming to the surface again, and if you could be aware of this present exhibition, life being a matter of successive and hopingly intelligent detours, foreground being the fruition of background, you would readily fill out the edges of this portrait for yourself, a life spent in plain beliefs, in despairs, understanding, and with more or less sudden vision accepting experience, made cautious with need of reasonableness, denying the importance of anything at all but the quality and principle of life itself.

Silence, solitude, two of the most exciting agencies I can think of, with certain degrees of representative laughter are sufficient, and the wit to learn that talk is not conversing, nor is action movement.

All of which returns us to your high respect for the illustrious solitudes.

You will understand more than anyone the meaning therefore, of Video et Gaudeo, and that what really charms the eye and the spirit are sure to bring well being, and what engulfs the ear so often proves to be little else than voyageless contraband.

And if I add the mystical anagram of Own, Won, ONE—you will again know too well what I mean.

I wish you perfect joy in your illustrious solitudes.

# On the Subject of Nativeness—A Tribute to Maine ☆

STRAND? (1937)

The subject matter of the pictures in this present exhibition is derived from my own native country—New England—and the country beyond to the north—geologically much the same thing, with, if possible, an added tang because it is if anything wilder still, and the people that inhabit it, fine types of hard boned sturdy beings, have the direct simplicity of these unique and original places, this country being of course, Nova Scotia. These people, the kind one expects to encounter in the forests where the moose and caribou range, and who, sauntering toward the nearer south in search of food which deep snows deny them, are on perilous ground, doomed to decrease in numbers. As a boy in Maine, one read the news items in the paper after October, and the casual daily report was—So-and-So lost in the woods, perished of hunger and cold, and often never found until the thaws of spring, and it is exactly the same today.

The opulent rigidity of this north country, which is a kind of cousin to Labrador and the further ice-fields, produces a simple, unaffected conduct and with it a kind of stark poetry exudes from their behaviours, that hardiness of gaze and frank earnestness of approach which is typical of all northerners which is sometimes as refreshing to the eye as cool spring water is to the throat, because there is the quality of direct companionship in it, and—if you are seen, you are seen "through," there is no mystery you can offer, quite like the encounter with the Indians in the southwest, for whom silent contact is the sure means of a declaration of friendship, and since you cannot deceive them, they make no attempt to deceive you, so that, generally speaking, how do you do is much the same thing as how do you do my friend, which is exactly the Indian method.

Those great sea faces up there in the north are wonderful with directness and trust, and since silence is the bond, silence is the enriching channel by which you make social contact, or at least to say, brief speech and much meat in it.

Husbands and sons are drowned at sea, and this is just as natural

112

to hear as if they died of the measles or of a fever, and these men who are pretty much as children always, go to their death without murmur and without reproach.

Maine is likewise a strong, simple, stately and perhaps brutal country, you get directness of demeanor, and you know where you stand, for lying is a detestation, as it is not in the cities.

To the outsider New England is New England, no matter what route he takes, he takes out his gasoline road map, and it is much the same thing to him because he thinks of routes and of how much ground he can cover, but tell this to the secular New Englander and you get into trouble, and for a Vermonter New England is never anything but Vermont—New Hampshire, being pretty much sold out to the rich invader, has without doubt its sense of pure locality when the said invader has left.

To the Maine-"iac" New England is never anything but Maine, he never says he comes from New England, he comes from Maine, and Maine is his country and his place of origins, bounded on every side by its people, its place, and its ideas, just as a Boston one would never dream of saying he is from Massachusetts, and how could he?

This quality of abstract yet definite reality appears in the realm of art in its strongest and most powerful degree in the paintings of Albert Ryder, who has said once and for all—all that will ever be known about that country, and it is given further local significance in the work of George Fuller and of Winslow Homer, who though having been born in Boston, spent the most expressive part of his life at Prout's Neck, Maine.

A fierce Yankee was Homer, keeping a shotgun behind his door for years against the local invader of his property, so the story goes, who must at that time have harrassed him.

In the field of music, Maine has come to the front with such names as Emma Eames of Bath, Lillian (Norton) Nordica of Skowhegan, Annie Louise Cary of Durham, as in the field of literature there are the names of Edwin Arlington Robinson of Gardiner, Edna St. Vincent Millay of Rockland, Wallace Gould and Holman Day of Lewiston, and as a native Maine artist, myself from Lewiston, and we are not forgetting Longfellow.

There is a new school of literature of Maine coming to the front such as the names of Rachel Field, Mary Ellen Chase, Gerald Warner Brace, William Haynes, Frederick Nebel, I. H. Carter, E.

Myers, B. A. Williams, and Robert Tristram Coffin, whose latest volume of local flavour verse surprises one with the vivid localism of its characterization, proving that when localism is true, it is bound to survive and recreate itself.

"The Country of the Pointed Firs" and the other attractive stories of Maine of Sara Orne Jewett did much to produce the local sense of literature, and the tradition has been carried on by the now well known others, Robert Frost added his sharp values to the west in New Hampshire.

If you will probably find never a mention of Maine in the stark poetry of Edwin Arlington Robinson, no one could be more representative in his type of speech, no one more typical of the bitter behaviours of place, but we must correct the New York art critic who says, "why do Vermont and Maine always weep" by remarking that they never weep, they grit their teeth and face the gale.

It is the habit of middle westerner regional rooters to speak of New England as the fag end of Europe, but that is because, knowing little or nothing about it, they dispatch it at once with a derogation of Harvard, which of course is not a place but a school.

The essential nativeness of Maine remains as it was, and the best Maine-iacs are devout with purposes of defense.

The Androscoggin, the Kennebec, and the Penobscot flow down to the sea as solemnly as ever, and the numberless inland lakes harbour the loon, and give rest to the angles of geese making south or north according to season, and the black bears roam over the mountain tops as usual.

If the Zeppelin rides the sky at night, and aeroplanes set flocks of sea gulls flying, the gulls remain the same and the rocks, pines, and thrashing seas never lose their power and their native tang.

Nativeness is built of such primitive things, and whatever is one's nativeness, one holds and never loses no matter how far afield the traveling may be.

Henry Adams' Boston is in every line of the "Education" and the great Jameses never shook the soil of their native heath from their traveling feet, not even Henry the European, who pled inwardly at the last for return, and if Edith Wharton spends a deal of her time at Hyéres in the South of France, she writes just as bitterly of her native New England, William James always discouraging the family habit of traversing Europe, came home finally and planted himself under his own loved Chocorua.

If there are no pictures of Maine in this present exhibition, it is due entirely to forward circumstance and never in any sense to lack of interest, my own education having begun in my native hills, going with me—these hills wherever I went, looking never more wonderful than they did to me in Paris, Berlin, or Provence.

Dogtown and Nova Scotia then, being the recent hunting ground of my art endeavors, are as much my native land as if I had been born in them, for they are of the same stout substance and texture, and bear the same steely integrity.

Those pictures which are not scenes, are in their way portraits of objects which relieves them from being still-lives, objects thrown up with the tides on the shores of the island where I have been living of late, the marine vistas to express the seas of the north, the objects at my feet everywhere which the tides washed up representing the visible life of place, such as fragments of rope thrown overboard out on the Grand Banks by the fishermen, or shells and other crustaces driven in from their moorings among the matted seaweed and the rocks, given up even as the lost at sea are sometimes given up.

This quality of nativeness is coloured by heritage, birth, and environment, and it is therefore for this reason that I wish to declare myself the painter from Maine.

We are subjects of our nativeness, and are at all times happily subject to it, only the mollusc, the chameleon, or the sponge being able to affect dissolution of this aspect.

When the picture makers with nature as their subject get closer than they have for some time been, there will naturally be better pictures of nature, and who more than Nature will be surprised, and perhaps more delighted?

And so I say to my native continent of Maine, be patient and forgiving, I will soon put my cheek to your cheek, expecting the welcome of the prodigal, and be glad of it, listening all the while to the slow, rich, solemn music of the Androscoggin, as it flows along.

# Pictures

*(1941)*

"The artist creates essentially by reason of an inward urge, which we may describe as the individual will to form, and whether he objectifies this in a picture, a statue, or a symphony—is rather a technical and formal matter than an individual problem. This is particularly the case with the great artist whose poem is plastic, whose portrait is poetical, and whose music is architectonic in effort."

From *Art and the Artist* by Dr. Otto Rank. A great book and should be read by every earnest artist. M.H.

What do pictures mean anyhow—I have been trying to find out for at least half a lifetime. I have no way of knowing what they do to the spectator, all I know is that a good picture will do a lot, and a bad picture will do a lot more. I will insert here the statement of Jean Cocteau: "the privileges of beauty are enormous, it affects even those who have no experience of it." ("Enfants Terribles").

For myself I have walked toward the good ones, because they have told me that pulling the trick off with something like intelligence is all there is to it to me, for I have no interest in the subject matter of a picture, not the slightest. A picture has but one meaning—is it well done, or isn't it—and if it is, it is sure to be a good picture whether the spectator likes it or not.

And I remember the old gag that we have heard so often, and is perhaps still being used: "I don't know anything about art, I only know what I like," and the only answer to that is—do you?

Gertrude Stein says that if you enjoy a thing, you understand it, and plenty of people enjoyed her "Saints" play who certainly did not know what it meant, if it meant anything at all.

I have been fed by some very grand pictures, and if I were driven to name but one picture that has meant the most to me, I would say the incredible picture performance of the "Night Watch" by Rembrandt in the Rijksmuseum in Amsterdam—having seen it twice, and having been sort of swept off my feet in admiration of it.

If there is such a thing as a relation between painting and music, well then—there is a wealth of Brahmsian symphonism in this picture.

Who has ever done a greater piece of painting than that picture—frankly speaking no one from any point of view, no one.

But the choice of one would limit me so I must include some others that have done so much for me—that burning little "Crucifixion" of Fra Angelico in the Metropolitan Museum in New York, any of the Memling portraits there also, the strangely exciting "Saint Sebastian" of Georges Dumesnil de la Tour, any of the monk pictures by Zurbarán, especially the white one in the Hispanic Museum also in New York; the large "Danseuses aux Bouquets" by Degas, O what a picture—several of the Gericaults in the recent show of French painting again at the Metropolitan—a good snow scene of Courbet, a good whispery Corot, a cubistic picture by the very gifted cubist, Roger de la Fresnaye—sometimes a Rubens, often a minor Dutch painter, especially Willem Van Aelst, O so distinguished, any ribald Breughel, any Greco, almost any Goya—well, I could live on these alone if I had never seen others, and Masaccio and Piero della Francesca must be brought in here—and I have seen almost thousands of others. I would do myself a wrong in leaving out one of the grandest names of all in the modern art world, perhaps the last of the great school of modern painting, Georges Rouault, with his faultless technical knowledge, and his deep and powerful humanism—a great spirit—great artist, great performer.

It is the metier that should interest a painter because, after all, it is what he knows about what he is doing that counts, and no amount of slurring or bluff will change that. Pigmental fluidity for me is like the production of tone in the voice—I still hear the incredible mezzo of the late Mme. Marie Delna, the same sort of male range in the voice of Maurice Reynaud, the same sort of thing in the voice of the present Ezio Pinza—Serkin at the piano, Piatigorsky at the cello, Bing Crosby singing with such deep-well toned warmth "Home on  the Range"—all of this is what moves me to paint, and I see no other excuse for painting pictures than to be "moved" to paint them.

But this is the performer's point of view, and I must not forget to speak of the Coptic embroideries, which for me are classics in great painting, because they must basically have been great painters who made them.

I think I was never more completely bowled over than when I saw the amazing collection of these embroideries which were recently shown by my friend Mr. Dikran Kelekian, who after possessing them for forty years, decided to uncover them at last, of which I am now the possessor of a number of fine examples, and when I want to know about great tonality, I get them out like a pack of cards and play a sort of solitaire.

One can go on and on about pictures, the main point is—does the painter know all his tricks, whatever tricks are, does he know them, if he doesn't—he isn't a painter.

That is all that pictures mean to me, actually all. Theoretical painting has little or no meaning for me, because it takes place above the eyebrows—I want the whole body, the whole flesh, in painting. Renoir said that he painted with all of his manhood, and is it not evident?

It is the "blood" of good painting, that makes it all right, with me.

# PART II

## From VARIED PATTERNS
## (1923-1929)

*Hartley began to compile these essays while living in southern France between
1923 and 1929. The thirty-six essays comprising the manuscript—at one
time entitled "European Art Notes"—largely concern his encounters with
European modernism of the 1920s as well as his visits to some of the great
museums of Belgium, Florence and Rome. On his return to the United States
in March of 1930 he had the manuscript typed by a friend, intending to have
it published as a book. First, however, he submitted individual essays to*
Vanity Fair *and* Magazine of the Arts—*journals where he had friendly
contacts—but with no success. He then wanted to take the manuscript to his
friend Albert Boni who had published* Adventures in the Arts *ten years
before, but realizing that a book of "casual essays" on art and the theater was
not a particularly profitable enterprise in a time of economic depression, he
despaired of ever having the book published, and it has remained unpublished
until now.*

*With the onslaught of World War I, the initial rush of American avant-
garde artists to Europe was sharply curtailed, and by the time the war ended,
most of those artists had settled down to their own business at home. Hartley,
however, chose to continue living abroad and to voice his reactions to post-war
art activities in Paris and elsewhere. In fact, he trifled with the notion of
earning his living as a foreign art correspondent for some newspaper like* The
Christian Science Monitor, *though he lacked the wherewithal to follow
through on such a demanding project. As the work of an American artist
writing about European art trends, it is unfortunate that his appraisal of the
situation which is characterized by candor and fresh insights, did not find its
way to an American audience of the time. Nevertheless the vitality of his
message endures, providing us with a unique historical perspective.*

*The selections included here demonstrate the polarities in Hartley's
evaluation of post-war French art and help explain the development of his
own thought. On the one hand was his abhorrence of the excessive personalism
he found rampant in Paris art circles: the cubists who were marking time
repeating themselves "at exceedingly high prices" and the surrealists with their
"super-sensations" and "subterfuges for literary effusions of a not very deep
character" ("Max Ernst"). On the other hand, authentic personalism could be
found in the work of Paul Klee who, though not by any means a naive
painter, was nonetheless gifted, in Hartley's estimation, with a genuine
simplicity and purity of vision which made him the inimitable "father of these
soaring but flightless neophytes"—the surrealists. The crux of the distinction
between Klee and the others is in the sources of their private visions. Klee, like
Albert Ryder and Francis Thompson, relied, in Hartley's view, upon*

*natural imaginative faculties; whereas the surrealists' work evolved from cerebral games aimed at theatrical effects.*

*The culminating statement of his reaction to the deadening influence of effete personalism can be found in "St. Thérèse of Lisieux." Our interest in this essay stems not so much from the details of St. Thérèse's life described here in Hartley's typically fervent style, as from the effect her life and writings had on him, especially on two accounts: that she was a child mystic, filled with the wisdom of the innocence; and that her life belonged "in the field of esthetic creation." She appealed to him for the same reason he appreciated Klee, Henri Rousseau, Thompson, or American primitive art.*

*In the essay he cites Havelock Ellis's chapter "The Art of Religion" in* The Dance of Life, *where he claims that religious mysticism "is an art which instinctively reveals to us the secrets of other arts. It presents to us in the most naked and essential way the inward experience which has inspired men to find modes of expression which are transmutations of the art of religion and yet have on the surface nothing to indicate that this is so. It has often been seen in poetry and in music and in painting."[1] By placing St. Thérèse's pious accomplishments in the domain of art, Hartley (in the light of Ellis's argument) implies that mystical experience can provide one with a means to unlock deep treasures inherent in art, poetry and music—and this despite the fact that the modern artist, like himself, is seldom a believer in religious doctrines.*

*In the context of these* Varied Patterns *essays, it is clear that this extended period abroad in the '20s, rather than being time wasted, provided him with proving ground upon which to test and assimilate the forces of modernism, and from which his unmistakable individuality as artist and writer would emerge in the 1930s.*

---

[1](Boston and New York: Houghton Mifflin Co., 1923), p. 237.

# Arezzo and Piero

*(c. 1923)*

What a clear gem embedded in superb matrix—The Apennines.

The train was three quarters of an hour late leaving Firenze and I had little hope of achieving my object therefore for that day, namely to get at least one look before nightfall, to get into the church of San Francesca.

At four o'clock however Arezzo was reached and I put myself into a mid-Victorian fiacre and said "Stella d'Italia."

It all had a silvery look, Arezzo in the late afternoon of early winter and brightened up my senses after such a surfeit of tourist-ridden Firenze and the never ending parade about town of faded, jaded English—for the English types that tour are no more attractive than any other type and all the tourists of the world seemed bland in Firenze, so picturesque, pretty, famous and excessively dull as a city. How can anyone live in Firenze, so worn and weary with its traditions?

Finding the Albergo Stella d'Italia a very nondescript little hostelry recommended to me by a literary friend, but clean, I deposited my baggage and went to the church and straight down to the altar and behind. There they were, those very Piero della Francescas as one might say, in the flesh—knowing them so long in the spirit, what a thrill then to be actually with them. If I had specific reasons for going south it was for Masaccio and Piero. There is of course always something one doesn't get in a photo of a thing, a place or a person, until after one has really encountered them, and "touching" these frescoes I had known so long and so eagerly wished to see face to face was like going from a thick window where you have watched skies, flowers, fruits and natural beings, out to the very objects themselves. This sort of experience seems inevitably to give them being, which they do not actually possess.

I had expected an almost severity, though not the metaphysical intensity of Masaccio. I knew how much deeper they would be than Botticelli, so all on the surface, almost nobler in design, far nobler

indeed they are than any others I can recall, these frescoes, in the great bulk of those around Firenze.

Thank God for the coolness of this man, for the sort of acrid tang in his spirit, something to offset the nauseating sweetness of the others. Castagno had helped a deal in this respect but Castagno is somehow bitter and ironic. Not so, Piero—not cynical like the brilliant Mantegna or the somewhat perverse Pollaiuolo, far less lost in the higher mysticism than [Fra] Angelico, remaining on earth, this clear brightness away from men yet not utterly aloof, or if so, then agreeably—the Bach-like sense of architectonics and of the dismissal of extraneous ornamentation.

I can think of no greater majesty of style, no greater simplicity excepting of course in the Chinese where all is law and order, poise and serenity, such a sense of wall-spacing and the perfect comprehension of what must be denied for the ideas at hand. Such tact in detail, grandeur of mass, splendour of orchestration, incomparable sense of pageantry, the going toward a centre of things, of group sensations joined in a single movement without the intrusion of illustrative impulse, so typical of Lippi in the [Sta. Maria] Novella, or Gozzoli in [the] Palazzo Riccardi, never in Masaccio or in Castagno, not in this highest, for me, of all of them, Piero della Francesca.

What beautiful sturdy actual men and women with what superb horses, incomparable landscape touches, set off with matchless groupings of hilltown architecture. I had expected grandeur, elegance and nobility of diction and I found it—such commendable passion for coolness, hardness, light and the finest feeling imaginable for dramatic gesture without ultra gesticulation or tortuous design, a mistake so often made by one so incontestable as Michelangelo especially in the "Last Judgment" in the Vatican. I can say now that I know what fine painting is, after seeing these, for me, greatest of all Italians because they appeal most, very cold and very clear.

Directly across the street from [the] Constanza Café I see the door of the Chiesa closing at noon, for this is the second visit to these impeccable frescoes. I wait for the re-opening for perhaps the last view of these brilliant works before departure for Orvieto and Rome. Perhaps [noon?] is the best light of all I come to think, for Piero—clear, cold, hard, testing in every way these works, from the last glow of yesterday afternoon when I seemed to feel them a little

thin, growing in force, as all great things grow on one, flooding one's being with their fullness and simplicity.

It is curious, I remark, this seemingly irrelevant application of details, such as dots along the edges of a horse's legs to represent hair, as well as the worked out curls in the hair of men without hats, and the introduction of two or three tiny swans in the distant river that passes in and out of a splendid brown and white landscape between the bodies of the two horses; and is there a grander piece of unified composition any where than in the right section top "Morte e Sepultura d'Adamo" of the grand right wall, replete with the grace of feminine austerity and simplicity, the women having faces perhaps a little too young-mannish for females. And what appreciation of the silent splendour of a city to the left, of the "Invenzione e Verificazione della Santa Croce"—above also the "Dispatta de Massenzio."

How they shine out, these units, above the world of ideas and of realities, how they dominate in quietude, this arrangement of precious stone-like directness in a severe setting of rusty iron hills edged with the white incrustations of winter, these Apennines, in a little brown city of oxidized bronze and over there, amid a much greater confusion of good taste and bad taste, the Brancacci Chapel of the [Sta. Maria del] Carmine in Firenze, everywhere indeed neighboring the work of the best men, insufferably bad baroque of the worst possible conception. And in point of emphatic comparison can you see for the moment a Murillo Madonna with upcast eyes or even a saccharine Raphael against these Pieros, how rude and sort of discursive they would seem in the presence of a spirit so magnificently august?

I have said before that I should like to go to Chartres Cathedral once a year to wash my eyes out of the soiled picture of the world, apply a bath of these windows to my eyes and a rich feast of purity from the sculpture there. And so I should like once a year to make my pilgrimage to the Carmine in Firenze, steal away and come down to Arezzo there to regale myself again in the presence of this stupendous intellect and soul of Piero, for these are events, they are not diversions, they are disclosures of that finer wisdom that makes men out of idlers and thinkers out of the self-centered. Piero was deep and deep with the sorrows of understanding and if he was not the type to go to the mountain and pray he was of that class of intelligents who face what is before them with unflinching eye and

believe in life in the measure in which belief is allotted to them. Masaccio was born with wisdom. Piero was a gentler dispenser of it and having lived a full span of years—twenty years of them blind— he had reasons for his understanding.

In the market place this morning in Arezzo, all alive with clacking tongues, and the flutter of domestic fowl, all bound together, all awaiting change of hands, of scenes, of destinies, in general, who among these peasants would ever suspect that one of the world's greatest masters had perfected their scene in the universal imagination of men; that here, on this very spot, where they live and die out their beginnings and their ends, one of their kind, a man like themselves, has fixed for all time their appearance among their own iron-hued hills.

Arezzo is a place and Piero della Francesca is a name, but the world would never be the world without them, as the world of art would not be the same if Piero had not been dispatched into it to give it tone and temper, dignity and concept.

O, the power to conform to the exact measure of taste in all things, not in art alone, as shown by the works of this wonderful Piero. I think of him as expressing recognizable universalities of sensation, taste, and good judgment.

# Rome and the Ultimate Splendour

*(c.1923)*

The week in Rome—Christmas time—a novel kind of Christmas holiday, Christmas the Coliseum!

All great and powerful spectacles produce the same effect in the beginning. Just as Niagara Falls did during the first hour. Something about them seems to defy surprise at once. It is their own steadiness, their continuity, I suspect, that keeps the crescendo for the last instead of the first moments. And I imagine the Egyptian periods [sic., pyramids] and the Inca Temples give more or less the same effect. Power, simplicity, grandeur, repose. These are things that men have done well—the Parthenon, the pyramids, the Coliseum. It is difficult in Rome to try to see art seriously and after several attempts I gave it up and I said to myself, this Coliseum holds for me all there is, and I returned there every day after. And how difficult it was to have any feeling for St. Peters with its tone of interior extravagance and tastelessness. And I suppose the two mile walk through the corridors from the portal of St. Peters up to the rear of the apostolic palaces and down, actually in, to the Sistine Chapel, may be worth the effort. I wonder.

The gloom that arises from this chapel—is it the fault of Michelangelo—all that spiritual ponderousness on the ceiling, where no such things should ever be—the supendous technical problem and virtuosity discounted by the great difficulty in seeing them at all, for to see them properly one must recline, naturally. Why should there ever be anything at all—of thought or metaphysic or symbolic intensity—on a ceiling and if there must be something why then anything deeper than a Tiepolo or a Paul Baudry? Why at all, however. But there are and I assure you they can be much better enjoyed in the Alinari photographs. I hurried back to the Coliseum to rid my eyes of the biliousness of the Cappella Sistina. Even the relief of little San Clemente with its three stages of history, how I relished the sound of running water under the lowest fountain coming from no one knows where, perhaps Marion Crawford could

tell,[1] but according to the Irish Dominican with his splendid brogue, having been flowing for two thousand years, part of these very foundations established from 600 B.C.

A week is of course not much in Rome with the eye tired and the body weary from too much Florence. Rome is a place to be lived in. Florence, like Arezzo, Orvieto and the other towns, to be looked at. Rome with its superb looking men and some of the most beautiful women I have ever seen, but these not on the streets you may be sure. No Italian woman of character could or would be seen in the streets.

# Decline in French Art

With the recent re-arrangement of the Musée du Luxembourg and the transference of the Caillebotte collection to the Louvre—this collection once so violently discussed and refused because of Cézanne chiefly—one begins to wonder just where French art stands these days. With all the movements over—and one need hardly bother about the trivial movement called surrealisme, with its mollusc aridities—the thought comes to one's mind what is the condition of French art of today with its lack of conspicuous energy and of outstanding personalities?

---

[1]Francis Marion Crawford's novel, *The Heart of Rome* (1903) is the story of a young architect's effort to find the "lost water" which supposedly flows beneath an ancient Roman palace.

One must already begin by putting the significant men into the field of yesterday. For Derain, Braque, Matisse in French art—and Picasso, the outsider, having done their work—are merely marking time, rounding out their ideas and products to a point of completion. Who are the French artists of today? Surely one is not expected to consider men like Utrillo, Gromaire, Fautrier as leaders of great movements or as founders of significant traditions.

Wilhelm Uhde in his book "Picasso and the French Tradition" makes the classification easier by saying that the prevailing art of today is European not French, however inspired in varying degrees by the French spirit and there are artists like Soutine, Chagall, Zak, Kisling, Marcoussis and the others—all of them outsiders—all of them distinctly not prime movers or creators of movements.

It is not without significance that Uhde places Picasso entirely outside the French tradition and the position is inevitable in view of the fact that Picasso is a foreigner and could not possess French emotions, though he could copy them, borrow from them, transpose them, which he certainly has done. He cannot hope to hold a place such as is occupied by Braque or Derain because he does not belong there. French art seems to have ended in the cubistic variations that exist at the present time in the harmonious expression of Braque. And who, having followed Picasso throughout his career can call it harmonious? It is quite as Uhde says, by virtue of his Spanish temperament, restless and quisitive [quixotic?].

The conspicuous rise of Derain from that majestic period of 1910 to 1915 is no longer in evidence and a petty series of dull heads, nudes, with now and then a dignified still life or landscape, give evidence that this artist has lost his tenacious spirit. It does not aspire any longer, it has succumbed possibly to the devastating effects of the war, possibly to the rush of success which has attended him. He seems to paint only when models stand waiting to be let in whose engagements he has forgotten, or when dealers and collectors refuse to leave, and is apparently happiest when he is considering neither model, dealer, or patron but when he is left entirely to his own private devices.

From Braque, Derain, Matisse, nothing more is to be expected. They have done their work and beautifully, but they are either rounding out earlier ideas or like most French artists repeating themselves. With cubism so dead that one hardly dares mention it,

and surrealisme having contributed at least one downfall to present-day art, namely those childish and ridiculous surrealiste effusions Picasso has seen fit to perpetrate, what more can be awaited? Surely no one will wonder what Dufy is doing, or if Fautrier is doing another disconsolate still life or a timid nude à la Carrière, trying to break through from a Maeterlinckean mist. How old fashioned this young man seems already and he has only just begun. Who is to be concerned with Dufresne or that most trivial of all trivialists, Deglenne or whether Lurcat or Survage are producing another design for a Russian ballet setting. For at the widest guess these must not be called pictures because they are only hints at best. Where is one to look then for a new force in French art? Can it be said that there is any? Is not painting in France in the same precarious position as the critics say of French literature, namely passing out of, as Remy de Gourmont says in his "Promenades Littéraires," "every important movement in art or literature has always invariably been preceded by a foreign stimulus" and French art is waiting for its stimulus. It means nothing, as I say, to have art shop windows full of Kislings, Modiglianis, Soutines, Coubines, Chagalls and others who are now classified as European. It means nothing at all, I repeat, that Picasso still struggles for sensationalism as shown by his fearful efforts at Dinard.[1] It means nothing that Chirico stands out today like a master against all this simple trickery and repetition, that the surrealistes produce a type of painting that can only please writers or actors for the screen. The recent re-arrangement of the Luxembourg proves probably the most curious point in the annals of modern painting—its refusal to admit cubism into its graces. Nothing entered there which expresses cubism pure and simple, even the Braque being of his post-cubist period. And he [is] certainly the most logical exponent of this movement as we know it today. And is it not a bit laughable that Picasso should find his only place in the great movement in Paris in the Jeu de Paume with all the other foreigners? And where else is he ever to be according to present laws and rules? Hardly a pleasing or a worthy recognition of this artist's prodigious effort and assumption of invention. Not even, as I remark in

---

[1]Hartley refers probably to a series of drawings and sculptures on the theme of metamorphosis which Picasso executed in 1928 while staying in Dinard, Normandy.

proceeding, not even a cubist picture of Léger, Metzinger—none of those others who have developed and defended modernism in general, and ultra-modernism, in France.

I remember Léonce Rosenberg once said to me in his gallery in the rue de Beaune "cubism is the art of the future." That was six years ago certainly and cubism so completely embalmed and preserved like the mummy that it now is. No art has ever had so magnificent a past, none with so complete an absence of future. What the surrealistes can do is make pictures that go with the present day funeral designs of the so-called interior decorators where every room is made to look in the end like the receiving room for a heart-broken family at the crematorium. That is the impression that the new decorative efforts of the last year's salon made on me.

The ironic position in which French artists of destruction [sic, distinction?] find themselves today is first of all best understood, and cleverly, by themselves. And their commercial repetitions are only a sign that business is business and that business is very good, especially in America where French art is still supposed to be living and moving and having great being. The question arises—is there a condition of creation in France today and if so where is it being concealed? Surely the exhibitions have not revealed it. The art of repetition thrives with disconcerting precision as always and it must always remain a marvel that these painters can so produce pictures as to "seem" to be creating all the while.

Epochs of art have died out before and the Bourgeoisie will tell you that France is economically and spiritually bankrupt. The new force is not to come from the "Europeans" even though it may satisfy the "Europeans" that they have entered the great field of art in France and been welcomed there because they have become "French-minded." Is this vital force in France on the decline? Who is then to say that it is not, in view of what has been seen these last few years and at the present moment? A feeling of depression comes over one as one makes the round of the Paris galleries. And I say this with feeling as I saw in six months time no less than 15,000 pictures, with nothing to stir me to make me feel that a new and quickened spirit has appeared in our midst. And the repetition of pictures is exactly like the repetition of roles on the stage. How is an actor expected to be "alive" after one thousand performances of anything? And so with pictures. When we hear privately that Vlaminck has threatened to

stop painting because he has enough money and is sick of painting, we feel that at least one courageous one has come forth from the crowd of esthetic cowards. And after all, if they are tired of painting and surely they must be, why don't they stop? What is there today to encourage painting anyhow? This is a question that needs answering urgently. As for the possible life in the art of today in France there are mighty few intimations that it exists. The dealers are of course pleased when artists repeat but who else can be? Artists have a right to choose their tricks like their clothes and give the eye a little decent nourishment.

# Max Ernst

*(1928)*

Unconscious disciple, let it be said, of the Rops-Knopff-Stuck school of thought and emotion. In other words, victims of old-fashioned symbolism, covered over with modernistic designing. A struggling toward the "Übermensch" of the ultra-sensitive. What can be said of these pictures save that they are accomplished and personal.

Do they not seem to the eye which finds things of the earth surrounded with super-sensations, to be a species of vain striving after excessive realization? First of all they are illustration and last of all they are illustration. They can be accepted freely as designs for a German underground, they might be accepted by the banal, worshipping mind as illuminations for the missa solemnis of today which is mechanical, commercial and altogether mercenary.

Are they so far sub-consciously from Moreau or Stuck's monumental epiphanies to the glory and the splendour of flesh? Do they look into anywhere, and if this is surrealisme, what do they touch above the earth? It can be said at once without further ado—nothing! Are they experienced truths, are they imagined experiences? Do they suggest a world of fresh emotion "lived" in by a new discoverer? Do not their titles even reveal them to be subterfuges for literary effusions of a not very deep character? And doesn't the gelatinous prose of M. René Crevel's preface do them in a little, these wilfully composed, manufactured pictures?

"Plus haut que la ciel, plus loin que le soleil est une couleur de mystère, et c'est pour quoi le peintre devenu prophète, à raison lorsqu'il nous dit que au dessus des Mages marche le minuit," etc. Are not these younger confrères with the pale faces and the violet mufflers just a little vapid in their realizations? We need not consider at all this Crevel preface as having anything to do with the Ernst pictures. And Ernst would probably say "a perfect description of what my pictures mean" and Crevel might say, "O, I wrote the same or almost the same yesterday for a game of Pelote-Basque" and you would be expected to believe that all surrealistic notions are a negation of this morning in connection with the search for the day after tomorrow which, when the dove breathes his first morning's breath, will suddenly be yesterday in the back of a fan-tail goldfish. And after all, why not? The afternoon's promenade among the new school of sublimated illustrations known as surrealisme in general, from Picabia's entertaining show on to Crotti's not so entertaining one, through the thinnest of all streams of Max Jacob and his playtoy pictures of Paris—so alike—and you come to feel that the so-called supervision plods with thick feet.

One cannot gulp down with ease the teutonic symbolism that invests every movement and aspect of Ernst, the quality of the paint itself, even.

Has not every painter of vision or of light gone through thick walls of blackest gloom to arrive at clearness and is this "far seeing" eye attributed to Ernst by Crevel any clue to a reality that anyone beyond Ernst himself may experience it.

This product as it stands in the present exhibition is a show of a certain type of easily assumed virtuosity and when I say they are illustrations I am serious because the photographers have done the same thing by manipulation of the plate and in photographic form

they are light and do give a sense of "other" life. But after all, isn't the undercurrent of symbolism just a bit of old-fashioned "Sturm and Drang" with which German painting has always been surfeited? We suspect that Ernst is devoid of humour for this reason that what is to be found in these pictures of his is not at all above life, but far below it and the cry that pierces the ear as one looks from canvas to canvas is a very Germanic "Ich bin, ich kann nicht anders," which, of course, is not very impressive or enlightening when the meaning is translated.

The transition from Picabia to Ernst is, I repeat, an interesting one, Picabia being all very natural, Ernst full of dogma and of viciousness. These pictures remind one in strong ways of the quality of the air in Berlin in the beginning of the war. Dogma surges in and out of them. These mechanisms, they have not the orthodox charm of modern plumbing or of electric wiring; it is the glib technical finish of them that gets them over.

We can well understand however that these pictures of Max Ernst might go well in a room with the new modern interior decoration of the French, certainly very heavily influenced by the German. Bruno Paul for example, who makes a sideboard for a dining room look exactly like a casket on pedestals and the rest of the room supplies the obsequious gloom.

A few weeks ago we thought Fautrier a very sad young man, with his apples and various fruits in deepest mourning and when we heard he was excessively shy we assumed that he was too shy to attack nature before him with his lungs full of fresh air. And one can hardly be interested in this young painter's Maeterlinckean sufferings or the fact that he certainly is strongly influenced by Carrière. What a combination to be struggling with in the subconscious, with all the world so gay and cheap and common outside!

The almost feminine delicacy of Fautrier is absent in Ernst. And a strict assertion of self affirms that he is the discoverer of his private world, if not a great revealer, and the combination of Ernst titles and Crevel prose produces an effect which seems to need an infusion of warm blood lest the body of this two-headed being succumb with pernicious anaemia.

A careful blow on the head by Courbet would doubtless release the clot and set the machinery to functioning and in all probability, normally.

These young knights with their aluminum armour, riding glass

horses under the courageous protection of their drapeau cerise seem easily satisfied with their respective personal translucensies and expect us to believe that their paradise "plus haut que le ciel, plus loin que le soleil" is a visible one because they see it, or think they see it themselves.

The quarrel is not with this seriousness, it is with the vapidity of their much lauded reality above reality and one fears for the Icarian precipitation they are destined to encounter.

What Max Ernst does is far more actual than what Crevel says he does, but the peculiar thing is that all of this "newest" type of thing is essentially illustrative and pleases the literary enthusiasts first. Cubism at least had its roots in the ground and grew like a well nourished tree, but surrealisme seems to tend toward parasitism always and feeds chiefly in miasmic air.

# Paul Klee

*(1929)*

The exhibition of the latest pictures of Paul Klee at Georges Bernheim's opened yesterday and revealed a persistent and consistent development of this most original of all modern Germans.

My first experience with the pictures of Paul Klee dates from 1913 when I had made the ennobling acquaintance of that other talented German, Franz Marc, with whom I had exchanged a series of letters apropos of his own pictures seen that year at the Tannhauser Galleries in Munich, and by this exchange of letters with Marc came

the cordial invitation from Marc personally on behalf of the Blaue
Reiter group composed of Marc, Kandinsky, Klee, Campendonck,
Bechtejeff, Gabrielle Münter and some others, to join them in their
exhibition. "But," I protested to Marc in these letters, "you have not
seen my pictures, you might not like them." "It doesn't matter,"
replied Marc "what you write proves that you have something to
say," and forthwith the pictures were forwarded to Munich and I
followed them, to be greeted warmly by the members of this
group—the now famous Blaue Reiter group which did a great deal
for whatever modern art exists in Germany today.

Marc and Kandinsky were indefatigable in their efforts and
devotions and much good was accomplished by them. Marc was a
huge handsome Bavarian with some French admixture, I think he
told me during my memorable three day visit to him in the Bavarian
Alps at Sindelsdorf. A very handsome and sympathetic human
being and in this grouping in general I recall the eery, that is to say,
then eery but orderly little figure of Paul Klee always off at one side
of whatever speech or action there may have been. I was conscious of
his engaging presence, all the more charming by its wilful reticence
and what seemed an ardent desire to be still in the presence of so
much psychic movement.

Kandinsky was always a formal, and I may even say, honorably, a
somewhat formidable experience in a personal sense. Perhaps his
excessive Russianism accounts for this, but with Klee it was quite
the reverse. One felt as if one must not disturb the condition of his
being by anything irrelevant to it.

And this present exhibition of Paul Klee gives full evidence that he
has been consistently himself for the entire fifteen years I have been
familiar with his work.

That the surrealistes should suddenly find him to be one of their
best geniuses is of course no less than humorous. And what his
followers, or at least his imitative sympathizers have to offer, one can
always know that before the word was ever coined or thought of
coming into existence, Klee was pursuing his above-earth fantasies
and making esthetic realities of them.

That Klee should have Mr. Crevel speaking for him, running after
words so swiftly, falling down breathless before a word like
"cielarium," is it seems to me, a little irrelevant and only emphasizes
still more the dignified aloofness of Klee, the longing to live quietly

in his own world of fancy and instructive invention, and merely shows Crevel's rather hectic passion for strange fish and stillborn flowers.

Paul Klee produces no such neurotic culture. He is always normal in his emotions, reasonable in his handling of them and by some unaccountable reason, being German, he escapes from the particularly German passion for the sordid in esthetic experience.

Klee likewise escapes all applications like "naive," "child-like," and all that. He is neither naive [n]or child-like [n]or childish. He is merely absorbed in recording simply simple associations of ideas. He is free of cult for he is not interested in it. Klee, I repeat, is not a cult or a school or a system of esthetics. He cannot be copied so readily as the systematized painting of Kandinsky can be and has been. He is in one sense probably the most dangerous personality in the whole range of modern painting because he is bound, involuntarily, to lead countless others to think their experience or imagined experience identical with his own, and this is of course thoroughly untrue.

If Klee believes in the more elemental and spontaneous drawing of the cave dwellers, those who have scratched in sand or on stone their immediate reactions to nature—well, he simply believes it—that's all, and it becomes to him the natural type of expression.

The works of Paul Klee contain their own life because he is not fishing in murky and soiled waters. He is not casting a platinum hook in a nacreous and diaphanous sky. He is not shipping a coral mast in Crevel's "cielarium." He is merely covering and vitalizing a common rectangle with luminous emotions and experiences.

These experiences of Paul Klee divulge a private radiance which as far as I am concerned, Kandinsky never had. And they at least do not drag a weary wing such as those time-worn birds of Max Ernst. The quarrel is not against Ernst, Crevel et Cie. It is merely that they are talking with a a cleft tongue and calling a lisp a language. It has recently been said by a French critic of surrealiste literature that it is a new style which has already been invented. And now we have Paul Klee as the father of these soaring but flightless neophytes.

The head of Paul Klee is not severed, floating in space. He is not a seraphic derangement in our plausible experience. He records simply and there is nothing profound or evasive about them. He is not interested in nature—only in sensations and his reaction toward

them. And his esthetic lies in his purity of attitude toward the life evolved in each picture he essays to produce.

He will lead most astray, those who think they can go straight toward him.

His eyes are in his head, they do not float above his eyebrow, on ribbon made of neurotic tissues.

I can fancy that the pictures of Paul Klee might please children because there is no trace of heavy thinking in them. They are the product of expression pure and simple. They have the look of spontaneous harmonic vision, even if some of them apprise one of the fact that a terrific labour has been involved. I hope none of the theosophists, kabbalists or occultists come too close to Klee and his pictures, for they will exhibit a passionate desire to disclose to him his infinite wisdom in the language of signs, and how terrible this would be.

# Picabia—Arch-Esthete

*(1929)*

A further cry from the vivid epoch of the eighteen-nineties could hardly be found than in the new pictures of this modern of moderns, Francis Picabia. I had almost said "most modern of moderns" and if we hadn't been let in two years ago upon the new style of Picabia at the Intimate Gallery in New York we would feel inclined to say that Picabia had ventured still further into the land of the absurd, and perhaps this is completely true. It is not known to many outside the

most intimate just how much Picabia has produced since that memorable exhibition of the Section d'Or in nineteen-thirteen which was perhaps the best orchestrated exhibit of the then preposterous cubists, when all of them appeared in their variable splendour, and in which their future successes were to be established. But there are three distinct periods to be recalled of Picabia's special production. Those of the Section d'Or where ultra dimensional spaces and movements were considered, then the later period of sculptural volumes in which metals were employed and which some conveniently classified as sublimated plumbing and now we are presented, as a sort of clarion call to the real season of painting in Paris, with a series of paintings and drawings by Picabia in which no relieved volumes appear, only illustrational qualities and some of them pleasingly old-fashioned, old emotions revivified and made new.

Picabia was always considered among the better cubists. He was probably the best of the Dadaists and he is certainly by far the only surrealiste to be considered, even though the younger men might consider him the Rembrandt of this movement. It must be very trying to be doomed all one's life to represent the "isms" and yet that is what happens in Paris.

But a man like Picabia is hardly to be concerned with dogmas outside himself, or is he to be considered a dogmatist at all? He steps aside from all of them and produces a type of expression as original as it is sure to be involably unofficial. Mentally considered, these pictures are distinctly of the illustrative type, pictures made from thoughts, and do not descend completely into the world of nature, not far below the eyebrows, let one say. There seems to be in them almost a fear lest too much of life break forth from them and one comes to call them translucent diablerie. More seriously considered they might be called illustrations for the new divine comedy of the twentieth century, as yet unwritten, perhaps never to be written, perhaps being written every day by the young men with pale faces and pale violet inhibitions, for a kind of modern equivalent in sensations of Nietzsche, Goya, da Vinci seems to break forth everywhere, from these pictures and in this sense, thank the stars, no two are alike, for Picabia, being rich, has no need of repetition and paints strictly to amuse himself and this not to be forgotten—to "amuse."

Nothing is dramatized, no trace of pseudo-conception, no trace of gloom, no hope, no morality, immorality or unmorality. Nothing as

childish as any of these qualities. It is the expression of a working mind juggling, with disconcerting dexterity, with all those sensations that have risen above desire. It is the survey of the world today as it happens to be happening, to one man. A whitened Zarathustra appears to be its prevailing spirit. It will be best understood by the Latin temperament because it is overflowing with Latin impertinence. The butterfly, the ass's hoof appear frequently, disturbing the juggler in his gentle reflections, the toreador surprised at being observed, the dancer, the acrobat of dreams, the thoughts and the persistent despairs of woman, and the idleness of vain earnestness suggest a clue to the scheme of things.

You see merely the traced bodies of women of the world beyond the chance of evil and you see the eyes of good young men and of envious gigolos peering calmly out of their persons, as fish peer through the glass sheaths of their aquaria and see nothing but themselves.

Picabia has, it seems, in these pictures presumed to write the unfinished cantos of the last divine comedy, metallic, brittle, concise, which is the history of life of the present moment where all that is trivial is too certain for tears and all that is noble is too light for laughter.

The smile of understanding permeates all of these pictured situations, and a Giocondian sneer emanates from all of them, and their beauty lies in the remarkable coordination of images that choose to appear upon the same scene of action together.

It is the clue to the newest phase of art of the present moment that presides here and the insistent element in these completed sophisticated themes is that they must never seem so crude as to descend below the surface, never so vulgar as to soar too far above it, never to be so credulous as to believe there is a grain of pure truth to anything, never to assume that any superimposed sincerity is the reason for their existence, yet by the nature of their intention we are to assume that sincerity is imposed.

They exist as works of art and their aim is that the eye shall be amused and the mind disturbed from too much confidence.

Apparently Picabia has descended into hell, and ascended into heaven and finds them both alike—full of heartrending illusions and has come to the conclusion that after all, earth with its cheap degradations is best because it is the average experience of all.

Picabia is not moved or inspired or dejected, he is not a rhapsodist,

not in special revolt at anything unless it is at the poor importance of
being in earnest. He merely registers, rhythmically and with
marked skill a varied range of glacial concepts. It is almost, to be
extravagant, as if he had come to sympathize with the iceberg and
achieved a profound pity for the volcano. He is impressed through
the media of his thoughts which flee from all superimposed reflection
and as far as can be imagined from anything that in the least savours
of salvation. He retreats as rapidly as wings will take him from all the
banalities of candour. He would permit no teutonisms of Rops to
permeate his scene. Wings figure in these coloured designs, these
ultra post-Blakeian illuminations of the bright world of yesterday
evening and there are flowers of not too exotic a nature and a
plentiful supply of women's lips, shapes like scimitars cut through
planes where cupids sit corpulent with wonder and like the angels of
Raphael, never without sly gifts for knowledge.

All of these shapes have the same cool, carved edges. They present
merely the range and scope of a middle twentieth-century sensibility
looking really more back on the first quarter of experience and
predicting no engaging future; a projected sensibility perfectly
attached to all the motor activities familiar to an active, living,
responding being. As for their expression of originality, they simply
put over into the field of reality what all other grasping brains would
like to have done. It is the passion of second rate natures to want to be
first and the privilege of the first rate, to be so. Every camel has, so to
speak, marched through the eye of this needle, the sharpest of the
present century to pierce the flesh of mankind.

And as I have intimated, these thoughts and these pictures are
made almost chiefly from thoughts, are the concise offspring of a
whitened brain, of a frigid Zarathustra, who sat among the snow
peaks until they reddened into perpetual dusk from which there is to
be no escape.

If any yearning for human experience is important then one must
walk away from these insidious arch-comedies that are too thin to be
called satires, too fragile to be called cynical. It will be no use to
consult Picabia, assuming that he speaks the most foreign of
languages, departing, not presuming to ask of whom they are, these
images or what they may have to say to each other, these embodi-
ments of glacially related strangers appearing in the single scene of
action, related only to each other like prisoners in adjoining cells—

that the same kind of bars repelling them, [have] an uncommon gift for smiling obliquely at each other, never again being so banal as to laugh derisively or to weep a ridiculous tear of self-pity.

It is a kind of previsioning of inner television these pictures represent, instantaneous shapes seen through the flimsiest of gauze shadows, not a trace of dead imagery because they never presume to represent anything not lived, as in Rops, Moreau, even Redon, and all of that lifeless jargon.

They refer strictly to life itself and no morbid reflection on life. Their morbidness, if there is any, is that they show life lived too fiercely and swiftly. They are full of everything and represent nothing, beyond a moment's investigation, and for this reason are [as] replete with common wisdom as they are devoid of cheap casual references.

Clarity of reasoning might seem too heavy a descriptive caption for these illustrative arrangements but their creator has certainly thought his way out to every edge of the desert of the mind and found even wind blowing there tenaciously, disturbing the sought-for peace.

It is the mind that stiffens first with the vast rush of varied experience, and it is just this quality that is necessary when the artist essays to represent the impersonal characteristic of life as it comes to him, and only a sentimentalist presumes to feel he has the inevitable clue; and a sure simplicity of sense that can perceive the unfailing comedy of errors is no small gift, and we are led to believe that Picabia has achieved this quality admirably.

There is the inclination to assert, as you go from one to another of these pictures, that a merciless portrayal of the fluctuant libido upon its most comic of errands, its preposterous pursuit, has been achieved. Translucent diablerie is not too stilted a phrase, not too precious or too fashionable, surely a very recent excursion into the world above ideas and above respect, even ultra-realistic, ultra-conceptional. It is the keen observation of one eye looking sharply into the world of sense and experience as all other eyes would not dare to wish to see.

That space between the eye and the brain, Picabia has traversed with exceptional virtuosity, and he will evade his self-appointed followers as he is without trace of dogma or repetitive trick.

This exhibition of Picabia will prove and it has already done so

indeed, the most disconcerting one of the year, as this artist is the single one who has emerged from the doubtful chrysalis of the past, and if Picabia is, despite his wishes and intentions, a natural cultist believing in one thing above all others, thought, pure and simple, for its own sake, we say again these pictures claim nothing because they assume nothing, therefore reveal nothing. They merely represent the organization of multiple images superbly rendered and represent most of all the translucent note of today, metallic to the last. With its reverence for wire, for glass, it is the thinnest era of all and must be understood in this way.

Any "jeune peintre" searching for an escape or to be in on a movement, so often typical of certain types of young men, who affect snobbishness, will find no relief or solace here because it is the product of personal style and of private experiences, in this case a singular unique fusion of Spanish temper and French clarity. No message, above all, no message, no call for prestige, an aloofness which if it is to be finally considered glacial, is not forbidding.

It is the work of an artist's mind and every now and then an artist proves he has it, the glow of the electric tube, and shows, so to speak, that this drop of mercury has found its degree of poise on this special disc.

# Impressions of Provence
## From An American's Point of View

Loving a place has the same quality as loving a person—you either care deeply for it or you find a casual interest in it or no interest at all.

I am in love, so to speak then, with three sections of the world I know—two of them physically as well as psychologically, and the third by virtue of its character and appearance if not so well known equally appreciated and admired. The first, namely, New England or particularly my own state of Maine, with its excessive originality and distinction—second, New Mexico and the Arizona country in the great primeval southwest of the United States—and third, the perhaps still more piquant country of Provence. And when I say Provence I think of the true Provence. And my sensations and emotions stop at Marseilles, for I have no feeling for the Riviera because the country and the people are less typical there.

Being a painter I live the life of the eye and I have been inspired first of all by the scintillating light of Provence when the skies are at their best, so admirably perceived and expressed in the landscapes of Cézanne—certainly the most logical analyst of light the world of painting has known.

From the clear, hard, metallic light of my own native New England, austere to the point of brusqueness, to the warmer yet perhaps in its way still more metallic light of New Mexico and Arizona—though far richer in prismatic quality and chromatic range than in the northeast of the United States—I had come upon another aspect of the light problem here in this highly original and unique Provence.

This quality of light in nature has much to do in forming the appearance, and I might also say, the character of the people who live under its influence. I am certain it is that cold oblique light of the extreme north that makes its people introspective, sullen, bitter and often difficult. Northern climates tend to hide the nature and spontaneity of men, southern light tends to expand and enfold them—it gives the heart and the soul as well as the mind freedom from obstacles.

143

This golden, expanding light of Provence removes the sense of obstacle in my northern nature and I feel free, released and happy under its influence. And if I miss the quality of my own country which is essentially the dramatic element of the north, with all its primeval savagery and its elemental dangers, its abundance of wild animal life to give the association with nature the charm of thrilling incident, I am appeased with the geniality of the soil itself and the still friendly if somewhat reticent and retiring quality of the natural scene here in Provence. It is the light itself that has much to do with this quality of friendliness—the perpetual clarity of the day, where all things seen are to be seen perfectly, where fogs and mists offer no variation of mood—since climate itself gives a kind of temperament to the natural scene and makes it what it seems—either grave or gay, smiling or morose.

I miss, as I have said, by virtue of my natural heritage, all that glamour of wild life that inhabits the scene to which I was born. I miss the barking of the fox, the beautiful soft-eyed glances of the wild deer. I miss the mink, fishing in the mountain streams, the hunt over the mountains for the wild black bear and the call of the partridge in the underbush. I miss the call of the coyote among the sage brush in the prairies of New Mexico, the soft voices of the American Indians and the Spanish songs of the Mexicans under the tamarisk trees in the moonlight, for it is the Spanish language one hears in New Mexico along with the English of the whites. I miss the great folk dances of the American Indians, their religious summer dances and winter dances—all of which have to do with the symbolic phases of their ancient religious rites. All these I miss, but the haunting, appealing qualities and aspects of Provence provide new pleasures and satisfactions to offset those native losses spoken of here.

Provence is abundantly rich in native charms and native distinctions of the race which inhabits it, and therefore knows and understands best of all its beauties and distinctions [and] ignores them. None of these things are hidden from the stranger's sympathetic eye and mind, for out of all earth come these splendours and revelations to those who are receptive and willing to accept them. Esthetically speaking, no one person has given forth more of this understanding and insight into the secrets of the light of Provence than Cézanne, himself a native citizen and partaker in its splendours,

himself a fit representative for all those Mediterranean concepts from which so much fine art has come. It is hardly likely that many citizens of Provence have analyzed this aspect of their country, and no one has understood its essential character better than this gifted genius of Provence, so long overshadowed by the mystery of his perception and the austerity of his ideas. Cézanne figures in the history of modern esthetics among its greatest contributors, and the greater outer world owes more to Cézanne's masterful analysis of light than to any other master in the field of modern art. And what he achieved most of all was the very uniqueness of Provence itself, and what the poets have done to give a literary understanding of this country, Cézanne has accelerated by his highly specialized gifts for seeing and being able to render the quality of the light itself, so peculiar to Provence as not to be found anywhere else on the earth's variable surface. What he wished to represent when he says "that thing between himself and the object" is nothing else than the element of light surrounding these objects and the light is the very light of Provence as we have learned to know it who have had the special pleasure of association with it. But one must be a lover of light, a lover of the noble sun itself if one is to understand the single outstanding aspect of the country of Provence.

Among the paysagistes of Provence, and I am not familiar with the number, I know of two who have given its quality and its character as it is to be found. [Jean-François] Gigoux, in the style in which his artistic tastes were formed and Cézanne in the style which he himself invented. If I do not speak too enthusiastically of Van Gogh it is because I feel he did not represent it "interiorly," because he was not literally of it, he was not, by virtue of his race, inherently involved in its conscious and subconscious beauties. For Van Gogh as a human being I have only the purest sympathy and admiration, but I have, on the other hand, only purest pity for the inevitable tragedy of his life, that he was doomed to hasten by the impending limitation of his life, and nothing is ever understood or lived through haste or superficial comprehension.

What Cézanne had to offer was racial integrity and racial insight. Gigoux, the same, and Daumier, though he gave as far as I know, little attention to the actual qualities of his country, produced nevertheless a sense which can only be determined as essentially Mediterranean and, I should say mentally speaking, essentially

Marseillaise. Daumier rose to universal appreciation by universal
human means, but [it] is directly and solely through the qualities of
Provence that Cézanne arrived at his present interior or universal
significance.

But the qualities of Provence as landscape concern this essay
mostly. It is a country as rich in variation as the whole country of
France, for in Provence every aspect of landscape is to be found, and
if there are not exactly the gentle green meadows of Normandy with
its numbers of cows grazing quietly, you are provided with herds of
sheep and herds of goats that fit the scene with admirable natural-
ness, and it is in this feature that a strong similarity is to be found
with some phases of landscape in New Mexico.

There is, generally speaking, an admirable austerity in the general
landscape of Provence. I emphasize the quality of austerity because I
feel that austerity is one of the essential features of rich, dignified
landscape and certainly of dignified painting of nature. Courbet
produced the noble austerity of the sea and of the deep woodland.
And if we must say that the quality of austerity is absent in so great a
painter of landscape as Corot, there is a noble simplicity which takes
on the quality of grandeur in the mind and refers us again to the
classical austerities of Poussin and the influence of this master as it is
to be found in Cézanne. Where Daumier used landscape in his Don
Quixote scenes it seems perfectly evident they are the simplified
aspects of the hills of Marseilles as once he knew them, and these
very hills of Marseilles, let it here be remarked, offer some of the
most dignified qualities to be found anywhere in the varying aspects
and appearance of nature and it is in the very heart of these hills great
beauty is to be found, almost undisturbed by the fretfulness of
mankind. I speak more particularly of the special section of them
between Marseilles itself and Cassis. They are a unique and edifying
spectacle for the searching and understanding eye. Aspects of nature
are very like human individuals—they are so similar in type that you
can fit one over the other and mark no significant change. There the
original motive appears, unlike all else—certain simple but remark-
able stretches between Avignon and Nîmes, almost Chinese in this
purity of movement, of rhythm and of form—and that most
terrifying hypnotizing of all landscape motives in Provence—if not
of all France or Europe—the strange and bizarre Les Baux. I am sure
if the Chinese had witnessed these curious formations another epoch

would have been added to their magnificent understanding of art, so replete with the wisdom of nature and the consequent mystery of it. Les Baux is as great a spectacle to my mind, for the eye alone, as the Grand Canyon, Niagara Falls, Popocatapetl, Fujiyama, and all spectacles are important to the artist's eye if he is to understand the relation of appearances in nature. To understand the mountain is to know the tree, and all qualities must be penetrated before they can be truly revealed. The aspects of nature which make for the pictorial presentation of it must be searched for and this is the mission of esthetics as well described by Cézanne as by any one.

"Art is a harmony parallel with nature." And until the qualities of nature are understood the esthetic value of nature will not be revealed. This principle was perhaps best understood by the Chinese whose artists were first of all filled with the wisdom of nature. No superficial copying of surface avails the least significance. The element "within" is that which qualifies the surface. And it is for this reason chiefly that the countless minor painters of Provence achieve nothing because they have not searched for the underlying wisdom peculiar to the nature of Provence. But this is chiefly a personal matter and he who is not a searcher for the meaning of light cannot be expected to produce the understanding of light. This remark is meant to contain no metaphysical significance whatever. It is meant merely in the sense of visual science. A country in which light is the paramount characteristic demands that light be studied and Provence is essentially a country of light.

With my northern way of enjoying all things from a certain isolated angle I have come to find a singular element in Provence essentially congenial to me both as person and as artist, and if my sense of inquiry is not intellectual but instinctive I take the liberty of assuming that instinctively there is something in the light and the natural aspects of Provence that "belong" to me in that it offers to me a quality of "air," and by this I mean the inherent emanation from the land itself that gives my very feet a sense of home. The year and the moment are the same where sympathy is revealed. The man who loves his earth must hasten to gather in its splendours for the surfaces are being rapidly changed, not that nature wishes it to be so, but civilization decides that it must be so. It is to be hoped that all those Provençaux who love the old and edifying customs of their country are not labouring in vain to protect them from annihilation, but with

the present trend of modernity how much longer will it be before all sweet and gracious customs disappear and in their place only a mechanized existence of rather charmless ideas prevails. I am happy that I, at least as a foreigner, have not been denied the beauties of the Provençale customs that still show and give beauteous life. For I have seen the farandole and heard the haunting music of the drum and flute and my emotions have been gratified, my eyes, I may almost say, exalted.

Provence is for me a beauteous spectacle, the variation and the originality of which I never seem to weary.

There is life in the light here and the sun is master of all. Who cannot love the sun could find no peace or comforting repose within the enfolding kindly expanse of voluminous Provence.

## Toulouse-Lautrec at Albi

*(c. 1929)*

From all this twelfth-century uniqueness and Poussinesque nobility of certain aspects of Albi, you are plunged into the most curious, almost anomalous variance that could possibly be found, into the hyper-sophisticated end of the nineteenth century.

For, in the Archbishop's palace attached to the cathedral is a museum collection displaying one of the most fascinating pages of modern history known to us. And when I say anomalous, it is true, for of all the people in the world of artists, why should one come upon such an extraordinary array of the work of this genius, here?

The answer is simple—Albi was the home town if not the

birthplace of Henri de Toulouse-Lautrec, one of the most brilliant, most gifted artists of modern times, and this collection is the gift to the city of Albi of the Comtesse de Toulouse-Lautrec, his mother, as a memorial to her distinguished son, prodigious artist, both in unfailing quality and astounding quantity of work, who at thirty-seven had sounded all the heights and depths that one body, mind, and spirit could achieve, and there was no more for him to know, nothing more certainly to know, or tell of his own vivid period, one of the finest historians of period life that exists in the special province of art.

Lautrec was an astounding documentarian, and naturally, an astounding and merciless analyst. He was not interested in fabricating prettiness, he drew and painted what he saw, and he saw it all in terms of itself. He was a genius in observation, and remarkable possessor of a phenomenal gift to put it down.

Folio upon folio of his lithographs and gouaches alone, are with us to tell the radiant story of his period, and of his scalpel-like vision, for his eyes cut like a knife into the very internals of those whom he portrayed, and it was as if he saw them clearer in the way they saw themselves, for every mirror presents disengaging revelations no matter how much it might wish to deny.

How staid, formal, and correct, the gift of Degas seems to us beside the effervescent, almost acrid incisions, bitter and cynical very often as they were, into the very heart and soul of humanity.

Gaiety and misery were all the same to him, he understood them both, and for all that one can see, he had no partiality, at least no sentimental partiality.

It was part of his nature perhaps, to poetically ridicule, but unless all mankind is essentially sensitive, he was cruel to no one, he presented his types, as I have said, with finer clarity and precision than they could see themselves, and his humour and satire are, in the end, of a gentle, harmless, and really kindly sort.

He did not wish to malign his subjects, he saw them merely in their most acute moments of fantasy, often at their most fantastic, most bizarre, as artists and personalities are apt to like to be presented, especially the French ones, who have a nice feeling for the delicately comic in everything.

He saw the other side of truth, so to say, which [is] the element of tragi-comedy in experience.

Degas hated women, flowers, and children, it is said, and yet how

appealing it is to learn that in his old age he loved to have his house-keeper read the Arabian Nights to him, consolation to him, perhaps, for having concentrated so long on the ugliness in women, for he was the first to see a kind of picturesqueness in the laundress, and the scrub-woman. For Lautrec, all of his moments, days, nights, and years, until the end, were a swift equivalent for the Arabian Nights, and he was incessantly bewitched with the pathetic charms of his visions and experiences. Lautrec had apparently no time for hatreds, unless it was a hatred of ignorance of life, and he spent all his hours and emotions in the thick of his scenes, absorbing life's qualities and essences, semblances and appearances to the point almost of scientific saturation, with the finest kind of spiritual intensity.

He read out of every human being he came in contact with, their private as well as their public, appealingly personal history as he saw them in the instant; he was amazingly versed in every nuance of his subject's variations, and he left nothing that did not instantly take on and breathe the life that was under observation.

He gave no time to thinking them out, he saw them, and saw them completely. Life was all one thing to him, as artistic experience, and he had no choice but to live all of it, and to live it as often happens, to the point of disaster, for he died of an over-draught of life at thirty-seven, exhausted with the whirl of the wheel.

It is enlightening enough to come upon this surprise in twelfth-century Albi, to find so brilliant a collection of many of his best works in all mediums, several hundred of them, and to note his developments from early boyish fumblings with paint to the last superbly comprehensive, virile, finished works of art, noble in every sense of the word, profound, delicate, sincere, and in that other sense, pitiably revealing, for the life that appealed to him most was not the life by the home-fires and conventional chandeliers, it was the life of what is called the underworld, that picturesque element that lives both under the surface, and upon it, and at the same time never above it, the life that never strays from cowardice, or superimposed principles from the vital element itself, which is, in the end, just life.

Lautrec was himself what is called an ugly person to look upon, with a crippled body, lips that appear to have drunk from every vicious vessel, but with eyes and brain that penetrated beyond every evil, every good, into the qualities of things themselves.

He saw all those states of being in the process of debauch as they come to the surface at last, to tell of the triumph and defeat of hearts and souls, beyond all those states which even the individuals themselves could not see, or if seeing, comprehend, he was their logical visualist, and such individuals often, through vast and varied experience, have derived the cleverest of philosophies, and know the meaning of their downfall, far in advance because they are the perfect, uncompromising spendthrifts, and accept their dramas with an almost spiritual vengeance. The curious aspect of Lautrec and all of his prodigious output lies in the fact that if he was excessively revealing, he was never vulgar, never common, never lacking in the exact measure of taste to see after all, the poignant beauty beyond the insult, so to say, for life in the end, becomes an insult to all those types he has portrayed, who have put their entire faith in life, body and soul, and when the soul through bitter years of harshness departs, the body is the final and inevitable sufferer, and it is exactly here that Lautrec displays his finest feelings and sensibilities, for he never injures those "low" women that he pictures so mercilessly by calling them slut, in his drawings and designs.

I am thinking naturally of the countless drawings he made from these types, and some of his very finest pictures and drawings are of them, studied in the closed houses where he was said to have lived for a time that he might better know and observe his subjects, and with what sympathy and understanding these were accomplished is to be observed most especially in the fine painting called "Au Salon" which is in the collection at Albi, the drawing room of a house, where the purchasable women are collected waiting for their patrons, and what astounding revelation of life it must have been for him, these drawings and paintings remarkably express.

Lautrec was, as his eyes touched a theme, instantly aware of all its actualities, all its suggestiveness, all its hidden as well as revealed truths; he saw his subjects as they were, artistic personages and prostitutes, and aristocrats alike, and gave them whatever degree of respect he felt belonged to them. He made clear the purity of the one, and the viciousness of the other, for his powers of observation were sharpened to a razor-like sharpness, uncompromising, never descending to hypocritical flattery.

If he saw loveliness, he expressed loveliness, but it is not clear that loveliness was his ultimate delight. He found more material in the

delicately ironic appearance, the satirical profile. If Lautrec may have wounded some of his subjects by too close a scrutiny, he wounded their vanity and not them, he showed them more exactly to the outer world than they could show themselves, because he was the profounder observer of their own appearances.

He did not, like André Rouveyre[1] of the later day, brutalize unmercifully some of his best subjects, Réjane for instance, making her out nothing less than a hideous monster, the difference between the finer artist Lautrec and Rouveyre being that Lautrec had no interest or time for hatreds, and apparently Rouveyre had time for nothing else, and still lives that way, according to accounts.

Lautrec was far too lyrical to be addicted to bitterness. There is the touch always of kindly smiling in every [one] of his satires, and his biographers speak of him as a very gentle, amiable, and companionable soul. Lautrec had little time for interests in reflection, and he was the finer artist for this reason—he did not strike at life with python fangs à la Rouveyre or à la Rouault, he caressed life into submission with a delicate and friendly persuasion, and in the end, he has no rivals and no successors.

It was the great, revealing, comédie humaine that absorbed Lautrec to the last drop of his pulsing blood, and to his last failing, sensitive breath, and the rush of life left him a ragged and tired little man, far too early.

Superb recorder of life's immense ironies and petty satisfactions. To know the story of Lautrec it will be necessary to go to the beautiful city of Albi, because the rest of this story is brilliantly told there in the delectable series of paintings and drawings, seldom seen outside the exclusive circles of art excepting by the elect few, because they were held as precious and private property, and you have the brilliant and scintillating connoisseur of life's values and variations here, it being in no sense a studio-scraped collection as sometimes happens when families wish to generously donate. And what you see on the walls at present not too perfectly lighted as is often the case, especially in the best, most famous museums, is but a part of the great gift, for the rest is kept behind locked doors in

---

[1]André Rouveyre was a friend of Guillaume Apollinaire, who contributed violent caricatures to various newspapers and journals and later executed a series of psychological *Portraits contemporains.*

special folios, over two hundred amazing specimens for which hanging space had not been made available.

You will see in this same room, if you are fortunate enough to be admitted, and I freely suspect the only price is unqualified interest in the subject, the superb cartoons in the original for Yvette Guilbert with the famous black gloves, the first vivid study for Caudieux, and the original poster for "La Nuit Blanche."

You will find Lautrec in all his pulsing splendour in that room, you will feel it best because you are alone with him, and because the genial conservator knows that you have come a long way with a single purpose.

You will have been asked to dine, so to speak, and the repast will be sumptuous, and nourishing.

Albi is proud of its modern treasures as well as its ancient ones, and it has every right to be.

# The Ingres Museum at Montauban

*(c. 1929)*

Five thousand drawings. Does the idea of five thousand of any one thing to look at seem a matter of special inspiration, no matter how you may care?

Anything of a museum nature fatigues in time, and you leave a museum like that of Ingres, done in, not with so much elegance and distinction, for these do not abound here, but with sheer quantity alone.

I rang the bell of the concierge one afternoon, and out popped a peppery fox terrier, and the concierge herself directly followed. Decidedly "Madame," for the pearls in her ears were large, very large indeed, for a concierge, the rest of her vivacious person all frill and vanity of the end of the middle years that seemed to have escaped the ironies of the jet period to which this lady certainly belonged, both in appearance and character.

The ordeal of looking at these Ingres drawings, and it is an ordeal, left me feeling the need of stimulants and a not too fine feeling for my pains.

Having just left the rich full-flowing charm of Albi, all warmth and sparkle, with the quality of fine, heavy old brocades about it, the change in tone and temper to that of Montauban seemed brittle, brusque, and harsh, it being the ancient center of Protestantism in France I was told, this in itself possibly accounting for the change.

But you must be willing to pay all such prices in search of artistic values, and to transpose oneself from the quality of the one to another is part of the general business of treasure seeking.

Museums are full of droll consequences in this respect, some of them destroy your sensibilities because they are so poor, other[s] fatigue them because they are so good.

There is a vast aggregate of documental notation in this museum of Ingres, and the quantity of precious material is small in relation to the great number of designs, and I think it is safe to say that of these five thousand drawings, four-fifths of them could have been done by anyone with common, academic obsession.

The paintings are few in number, thoroughly representative however, which means of course that if you like your drawings coloured, you will enjoy your Ingres paintings wherever they are, as he himself is supposed to have remarked that if the drawing is all right, it doesn't matter about the colour, and in the large compositions of Ingres, the colour is about as unattractive as colour can be.

We can easily accept the little motto written by the great draughtsman on one of his small palettes in this museum, inscribed sentimentally, "it is not thy fault the pictures are not better."

Montauban is a curiously interesting city, nevertheless, full of singular energy and virility, imposed with a masculine monumentality on the banks of the Tarn, and offers, as I have said, a kind of brusqueness after the gentleness and great-lady quality of some of the smaller cities of France.

It comes upon the eye with a kind of hardness, as the bread of the Tarn region affects the gums.

The types of Montauban are for all that, sympathetic for their ruggedness, generally inclined to reddish brown cheeks, almost more southern if possible than the other southern types, with full bloodedness, and the appearance of coarse, good nature, and I think they must eat well in this section of the Midi, for they are not neurasthenically green and violet, mouldy-hued, as the types of Paris are.

Superb looking geese and cleansed goose-livers abounded in the market place, laid upon snow white linen, and regarded by the eager spectators as in the nature of museum pieces, which they certainly were.

I dilate here upon this type of southern characteristic because Ingres, as one sees him in portraits by himself, might be met turning any corner in Montauban, so much was he the type of his native city, strong, sturdy, handsome, replete with calm, masculine strength.

There seems never to have been a time when Ingres was not interested in the antique and in its classical influence, as the multiple fragments and full drawings show, some of these fragments no larger than a playing-card, crowded with exquisite, coin-like detail, too full indeed to offer repose for the eye, only in the end, astonishment at the skill displayed and the passion to perpetuate in modern times, the ancient spirit. But, unless you come to Montauban for information, and this must be your motive, all the rooms will look alike to you, and you must of all things pass the dreadful large picture "Jesus Among the Doctors" in the lower gallery, given by Ingres himself to his native city, so huge in size and so meager in import, either spiritually or esthetically, revealing nothing in the end but his passion to emulate his chosen master, Raphael, and to gratify the modern school of Rome.

All the life is so drawn out of these figures by the ceaseless labour of this artist, that they lose the sense of reality, become at most wearisome and unattractive designs, and you pass them up as having little to edify the eye or the mind in search for beauty, or for great pictorial realization, and Ingres was possessed of one idea in his voluminous production, to acquire the flawlessly seeing eye, and his distinction simmers down, in the end, to a certain number of remarkable portraits, and to those extraordinary drawings such as the one in the Louvre, of "La Famille Forestier," and the superb

studies like the one of [François Marius] Granet in the attractive
little museum of Aix-en-Provence.

His highest accomplishment was of course to push a drawing into
the complete terms of a painting, and colour, as he certainly
conceived it, would vulgarize them, and, as is well known, it was not
the great age of the colourist in the art of his time.

To reduce the terms of life to an esthetic husk is what, in the end,
seems to be the keynote of the art of Ingres, scholastic culture, and
not that great, pulsing feeling for life that was expressed before him,
and which was to come after him, to reduce an idea to the limits of a
cameo silhouette as inspired by the Greeks and by Raphael, this was
his conspicuous and brilliant success.

The outside, and nothing but the outside, is what you find in an
Ingres drawing or portrait, little else, but what is given of this
outside is the product of a genius in modern draughtsmanship.

It is clear, exact, cool, and humanly speaking, without feeling. To
see the exterior perfectly was all that Ingres desired, and is what he
saw, and you are glad after you leave these works of art to go out into
the street, to watch people breathe, and have coming being.

A small drawing by Raphael himself in one of the lower rooms
among the many private souvenirs of Ingres gives one the idea of
what Ingres was after, and the difference in ultimate sensibility is
notable.

You feel, as you go about among the never-ending files of
drawings of Ingres, that after all, dogma was his obsession, and not
life. This museum reeks of the dogma of dead days, dead traditions,
and at its best it was not a great period, and yet, as dogma, the best of
it is to be found here.

No one has done more with that kind of drawing than this master,
but you come to long so for a least touch of the simple impulse of life,
and the eye wearies of looking at paid models assuming antique
poses, clothed in draperies from the academic wardrobe.

None of the fiery, grandiose, tempestuous emotion of a Michel-
angelo, or a Rubens, none of that calm, deep wisdom of Leonardo.
The museum of Montauban comes finally to seem like the product of
a ceaseless factory, not of the stirrings of a deep-flowing tempera-
ment. As for the paintings, the important composition like "L'A-
pothéose d'Homère" in the Louvre, and the "Jupiter and Thetis" in
the museum of Aix-en-Provence, it is to shrink with the banality of
their academic achievements.

Prettiness overcomes so much of Ingres' painting, prettier than Raphael's numberless madonnas, and that is saying a great deal, the sap never too sustaining in Raphael, becomes the thinnest syrup in Ingres. The largest drawing of the head of Granet, for the portrait of this handsome but very superficial artist gives all that Ingres had to say, and it is too large in scale for that kind of drawing, the smaller one in the museum of Aix-en-Provence being both beautiful, and thoroughly representative of what he wished to convey.

Ingres was distinctly the best draughtsman of his time and in his style, and if labour alone were sufficient, he would be classed among the greatest of all artists which he of course is not.

He had what might be called the smartest manner of realizing externals, the outside in all its obvious outsideness, and in many cases, its emptiness, but documentation is one thing, and interpretation is another, and Ingres had little interest in interpretation.

He appeals to the latest moderns for this reason, he seems in fact to have removed rather, the classical charm from the classical, and put in its place a skilfully organized map of factual relations. There is of course excellent material for study in Ingres for the student, because there is in his best drawings the quality of order, exactness, judgment, and accurate observation.

He does not, however, in the end, represent life, but the dogmatic, academic notion of life.

If you go to Montauban, you must be prepared for a test, but you will find that geniuses are not always impeccable performers, as has long since been proven.

Ingres, and Lautrec, what extraordinary opposites they were, the one, inviolable dogma, the other, inviolable escape from it, and these two museum collections, within two hours ride of each other, leave you to decide your preference.

It is, in the end, Lautrec that appeals to me most, because it is direct transmission.

# St. Thérèse of Lisieux

*(1929–31)*

"Regard papa, mon nom est écrit dans le ciel."
(Thérèse Martin to her father)

From a non-Catholic point of view.

On a certain day in September 1929 in the town of Lisieux in Normandy the corner stone was laid for the large basilica to be completed through contributions of the Catholic world to the memory, the glory and the miraculous achievements of one of the simplest and purest of child souls, ascended to its longed-for heaven, looking down now, with assurance, filled with everlasting faith that by ascending there she could do great works on earth by the purification of her soul in attendance upon the commands of her sacred Father.

The question first arises, what can a child of eight know or conceive of the everlasting mysteries, even though Blake is said to have seen God's face against the window at the age of four, his first experience in the supernatural. And it is with the above remark to her father one evening in the garden at Lisieux that the first concepts of the religious and holy life were made clear to little Thérèse Martin, and the only reply can be, she cannot possibly know the meaning of them, but here is a child whose origin, being ultra pious, basically religious, her father and mother both aspiring to holy orders and subsequent sainthood, for some logical reason not obtaining them, accepted their fate in obedience to the celestial will, set out to raise a family of children in which real holiness should come to life and bloom. And out of these ardent desires there comes to the surface the remarkable child Thérèse, who, let it be understood, is not ever mindful in her early consciousness that she has come on earth to stay for long, but is merely passing on her way to sit at the right hand of her heavenly Father, and from the first moment when ambition springs into consciousness in this child's heart and soul there is unflagging effort and determination on her part to

become utterly pure and holy so that she may become the veritable bride of Christ.

At the age of fifteen she has so formed her determination to enter the nunnery of Carmel that she pleads with the mother superior to let her in and because of her youth they cannot comply, so she continues to go to Rome to gain audience with Pope Leo XIII, does so, finds herself at the knees of his august dignity, pleads with him, is refused and after some delay something appears in the child's eyes, her request is granted, and she begins her novitiate in the cloister, so reverently coveted by her. And it is in this cloister among the severe Carmelites that this tender young girl, knowing nothing of the world or its sins, seeks to complete her purification and at the age of twenty-four dies of tuberculosis, and her soul enters into the Kingdom of her Lord God. In eight childish years she had prepared the basis of an eternal sainthood for whom this basilica is now being raised because of the miracles performed through her entry into sainthood. And the loveliness of her remark in the throes of death— "after my death I will let fall a shower of roses"—this the declaration of a child, born among humans, having played with dolls and other childish toys like other children, these toys being preserved along with the relic of her body now reposing in a casket in the Cathedral of Lisieux—born among humans, transcending them by spiritual gifts that many a bishop or cardinal or abbess, even pope, might envy for purity, nothing but her child's ardour and her child's belief to carry her through, merely to prove that in order to enter into the Kingdom of Heaven one must become as little children. Apparently miracle, regardless of its nature, is always present among us. Not being a Catholic and, in the church sense, not even a believer, I am only speaking of this child's life as in the nature of an exquisite romance, poetical in the extreme, full of the deeper wisdom that comes from the innocence of little children, and of the profounder needs of mankind in general.

The life of "St. Thérèse de l'Enfant Jesus of Lisieux," begun in the evening of January second, 1873, and ended twenty-four years later in 1897, is witness to the fact that spirituality may always be alive when we are inclined to think it most dead, judging by the habits and actions of common men and women of today, especially of today, which seem to exemplify the remark of Dr. Bernard Iddings Bell, warden of St. Stephen's College at chapel in Columbia College

recently—that the earth has no Christian nation—a world without belief. Therefore Havelock Ellis in his "Dance of Life" in the chapter "The Art of Religion" has this to say—"The mystics are not only themselves an incarnation of beauty, but they reflect beauty on all who, with understanding, approach them." And he earlier says somewhere that Leonardo da Vinci was as great a mystic as St. Francis of Assisi.

Belonging specifically by virtue of occupation to the cult of Leonardo we can all as painters I think, profoundly attest the splendour of this artist in this direction, that Leonardo rose as high as it is possible for the artist's mind to go and keep in pure form in the field of wisdom and in this sense of mysticism.

The child Thérèse Martin was not more than ordinarily cultivated and in the intellectual sense certainly not more than average, but from the first she was imbued with vision and the power of visitation such as is given to very few of her age and ranks her among the engaging prodigies along with Mozart in music and others in various capacities. The appearance of the prodigy in mystical and religious fields is rare for the obvious reason, for it is not given to children to see farther than themselves and that in a very ordinary way.

Thérèse Martin's background was fixed for her. She had nothing to make in that sense for she was the natural blossoming of two ultra religious parents who themselves had hoped to attain to her powers and perfections and were denied by reason of some flaw in their natures from achieving this high purpose for themselves. The problem then of Thérèse Martin is therefore just as much of an esthetic theme as religious for here is the perfecting of the human soul, surely as important a work of art as one can conceive, just as a plastic mind is the finest achievement outside the religious field.

Little St. Thérèse was a natural artist for she wrote creditable prose and poetry. She even painted, found her purest expression esthetically speaking in the far and radiant heights of religion, for one has only to read her "Vie d'une Ame" and her "Conseils et Souvenirs et Prières" to appreciate how perfectly she had arrived in the metier of her conceptions as well as in the true spirit of them.

She speaks everywhere as if she had never heard any other language but that of Heaven spoken and one doesn't have to be either Catholic or believer even to feel and enjoy the delicate purity of this child's soul and mind. One can take up the theme as a fascinating romance and find pleasure in the perusal of it.

That this child Thérèse Martin should know that there was but one goal for her, the ascent into Heaven, and that she should be able to picture it so clearly to herself, to visualize how the soul may rise to invisible heights and send its power down again to earth for those who are earth chained, earth ridden, speaks for the perfect sense of the relation of artistry to the religious function, and this is everywhere in evidence in the letters written by her to her superior and her own flesh and blood sisters; she builds up her mystic amities with the logic of an ultra-intelligent being. She speaks her language with the correct accent, remembering of course that she is a Roman Catholic and is speaking entirely to them, for the book of her life assumes that her readers will be in the church of her faith.

But that is not necessary to enjoy the romance and the purity of this child's life and mind and the surety of her vision. She sees from the very first how perfect Heaven is and has but one consuming desire, to get there as quickly as possible so that in the end, when she is duly purified and accepted, and after death her miracles being almost immediately proven, she begins at once to do good work by the spirit's descension among mankind, and the proof of her certainties and of her power has been realized to such a degree as to stir the whole world to a plausible belief that religion may once again return among men, despite the truthful assertions of the present hour of Dr. Bell with whom one is certainly inclined to agree.

And this is precisely the office and the function of the mystic—to make the world aware that all these treasures are obtainable. The spirit of purity and mysticism is, as we know, rarely met with in the world of painting and there have been very few truly religious painters. In fact, I know of no one who can be called purely religious outside of Fra Angelico. Certainly there is no trace of religion in Rubens's "Descent from the Cross." Magnificent as it is as performance, it is embarrassingly irreligious in quality, and it seldom happens even in the Renaissance period that painting comes to perfect religious beauty. But when I think of the Monastery of San Marco and its cells so beautifully decorated by Fra Angelico and the various single paintings by this fine artist and spirit I am convinced that here the holiness of heaven descended just as I feel convinced in my imagination that little St. Thérèse of Lisieux is an appointed child of the God she believed in and knew unquestionably.

Reading the Christian mystics to one who is not avowedly a religionist becomes at least a romantic excursion into the souls of

other beings just as "The Varieties of Religious Experience" of William James is one of the most appealing novels in the language, and the certainty with which the mystics speak is perhaps the most appealing aspect of their spirits.

Boehme, Ruysbroek, Eckhart, Tauler, Suso, St. Thérèse the Elder or Teresa of Spain— not to attempt to enumerate those others who have seen the "glory" and have been revivified—all these have but one speech and one living thought, and it is evident that each has found the living truth for himself.

Has there ever been a more gifted child mystic than St. Thérèse de l'Enfant Jesus of Lisieux, one in whom perfect innocence has been nourished and blended with purity of spirit, seeking the only reward with which it can be satisfied and achieving it? And is it not a rather engaging picture, very like the "Ascension of St. Rose of Lima" by Aubrey Beardsley, from the folds of whose robes far above the city and the fields, flowers are gently falling to earth—this St. Thérèse, a simple child of the earth by sheer purity of purpose and ideals, conferring her own benediction as she ascends—"after my death I will let fall a shower of roses"—engaging enough indeed, speedy the accomplishment, noble the design. For the earth as we earth-ridden ones know it today has need of just such convictions and assurances—it has need of a child's flowers and a child's smiles.

At the age of eight, discovering her initial "T" in the formation of the constellations, in the sky above her as she walked in the garden with her father, uttering the significant symbolic phrase that was to be so perfectly evolved, for the name of little Thérèse Martin is written in the sky, above Lisieux at least, forever.

In this speech is the clear sign of her mysticism, and her purposes were sure and ordained. Here is the basis of her exquisite spiritual argument, leaving her dolls and her toys because a vision of magnificent business had overtaken her.

I had taken a great fancy to this child as I read of her from day to day on the beach at Cannes in the south of France where I was then summering and sunbathing three years ago. I could seem to hear her very voice as I read her "Conseils et Prières" and the letters replete with ardour and piety.

In this day when the earth is so devoid of religious feelings and convictions, or when religion itself is being turned into a summer picnic with coloured flowers and vast flashes of light, crashes of

irrelevant music in the Protestant world, a vision like that of St. Thérèse de l'Enfant Jesus of Lisieux coming across the void redeems the faded picture, and her fresh, sweet childishness appeals poetically to those at least who have to have new visions of old things in order to sense them at all.

That St. Thérèse of Lisieux, being physically dead but thirty years, therefore a tiny infant in the beginning of her immortal labours, has created so many miracles is a strange picture in our world today still obsessed by war tragedies and war hypocrisies, whole crowds flocking to her shrine at Lisieux, being cured of their physical and spiritual ills—one can only say, "what a child."

I have written of this little girl because I think she comes into the field of esthetic creation and has achieved what is certainly the finest work of art that can be achieved, a pure soul. It is no small matter in these times, a perfect symbol of beauty created in the short space of eight years, endowed with everlasting life.

# PART III

# EUROPE AND AMERICA
## (1930-1943)

*The years between Hartley's return from France in 1930 and his death in 1943 were among his most productive, both in painting and writing. Part III consists of essays on art from uncollected manuscripts written during those years. None have been previously published, nor even—from existing evidence—submitted for consideration, yet a large proportion of them are in the nature of reviews of specific exhibitions. Though he rarely dated them, most can be placed quite accurately from internal evidence or references in letters.*

*Hartley's return home also signalled a return to American issues in his writing. The political isolationism that infected the United States after World War I was paralleled in the art world in the late 1920s and '30s by voices like those of Peyton Boswell and Thomas Craven calling for a resurgence of American values to replace what they felt was the degenerate alien influence of European modernism. Hartley's position as a writer and artist lay neither with the basically conservative views of Craven et al., nor, as we have seen from* Varied Patterns, *with the dominating trends of late cubism and surrealism. Typically, Hartley was hewing out his own position.*

*Oddly enough he and Craven started from the same base, at least in terms of their rhetoric. They each asserted that art must stem directly from life experience. Repeatedly throughout* Modern Art (1934) *Craven speaks of the necessity for artists to reaffirm art as a human activity, encompassing the lives of real people. Such an argument accords with Hartley's own experiential orientation. But Craven, unlike Hartley, held to a reactionary concept of experience as tied to a geographically determined environment, which must be portrayed only in realistic terms. Nor would he concede the degree to which Hartley relied on imagination in determing the creative process.*

*In the essay "Eakins, Homer, Ryder," which focusses primarily on Eakins, he notes that all three were realists though of distinctly different types. By identifying Eakins with Wilhelm Leibl, Hans Holbein and even Hans Thoma, Hartley argues that he was not purely American in type. He cites John Erskine's definition of naturalism to explain the discomfort he feels with the factualism of Eakins's painting—a weakness he attributes to lack of sufficient poetic element.*

*Craven attacked what he called the "purists"—art-for-art's sake abstract or semi-abstract painters—who turned to the revolutions of European art for their idiom. Hartley, however, allied himself with neither camp. He says in this essay (implying the visual arts as well as poetry), "There is much superior talk these days as to the right of poetry to exist for itself without any regard for the realities of life." He had always held to the "realities of life," whether he*

painted in an abstract mode or not, but he could never limit himself to reportorial expression like that of Eakins or the regionalist painters. He concludes by asking if perhaps John Singleton Copley is not more typically American than Eakins; "Copley's Americanism" may have been a response to this question. There he defines Copley's Americanism by pointing to the Yankee quality of metallic hardness and love of stuffs in his early work. In William Harnett too he finds this admirable tactile quality, calling it a "myopic vision." Harnett's art, with its non-intellectual approach exposes what Hartley calls the "spurious realism" of the day, doubtless a two-pronged jab at surrealism and social realism.

"Is There an American Art?" confronts the issue of regionalism head on. It was written in 1938 when he had finally re-established his New England roots. He had returned to his native Maine, he claimed, not merely to paint its timbers and granite—much as he loved these—but "because in them rests the kind of integrity I believe in and from which source I draw my private strength, both spiritually and esthetically." Although he was proud of being recognized in Maine as a genuine regional artist, he accepted the honor gratuitously and did not want his paintings to be classed as merely a local expression.

His interests in this decade were not, however, limited to chauvinistic issues, nor were his heroes only Americans. The contrasts suggested here between Gauguin and Rouault or Epstein and Lipchitz demonstrate that Hartley's critical assessment was based more on the degree of humanism, integrity, and impersonalism (or lack of excessive ego) expressed by a particular artist. Such qualities are universal, not national, and in his late writings the theme of universalism emerges as the greatest artistic value.

# Eakins, Homer, Ryder

*(1930)*

The recent exhibition of basic American art at the Modern Museum was a very revealing affair.

It would be difficult to say which of these three is the more distinguished, because the declaration in favor of any one of them would expose one to the danger of acute criticism on the part of the jealous upholder of the integral quality that is supposed to constitute a basis for a real and vital American art.

According to the prevailing prejudice—and this is very marked at the moment—in order to be an American artist in the basic sense, one must live, move, and have one's entire being in the strictly American atmosphere. There are sound reasons for believing this and yet there are significant examples to the contrary.

We are not moved to anything but regret when we read of the tragic death by suicide yesterday of Jules Pascin[1] the "distinguished American painter"—but we must get down to finer facts than this, for there was not the least trace of Americanism whatsoever in the work of this talented painter. There was nothing American about him but his papers, anymore than there is Americanism to be found in the talented young author Julien Green.[2] Being American according to this hard and fast rule is not being absorbed in a fresher kind of esthetics but a solider kind of solidity in geographical experience.

America is flooded with French art, but the American must not be interested in de-nationalized esthetics. He must exploit his national characteristic and what are these characteristics then? We are to believe that Eakins and Homer and Ryder are strictly American, and in these three painters we find three varieties of this quality. There is the unalloyed realism of Eakins. There is the romantic realism of Homer, and there is the dramatic mysticism of Ryder.

---

[1] June 20, 1930.
[2] Born in Paris of American parentage, Julien Green lived in France and wrote his novels in French.

None of these three artists has anything whatsoever to do with the other. They are not products of a national interest but of an inherently national temper. Could the type of realism as expressed by Eakins be produced anywhere else? We are convinced that it could, and that it has been, and from some points of view in vastly more entertaining degrees. There was Holbein, and much nearer to Eakins there were Duveneck and Wilhelm Leibl. I don't know where to find myself in the presence of Eakins. I can't feel myself leaving them [him?] utterly, and yet I don't know where to stay.

In the essay of John Erskine on the "Cult of the Natural" he has this to say. " This is the nature which the realists cultivate today, they report these facts of life from which art might take its beginning, but they report them as much as possible in an arrested state, for fear they might pass on into art."[1]

This is not so far removed it seems to me from the Eakins principle, but the point is not whether nature is greater than art, in this case, but whether reportorial concept is more real than romantic or mystical, poetic concept.

Degas for instance, long since placed among the sublimated illustrators, gave us his sense of race track truths in terms that gratify both the love of facts and artistic appreciation of them. Holbein was essentially the illustrator also but he saw his facts out to a very logical end.

The "raw material" of life, unadorned—unashamed of its rawness—seems to be the thing that moved Eakins to expression and whatever else is added, and there is little that is added by Eakins himself, must be smuggled in by the willing eye of the beholder.

How are we to consider Eakins then—as a photographer of the facts of life—or as an interpreter of the truth in them? As a photographer I do not find him interesting for there is in such case a Memling to consider, and as an interpreter of the truth in nature there is a man like Leibl to consider. Eakins is far more akin to Leibl and I fancy they had more or less the same racial origins for there is a sense of thinking and pondering that is alike in them, but I am always stranded with an Eakins and never so with a Leibl.

Courbet was no small stickler for facts either, but Courbet

---

[1]*American Character and Other Essays* (Indianapolis: The Bobbs-Merrill Company, 1927), pp. 91-133.

certainly had no fears that his conception of facts "might pass over into art"—for they never did anything else.

This passion for nearness to the earth is however a gratifying thing these days, and if unalloyed honesty of purpose is one of the clues to the higher realization of art then we must assume that Eakins is entitled to a high place, and this clutching to the side of nature and of truth in these days of so much esthetic fabrication is certainly a commendable matter, not because nature is more respectable than art but because it offers average experience and average concept. And the matter becomes a kind of conundrum at this hour as to whether truth accurately observed, or whether truth revealed and idealized is the thing we are to care for most.

Technically, Eakins belongs to a very dry school of realistic painting the founders of which were his own teacher Bonnat, Gérôme of the Ecole des Beaux Arts, Carolus Duran, Cabanel and the driest of them all in the field of romanticism, Moreau. There are two notions in the rendition of the fact. There is the plain notion and the grand notion, and there is no question but that Eakins preferred the plain. His own portrait study of himself would seem to indicate that he abhorred all sense of embellishment for he looks like a piece of the earth himself, and in contrast to the multitude of vaporous esthetics of the present hour it is good enough to come upon so solid a sense of things.

Eakins certainly had neither interest in or patience with the frills and furbelows of interpretation. He wished to have his notion of beauty correspond with his concept of truth—and truth to him was seeing things exactly as they are. He was therefore reportorial and not interpretative.

Apart from the cloying sentimentalism of Hans Thoma there is something there that makes one think that the men were similar in quality and structure, save that in Thoma there always seemed to exude a phlegmatic sense, a kind of bovine conception of plain things, and there is a heaviness about Eakins that seems almost irrelevant in the field of picture making.

One thing however is certain, Eakins was not a "museum" painter as I have elsewhere said of Leibl.[1] Neither of these men had their eye or mind upon the medal, or upon anything but the rendition of their

---

[1]Wilhelm Leibl" from the *Varied Patterns* MS (YCAL, Hartley/Berger Archive).

object of interest, and this object of interest was the unalloyed humanism of human beings.

And the question rises, how much are we to be interested in painting for itself or in the truth for itself? And if the truth is to be painted, and the painting does not interest, and one is not interested in the fact for itself, then where does the esthetic pleasure come in? I can frankly say only for myself, I am not interested in Eakins' fact, and certainly not in his style of painting so I seem to find myself sort of washed up by a curious tide, and left.

It doesn't do to say there is no poetry in Eakins at all, because in the end a realization of the truth is often a very poetic affair, and science very often a romantic affair. Einstein, the outstanding mathematician of the day, is a very gentle romantic, a very poetical person. Where is one to step off in these things?

If I could feel that all life were to be found in these paintings of Eakins, I would say that Eakins is a very superior artist. One could almost dare to say that a Shakespearian version and the version of the Old Homestead are one and the same thing. And certainly in the end Wordsworth is a greater poet than Coleridge for the reason that he is saturated in the qualities of nature and is likewise saturated in the realities of nature as well as in the poetry of realities. There is much superior talk these days as to the right of poetry to exist for itself without any regard for the realities of life or the significance of nature itself, and there is always the reverse argument that narrative is the most satisfying aspect of poetical expression.

In any case, Eakins doesn't tell you how marvellous or how inspiring the fact is—he merely presents it—and the question arises only in Eakins' case as to whether in all truth he wasn't potentially a natural sculptor, and that his subjects would have been more entertaining in sculptural form. You can only take Eakins as he is—and you can't have him different, and in the end if I personally cannot have him different, I can't seem to take him, and I cannot leave him either. He is a curious quandary in my experience and my ideas are running very much away these days toward the qualities of life as it is and the essential truths of experience—experience unembellished and unadorned.

And as for more enlightening comparisons this Modern Museum exhibition would I think have proven more thrilling if Fuller, Homer Martin, Blakelock at his best and perhaps Inness also [had been

included]. The public would have had a still clearer idea of what it is that constitutes a possible and plausible basis for a genuine American art.

And another question is, shall an artist be perpetually present in his picture as is the fashion today, or shall he step out of it as completely as possible? Art is certainly having enough of private egotism. Eakins is decidedly a stepper-out, and yet with all his honesty is he as American as John Singleton Copley?

## Copley's Americanism

*(c. 1930)*

John Singleton Copley [should], it seems to me have become through comparison, the most American of all the artists who form the background of American painting from its inception until the present day. In spite of the fact that the "grand school" of English portraiture was in full swing, and enjoyed its great vogue in Copley's time, and that Reynolds, Gainsborough, Raeburn, and the others, were producing masterful portrait decorations, and that Copley himself lived in London for a time, and doubtless also enjoyed a success of his own there, the special quality that gives the Copley pictures their peculiar distinction is a national one, that is to say, those metallic, almost dissonant harmonies and highly incised acrid rhythms and designs could only have been produced by American temper and American sensibility. I have thought very often in my absence from this country of these fine portraits of Copley and have

been impressed with their lack of flourish or over-statement, all affectations of a day, unless one thinks of his manner of posing his sitters as an affectation of a day. In the portrait of Jeremiah Lee, it is a gentleman of force and power that one observes, standing by a table of gilt, with a plausible landscape revealed by an elaborately designed portiere half drawn back, and the portrait of Mrs. Jeremiah Lee[1] ascending a hardly plausible staircase, dressed in a handsome satin gown lightly trimmed with ermine at the neck, is a very chic performance, coldly painted to be sure as all the Copley portraits are, but the question of period affectation appears in the cluster of fruits where the right hand holds the dress in the lifted folds, a place no one would be likely to hold such weight so casually for long.

But it is to be remembered that in all stylistic portraiture liberties of such a nature were always taken, and these notions form merely an aspect of the prescribed rhetoric of the day, so that we are led to accept these odd decorative irrelevancies, and to think of them reasonably, or to think nothing at all of them as regards their factual possibility. Portraiture is always a cause for questioning just how like the person they have come to be.

We suspect, for example, that Bronzino painted his people very much as they were, and if these portraits are nearly always excessively metallic, they are, one wants to think, replete with veracity. When we look at a portrait by Holbein, or by Dürer, by Cranach, or more especially by Memling, we can be sure that photographic representation as employed by these great artists discloses with exceptional veracity all the outer characteristics of their subjects who would readily assent to their fine sense of likeness.

Modern portraiture never seems so convincing, excepting in the case of specializing portraitists like Ingres, Degas, and even Courbet, where the image of the sitter was deeply and intelligently studied, and one is led to feel also that in spite of the stylistic bravado that enters so brilliantly into the portraits of Hals as seen in those remarkable "breakfast" groups of his in the museum at Haarlem, a remarkable sense of truth to subject has been attained, and one leaves them satisfied that exactitude of vision is the prevailing quality of them, that these gentlemen were the recognized statesmen and dignitaries of their time, and you come to feel when you go out into

---

[1]Both portraits are in the Wadsworth Atheneum, Hartford, Connecticut.

the streets of Holland that any common type, if he were ruffed and ribboned as these gentlemen were, could instantly be turned into Hals portraits, so true he was to the types of his race and nation, just as one would be sure to find in the streets of Spain exact types that would tally with the portraits of Goya, and of Greco and Velasquez.

The portrait painter does not always possess this highly defined, photographic instinct or capacity, and just how much of this essential element has entered into English portraiture it is difficult to say, for there is always present the element of flattery and flamboyant assertion to be remarked.

In the case of Memling for instance, in those incredible portrait heads of his in the Museum at Brussels, you are sure that this artist was much closer to his facts than the handsomest Reynolds or the cleverest Gainsborough, and that he was neither interested in or reducible to the tendency to flattery which gives later portraiture its prestige and unlimited approval.

Most people like gorgeousness, they are impressed with grandiosity and the assumption of dignity that gold and velvet implies, just as most people are apt to like floridity and melodic sweetness in music. They like the superficial niceties of a Laszlo, a Halmy, or a McVey, and all women who have their portraits painted want to be made to look like duchesses, just as merchants want to be made to look like men of great significance.

John Singleton Copley had none of these prized tendencies, and apparently no interest in them, and I think it is more than likely also that he had no particular interest in his sitters beyond the obvious importance of making his portraits look like them in an external sense, for he never goes too deeply into characterization to disturb the outer appearance of them. He seems to possess but one desire, and that was to see them as they were, and not to think anything unusual about them, which makes him in the sense of portraiture, a natural and careful historian. Certainly neither Mrs. Skinner[1] or Mrs. Jeremiah Lee could ever assume that they had been "prettified" by Copley, for they were not, and we find them as they undoubtedly were, just women of their time, without unusual gifts or powers, merely ladies of a certain representative position. Copley would be considered today, if he was not in his own time, a bit brutal in his

---

[1]In the Museum of Fine Arts, Boston.

renderings, for he offered no embellishment of his subjects, and he made no special deference in his treatments of sex. He simply saw men and women, and we are confident that he gave them as they were, he had no cheapness about him, and he certainly was not in any sense cloyingly romantic, as is to be found in so much English portraiture. But English life and American life are vastly different things, and this hard sticking to facts is the distinguishing character-istic of American sensibility in art.

You take your Copley as you find him, and if you find him too cold, you will miss his finest distinctions, but it is exactly this very coldness that makes him attractive, and in the end you come, or so it seems to me, to think of Copley's portraits as the best and most typical of what exists today in the notion of American sensibility in art. In other words, Copley never "slopped" over. If he had any excess at all, and I do not feel that he had, it was on the side of restraint and reserve, of discretion, of cutting down to the last his simple appreciation of his material and [he] permitted no trace of flourish to mar his performances. Copley was always measured, always tempered with evenness, and because of this sense of regularity and measure, there is a distinct racial decisiveness about what he had to say. He saw and felt as an American would be likely to feel about American traits and appearances, and he did not subject these traits and appearances to virtuosic bravado which is often the defect of portraitists greater than himself.

Copley's special distinction lies in his very acute and almost uncanny sense of the reality of stuffs, and his satins, silks, wools, laces, and velvets are different from other portraitists, and he never confuses his materials by unrelated technical treatment of them. Copley had one very special gift—he could induce a unique sense of metallic intensity from his appreciations of monochrome, he had in quite a different degree something of the capacity of Zurbarán for driving simple monochrome to a high pitch of tonal richness and beauty. In any case these racial traits in the appreciation of tonal values are attractive to us in the way they present themselves, and in Copley it is his essential Americanism that appeals, just as in Goya you are made to feel the hot, tempestuousness of Spanish blood, in Zurbarán the quality of essential religiousness, in Greco the quality that every real Spaniard is a mystic and a sufferer, an essential believer in pain.

Copley makes you feel that every one he painted was an American, the American in process of being observed by the acutest of American observation. All this may sound like twaddle in the end, but the spectator can be sure that every feeling that Copley had was an American feeling, every observation an American observation. He leaves you nowhere in mid-air about these things, for pure Americanism pours out of his pictures, and there is very excellent painting in them besides, the kind of painting that modernists of today very highly respect.

The Copley portraits were made for American homes and the pictures fitted in admirably with the houses and furniture of the time, the time being far more strictly American racially than it is now, for bloodstreams have been mixed, and no such unalloyed Americanism is likely to spring forth in the better painting of today, at least none more concentrated in its quality.

And what I personally like about these paintings of Copley is his original faculty of getting a fresh range and tonality out of the same old palette. It almost seems as if he had a strong aversion to conventional sensibilities, and sought to recreate them by fresh personal standards, sought even by definite selection to avoid banalities of colour and tone which are apt to appear in so much painting, especially portrait painting, and most of all, sought to avoid all cloying sweetness, and of this, thank the ruling powers, no trace exists.

One has only to refer to his fine portrait of Governor Hill[1] in ivory and blue, to realize how unique he was in his sense of fresh values and tones, and there is again, no light skipping of passages in the painting, as is frequently to be found in great portraits, in Rubens for example in his employment of transparent shadows and excessive opacity of lights.

Perhaps you will be inclined to differ and feel that there is too much of formalism in Copley's production, but there is much to be said for his exactness, much that appeals in his adherence to customary experience.

----

[1]Copley painted Henry Hill (who was not a governor), and Moses Gill, who later became Governor of Rhode Island. Hartley is probably referring to the later painting which is in the Museum of the Rhode Island School of Design, and is indeed ivory and blue in tonality.

This quality of Copley's might even be termed "Yankeeism" in art, so much has it to do with the natural acridity of the Yankee temperament. Copley was of course an excellently trained painter and the result if you think it cool, is still attractively clear and precise, not muddled with excesses or the dull invasion of faddism, and his painting comes upon the eye today, after so much ponderous travail through the desert of fashionable esthetics, as a very pleasant and refreshing experience with [a] very racial idealism, its accuracy of vision, and simplicity of expression.

# Wm. M. Harnett, Painter of Realism

Since it is quite the fad these days to be returning to nature and the objective experience, we have with us at this moment the most curious sort of realistic vision that we know in the field of modern painting, in the pictures of this American, Wm. M. Harnett.

There was a time when we laughed at painting like this—it was to be found often in junk-shops, lying about amid other debris much in the manner that the now majestic and famous pictures of the greatest American artist, Albert Pinkham Ryder [were]. Those of us who knew Ryder personally, even slightly or more intimately, are aware of the incredible state of disorder in which the great pictures of our American imaginative lay in his veritable junk-shop of a tenement near the corner of Eighth Avenue and Sixteenth Street—suspected by no one in his neighborhood as being more than a funny old man of

odd habits, who was seldom seen in daylight, but more frequently in the evening as I often saw him, and probably on into the morning by those who were out at such hours. No greater contrast could possibly be found in matters of relation than the work of Albert Ryder and that of Wm. M. Harnett, for Ryder had none of the myopic sense of reality—and if Harnett had that and little else, he was able to make reality real to himself, for in the strict sense he was without personal life—he interpreted nothing—he in plain terms, had nothing to say—he had no esthetic motive—he was interested only in getting down a group of the commonest objects—for the pictures are all still-lives—and [in] expressing every single aspect about them, not merely their shapes in the camera sense, but also their individual textures.

It would seem indeed that nothing but the things and their textures interested him, the kinds of materials objects were made of, the leather book, the pipe, the match, the crockery pot, the violin, the newspaper, the postage stamp, a worn letter, a casual photograph—the plainest kind of objects that had been worn with age, usage, even the effect of time on them—since time figures in every adventure, and these objects all had the adventures of usage, of being handled, employed according to their functions, laid aside, kept about because there was something about them that expected them to continue to exist, a kind of unintentional romance even because human hands had touched them and made use of them.

Harnett invested all his paintings with the reality of things, having nothing to do with interpretations. The association of ideas in the surrealist manner had no significance at all, and the surrealists have had and still have their almost painful sense of reality, as we find in the skillful but disconcerting paintings of Salvador Dali.

In the small painting [by] Dali called "The Persistence of Memory" owned by the Museum of Modern Art, you have an acute sense of realism, but it is realism acting a play of the mind—there is drama involved—one of the watches is melting away under the pressure of time and the [assaults?] of memory—the other—and it is a gold one—is being crawled over by a company of ants who seem absorbed in nothing else than the certain tick-tock of the moments as incised by the hands above the numerals themselves, and there is a desert of meaning in the distance—a dramatic little picture if there ever was one—and in the comforting sense without any of the

visceral debauchery that is pictured so harrassingly in the recent paintings of Dali. Dali is not an American. He is a citizen of an irregular world defending itself against the regular—all of which is naturally this artist's business.

I dwell on Dali's gift for realism because it is not so unlike that of Harnett, and there is another of the same school—Pierre Roy. Edith Halpert tells of a visit Roy made to the Harnett show, stayed an hour, and was embarrassed when she asked this painter how he liked—esthetically speaking—having an American ancestor.

It seems to me that a comparison may be made among these artists of their type of painting, but there is a difference, and that difference appears to me to be that Harnett's point of view is distinctly masculine—his sense of reality is rugged while that of Dali and Roy is of a feminine quality, as there is—in spite of all—a tendency to prettify all that they paint. There is no "punch" in the surrealists and there distinctly is in Harnett. This artist goes further than anyone else. He paints a newspaper and it can actually be read. The type is distinctly readable—no simulating here, but a direct visual contact with all that Harnett looked at, and because there is no interpretation in Harnett, there is nothing to bother about, nothing to confuse, nothing to interpret, there are in the common sense no mind-workings— there is the myopic persistence to render every single thing, singly.

With all this lack of estheticism in Harnett, for it does not intend to represent beauty, it has a beauty because it has a dignified sense of the fact seen for itself.

Almost without exception, given this sort of passion for minuteness, there is usually the feeling of smallness present. There is usually the sense of the finicky approach, but this is not the case with Harnett, for there is even a kind of orchestral severity about his paintings. He has as full-toned a sense of monochrome values as can be found and you seldom find this quality in this sort of painting. Perhaps orchestral severity is too fussy a phrase, but Harnett has true gifts as a composer, a designer—his pictures are all set-up after true laws—he produces the full sense of the form and he wastes no sentiments about his ideas, for these pictures are flagrantly unsentimental. They do not show the emotional earnestness of those painters who are obsessed with objective modernity and do not "strive" toward this end.

There is never a trace of this masculine richness in the paintings of artists of this type, not even Holbein escapes from the accusation of prettiness.

The fact that you feel you can "touch" the objects of Harnett is not what makes these paintings significant either. It is because there is a direct reasoning taking place in them—every object and every texture is what it is and is not made into anything else by application of false fantasy. Until Harnett I had sort of decided that Roy was the last word in this sort of painting but I think it safe to say that Roy will agree since he was embarrassingly impressed that Harnett has said all there is to say on this matter of rendering realism.

Harnett must have been a dogged individualist else with his various times of residence abroad, in London, Paris, Munich or wherever, he could with a less definite sense of meaning have been carried a little this way or that in favour of prevailing modes, but there isn't a trace anywhere of this to be found in Harnett. The pictures of all periods have to a surprising degree the same kind of he-man ruggedness—he "weeps" about nothing at any time.

This same kind of painting plus intellect plus spirit, plus a certain amount of super-sensibility would have made Harnett into a greater artist than he was, for after all copying textures and surfaces is not a great matter, but it is troubling to us now, since the tendency is to copy the truth, that this man Harnett long ago beat those, who have the same thing in mind today, at their own game.

How many succeed in painting, no matter what the motive intended—how many or how few rather become the real thing in whatever mode? Harnett is one of the very few who succeeded in that sort of obvious representation; we have seen this sort of painting when it was amazing but not dignified, and it is not that Harnett was, I believe, accused of forgery with his portrait of a dollar bill that gives him his appeal to us now. It is only because he really and truly succeeded—whereas almost all of the other painters failed—because they were more easily satisfied with a vaguer success. Anyone who wants to know how difficult it is technically speaking to copy these common textures, then let him try—even the myopically gifted do not always carry away the trophy.

If I may speak for myself a moment, I should like to say that no painter has been or is more enamoured of this sort of painting than myself and if I have for some time made weekly voyages to the

Altman collection where the marvelous Memlings hang in the Metropolitan Museum, it is not because I know it to be the latest mode among the modists—it has been because one learns there how qualities and textures may be rendered actually without fussiness because Memling who is called by no less a photographer than Alfred Stieglitz, the first photographer, had that gift to see all forms and substances in terms of their own language. And the nearest possible approach to the image desired is the natural longing of any intelligent person who paints.

The Dutch painters had this to an unbelievable degree also, painters such as Van Huysum and Abraham Mignon especially, whose outstanding habit was to paint a bird's nest usually in the lower right hand corner, and to give an exact sensation of all the textures of that object, such as the twigs and fibres of which it was made, the soft linings of the same, the exact quality of the eggs, with nearly always a lone feather clinging to some edge or other.

As for the various flowers, and all their botanical accuracies—as well as the realistic images of casual butterflies—an insect crawling into a flower, or a caterpillar in the act of ambulation—all are given with precise imagery and have an admirable kind of beauty about them to boot.

There is no knowing how Harnett would have done flowers as I have seen none if he did them, but quite likely his maleness was interested in a masculine sense of truth and volume.

It is always pleasant this matter of rediscovery, and Harnett is distinctly a happy find in the world of art because, and only because, he does what he wishes to do. He states an associated objective truth—exactly, and as a result so much spurious realism has been exposed.

# Mark Tobey

*(1931)*

With the appearance of three paintings of Mark Tobey in the recent American exhibition in the Museum of Modern Art, a new American quality appeared, that is to say, a new personality working out its own destiny, its own relation to life, came to view, and if the work of this painter did not startle the ordinary spectator looking for theatrical sublimations or aggressive insistence upon theoretical extravagances, it registered at once the presence of a real artist, and revealed to a few discerning ones at least that a very distinctive talent had weathered the storm, had come to the light ready for its quota of praise or condemnation, and it is safe to say the work of Mark Tobey will survive all superfluousness in either direction.

Those trivial modernists who believe that tin-smithery or bad photography in painting is the highest form of the expression of the day, will find little pleasure in this work because the assertion will at once be made that too much of the quality of life enters these pictures to permit of pure expression, and in their particular sense they will be right, but in the end, prescribed points of view or exaggerated preferences have nothing to do with this matter.

Tobey is quite in line with the ultra-realists because he departs from external presentations of life, and gives what after all are his own particular deductions, and if these deductions enter the realms of the psychologic and the psychic, then he is still more modern than the local modernists. This painter is not an advertising designer, and this places him at once out of the pale of common, photographic geometry.

Tobey is a thinker and a mystic—what an anomaly, what a faux pas to have something to reveal in art these days. To vacillate between life and death in pictures is hardly the theme of the poseurs of the day, and yet it is the special experience of this man to do so. He may even be suspected of being interested in the equations of immortality. Tobey does not paint mechanistic designs in the cheap industrial sense, he is not fooled into thinking that pictures of

machinery are as good as the machines themselves. He paints, we might rather say, mechanistic designs in the psychic sense, and he is at his best in the depiction of human states of being. He is a searcher and a revealer of the inner condition, ostracized as this condition is apt to be by the worshippers of the actual appearance of things.

Tobey is a searcher and a revealer of this inner condition, he sees the exterior, but he sees with an almost surgical severity what lies beneath the surface, that quality that gives a face and a body its way of looking and being under the influence of psychological struggle, he reveals what he has seen and felt, and he has seen clearly and felt with special gravity the depths of the tides that wash against the barricades of the human spirit.

Tobey is a clairvoyant, a revealer of the content of shapes, and he finds a consistent harmonic synthesis for these revelations.

The work of Mark Tobey has remained singularly absent from the field of present day American esthetics until now because he has been occupied for many years doing realistic portraits of the casuals that come and go, who have little or nothing to do with the involved states of man, and do not, or could not want to know anything about them. The selected exhibition which at the present moment is on view at the Contemporary Arts Club will do much to carry the name of Mark Tobey forward in the realm where it rightfully belongs, into the field of real expressionists of this country, and with a surfeit of commoners who reveal nothing or little more than poorly observed realities, it is important to welcome a subtler experience of these same realities. There are but two ways of observation these days, and the choice of the artist must lie inevitably between them. He must either return to objective life in the intellectual manner of Courbet, or he must remain among the analysts of the inner experience, and the break toward the conscious outward is far more difficult than it seems. Cubism is responsible for this, and as soon as this type of abstraction is washed out of esthetic intellectualization, the rest will be an increasingly simple matter. Until then we shall have the various shades of surrealism which now pervade.

As to whether Mark Tobey is an essential surrealist, it is not important to say. He knows what photographic realism is for he has practiced it for years, and it [is] perhaps the very revolt against so much superficial observation that has led him into the interior, and in the end, to himself.

Tobey is, I repeat, an out and out clairvoyant, a revealer of what is not to be seen by the eye but penetrated by the mind, and it is in this that provides this painter with his specific intellectualism. He is concerned with how much of the volume and the intensity of life he can attract, and he is able to attract all of it because he understands all of it, and is able, furthermore, to place it in his own scale and comprehension of experience.

Mark Tobey is a man who lives every moment, and by living is meant not acting so much himself as letting life act every moment upon him. He visualizes every sensation plastically, and gives the plastic sense of his encounter, and he is not troubled as to how exactly alike his pictures are, for he is not a repetitionist, and he is likely to vacillate between abstracted, objective emotion and deep mystical interventions. The origins of psychological reaction in the pictures of Mark Tobey are real and unclouded. He has two highly defined strains in him, Teutonic and Celtic, and if there is to be any best, it is perhaps the Celt that arrives at its highest in these pictures of his. He studies all kinds of life and gives the essence of life to all he does, and his pictures do not "go to sleep" for lack of the proper, intensified experience.

There are at least a half dozen small pictures in the present exhibition which would give Mark Tobey immediate place in the esthetic appreciation of artists anywhere in the world, all of them done in refined gouache, revealing finely registered emotions coupled with excellent technical expression.

One is of two prostrate figures, man and woman, who[se] effigies disclose the cool peace of death that has overcome them, revealing an immense sense of the calm of the inevitable in its tones of ultimate whiteness.

A second is the presentation of a vast room with a doorway looking out upon a wide stretch of wasteland troubled with the stress of storm. Nothing comes into the relation of the room but the upright presence of a roseate fish, and the episode is ended.

A third, a landscape tiny and perfect, discloses a scene with houses and land in relation to a stretch of sky and sea with ships in the offing, and it is in these several pictures that the ominous sense of the north penetrates most deeply, and in the end proves Tobey to be a distinct interpreter of the north to whom the north is bound to tell its none too friendly secrets.

The rest of the exhibit is made up of human gestures and human states of being, of spiritual entities relating to their respective types in which the life of each is locked and sealed with a spiritual permanence.

Other pictures are more appealing in this exhibit than those I have described superficially, but it is in precisely these that Mark Tobey comes to himself and shows us what he really is, and what we may legitimately expect of him, for they contain at [their] fullest the mystic element which is the keynote of his visualization and of his final interpretation.

Just how much of an audience Mark Tobey will acquire for his type of expression remains to be seen, but it is enough for the present that he has come to the surface among the artists full fledged, bearing all the necessary credentials of a respectable and satisfying artist. Obscurity is often of great value and enhances the value of [a] man more than conspicuous presence from year to year is likely to do. That Tobey is permanently among us at the age of forty is in its way a matter of kindness of fate. Tobey is a pedestrian of the solid earth, he is a strong, athletic person with a keen mind and a sharp sense. He is not a silly dreamer or a trifler waiting for soft cushions to languish on, he finds the stones themselves to be kindly and eloquent. He does not need to promise anything because he has established his comprehension of the laws of experience, of expression, and of private revelation.

# American Primitives

*(1930–31)*

Anyone who is weary of the hocus-pocus of intellectualism in art, who seeks relief from the everlasting interrogation of the subject, who tires most of all of the greatest bore among the phrases of well worn speech, namely, "What is Art," had better take himself over to the Newark Museum and thereby refresh himself with a bath of gentleness for the eye and the mind in the presence of these delightful American primitives, none of which gives hint that art was ever meant to be anything but a simple visual pleasure, that it was ever meant to enter the fields of mechanistic invention or of metaphysical debauch.

Allowing for certain minor differences in racial impulse and racial temper, primitive pictures seem to be more or less alike the world over, in the special sense that these happy unknowns are never concerned with anything but to make a picture that will represent as concretely and as simply as possible a pleasure that has come to them out of the great source from which all experience is drawn.

What a fortunate time it was when these artists were living in the flush of their desires and were not impelled by absurd attempts at professionalism, as most of us are today. I doubt very much that in this age of affectation and assertion, where everyone feels he can declare himself adept in six lessons of something, an amateur of the type to be found in these American primitives could hold his own. There are no amateurs today, everyone is a professional, no matter what the field of expression may be, and the ingratiating charm of amateurship is gone from our midst, forever, and there can be no childish impulses today, for everyone is expected to assume adult wisdom and adult superficiality. In the eighteenth and nineteenth centuries there were plenty of amateurs, but it is certain that twentieth-century mechanism has destroyed all these simple impulses, and we are finding our amateurs among the idle rich whose chief ambition seems to be to escape from the condemnation of their riches.

The carriage painter for example who painted flowers and fruits on wagons so handsomely exists no more, for the obvious reason that there are no wagons to paint. Many of these wagon pictures were beautifully done and revealed true artistic skill, fine taste, and in nearly every case a genuine understanding of nature.

Curiously enough, in Europe, a whole new group of amateurs have come to the surface, inspired in all probability by the magnificent ascension into the world of real art by that quaint and gifted amateur, Henri Rousseau, and it is quite the fashion now to own a Vivin, a Bombois, a Boyer, a Serafine, a Farge instead of a Picasso or a Braque, not merely because it is cheaper to procure, but because it is more pleasing and restful to look at, for the problem picture has become a kind of modern anomaly, and art is rapidly returning to the more elemental qualities of its purpose, namely that of pure pleasure without struggle and without metaphysical or intellectual or any other too noble import.

There are always people who feel that life on the level with itself, life that is neither above the ground or below it, offers enough interest or pleasure, and nothing more need be expected [of] it, for life is just like art, it needs a rest from all problematical interrogation and dissection, and when it comes to the final show-down what has art to do with mathematical or metaphysical relativities? Surrealism has done all that can be done with these notions. We have seen to what thin ends calligraphy in painting has come, cubism has long since done all that be done with diagrammatic notions, and we have arrived back to where the thing started from with the drawings of those first primitives in the Altamira caves, of the ice period and all that, where the primitives of the time expressed in terms of impeccable skill and excellence their objective, first hand experience, the conquest of the animal for sport and for food, and you find astoundingly sophisticated representations of the buffalo and the deer that will never be improved upon either for esthetic perfection or the perfect observations of nature, so long as art remains an essential necessity in the expression of life and of the concept of life.

It seems curiously imbedded in the deeper recesses of consciousness of the human being, no matter what the state of ignorance or of cultivation, to want to make an embodiment or image on a surface, which will represent a living vital experience. It is these modern modes and intellectualized manners of thinking that have come

between the spontaneous evocation of the simple image, and the uninvolved, receptive sense.

What a relief it is for us who are tired of art, as we have been forced ever since impressionism took hold to go back for instance to the honest-to-God realization of an artist like Courbet for example or those simple studies of Corot in his Roman period, for whom there were no hyper-intellectualized notions of what art was meant to be, who were so magnificently in touch with the earth and the dynamic elements of sea and sky, of light and shadow, of rock, tree, and the animal life that lives so handsomely along with them that they found no time or reason for cerebral attenuations, whose existence as human beings was so like the rest of life as to be a reasonable sensing part of it, for whom representation was the reasonable sign of logical existence, but then that was the age of earth and all its meanings. The mechanistic age had not yet stepped in with thundering feet, and art was not expected to take part in scientific derivations. There was no hint that calligraphic design would take the place of visual objective experience.

This primitive painting has nothing to do with intellectualized representation, it has but one concern, namely the desire of the simple mind to satisfy a deferred longing to create a comprehensible, and reasonable representation of nature such as the simple eye has seen or the simple imagination has conjured.

These primitive artists are seldom at a loss to invent a technique which will express what they wish to envisage. They enter the instinctive degrees of analysis at once, and note the kind of object it is, they note the character of a tree, the way the bark and the leaf inhabit it, they note the way the rock settles and sits, the way the earth undulates and by what various forms it is vegetated, and an expression comes to them by this very passion for descriptive invention. If they do not all rise to the finer heights of art as in the case of Henri Rousseau, the French modern primitive, they nevertheless show degrees of taste and perception which the more affected type of artist would do well to observe and imitate.

Painting calls first of all for the gift of visual accuracy and the better an object has been seen, the more sensible a representation of the object is likely to be, and a picture therefore has but one purpose, and that is to show how much the artist has understood of what it is he wishes to express, just how clearly he has looked at what he has seen.

Painting has been too much involved and needs a good purge from all this extraneous application of intellectualized problem and premise.

But the talk here is to be of a specific group of American primitives. We are shown an exhibition arranged and presented by the Newark Museum through the special efforts of Holger Cahill, assistant director of the museum, and a most laudable and worthy exhibition it proves itself to be. It is a great pity in a way, that all this sort of painting must be driven out by the sophistications of the mechanistic era.

A visit to the Peabody Museum at Salem, Mass., reveals again an exhilarating collection of marine pictures so beautifully painted as to put to shame from the point of view of veracity of vision and of loyalty to facts those artists who think they see, and whose eyes have never been really opened to those things they assume to see. These pictures beautify their subject matter because the love of subject was of paramount importance. These elemental artists were natural seamen and knew every fragment of the anatomy of the ship, and would never by the wildest guess be caught assuming knowledge which they did not possess. The pictures of these artists are therefore replete from the point of view of documentation, and reflect as well high credit upon their creator for the art quality that comes to the surface, proving that almost anyone can show degrees of taste apart from gifts of perception and it is not always a question of how professional the actual handling of the pigments may be, for it often happens that the worst bungler in point of technique produces a peculiar tactile value which produces pictorial quality for itself, and here is where the quality of invention comes in.

One of the pictures in the Newark Museum exhibit returns to my memory as being one of the most attractive in the present show, but it is not the Bark Ella entering the harbour of Montevideo herself that most excites my preference, it is the painting of the city of Montevideo over beyond her stern that most engages my attention, that comes to me as one of the prettiest pieces of amateur painting that I have seen in a long time. What a radiant sense of a populated city it gives, this little stretch of several inches to the right of the canvas. It is evident that A. Stanwood the artist of this picture knew his ship, that he had painted ships before and that he was accustomed to a kind of repetitive similarity in his treatment of them, but the landscape behind the ship was far more of an original problem for

him, and the inventive charm that is disclosed in the landscape aspects of the picture give him the right to admiration and special praise, and there is no doubt that he was unquestionably in love with the city beyond the waves, proven by an almost sensual desire to give to it all of his expressive enthusiasm.

Then there is the delightful picture of the locomotive "Briar Cliff," apparently dressed in her Sunday best, about to start out for a tour of exhibition. Certainly no locomotive was ever more engagingly caparisoned in her naturally florid era, no machine, however primitive was ever made to seem more like a grand lady of society with her red and yellow stripings, and a bouquet of roses very preciously painted upon her steam tank.

From these one may turn to the very sinister but very distinguished picture of Mt. Vernon, artist unknown, whose feeling for the dramatic intensity of monochrome is nothing less than remarkable. From these pictures one turns to another remarkable little piece of painting, a fine piece of documentation, the exceptional landscape of Leadville, Colorado, signed "Harriet Harris—1880." Obviously the work of a "lady" this picture is feminine throughout in its concept and treatment, and gives the impression that this lady artist was not without her experience in painting on china, silk, satin, and velvet, but here again it is the documentation alone that gives this picture its right to be respected. It gives an unquestionable sense of the southwestern species of geological formation and reveals a very different quality of representation from all other pictures in the [exhibition, and] exhibits more advanced understanding of the qualities of tone and the true characteristics of nature, and stands, from a personal point of view, as the most accomplished visualization of document in the show. Colorado on a seashell if you like, is the quality of this picture, imbued with nacreous subtleties and a clear sense of the sharpness of light which is typical of that southwestern country.

Mr. Joseph Pickett—storekeeper, will change your mind entirely as to what a picture may be, for here is little or no documentation at all, or at least it was not the copying of a scene but the invention of the scene, not the physical fact but the element of historical fantasy that moved this amateur to expression. Mr. Pickett is pleased to portray which he calls "Coryell's Ferry—1776, New Hope, Pa." The attraction of this picture is not its subject matter, but the very

unusual manner in which bodies and textures are expressed. He goes in for the deep flowing of the river, the abrupt eruption of the water as it comes in contact with the rocks which impede its flow, he builds out the body of the torrential waves as they come against the rocks, and likewise builds out the rocks to a considerable degree of relief to give the static implacability of rock, and the turmoil of the water that rushes upon it. He analyzes his simple elements in a very inventive fashion, his houses stand, his trees sway, his rocks are firm in their foundations, his waters rush and recede, tumble and pass on their turbulent way.

And the surprise of this picture comes in the mannerism employed in the representation of animal life, these images being built out from the canvas to the height of a full eighth of an inch, and give in a very peculiar manner the quality and bulk of these beings in relation to the other images that invest the scene with a peculiarly inventive charm and distinction, and yet when the idea is complete you have a highly decorative design which depends much more upon romantic interpretation of historical fact than upon naturalistic veracity.

And so it is, you pass from one picture to another, and you are impressed more by the passion to express what these primitives understand by the word "beauty" than by any other intention that art may apply, and as is nearly always the case with amateurs, an exhilarating lack of affectation impresses the eye, and comforts the mind agreeably. None of these artists assumed anything but the desire to register in terms of the given medium a peculiar pleasure derived from nature, no one of them is trying to prove an esthetic case, and herein lies the very special pleasure of these primitive paintings.

As for the Americanism that exists in them, that takes care of itself. These pictures could have been done by no one else, for nothing exists in them but specialized, American sensitivity. The quality that makes Copley, Audubon, Earl and the other Americans what they are to us, is the same quality that tempers all these primitive pictures, they are essentially cool, restrained and brittle, and they are happily devoid of extraneous showmanship.

# John Kane of Pittsburgh

*(c.1935)*

The pictures of John Kane of Pittsburgh seen in a body at the Valentine Gallery last season in the nature of a memorial show come with a sense of timeliness, joining in the rush towards nationalism in American art.

Kane was an amateur, jack-of-all-trades, for amateurs often take the curse off professional painting by their unaffected simplicity and refresh the eye again from much of the pedestrian exuberance of the average show from week to week. Kane was an amateur out and out, these pictures have no pretense about them save the love of the city which is depicted here, in which he lived apparently most of his life, and knew in the local sense as one knows an old fashioned book on the parlour table. Kane was every kind of a workman according to report, of Scotch ancestry, and you certainly get the sense of the heath in his colour which is probably more natural to that heath than it is to Pittsburgh, for the Scotch are tenacious when it comes to atavistic values, and so are many other races.

With pride he tells you that he knew all about the making of a house before he built it, he knew all about bricks, mortar, and stone for he had worked for years with them. There is the sense of workman's caress in all of his details, the pictures being built up mainly of details which is the natural manner of the amateur. He loved everything about his scene, he loved his engines, his railroad ties, handled them with a workman's devotion, and you need not be bothered by the fact that the whole process of picture making with this painter was likewise workmanish.

Do we like the Kane pictures because the force of concept or of intellectual affectation is absent from them, do we like them for the sense of dreamy absorption that is in them, because of the childish faith that beauty is the substance of the thing we believe in?

Kane was in a sense something like the same kind of a man that Rousseau the douanier was, though of course he was not nearly as childish, for he had coped with the practical world and was

sophisticated in its ways, and he was not by any means the same kind of a good painter, for Rousseau had that quality which is unmistakable as belonging to the true artist. He [Kane] would however figure well with the "peintres de Dimanche" and of course look like a classic among them. But [there was] the sweep of imagination in Rousseau because first of all [he] believed in magic, and as a young man he had been sent out to the tropics, and that would set the eye and mind of any native to whirling about like a top on its own axis for where Rousseau saw tigers and monkeys and huge terrifying flowers and leaves, Kane saw nothing but the bricks and mortar of Pittsburgh, and never step[ped] out from among the facts long enough to conjure up images of anything else. He was a man and saw practical shapes and practical values, and he does not put over the magic of his experience as Rousseau [does], for Rousseau was, to the end of his life a case of arrested development psychologically speaking, which was the quality that made his pictures contain that dream element, that looking for mysteries under the leaves and strange thoughts to fly out from the lips of flowers.

It didn't take long for the esthetic sophisticates of Paris to swoop down on Rousseau's pictures, because all the painters sensed at once that here was a real one, and we have the story of how Picasso saw the tall portrait of Mme. Rousseau standing in a garden, a kitten among the pansies playing at her feet, a very superior piece of painting indeed, and paid the laughable sum of five francs for it, in a second hand shop.

The value of Kane lies in the fact that he senses there was something more to life than just laying bricks and mortar, and some spirit of the past must have been gnawing at his vitals to switch him over into the field of higher expression, for he emerged eventually in his way, a full fledged artist, and by the integrity of his vision learned to fall in love with what he saw—made marriage with the element and became a faithful and devoted lover.

He is perhaps not as true to his vision as Rousseau was, that is to say, he was not ingrained as Rousseau was in the nature of his experience, he was not the lyricist that the douanier was, and he was not worshipping his native earth in the same way, no one perhaps does that as much as a Frenchman, for a Frenchman always thinks of France as the universe, else how could he keep his sensations as pure as he does.

It is all a matter of tempo, naturally, and if Kane was a bit heavy in his exuberance, he was nevertheless an exuberant nature, and had the simple thought of glorifying Pittsburgh because he thought he loved it more than anyone else, and probably he did.

Would that we find the same sort of Pittsburgh in the Pittsburgh that Kane saw—probably not, for it is by nature a city of tragedy in the human sense for when you see the clouds and coils of smoke rising above the city you see the tired souls of men writhing round in it, as is the case with all industrial cities. Pittsburgh itself is an overwhelming thing, but in Kane it is not so overwhelming as it is a sort of kindly gentle place, and this is undoubtedly the way Kane thought of it.

The rows and rows of workmen's houses that squat on a hillside above the river and the railroad tracks are probably not as tranquil as Kane makes them, they would be likely to have something more than the appearance of so many seeds sewn in rows. The thing itself would not give us the hooked rug appearance that these pictures do, but the thing that makes Kane pictorial in his emotions is that he did not go about hunting for something else, he did not run to the Africas of novelty, he stayed right at home, and let his sentiments run loose among the plain things of daily life, and fitted himself into enthusiasm over all the things that nobody else could care about, because they had not the emotion to care about them.

That he loved Pittsburgh is evident in all of his pictures, yet somehow I for myself would always be wanting the real picture of Pittsburgh because it would have more power in it, and a certain kind of dramatic grandeur which the Kane pictures do not have. They never get quite down to the bed rock fierceness of the place, so that the vitality there is in Kane's pictures is not so much the natural vitality of place, the vitality of saturation and information, as it is the plain man's love of the things among which he toiled.

He sees the brick before the wall, the tie before the rail, the funnel before the engine. You don't get the passion that Utrillo gave to his walls before he emerged from his tragic period and became a mechanical painter of churches without feeling for the meaning of the church, for in the early days Utrillo was a miserable man, and he poured his misery into his paint, which gives it the peculiar quality of dripping tears that it has. But there you have it, a vastly different temperament altogether, and Kane was too regular-minded for that.

There is a snow picture that takes the eye, and an evening picture with a peculiar sun going down over a singularly personal field of grain, in which is produced that specialized sense of silence which attends so many plain aspects of nature, [of] acquiescence rather than of persistence in the going of the day.

A touch of the excitable or the rhapsodic in Kane would have added a little more snap to these pictures, a touch of disillusionment even, a little more of the sense of persistent grandeur out and out, but—as Kane was a Scotsman the quality of restraint was more natural to him.

He did not, curiously enough, care about his skies very much, for they are all alike, they couldn't possibly have been true to the nature of that place in exactly the same way, and is Pittsburgh ever at any time free from the murk of forging commercialism? I doubt it. There is no drama of smoke and flaming metal in Kane's pictures almost as if Pittsburgh had never heard of these things, no struggle of any sort, which gives the pictures of Kane in a way a kind of unreality. His interest seemed to stop at the horizon and so his skies all go the same way, like flocks of sheep to their aerial destination.

For all that you may enjoy the Kane pictures for not being arrogantly professional, thank him almost, for not knowing what the dogmatic sense of art is, and even with whatever lack of dynamic effects, we get better pictures of Pittsburgh than the profession has ever given us.

There is perhaps such a thing as too much normality in the vision of some people, and perhaps a little wildness in Kane's nature might have helped his pictures, and given them a little more flip, a little more excitement for the imagination, but take him as you find him, and you will find him all right, no bluff, no assumption, and no cheap plagiarism, and of that there is always enough in current exhibitions.

# Is There an American Art?

*(c. 1938)*

Borrowing the caption from a well known writer on art[1]—the question is apt and provocative of serious consideration. If the propagandists of the idea were less earnest than they are, we should think them purveyors of the artifact.

What is true however, and there is no mistake in this—there is almost a kind of melancholy attached to the chauvinism of certain painters of today and in the attitude of their defenders as well.

Not so long ago we heard much of regional painting and were surprised to find that the middle west was the great new area from which American art is to spring. A relative of mine by marriage who comes from the western areas, Kansas possibly, spoke so eloquently to me one day on the emotional exaltation she experiences looking at a vast acreage of corn.

It was a new symbol to me of glory, and I began to see the vast sea of cornstalks waving gently in the breeze and I felt certain I could understand her, since I could picture for myself a synthesized image in vegetable form of the waves of localized ocean here on the coast of my own Maine.

I have a love for trees, naturally—and [am] so localized in my emotion in this respect that I am not completely stirred in these ways until I come upon a pine, a spruce, or a fir. I can well believe that harvest time in the corn belt is something well worth seeing as a native natural spectacle, but I am more locally moved when a load of tall timbers is passing by on a truck, or a boatload of cod or haddock or mackerel is being unloaded in front of me, or I am equally moved when I see huge blocks of native granite lying around and receive a thrill when I know that a number of sixty foot columns of granite were excavated from the beautiful Maine Island of Vinal Haven which is a mass of solid granite as many of the islands are. It is really

---

[1] Stuart Davis in a letter of reply to Henry McBride, "Is There an American Art?" *Creative Art* (New York), VI, 2, Supp. (February 1930), 34-35.

what keeps them standing where they are, taking the brutal pressure of the high seas.

When we come to the art side of things, this brings in quite another case. The western chauvinists have shut their eyes to the polyglot aspects of art east of Chicago and with probably a fair degree of reason, since art in New York alone is distinctly a Europeanized affair, since the painters themselves are offshoots of recent strains, but that doesn't prevent them from being respected as American artists in whatever degree their Americanism is expressed.

We have the case of William Saroyan in literature who is certainly a perfect example of the fusion of one blood into another, or rather of one temper into another since his Americanism is so apparent above his racial heritage as to make him the vital force that he is. Mr. Saroyan is not troubled about his Americanism as an American value. He is naturally proud of it. He would never dream himself or permit anyone else to speak of him as an international artist.

It is quite plausible that Mr. Grant Wood realized the strength of his ideas as he was milking cows back home while he was sitting on the terrace of the Dôme in Paris. Such terraces will prove to anyone how unrelated he is to what is around him. So much for the candour and the piety of Mr. Wood's spirit.

We would not be fair to Mr. Wood or ourselves if we did not realize that he got something or other from the international sense of things, for when he returned to his native scene he proceeded to invent his local type, but it is not evident that he has invented a technique that fits it.

Anyone can project himself with half an imagination into any space, and since all that western country is vast, open, and supposedly free in spirit, there should be a convincing energy coming forth out of Mr. Wood's paintings which to many who are perfectly sincere, is not there. There is a much more related vitality and relation to the local scene in the painting and drawings of John Curry, but he too learned something from his European sojourns. We have the spectacular and amazing technical gift of Mr. Benton, for he is true muralist and one of the very few American muralists who knows what it is, but irrespective of the utterly illustrative aspect of his work, anyone can find that he has looked well and long at Rubens and Greco to name only two great European artists. We

have heard that Kansas, his native state, objects violently to his local portrayals, and that should count for something, for the best comment a painter can have on his painting will come from the people themselves of whatever locality, and I speak for myself a moment, [for] when a local type comes to see my Maine pictures and is convinced of their local veracity, I am not concerned as to just how great the art aspect is, for I myself am made of local granite and have been over the whole space of my life.

It is unthinkable that a native of any one spot can so change his hues, chamelion-wise as to disguise the raw bone of his basic nature.

In the case of Ingres the great French draughtsman, and in nearly all cases not only an un-French painter but a bad one, he spent his entire life—that is esthetic life—in Rome worshipping the superficial aspects of Raphael, and the long array of dull drawings in the museum at Montauban prove how stupid it is to try to be anything but what one is, and yet I presume the French themselves could in five minutes deliver an oration on the utter Frenchiness of Ingres' art. We might even go further and ask to have proven the Spanishness of Picasso which must be in his paintings but no one but a Spaniard could detect it, for he entered the world of art via the French portal, and out of what portal he expects to effect his exist, at the present rate, no one but himself can be aware.

Who would waste time thinking of the Italianism of Leonardo? He didn't have time to be local and he would have laughed at the idea—in fact he had a dreadful time in the society of his day, proving his right to recognition as a functioning member of society at all, and was shunned and despised—chiefly because he knew too much to be merely Italian.

Art itself is without a country in the strict sense. It is only localized when the artist has arisen in whatever locality, proving his unquestionable localism.

Discussions of an irrelevant nature, and critical dismissals in certain ultra-exclusive instances make no difference to a real artist who is grinding no local axe—in the esthetic sense. All this cry and hue from the middle west seems irrelevant and trivial really, and after all what writer would be fool enough to localize his emotions to such an extent that he would refuse to read Shakespeare or Homer or Plato because it might injure his localism.

It can make no difference to American art itself, if there is such a

thing, that the advertising megaphone has been shifted to the corn belt—it merely helps to stimulate escape from some complex which is entirely unwarranted one way or the other.

Outside of occasional excursions into the field of prevailing esthetics, I have done nothing else but prove my own specific localism which has been to paint my own native Maine and I do nothing else at the present moment and never expect to do anything else, and I am completely recognized as an authentic painter of Maine born in Maine, but this recognition comes I am happy to say from the state itself and the native spirit which recognizes the authenticity of my private and local emotion.

And for exactly this reason and no other I returned to my tall timbers and my granite cliffs—because in them rests the kind of integrity I believe in and from which source I draw my private strength both spiritually and esthetically.

For anyone to deny this would be like saying that Lillian Nordica and Emma Eames had lost their sacred localism because they became great exponents of European opera, or that Edwin Arlington Robinson lost his terrific Maine Yankeeism because he employed the principles of Greek tragedy.

Political interest has no place in art, and it is not in the strict sense dignified to blow trumpets that are not pure brass or silver in favour of aspects which in themselves are debatable.

The one thing that Oscar Wilde ever said that interests me is this, "We Irish are too poetic to be poets, but we are the greatest talkers since the Greeks," and it is positively comic the way this remark can be applied all along the line—too artistic to be artists, too actorish to be actors—too esthetic to be lovers of art—or too talkative to be completely eloquent.

There is no use "getting mad" at the ultra-Americans, because it is defeating the main purpose to shore chauvinism up among the pint house towers. I have been embarrassed twice in my life on the subject of Americanism—both times by Europeans who told me with almost tears in their eyes, how wonderful my America is. One forgives such ludicrous behavior because it is childish. I have not the advantage of Mayflower descendency, but the rest is good enough to travel on. There are no false notes in my private Americanism.

I have the peculiar experience of being debarred as a painter from the most significant museum in America on esthetic grounds because

my pictures do not "suit the present taste of the museum," and yet
the walls are covered with the hybrid element. Socially speaking I
am not compromised. I am merely debarred from participating in
funds bequeathed especially for Americans, by a peculiar dissipa-
tion of taste and decorum.

John Sloan is right, an American picture is a picture done by an
American in America. If that element is strictly there, theoretical
vagaries will do little harm.

So all there is to say is, more power to the Cornbelt. Doubtless
others will come along who will come as close or closer even to the
majesty of the idea. Doesn't it seem then for the moment, that the
much tabooed ivory tower, which is a purely pictorial affair has now
become a silo in the west?

There is this about the Craven-Boswell and whomever else art
propaganda. It takes art into thousands of homes, and as many more
thousands of occupants will learn quite comfortably that art is not
only a pleasant matter, but a natural function. So that we can hear all
over again with much more comfort, "I don't know anything about
art. I only know what I like."

The art sense has already begun to ramify in singular ways, for an
acquaintance of mine tells this amazingly fresh anecdote. He being
of Polish descent, made the acquaintance of some Polish-American
military men in Kansas City. After drinks, and the end of conversa-
tional refurbishment, a house of pleasure was suggested—an expen-
sive one. During the preliminaries in the parlor of the establishment,
one of the professional inmates discussed the relative merits of
Cézanne, Renoir, and Van Gogh. What that had to do with the rest
of the idea, heaven only knows, but even there art took the curse off
life, for at least one person, and as is well known prostitutes are often
ladies—and ladies of intelligence.

The simple truth is that the creative spirit is at home wherever that
spirit finds breath to draw. It is neither national or international. If
the knowledge of life is to be bounded by forty-eight states, that too
is another matter—and is of course informing.

No one need be victim of place, for any place is all there is—it
being the world where all life lives, and no American, not any real
one, can be anything but American no matter where he is.

# On the Persistence of the Imagination
## The Painting of Milton Avery,
## American Imaginative

*(1938)*

The recent large exhibition of the paintings of Milton Avery at the Valentine Gallery, perhaps the most provocative show of the nineteen-thirty-eight season since it was violently yes or no for this man, is a singular proof at this stage of the development of art in this country that the imagination when it is fixed for believing what it sees, cannot be deranged, modified, or annihilated.

Avery is an upstate New Yorker who until painting became his irrepressible ambition, was earning his daily bread in a rubber tire factory.

I doubt very much that Avery will accept the notion, or even be interested in it, that his two great esthetic forebears are James Ensor and Edvard Munch, but to my findings this proves to be so for me, but perhaps for me only.

Every artist is some sort of a relative of some other artist because it is only in the expansive field of art that such relatives are to be found. Corbino finds his driving force in Rubens and Delacroix, and John Koch finds his in Rubens, Fragonard, Boucher and Renoir—who is after all an eighteenth-century descendant, bringing over that spirit into the nineteenth century, and by joining impressionism to it, brings forth a new and vital product.

Avery, because of his temperament, and outlook on life which are of the brooding sort, will find it reasonable that he should stem from the artists I have named, only because he is more like them than any other artist I can think of. Avery is not an intellectual eclectic, but in the true sense an imaginative and a romantic one, and if he has no theories and he certainly hasn't, all he knows and goes by is his well defined feeling that two things are essential to a good picture—a sense of one's own experience, and the love of painting for its own sake.

Both Ensor and Munch were interested first of all in the arrestation of mood and if Ensor derives his emotion from a mixture of English and Belgian blood and by long residence in Belgium [and] is

classed as a Belgian painter, Munch is less mixed or not at all since he is, it is safe to say, completely Norwegian. If he at times is rather hyper-sonorous owing to his passion for the impressionists, his inner native mood is pre-eminently sombre and the outcome of an interior fiord supremacy.

I have never myself felt that Munch was a great painter, first of all because he permits himself to mix his technical metaphors by painting in oil with a water colour method, which is particularly in his case an abuse of the medium and by the excessive use of turpentine creating in the end a wash, instead of passages full of body. No such passages of rich body are to be found in Munch as are found in Rembrandt and Goya who are great among painters because—ranking with Titian, Giorgione and some others—to them depth of tone was inviolably implied in the nature of the depth of experience.

There is never depth of tone in Munch unless it be in his earlier paintings which from the reproductions seem to incline that way, but Munch has a curious gift for what may be called the pause or the spaces between movements of colour, which was one of Cézanne's greatest gifts. Cézanne was so often if not always ending pictures at the half way point, because he never got around to finishing them because the perversity of his temper interfered, but the quality that comes out in his unfinished pictures is a unique one, that no matter where he left off, the design is always locked, and nowhere is this more marked than in [his] water colour drawings.

Munch too had a marked feeling for the pause or for the vacant space, as Ensor had a marked feeling for the reality of fantasy, and if Ensor is lacking in this sense of locked design, he is never lacking in the life of the fantasy in ideas. Munch was, one may say, basically a tragedian, whereas Ensor was distinctly and primarily a comedian, and because his sense of comedy was founded acutely on the relation of tragedy to the facts of life as sensed by the mind through the emotions, he was much more poignant in his feeling for fantasy because he was a natural sentimentalist and believed in the spirit of laughter, hovering always closely to the meaning of tears. Munch never does, for the Ibsen touch comes to the surface from his choked sense of reality.

The image of the clown was a deeply moving one to Ensor, and as we all know clowns are among the most intellectually profound

often, as witness the case of Charlie Chaplin—they know, these clowns, that laughter is a fragile release only from monotone and from pain. You find this everywhere in Ensor, not merely because he employs the comic mask so much, but because the mask is the natural escape from misery, and as a figure in experience is as old as life.

How these two qualities come to be found in Avery is one of the engaging mysteries, but it is probably a very simple affair, a mere case of atavism, or a crossing of esthetic purpose at some given instance in the awakening consciousness, and we have as a result a singularly different type of American imaginative painting with a faint trace of Poe and Hawthorne in the substance of his response.

Avery is never bitter, he is never the over-wrought ironist, because I suspect life for Avery is a very simple affair. It is what it is for the artist, and when he realizes he is caught within the web of his own childish dreams, he learns that he is inevitably his own sort of poor fish, and that there is nothing to do but follow the "inscape" of it, for this word, employed by the distinguished poet Gerard Manley Hopkins, is defined as the desire to give the result of the experience and not the experience for itself, necessarily.

Avery experiences all sorts of obvious and common things, [and] sometimes his choice of [subject] matter is conventional, but his true imaginative gifts make these obvious and common things seem different, and they of course are because they have "become" so.

It is of no special consequence that the people in the room where Avery is are like himself, unaffected and forthrightly physical. It is what they have done to him that takes his eye because he does not know what they are, it is what they have become, what this number of people and things are doing to each other that becomes the picture which Avery wishes to express.

If there were a trace of superficiality or charlatanry in Avery, and there is not, we should have seen just that many more miles of pictures looking like the rest that run their course in the gallery exhibitions, the voltage of truly outstanding personal reaction being [so] amazingly small that after a month or two of labour, one can easily lump them all together and sign them by some hyphenated name, if not a separate one, and it is easy to suspect that a great many painters are essentially exhibition painters and get ready for their exhibitions over the summer in a perfunctory and casual manner,

frequenting the colonies of the sea, in the valleys, among the mountains, and on the prairies. One knows where they were physically by the kind of subject matter employed, but when they came via the imagination it was not so easy to make them out, because neither the eye [n]or the selective sense was at work. All the spectator of a picture wants to know is, what is the driving force, fact or fancy, [and] the only thing expected is that proof be furnished that either of these forces have been properly employed.

A painter may be on the side of the angels like Leon Hartl for example, who is a contemporary of Avery, though a few years older, and was showing his spiritual wares at the Brummer Gallery at the same moment. Here are two of the outstanding imaginative painters of the day, the one a pious lyricist, the other a comic, but a comic in the devout sense.

These new men painters will have a time of it getting recognition outside the corridors of art, and few of us feel the importance of the output of such men as these. Both these men are "project" men[1] [and] because they cannot earn a red cent any other way, they turn in their fine pictures every five weeks and the only thing that can be hoped for is that these pictures find their way into small galleries or even schools where no pupil need be ashamed to look because the quality is right in both these painters, and they will find true art staring them in the face. It is the art of the humble spirit in both cases and because life is something over and above the moments, fads and clichés of the day, fashions and modes, and every exhibition is full of this, these men are both willing to face the peril of believing that facts are in themselves nothing, but that what is felt, seen and created from this seeing and feeling is of paramount importance.

Our finest artist in the imaginative field, Albert P. Ryder, is the supreme example of this idea, for he during his sojourn with Daniel Cottier who was his ardent admirer and believer, venturing even as far as Morocco to my surprise, was the one in all painting of any country or school to prove himself the greatest painter of the tragedy and power of the sea, as Segantini was to prove himself master of the mountain. All this is "purism" of course and there is great mumble

---

[1]Hartley refers here to WPA "projects" during these depression years, when artists (himself included for a short period) were allotted a monthly stipend in exchange for so many paintings.

and cry at all this in both the fields of painting and of poetry, cry against the Mallarméan notion that poetry is "something else," meaning of course that the effect of the thing upon the consciousness is of more importance than the thing, and if this principle had not been believed in, we would not now have Rimbaud, Verlaine, Debussy, Valéry and whatever others there are who believed that the effect of the thing is more important than the thing. It is a notorious fact that the average painter is a bad photographer, and does not swing to the other end of the scale with any assurance either. We wouldn't have the delicate imagination of a Redon, flaming with glamorous fervors, or the gentle whispers of a Corot, we wouldn't have had our Ryder, Poe, Fuller, or Martin, all of whom were great imaginatives of our own personally racial kind.

It doesn't matter on what kind of ship a man goes to sea if he knows his ship and how to sail it, and if the imaginative quality is all, as Blake ardently says it is, [then] in these days of steel and streamline mechanization, one likes to believe that there are everywhere waiting to come to light, humble and true spirits such as those of Hartl and Avery.

Avery is a kind of musician in his own right, that is, he has a male voice of low register corresponding to the woodwinds, and by this I mean that his color scale is low and seldom rises above a heightened monochrome, but this is as you must have remarked the keynote of the greatest painting that has been done, from drawings of the cave men who ground their own colors from the earth which was composed of iron, ochre and coal substances, on to those master-pieces of monochrome synthesis, the Coptic embroideries, on up to Rembrandt who was of course first and last a monochromist.

Monochrome is on the whole more livable and great painters have understood this, and we see how perfectly the great masters understood how to swell their crescendos out of dark surround-ings.

Departing from black and white, rising in the scale to the umbers, the siennas, the ochres and a blue, you already have a sonorous gamut, with a chromatic vibrancy all its own. It has this defect—unless employed by a vibrant nature whose tendency is to "sing" like Zurbarán, it becomes stamped with the melancholy mood and we do not have to agree with Poe on this subject at all.

Avery will not be popular and no one knows this better than

himself and some of us others who for some reason or other out of all keeping [with] prevailing modes, believe that there is such a thing as painting for its own sake. There never seems to be a time when a principle is not in need of defense, and I am that definite about good painting that I never care what the subject is if the means by which it is expressed [are] eloquent, and true painters combine both.

The Averys and the Hartls will have little chance in the present scheme of things as they have already well learned. Since they are not painters of esthetic fashions, they are not propagandists save for the natural decency of the human spirit regardless of outer stress.

There is such a thing as being theatric about an emotion or a thought, but all that can be said is, if these aspects are all that can be felt in the presence of nature which is after all the greatest machine known to mankind which functions with such perfection as to leave the puny human mind in the lurch, all that can be said is that if the artist is to be effective at all, he shall at least trust the appearances and the forces of nature as something to start with for his major emoting. There is no quarrel with anything or anyone in the art world save perhaps the quarrel that must rise when art is not as good as it may seem to look, and there is a great deal of this.

Avery is not a great observer in the sense that Daumier and Lautrec were, and there is a faint flicker of resemblance in all of the ideas that Avery employs, because and only because this is the language of the comic spirit. Avery is not caustic, which is perhaps a defect since his subject matter is always within the range of the cynic comedian, but Avery is a simple human being without the slightest pretension, and in this simplicity reminds me of Marguerite Audoux, Alain Fournier, Jens Peter Jakobsen and Louis Hémon of Canada.[1] He feels a strange magic in the sudden appearance of things, knowing that things may become something else before one's very eyes and that something else is just as true to the things as what they were before the something happened.

Avery has I think gained a victory of late in the disposition of his vacant spaces, since they seem to be more in place than they were, and they do not have the vacuous look of things that do not function. He prefers to state his case in the simplest terms possible, he has something like the same sense for the comedy that emanates from the

---

[1]Authors Hartley was reading in the late 1930s.

interplay of qualities upon each other in life itself, and he also feels that no matter how droll the situation is, it also has its solider side.

Avery is not in the same class with Rouault as a dramatist of the comic spirit because he is in no sense a savage in this respect, and so it is not at all likely that the demand for the paintings of Milton Avery will ever be large or that he will draw to him great audiences, but he has a real one already, for he is not easy to forget or dismiss. He provokes interest for or against at all times and that is one sign of aliveness. It is by no means those painters who find favour among the flatulent critics who are the important ones, for they have their fashions too, but that need make no difference to those few for whom the critics have few or no words at all.

Milton Avery is worth thinking about chiefly because he represents that strange element that lives a life of its own regardless of the tempers and the fads of the day, of intellectual or political obsessions, for after all—the romantic imagination is as alive to the facts of the hour as the realistic notion is, it merely finds its interest in the over and aboveness of common experience.

It is interesting to dwell upon the work of men like Leon Hartl, Milton Avery and John Koch, who believe that the romantic spirit is as alive as it ever was, and that it is coming into its own again, and that regionalism is for obvious reasons but a localized aspect.

These men are all good painters because they believe first of all that painting itself is something to be keen about, this being due to natural causes because they are true artists by nature.

# Salutations for the Pictures of Leon Hartl

*(1938)*

To understand them one must have found the kind of innocence in the moment of observation to live like them as one looks at them. Are they not the infants of mercy in a steelbound condition where custom prescribed by innocence makes us shiver toward each other, calling it emotion, calling it even affection, when we have no area in our conflicted moment to find the way to such simple and noble gratuities.

Flowers that no one will have the time to look at because, well, flowers are flowers and therefore trivial, and the fruits of the fragrant afternoon melting to strange glamours of an approaching evening sun, ere twilight takes them up to a place which is no-voiced.

Must we suffer the hard walls of our once delicate decisions to crumble and fall about our bruised feet like flakes of lava from a burned out mountain—only the curved petals of perfected images floating before our eyes as moth-wing dust settles on toads' ears in a soft break of evening?

O these tender little Stations of the Cross made of hardly anything else than sprays of single roses enveloped in dew—gentle nosegays of the lily of the valley—hardly much to make singing pictures of and yet they sing, and who will tell the exact pain of the bone struggling to keep its white strength—to keep a false curtain from covering up in a kind of broken shame, the bliss of such sacredly guarded inventions.

We live here with our imagination—said Hartl to me speaking of the pretty spotless white room.

Songs to the moments that once were known for their fresh beauty. Is there a voice in this steel-bound condition of ourselves doomed to represent a country called the human world? Is there a voice that shall raise them like ikons above the pressed and pushed contention of our fooled beliefs?

I cannot help but love these little morning songs, for they give me better things than I can find over the edges of them.

208

How they have lived in a world like this—ask only the morning and the evening.

# Gauguin—for the Last Time

*(c. 1937)*

We have our visual prejudices as well as our mental and spiritual ones, and there are two art celebrities, who make me uncomfortable every time I am confronted with the idea of them—one is D. H. Lawrence—and the other is Paul Gauguin though by no means for the same reasons.

In order to try once again to see if I could overcome my prejudices in this matter of Gauguin, I read the book of Gauguin's son[1] for I had hoped that there might be in this book something that would change my mind, but I found none.

"Perhaps after all I am only painting pastiche"—which being Gauguin's own remark—sums him up for me as the epitome of all that is distasteful and in the end esthetically reprehensible to me.

It is always awful to me when men give up lucrative positions for the sake of art, and I know several cases of this sort. I suppose if I had not proceeded along on a certain line and achieved a kind of smug placing in the profession I had chosen I might feel different, but here is the case where a man runs off and leaves a perfectly respectable

---

[1]Pola Gauguin, *My Father Paul Gauguin*, trans. from Norwegian by Arthur G. Chater (New York: A. A. Knopf, 1937).

woman with a houseful of children to dig for herself, in order that he might be free and escape the burdens of civilization.

Gauguin was unquestionably blind to all this exactitude of vision—and the pity is that he never once rose to the magnitude of his own concepts which were large enough but which without the requisite sensitivity fell, like the cake in the oven which was too full of ingredients or failed of the requisite degree of heat.

Ice will as we know burn anyone's hand to definite pain, but there is none of that flame ever in Gauguin. A malady of the spirit deprived him from reaching the kind of religiosity he thought he felt for nature and for art—he was off key in his sense of the cosmos—he was flat where a little sharpness might have helped his tone.

He acquired, or so it seems to me, little else than a definite kind of softness which so often happens when persons utterly unfitted attempt to imbibe orientalisms of emotion when they are by nature completely incapable. Gauguin was a wanderer in a foreign field— he was decadent by nature when he should have been quite the reverse for the thing he wanted to do. His physical largesse did him out of his high placed purposes—he was by nature an indulgent indolent, and as a result a kind of transposed fatty degeneration of esthetic tissues engulfed him.

It is almost as if he had used the needle or the pipe without achieving any of the expected and desired results—he acquired no vision—only a complete laziness of the senses. It is a peculiar position to be in when one can't like the pictures of men who mean to be completely sincere and I think in all truth Gauguin meant to be that—his defects were not basically true even, as they were in Van Gogh whose spirit calls for nothing but admiration and whose painting leaves me in the ditch because I cannot help but like good painting—the case being however different since Van Gogh was tragically oppressed, and if he had been allowed the natural degrees of sanity requisite for true expression he might have become one of the great painters. It isn't enough to be merely a showman, and Gauguin was a showman par excellence.

It is not the way to begin to be great—one can dig in the field like Millet, one can steal potatoes from other people's fields because one's children are hungry, as is said of that always rewarding painter Sisley. One stays with one's problems it seems to me, but that comes into the field of esthetics and morals and that is somewhat beside the

point here, though I think it does help to bring about the note of falsity that runs through the bulk of this man's work.

If I wanted a fine example of the opposite of Gauguin I would seize at once upon Rouault who has all the qualities of greatness and none of the small aspects, whereas Gauguin completes for me the image of the opposite. Cézanne's judgment of Gauguin is by no means a wrong one, even though it has the element of hatred and jealousy in it—"O Gauguin, he is nothing but a flea on my back—he paints nothing but Chinese images," which is exactly true, save that compromising the Chinese is a little bit strong, for the Chinese have dignity where Gauguin has none.

If Gauguin had had the inviolable integrity of a painter like Van Gogh whose painting is not all in all attractive to me either, something perhaps really fine might have happened but alas, integrity was not to be his strong point.

Gauguin is not without some points in his favour, he had a sensibility for colour which never quite rose to the quality of knowledge—for which one goes to men like Delacroix—Renoir and Cézanne for exact and redeeming values. There are aspects of Gauguin's colour which at times make one think of vitrines if you like—he might have done good [display] windows. He might in all truth have done better murals than his easel pictures.

Gauguin is for me like an impressive piece of fruit of which one is never able to quite accept the pulp or the juice. There is an intermingling of alien acidity in his colour—it always seems to go bad in the wrong place, and as for his rambling design it reminds me of nothing more or less than casual excretion dropped in the shadow of a tree.

Ninety thousand dollars is a lot of money to pay for any modern picture, and we could have quite a number of really remarkable pictures for that amount of money—I even suspect it would buy several small Mantegna's and what a return that would be—pictures like the "Nativity" and the "Virgin and Child" in the Metropolitan Museum, which are the direct opposite and cold as ice, almost as cold as Crivelli was, whose flesh always seems about to crack open with a strange brilliant bitterness, [and] whose passion for ornamentation was almost sadistic since it all but terrorizes the eye—wherefore then the wasting of so much money upon a painter of pastiche?

Gauguin I feel however knew more about painting actually than Van Gogh did who seldom makes me feel that he knew as much as he should have known and for whom painting was a debaucherie, a disheartening salvation from the torture of his life which was as we know—a slowly creeping but forward pressing madness.

The quality of incandescence in Gauguin's colour never seems to really light up any of his ideas—it seems to recede into all but innocuous desuetude as one watches it—as one tries to pick up its pre-conceived and wished-for flow—it is like porcelain which didn't take the firing properly—it relies upon the accidents of chemicalization too much. Nature does some pretty smart performances in this line, as for instance in the case of Phoenician glass which derived its iridescence entirely from oxidation as it lay buried beneath the surface of things.

We look at certain of the butterflies such as "Urania Madagascarcensis"[1] where the colour refractions are exactly the same as in the glass spoken of above, which is of course no accident but prearranged and thoroughly conceived by those perplexing agencies which get us all in a dither so to speak as to just where this kind of exact knowledge comes from, as one refers again to the breasts of birds who live in strange ethers and are never seen below a certain altitude—the birds of paradise to be explicit—which are strange to say nearly all black or smokey brown in key, but from whose throats in love time float up breath-taking, flame-like refractory exuberances.

I am fishing around for similarities to help myself form a real basis for what Gauguin's colour might have been and which it fails to possess.

According to other painters who have lived in Pacific atmospheres, as for example the American John LaFarge, there is reason to believe that the light in those island countries is completely infiltrated with these higher irradiations, and there are moments in LaFarge when it seemed as if even he had achieved it, but there never seems to be a moment when this kind of knowledge comes off in the case of Gauguin.

It is certainly not what Gauguin saw that was at fault, but unmistakably what he was, for he suffered too from pretty much the

---

[1]As a young man Hartley made a detailed study of butterflies.

same complex as that otherwise fine artist in literature, D. H. Lawrence who was eternally attempting to displace the idea of Jehovah.

Real people do not have to swell their stomachs in order to seem bigger, and it has always seemed to me as if Gauguin was suffering from an exaggerated sense of obesity of the ego.

There is nothing absolute about Gauguin. What a deal of good it would have done him to take a Memling or even a Chardin for his clue, he needed very badly some of those aspects of myopia which made such delicate artists of certain men, Clouet and Corneille de Lyon for example, who were large in their concepts despite the miniature aspects of their observations.

# Georges Rouault

*(c. 1937)*

At the Pierre Matisse Gallery there is at the present moment a collection of paintings by a man who stands so much by himself away from all the prevailing esthetic chicaneries and legerdemain of his period that it is difficult to speak the exact truth, but emotional pressure would describe him as head and shoulders over all the others who have outdone him in popularity and commercial success, and only because it is their greater nature, and there is no denying that Rouault is superior to them all, by this very nature of his.

First of all he is blessed with two virtues either in or out of esthetics, namely, piety and humility. This remark alone of Rouault

to Georgette Passedoit who knew him well at a certain period—explain[s] the strength of his personality, "I shall not have the popularity of the others, but I shall thereby be left to myself." I am not sure these are the exact words but the substance of his meaning is contained in what I have put together from what Mlle. Passedoit told me.

I am indebted to the same lady for the most ingratiating [gratifying?] correction of a definite impression I had formed of Rouault solely from his works. I had almost "seen" him or so I thought, in his pictures—a smallish dark Frenchman with ice-cold cheeks and a hard porcelain forehead, with hands that might play with knives and a mind that might wield them without tremour—all of which is meant to say—a Baudelarian cynic of somber complexion and behavior, believing in nothing but the terrible thing called the moment because he had lived through it, and the promise of something better could be of no help because he had not encountered that shade of difference. Perhaps the fact that I knew him to be the appointed curator of the Gustave Moreau Museum at the rue de la Rochefoucauld in Paris, prejudiced me in favor of the dark physical image conjured up, to sort of go with the pictures.

The picture Mlle. Passedoit gives me of Rouault is vastly and engagingly the reverse—a blonde with blue eyes—a razor-like mind—an acutely friendly appreciation of human affairs and a warm curiosity about them—lover of conversation and even gossip, probably, when inspired—a thoroughly "open" and companionable person.

It is of course known by everyone who cares that Rouault's sense of pattern and colour are derived from his labours in the field of stained glass, by which means he has supported his wife and family of seven or eight children[1]—just as the sensuous appreciation of flesh and the nacreous sense of light and shadow in nature were derived by Renoir from his experience painting on china in the factories of Limoges.

Rouault is so much more impersonal in his gifts as painter that this alone would lift him above his utterly personal confreres like Matisse, Picasso, and Derain, who were and are first and last magnificent "showmen." They are aware of their own ramp every

---

[1]Actually, Rouault had four children.

minute and of the audience that is sure to flock to observe their "acting." They do their work "for" the public whereas Rouault, having no faculty for a public, worked for himself. Only today someone informed me, "Picasso is now painting flowers for Rosenberg, and the "for" is so typical of these great French merchants in art, the painters themselves, for they would cease doing what they are doing if these novelties or new lines of goods were not saleable.

The "flâneur" type of gallery visitor is now inclined to say that Rouault is not as impressive as he was, which is like saying not as good as he was, because the public such as it is for Rouault had decided for themselves that he is an essential tragedian and nothing else. I would transpose at least for myself this notion, and say that Rouault had come to terms with the world by rising above it and by this means had found peace which is another name for lyrical unity of spirit.

When a painter is as true as Rouault is, it is not necessary to think of him in terms of good and not so good, because what makes him fine is in every stroke he makes—even his single brush strokes, besides being of the nature of "vitrine" have a certainty of touch which is above emotion and lives in the realm of pure feeling, and this purity of feeling is the result of resignation to the fatal edicts of life which the artist often must encounter, that is the real artist to whom every waking moment is an encounter with the definite issues between negative and positive.

That Rouault is distinctly the pious type, though only himself could say how religious, is evident enough because he is rational enough to believe that the issue between life and nature must be fought through, and the battlefield for this experience is of course, the individual self.

I do not think it going too far to say that he has the intellectuality and the pious directness of painters like Masaccio and Piero della Francesca, who certainly were never concerned with modes and fashions, and they too, as we know, were not popular painters in their time because they were not typical voluptuaries.

I have recorded elsewhere[1] the remark of a Japanese scholar I met in the station at Arezzo after we had looked at the Pieros in the

---

[1] In "Orvieto and the Golden Wine" from the *Varied Patterns* MS (YCAL, Hartley/Berger Archive).

lingering afternoon light of winter, and though we did not know each other he apparently could not refrain from saying to me as we were waiting for the down train to Rome, "what do you think of the Piero women"—realizing only now what he said, "they are too brutal for the Japanese eye," and I even think now he used the word masculine in this regard, sex being without question for Piero in art at least, an extraneous matter, because it prevented thinking.

Sex plays little or no role in Rouault's paintings either, because male and female are to him ideas, and not merely material facts—he paints one with as much vigour and strength as the other because and solely because they are mediums by which ideas are expressed, and as such have no life of their own, being victims of reality itself.

Compared with the sensuality of Leonardo's feminine figures, Rouault is all but devoid of it, and yet by no means emasculated because he being a complete man couldn't be otherwise than rational in his sense of human predicament, and it would seem as if he feels that men and women have little chance to will anything of their own because they are being too intensely acted upon, which happens when men and women are really alive to all of everything.

The power to step aside and really see the drama is given only to the highest natures, and if Rouault has always seemed heretofore to be almost a cynic because his vision was so revolutionary, it seems as if now his vision had turned toward the light and to him conditions come into their own when possession has been relinquished.

There is an undeniable calm in these new pictures and if they are a bit graceful in colour as they seem to some, this colour merely lightens the burden of the forms under it. Rouault does not wear an esthetic monocle and that in itself is a relief. We form habits in our appreciation of the painters whom we reverence, and I suppose if I were to own a Rouault I would want to go back to the sinister ones because the drama of ideas is so intense in them and because I, having known Rouault's pictures for at least twenty years, have come to think of them as making all the other giants in art seem weak beside him.

If the peace of what seems like peace in the newer Rouault's exists, it certainly does not appear because it is advantageous in a material sense but because a kind of Buddhistic calm had come into the sphere of their maker, and that too would be an unquestionable reality. It may be because Rouault no longer questions that the new pictures

seem tranquil to some of us, but that is best understood by Rouault himself, but there is undeniably a "change of heart" in the movement and the colour of these new productions.

No matter what the conjecture, right or wrong, Rouault remains so far above the demonstrators of common esthetics that it comes as a relief to some of us to find such dignified aloofness in painting.

Walking alone is something of an achievement—perhaps the real solution. If so, Rouault has achieved this perfectly because his point of view being that the world and life are his persistent opponents, he faces them without reference to anyone else.

# Jacob Epstein's Adam

*(1940)*

As we who [have] know[n] Epstein over a long period of years are accustomed to the matter of sexual exhibitionism, no one need be surprised that this figure of purposed primitive eloquence goes to the extreme in the matter of phallic enormity, and [although some] might be disturbed by such shows, there was no sign of any disturbance in the room, which was visited in the quarter hour I was there, chiefly by women.

Aside from this phallic extravagance which is of course extremely animalistic without being in the least pornographic or profane, the figure is disturbing with its lack of true grandeur, and this seems to me to be its major defect. Many of us [are] accustomed by now to the stupendous force of the Aztec sculptures which I myself studied

every day for two months in Mexico City,[1] because the lesson in epic emotion to be drawn from these sculptures is of so profound a nature that one must not really miss it, even of course given our magic instances of this emotion in the profound chacmool and the still more stupendous Earth Mothers of enormous size, from which untold force emanates leaving the outside world more than a little weak in appearance in contrast when one has returned to it. Since ordinary mankind seldom bears the image of such greatness, one comes to Epstein's Adam prepared for great emotion, and I for one found little of it or not by any means as much as [has] been credited to it.

Epstein has first of all a terrific rival in this realm, for there are to be found in the Field Museum in Chicago[2] and no doubt in other museum collections I have not seen, the overwhelming sex idols of Polynesian peoples, where the two sexes are embodied in the one image and the breasts are equally as phallic as the phallus itself— with the mouth wide open in sex strain and the teeth grinding upon themselves, the eyes bulging out of their sockets, the whole embodiment of sex extasy as terrific as has probably ever been put into esthetic form.

Procreation is of course a common theme among the island savage peoples, and so you have the same idea in all of the African sculptures, since in nearly all cases there is the male and female idol to be worshipped. I am not at all informed in the archaeological sense as to just which tribe conceived this excessively tense sexual idol I have described, where both male and female sex forms are present in the same idol. Whether these idols are worshipped for the sake of inspiring procreation, in any event, there they are, and no modern artist no matter how liberated on such subjects, is able to present this sort of strength, because, merely, it is not in them, and the need is not the same, since religious notions are the nobler in the case of the savage peoples.

It is by no means the first time that Epstein has wished to bring this sort of thing into the modern picture, and he seems to have succeeded in England, of which he has for some time been a citizen—and the English public is accustomed to this sort of

---

[1]While there on a Guggenheim fellowship in 1932-33.

[2]Hartley stopped in Chicago in 1919 on his return to New York from a year and a half in the Southwest, and was there again in 1928.

affrontery but the whole thing seems to be nothing but a habitual
sensationalism on the part of Epstein.

D. H. Lawrence tried this sort of thing in his book "Lady
Chatterley's Lover" and the result was foolish, for no man would
ever be able to believe that any man would talk such adolescent
wood-pile nonsense to any woman no matter how moronic on such
matters she might be—even in England, most of all in England, let's
say.

I was myself present at the covering of Epstein's monument to
Oscar Wilde in Père Lachaise [cemetery] as a guest of the sculptor
himself and his wife.[1] The authorities had come down on such
unwonted crudity in so sacred a place as the valley of the dead—and
so the monument was to be covered with a tarpaulin until such time
as definite decisions could be made. A fish wife or the Parisian
equivalent passing by, halted for a moment, hands on hips, basket on
arm, and let out a shriek of cynical laughter at the diminutive
proportions displayed—the words of which dame need not be
inserted here.

Epstein had already started if I am not mistaken, about this time,
or perhaps pervious, with his figures for a building of the Medical
Association of London,[2] the which I did not see. It is more or less
remarkable that no protests have as yet come against this figure of
Adam since its flagrant proportions are startling enough, but we find
plenty of frank statements in the popular literature of the day, and
without any doubt children are no longer "frightened" in such
matters, for present during my stay was a mother of somewhere
around forty with her two adolescent children, a boy of fifteen or
sixteen and a girl of twelve or fourteen, obviously of the better
families and there was no sign on any of their faces of shock or
disgust—there was no oblique whispering going on anywhere, and
so at least the Adam stands as it is, to be looked at, to be impressed
with, or to leave it as a kind of modern conundrum. The things does
not seem to be unified in feeling. It represents a man undersized as
primitive man was, with thick legs, far too short in its members if
anatomical veracity is to be accounted for, and Michelangelo was
never amiss in this. The head reminds me of the Aztec masks—the

---

[1]In September 1912.

[2]Completed in 1908.

body as a whole seems cramped to accommodate the size of the stone—but that would not be Epstein's admission—though he could easily admit that one more foot in height would have immensified his theme, since for his colossal purpose there is need for stricter adherence to anatomical veracity. In other words it has the figure of a truck-driver and the type is familiar around the meat markets because sides of beef have to be juggled with nonchalance.

There is room here also for excruciating ribaldry and if the flash hyper-sophisticates become aware of this, then the quelling of laughter will be in order, since after all, the half of what Epstein portrays would be ample for Adam since he must have been below the average man, according to this figure, the rest being therefore a case of adolescent wish-fulfillment. This Adam is of course sculptural but it is not to my eye the quintessence of monumentality, and it suggests a kind of jiu-jitsu prowess coupled with talmudic determination. I am in no sense frivolous—quite the contrary— when I say this Adam might be humming to himself the Kol Nidre or whispering passages of the Kabbalah.

Epstein is essentially a theatric nature, and always has thought in terms of the theatre of moi-même. He is a most respectable and likeable person but he is first, last and always, moi-même Jacob.

I am thoroughly earnest when I say that having feasted on chacmool and the stupendous Mother Earth of the Aztecs and the pyramids of Tenochtitlàn, I think this figure beside them, small. I have a Guerrero mask of which I am the proud possessor that, though it fits in the palm of my hand—is the size of the world as feeble man can know it.

The symbolic significance of the universe is so knocked into a cocked hat these days by what wonderful man is doing to the decent surface of the earth, [that] anyone who tries to see it through the maze of epileptic drooling at the mouth is doing himself a kind of injury even, for man these days is an utterly ridiculous matter, and I am not relying on Dr. Hooton[1] of Harvard in saying this, for being a human animal is something of a shameless comedy—or am I wrong?

I would not think therefore that Epstein had sensed the God-shape of the universe, as I would not feel that Blake had either, but

---

[1]Dr. Earnest Albert Hooton, anthropologist and author of such books as *Apes, Men and Morons* (1937) and *Why Men Behave like Apes and Vice Versa* (1940).

Blake's Job images are very near to something like Epstein's purpose, and Blake's mind was utterly and totally pure because he had not only conquered heaven, he had achieved it, and the world to him was sifting sawdust flowing through the fingers as grains in an hour glass.

So that for me I did not come away thinking Epstein had at last relieved phallic worship of all stigma, because the true force of this statue lies in its back view and not in its front. But take it or leave it, and the sex neurotics may have access to a small but very elaborate and precious Last Supper in mother of pearl, said to be made by monks requiring one hundred years for its performance, which is neither convincing [n]or important.

You get the feeling from this Adam that we must go devoutly and divinely pagan, but that is also something that will be Sanskrit in a streamlined chromium world like this, which is interested in synthetic hairbrushes with bristles of a like material, and handsome enough they are.

For myself I repeat, I will stick to the chacmool and the Mother Earth of the Aztec, content to know size, power, and depth, leaving Epstein or any other artist obsessed with symbolic revelation to his private immensities, for we are obliged from moment to moment now to face the tissue veracities, and so one man's glorification of himself doesn't go far in the scale of things.

The rest of the sculptures [in the exhibition] struck me as trivial, bordering on costume embellishment, so many treatments of surface that border upon caricatures of the medium, without true classical [repose?].

And so it is more comfortable, comforting even, to take the light point of view and entertain oneself with the comedy of outward manners and not be too impressed with the travesties of inward behavior.

I find Epstein no bigger than the rest of us, and that probably would be annoying to him with his desire to appease the Kabbalah which is obviously a great attempt to represent something more, or a religious, ethical and moral "quelque chose d'autre."

We are obliged, whether we will or not [to accept?] the nonsense of existence the way it is now presented to us, and that ought to help us a lot to spend our time quietly, and even playfully. There are those who think glandular excesses impressive, but that is hardly fair.

# Roger de la Fresnaye

*(c. 1942)*

I am fondling this morning one my few rare possessions, and when I say fondling, I mean exactly that—just as when a connoisseur of gems or shells loves the very click of them in the palm of his hand[1]—I am fondling a now very rare folio of drawings and gouaches of one of the most significant artists of the modern movement, none other than Roger de la Fresnaye.

Somehow when I look at these works of a man that was destined to die young[2]—I am always conscious in them of a spirit very highly born, and one that conducted itself to the end with the high meaning of simple experience.

There is the aristocratic aroma of true breeding hovering over everything this man of genuine talent essayed to do—there is never a lapse of ordinary response in these works of art and he never condescended to be esthetically chic—he was moved away for part of his life from what was a natural classicism. Even when he essayed to perform cubism, it was still something of his own, evolved from prevailing theories—he never sacrificed his talents to the force of eclecticism that was around him, and like painters such as Derain and Segonzac he kept to his classical convictions, and if unlike them, he was intrigued by the fascination of cubism—and what really expressive painter hasn't been—he kept to his own purity of emotional response which kept him from being common or even vulgar in his reactions. I have never seen a painting of de la Fresnaye which didn't have a something plus in it—a something far better than the average, and if he perhaps may not be classed as one of the

---

[1] Hartley was such a connoisseur. He loved precious and semi-precious gems, had considerable knowledge of them, and once wrote an essay entitled "Shell Polishers" about a family business of this unusual trade in Hamburg, Germany (YCAL, Hartley/Berger Archive). Hartley's unique collection of jewelry is preserved in the Treat Gallery.

[2] De la Fresnaye died at the age of 40 in 1925.

major forces such as Picasso and Matisse he will always, like Juan Gris, remain one of the choice spirits of his time and generation.

If this artist is always over on the side of rare flavours of caviar to the bourgeois taste, he holds like Gris, a something else—quelque choses d'autre—which Mallarmé classified as pure poetry.

It is perhaps the utter lack of theatricism that keeps these men in their pure field—such as Maurice de Guerin, Alain Fournier and even St. John Perse who has given us the true and inviolable sense of poetry today that will go far toward correcting the exaggerations of the ultra nouveau so to call it—in modern verse.

We have another and very new case in point in the exceptionally fine poems of José Garcia Villa, in his first book published after long deliberation—"Have Come, Am Here." [Garcia]—being a perfectly informed poet on all the ways that poetry may express itself—becomes new to us by being devoutly personal without trace of defunct eclecticism.

If you are familiar with early music, you will find this something among the seventeenth- and eighteenth-century composers, such as Rameau, Monteverdi, and the greatest of them all, Gluck—who made great experience out of melody itself.

Listen to the madrigals of Monteverdi, and you will think of them as music written for the first time—they will come to you as Debussy, Ravel et Cie will not, as fine as they really are. They will come to you as highly developed departures. You will not be thinking that Debussy was devoutly impressed with Wagner's "Tristan and Isolde," which did so much to further the emotional responses of this great modern musician.

You will be aware that the devotion of Roger de la Fresnaye to Claude Lorraine and Poussin was not without meaning, and it is only because some spirits are born pure, and the only sustenance that feeds them is purity itself.

You will find this even in the richest and best of Rembrandt, especially in "The Night Watch," the "Self Portrait,[1]" and the picture of "The Polish Rider," a something over and above the rhythms and the forms of life—even the sense of actualilty in these particular paintings is permeated with something more than mere life itself—

---

[1]Probably the *Self Portrait* in the Frick Museum which, he says elsewhere, hung next to *The Polish Rider*.

they are instinct with that substance which makes some moments
greater than others, and makes of one moment—and it will be a
"divine" one—when all the world and all of life is seen clearly and is
felt clearly—as the tone of a great bell in a tower.

It is as if in the greatest works of art, something like scientific
perception has been achieved, as in so many of Leonardo's drawings,
from which I feel de la Fresnaye at his best is never very far—since
microcosmic sensibility seems to pervade them—you feel the quality
of finality in line and tone as well as forms pervade them.

As I have inferred [implied?] previously, there is never a lapse of
taste or concept in anything de la Fresnaye was able to accomplish in
the brief span of his life—brevity meaning little or nothing in this
case—since his intellect and spirit were inordinately mature and he
was not in the slightest degree conscious of serving or desiring to
serve a conventional public.

The case of this artist is one of the clearest and best with which I
am familiar of that type of true artist who saw the real value of
appearances and organized his sense of appearances into a synthe-
sized reality of his own.

It is probably sophistication only that can prove the meaning of
simplified, pure sensation, as [a] kind of expressive innocence is
bound to come to the front. The values are placed because of the
complete sense of what it is that create[s] values—so that the
sophistication of de la Fresnaye is that of the fine artist and never in
any sense that of the bounder which is too often to be found in
average or common works of art.

It is not difficult to name certain works of art vulgar because a
cheap and undignified esthetic impulse directs them and I am not
one who can excuse so great an artist as Picasso from this—and this is
attributable to what that fine artist Lipchitz classified to me as "bel
canto" when I asked him how he felt about this Spanish artist—just
as when I asked him how he felt about André Masson—the reply was
a rare an[d] exquisite one, "Il [ne] connais pas la sentiment du
sacrifice," and I have never heard a more perceptive phrase uttered
by anyone, on any subject.

It is a phrase that might be pinned up over the desk of many an
extravagant writer, especially—which gift is so wanting in so
many—tact of omission is what Pater once called it—who was surely
a stickler for exactness of mood and precision of emotion.

There is so much bluffery these days in the fields of esthetic expression that it is good to come upon artists of distinction like de la Fresnaye, Juan Gris in his way, José Garcia Villa and St. John Perse in their sense of poetry. One can lie back and release the spirit in them—whereas the excessive and extravagant eclecticism of the smarty type is nearly always fatiguing because we don't enter their world and have no profound urge to do so.

I could not exactly say and speak truthfully, that de la Fresnaye sweeps one off one's feet in the exhausting manner of a Géricault whose sense of physical reality was stupendous, but it is quite another issue and the repose of the soul is quite another matter, but if it is repose you are looking for and need, you can lie back and regain lost energies in the presence of work like that of de la Fresnaye, because it was in the pure world of spiritual experience that this man lived, and out of this purity came a factual sense of this quality and made it what it is—a truly great experience.

It all depends upon how you feel, naturally—whether you want your erotic or neurotic organism excited—whether the fine experience of clear-mindedness elevates you, or whether you can discard all that and live for the meaning of beauty alone—which is [a] very positive and living experience if you are neither formal [n]or officious about it, just as the pure idea of religious elevation is a great experience if you feel that way about it.

I have read all the Christian mystics reverently and though I can believe none of them, I can live into their fervours and believe them as they unfold their consuming convictions.

Who can read two poems or only one even of Richard Rolle the first English mystic, or of St. John of the Cross or Thompson's "Hound of Heaven" without being moved to the last pitch with their comprehension of the meaning of their extravagances.

So it is with good music—so it is with good poetry—so it is with good painting—and if I enjoy the first class painting of Roger de la Fresnaye, it is because I find there the true meaning of all that experience can mean. I do not know that de la Fresnaye will ever break out of the limited circles which confine him and in a sense make him prisoner, but he will live forever there as long as there are two or three gathered together in the name of fine experience, therefore of fine living—and that is in a sense sufficient.

Look up and down the line of modern art experience—as far back

as the original cubist enthusiasms—and you will find none to displace him. You will find one spirit equal to his and greater in intellectual clarity. You will find Marcel Duchamp in his immortal "Nude Descending the Staircase" which no artist since that time has rivalled—simply because and only because it is a great example of esthetic and intellectual clarity—and in this sense stronger of course than de la Fresnaye. We need not be concerned with major and minor here—it is only necessary to feel the sense of exactitudes in emotion and of clear thinking, and de la Fresnaye is completely in control of these aspects of experience as related to life. He never steps very far out of a kind of silvered monochrome but it is a sort of refreshing harp and flute music as compared to too much brass and percussion.

Roger de la Fresnaye will be taken more seriously than he has been because he was sort of snowed under by the storm of definite personalities—but he has survived like the snowfield upon the high mountain because nothing can efface its veracity and its virile force.

## Some Words on Piero and Masaccio

I come every now and then back to my first sweeping surprise in the presence of Masaccio, first of all in the little chapel of the Carmine in Florence, with the amazing "Expulsion of Adam and Eve" on a small side wall, as if more like an afterthought than a premeditated ornate decoration.

What living humanism pulsated in the heart and mind of this

gifted young man, such plausible sense of reality, where for example does there exist in all the range of religious art a more downright humanistic interpretation of Christ than is to be found in this decoration of "The Tribute Money," its sense of likeness to other men, its apartness from other men, its relation to the great spiritual characters of all time, Christ the redeemer of mankind, aware of his purposes more than of his power, humility and wisdom extreme in the face, pain that is not agony so much [as] the pain of deep desiring, of longing to set the world free of its troubles and its agonies, a face not tortured with death on the cross, no distortions and morbid interpretations here—just a man with something else, a man among men, masculine in his confidence for once, a man with something more than man in him, doomed divinely to the splendours of singular wisdom.

Even Leonardo's face [of Christ] in "The Last Supper" as splendid as it is in suffering does not give forth the peculiar rationality of appearance as does this Christus of Masaccio.

From where does such singular knowledge come in a man like Masaccio, young, dying at twenty-seven, having in all of his pictures such an advanced notion of life in its entirety and the meaning of art in its relation to life—life in relation to art—life in relation, best of all, to itself, for life is first and last a human experience and not an artistic one, for in the end what knowledge does even the superior artist have of life, more than of its surfaces?

What are the cultivation and the saccharine trivialities of a Raphael compared to the deep resounding bell tones of a Masaccio— little else than lyric tintinabulation—Raphael the gracious, the sweet, the clever, the tiresome producer of operatic legerdemain perhaps, but little else.

Who goes among all of them deeper in these ways than the young Masaccio, save Piero—Piero of the great mind, and the sweeping concept, of the high regard for simplicity and the last reduction of emotion, glorious tact, superb rendering of the pause in rhythm, allowing no ridiculous effervescence or commonplace ebullience to over-ride his sense of measure, order, proportion and reality.

No one has ever surpassed these men, no one ever will, because the measure of experience in them has been completed—all the music-making of the Botticellis silenced by sober nuance and majestic appreciation. Masaccio the only painter of a Christ that is at

all tenable and logical from a humanistic point of view, the only one to whom any plain human might turn and say "good morning Lord, and is it well with you."

How one shrinks from all the physical barbarism of all the other Christs, especially the Christ of the Spanish concept—terrifying, terrible, humiliating—the vulgar of the Christs of Rubens—the sick neuroticism of the Christs of Greco—Masaccio's the only face that can take its place among the great faces of history.

With the "Ressurrection" of Piero at Borgo San Sepolcro, it is not the physical being here that appeals, but the mental concept, for here is truly a being who has transcended the grave while the soldiers sleep, here is one who has supremely triumphed—supreme victor in a conspicuous cause. It is not the vision of an effeminate spiritual nature, it is much too much the fighter for noble ideas, and whether this Christ ascends to Heaven to be an obscene abstraction, is hardly to be believed or expected, for this Christ has triumphed over death and the grave, and is risen to go out upon a warrior's mission.

And if one cares at all for Christian images these two bring one closer to the humanistic plausibility of the image, for both Masaccio and Piero were great see-ers. They derived their source of experience from humanity itself and knew that what they poured into their images would be recognized by the casual spectator as something close to themselves—something human, something real, something touchable, lovable, truly approachable and kind.

# Posing for Lipchitz

*(c. 1942–43)*

When Lipchitz, who is the only modern sculptor that ever has moved me, said to me at the preview of the abstract show on the second floor [of] Helena Rubinstein's beauty palace—"mais vous avez une bonne tête—voulez vous venez me voir" I felt a unique kind of satisfaction because I knew that something thoroughly representative would come of it.

And so the day was appointed and the visit made to Lipchitz and his wife to be further "regarded" and looked over with the usual simplicity and elegance of distinguished people. The remarks that were made on the subject of sculptural splendours in my head did nothing but encourage me in the hope that the decision would be favorable, which it was, and the day and the hours for the sittings were appointed.

I have in the course of the years been painted by various people, and twice before this had given time to two other sculptors of lesser significance, so that the posing itself was nothing new—as I have been often photographed by great and small[1] chiefly because I am said to be photogenic, but here was something new and really diverting as I knew that a man of great significance was about to get into the job.

The clay was being set up in the armature and even in the rawness of the first condition we could feel the telling strokes making their logical appearances in the right places, and I could see myself becoming a new kind of thing—a new entity even—an almost fourth dimensional reality was slowly and surely taking place. I could feel

---

[1]Arnold Rönnebeck executed two heads of Hartley, one in 1915 which is now in the Hudson Walker Collection of the University of Minnesota Art Gallery; the other, done in 1923, is apparently lost. Another bust was done around 1915 when Hartley was in Germany by Swiss sculptor Fritz Huf. Hartley's portrait was painted twice by Ben Benn, and by Peggy Bacon, Milton Avery, and John Bloomshield. He was photographed by Alfred Stieglitz, Paul Strand, Alfredo Valente, George Platt Lynes, and Man Ray, among others.

myself beginning to be created in terms of definitive meanings—I could feel myself entering the world of concise creativity.

In the situation of the fifth pose, to which ten hours had already been given, I could see a being coming into existence—a third entity taking shape in the presence of myself and the man involved in the presentation.

There are three of us now—the third being always between us—he Lipchitz on the one side—the authori[ta]tive looking semblance in the center—and myself on the other side. While this man is studying me, I am studying him. I see a visage that makes me think considerably of a melange of the heads of Baudelaire, and of Poe. The head of the man who confronts me is wide of forehead—it holds two orbs that seem to swoop down like a condor from some Andean slope, as upon a sheep perhaps, lying in a slant of sunlight.

I can even see, it seems to me, the talons of quick observation clutching at the flesh of the given idea. I am no longer aware of the thing I am to myself, because the thing I am on the armature is becoming a fact in microcosmic conception.

It is perhaps this that makes me sort of half somnolent, even though I am aware that I must keep in a true condition of plasticity within, as only this can bring the self to the surface of the face, so that in the exact moment of observation I will be "there."

Nevertheless as I am turned about on the posing stool, my eyes must rest somewhere, and so they run the range of the several powerful Europas which are this great sculptor's newest creations, representing the terrible tragedy of the disruption of the soul of a continent. I follow them to the magnificent small crucible which is a true piece of sculpture in itself—to a cuplike fragment which is unquestionably a meteoric fragment of a fallen star.[1] There are fruits resting in a dish—chiefly lemons and oranges slowly turning into pieces of sculpture in themselves—taking as it were dictation from the prevailing atmosphere of the room.

I come to a precious little medallion which is a fine portrait of that genius among painters, _____ whose enormous talents were to do so much for Delacroix and others of their time. The crucibles—for there are two—one encrusted with the dead embers

---

[1]With his knowledge of mysticism, and in the context of the next paragraph, it is quite possible that Hartley was aware of the life-giving potency believed by the Syrians to exist in meteor stones.

of cooled metals—are dark and have the look of worlds closed in upon the dignity and majesty of cosmological inferences. They are like volcanoes chilled by glacial pressures and are now permanently extinct. They have the acute solemnity of a snowflake—and the massed body of a mountain, as well. I am eager to know what secrets they have held.

I see the morsels of clay becoming electric between the fingers of this very living sculptor—nothing goes down that does not take significant form—new planes of light are being discovered as they fall into place—a kind of classic elegance is being evolved out of an objective image which happens to be my fortunate self, yet it is not myself merely—it is myself in relation to the rest of the world about me which makes me aware of the aliveness of myself—it is even the not-self I see coming into being before me. There is something of the speech of universal rhetoric about it all, and it is comforting to learn as I watch that the planes of my head can and even do bear relationship to a slant of the pyramid or the curve of the back or beak of an Egyptian hawk, for the very condition of my head relates me to the family of the hawks and eagles, and because I am in no sense a narcissistic being, I can speak of myself in relation to the visible forms of the natural world, which shafts of sharp light have uncovered and made real.

There are three heads now in existence as a result of this sculptor's vital interest. The second, if perhaps casual, is a living portrait of a human idea.

Proceeding from the Fifth Avenue bus across Washington Square, one sees of course many representatives of nature in its multi-various aspects.

I was arrested completely in front of a man seated on a bench— obviously Italian—he was swarthy, animalistic, and virile—he was in his later middle years, and at the given instance he was asleep due to the summer pressure of the heat no doubt. His mouth was open and his thick arms rested on the back of the bench, his bulky hand supporting the sleeping head.

This image was deeply impressed on my memory with photo-graphic precision, and when I reached the studio of Lipchitz, I told him I had just seen a fine piece of sculpture in the park which he would certainly like to have seen, and proceeded to give a plastic representation of it.

I must have succeeded well, for it moved Lipchitz to fresh

enthusiasm, and he asked me if I would "do" it for him which I was pleased to do—the result being a form-pose head of exceptional reality—so that the image of the sleeping man can be seen as it passed through me and because by the gift of instinct, myself.

At the sixteenth pose the sleeping man [was] moved out of the way and put under moist cloths to "ripen" [and] a third head was begun. This time in the nature of the original first—to become again a realized portrait of the thing I was and had become under his scrutiny, and I could see myself in terms of relation to the outside world—a thing living its own life—invented by the distinguished spectator and observer—a thing in which the dimension of my outer self had taken on the inner livingness which has been created by me, in relation to all the issues of life outside me. I could even feel the dignity of my own aspirations in it—that substance which has driven me toward my own goal, which had made me a creator in my own right—so that what the third head now is—is the result of vast funds of knowledge and experience derived by Lipchitz himself from his own right relation to things as they are.

As I have already said, I do not move toward sculpture as a finished product, but that is because I am a painter, though it must be said that any good painter must have something of a sculptor in him in order to give the true sense and shape of life as forms no matter how simple the object of inspiration may be.

We see to what remarkable lengths this notion was driven by one of the most original painters of all time. We see how deep the comprehensions were of Cézanne, how "new" his approach was, and it was therefore possible for him "to paint an apple that would astonish Paris." We know these apples now to our immense satisfaction—how they had become by the depth of his feeling and his acute penetration—something to equal the vast image of the pyramids—the world so to speak, as apples, and as apple, the world. So much that passes for sculpture is but a matter of cut stone and figures and ends nowhere in the scale of relation to tangible experience.

Who will ever forget that amazing exhibition which was given by Joseph Brummer in his earlier gallery, of the work of Lipchitz when every piece, and many of them were large—signed itself off into historic importance because each unit was a highly defined representation of the cosmological aspect of things seen and felt through a warm and highly intelligent artist's understanding. There are no

theatrics in the sculpture of Lipchitz. There are no mawkish sentimentalities in this work. There is never a trace of thoughtlessness or of slipshod thinking. The work stands alone, in all its exact dignity, its exact sense of living truth as well as of esthetic truth, neither of these things sacrificed to the other, but here all qualities are the result of having seen them all in the one—and the one in the all—each fragment of life being but a modulation of all experience.

Complete appreciation—that is what makes any work of art good. You will find it in Vermeer, as well as in Uccello's "Battle of Romano"—you will find it in the Rembrandt portrait of himself—it is there in a single Egyptian bead ornamentation, and how often have I studied these, each one a unit of life itself—in the living organism of the Parthenon. All true works of art breathe the very substance of all life, and so it comes to me and from me, the work of Lipchitz is like that—it never bogs down anywhere, never becomes soggy with sentimentalism, [is] never overridden with theatric trivia—it holds its own druidic grandeur no matter what the subject is. The "Europas" which have absorbed this sculptor of late because of his own tragic fate in the present derangement of things, are fairly crowded with the struggle of the spirit against awful odds—there is the terrific determination in them to live despite all obstacles—there is also in them the faith of a man who feels that life is not all horror and devastation, that under the given conditions little else than abject chaos can be the result, and that only a stoic sense of things can bring one through all trial, all tribulation.

The drawing that I am proud to own is of one of the Europa moods, and I never look at it without feeling that life is far more significant than the cheap passions and obsessions of the self, there is even a kind of religious fire in it, a sheer burning of the soul that longs for a return to the finer state of things.

Like all important artists, Lipchitz is outwardly a very gentle simple person, that is, he is simplified as any discerning human being must be, by his complete sense of nature and the part that art is to play in conjunction with it.

I look upon the twenty-eight poses that were given to this great sculptor as a kind of contribution to the finer aspect of things. I feel richer for having spent so many hours in the presence of this man, whom life had taught so much and so deeply, as to make it possible for him to smile generously with the same lack of complication as one

finds in, shall we say, the St. Anne of Leonardo, the only one that really knew the profound significance of that smile, whose life was to prove that sincerity and a passion for exact knowledge are even dangerous issues and leave little else than bitter wakes in the blood stream of life itself.

The drawing which Leonardo made of himself, one of the great creations of time, shows how a profound man has learned to suffer, and we come to the perplexing remark of his, "it is easy to be universal" with a kind of choke in the throat—because no profound wisdom or complete sense of all things can do, and does little else than leave a scar upon the heart, from which blood never quite ceases to flow.

It is not far from the touching smile to the mood of deep suffering, and only a great nature can completely know that, and I feel that Lipchitz has learned this secret and is therefore free of blame—even of praise—he is free because like all great spirits he has paid liberally and even cheerfully, for his freedom.

The work of Lipchitz walks with life, and will therefore never settle into a cold shadow of a museum without deriding it. He will make such a spot even ashamed of its all but innocuous diffidence. My world is larger because I know this man and I can offer no better praise.

# PART IV

# From THE SPANGLE OF EXISTENCE

## Casual Dissertations

"Would you that spangle of
existence spend
about the secret,
Quick about it—friend."
               Rubaiyat—49th stanza

"Ah, take the cash and let
the credit go
nor heed the rumble of
the distant drum."
               Rubaiyat—13th stanza

*In the last five or six years of his life Hartley concentrated more energy into his writing than ever before. His letters are filled with descriptions of reorganizing, rewriting, and typing both prose and poetry manuscripts, the latest plans for submissions, and of rejections, and acceptances. These same years saw more of his work published than at any time since the 1917-21 period—two books of poetry, six major essays, and some miscellaneous items.*

*In February 1938 he gave Edward Dahlberg a collection of essays entitled* Fragile Gossip *which Dahlberg submitted to Harrison Smith, then an editor at Doubleday Doran; in August the manuscript was rejected. Undaunted, he gave it to Henry Allen Moe, Secretary of the John Simon Guggenheim Foundation, who encouraged him to apply for a fellowship in creative writing on the basis of the collection. This Hartley did in 1939 but without success. Although the manuscript was returned to him in May of that year,* Fragile Gossip *was not found among the papers in his estate and is apparently lost. It is reasonable to assume, however, considering his habit of re-shuffling essays and published articles into new formats, that many of the pieces now comprising* The Spangle of Existence *(which he began to compile as early as 1937) were originally in the earlier collection. Organization, revision, and typing of* The Spangle of Existence *occupied him through the fall of 1942 when Monroe Wheeler of the Museum of Modern Art offered to have it professionally typed for him so that he could submit a polished copy to a literary agent. That text is now in the Museum's Library. Hartley's own typescript, difficult as it is because of his poor typing and his habit of single-spacing (no doubt to economize on paper), has been used in this edition.*

*The manuscript contains forty-two essays on art, literature and the entertainment world. Of the ones printed here, six (including "Farewell, Charles" which is in Part I) were published between 1936 and 1939. They all have the mark of a mature writer in both the substance of his message and his use of language. He had learned, he admitted in letters, how to revise his prose.*

*The underlying themes of the essays are those which had always occupied his thought: the predicament of the imaginative artist in modern society; the relationship between art and life; and the problem of intellectuality in art. But now he was approaching them from the position of "clarified experience." He had arrived at the conviction, forged from the exigencies of his life and his development as an artist, that the greatest art strives to express that dimension of experience beyond material fact—a conviction most potently expressed in the essays on Ryder and Gaston Lachaise, and most clearly in "The Element of Absolutism in Leonardo's Drawings."*

*In the pieces on George Fuller and Ryder, he picks up the recurrent theme of the "hermit radicals" of American art. Fuller belonged in this category because of the "deep-lunged sense of life" which animated his whole experience, both as farmer and painter. From his depiction of Fuller's modest farming and family life, we see—in perhaps the clearest terms anywhere in his writing—what Hartley means by the relationship between art and life (the basis also of his admiration for John James Audubon). In the twenty years between his two major articles on Ryder (1917 and 1936), Hartley had had his own financial and spiritual struggles, lending solemn import to the 1936 essay with its deep-rooted feelings about what it means to be an artist and a New Englander; to face poverty and yet stick to the vision; to know the meaning of "being alone with the Alone."*

*Like Ryder and others that Hartly wrote about, Leonardo da Vinci "was out of joint with his time." If Ryder was Hartley's mentor of imaginative expression, Leonardo was the artist who most successfully "arranged his intellectual and spiritual relativities in order in the manner of a logician." This logical balance contributed to Leonardo's "absolutism": "his knowledge of the all and everything of things"—a knowledge which "like pure wisdom, is above the human demonstration" and approaches the "divine," or absolutist, idea of things.*

*The sense of absolutism in Leonardo (or, perhaps to lesser degrees, in George de la Tour, Masaccio, Piero, Rembrandt) is the element which lends credence to his religious pictures. Absolutism, as Hartley saw it, is the ability to render the divine in convincing human terms.*

*The artist as divine see-er, seems a natural culmination of Hartley's esthetics, and Valéry's biographical approach to Leonardo finds a parallel in Hartley's own critical method. In almost every piece of prose he puts himself in the place of the one he is writing about, evaluating each work with the "substance" of his own being, so that from each essay something of his own nature (the "beginning" of oneself described by Valéry) comes forth.*

# Memling Portraits

*(1939)*

I am perusing a little book of illustrations of the work of this "Fra Angelico of the North" as he has been called. This may perhaps apply somewhat to the religious type of picture which he painted and certainly like all others, as a commission for which he got well paid, and if the sacredest of characters could see themselves as they have been painted by the great artists they would have the most unbelievable shock of their sacred lives, for no matter what the Christ may have looked like, and his sacred Mother also, they never could have looked like any of these depictions, and so it is to excuse this flattering appellation, since Memling was not a profoundly religious painter, such as the great Fra Angelico was, unless the Flemish soul is by nature of the shyer and more evasive sort, and I doubt it.

It is natural for me to think of two names in association with each other, each being rapturous victims of the same idea, and that is the Yorkshire mystic Richard Rolle, and the Fra Angelico. You will not find in Memling as a religious painter any such element of "Glory Glory" as is to be found in every stroke of the holy Angelico for he was distinctly illuminated, and it is very much to be doubted if Memling was, but in this case the illumination comes in purely in the field of the intellect for no one has ever seen life as accurately and with the same fullness of understanding unless of course it is Albrecht Dürer in that all but unbelievable portrait of himself.

Memling endears himself to us, or better to say he excites us by his unrivalled power to see the all in all of everything. From the purely physical standpoint, he saw with the eye of an inspired camera, everything there was to see down to the last milimeter of observation.

When it comes to religiosity in painting, is it not singular that both Fra Angelico and Blake should have presented Christ in unmistakable womanly form, and go for this idea chiefly to the drawing of the "Ascension" of Blake, for nothing could possibly be more female in

appearance, or is it as some who think deeply on the subject of the soul believe, the soul itself to be the feminine aspect.

I am driven in this thought across the bridge over the Arno above the Via Tuornaboni, entering the church of the Carmine once again, to see the amazing expulsion of Adam and Eve from the garden, and from that to the, at least for me, only plausible Christ figure in the "Tribute Money" fresco of Masaccio, and I think it is safe to say that it is the only completely denationalized and spiritually rationalized pictural concept of Christ in the whole range of religious painting, and is there a human being living who can ever believe the awful and indeed preposterous Christ of Rubens in that breath-taking performance of Rubens' "Crucifixion" in the Cathedral of Antwerp, which you may now only see by dropping a coin in someone's hand, or am I wrong in saying that you even buy a ticket, and with the turning in of this, the curtain is drawn, an extraordinary peep show in any event, but as for religious feeling not a trace, for it is theatrical-æsthetic to the last, and Christ, no matter how you think he might have looked, could never in the width of this world [have] looked like a Flemish butcher.

As a whole religious pictures are never convincing as works produced by the devotion of the spirit, as it was a commerce— exactly as the religious imagery of the churches of today are a commerce, the difference lying of course in the fact that they were great works of art.

And so it is not Memling the religious painter that we admire most, but Memling the incredible observer of human forms, and quite often revealer of inner states of being, and it is to these portraits of his that I turn for pleasure and hurry as speedily as possible from his sickly and unbelievable "Pieta," since no one looking like that could possibly have been the instrument of the desired salvation of the world, utterly and completely androgynous as it is.

That Memling's spirit was a highly refined one, every one of his works bears distinguished trace, and he comes closer to the condition of pure religious feeling than most of the painters who were completely preoccupied with these thoughts and images and yet he was no match at all for the refined and devout soul of Angelico whose works breathe of the very heaven that he knew he saw, the very light of which penetrated through him like the light from a perfect place.

Coming to the portraits, it seems as if Memling struck his by far

highest note there, because it is his truest note, and for proof of this
one must turn to the unrivalled portraits of Tommaso Portinari and
his wife, and the two even greater renderings of Guillaume Moreel
and that of his wife Barbara de Vlaenderbergh. There is a humanism
in the faces that even exceeds Dürer in this respect, since they are
warm with human emotions and all but plapitate before you, gently.

These portraits leave nothing to be desired, there is nothing left to
improve on, they are perfect examples of things seen and rendered
completely as seen, plus that peculiar gift of the imagination which
makes them members of a universal world.

It is quite probable that a northerner responds to the Memling
type of understanding, because it is cool, concise, simple and true,
wants no romantic or theatric embellishments, and in the case of the
Memling portraits every one of the personages seems about to speak
some simple conviction, but carefully so as not to disturb a world
which has no time or patience for its plain secret.

As for the portrait of Barbara de Vlaenderbergh, where in all art
will you find a more precise and subtle rendering of the feminine
spirit, with the veil over it which sort of seems to half shield the lady
from the world, and yet to let in by recommendation some of its less
awful confidences.

The curious egg-shell texture of the Memling flesh reminds one of
the Chinese notion of physical surfaces, and if the colour never rises
beyond a fairly resonant monochrome, there is always the idea that it
lives its own life and carries on its own private tradition.

There is unending refinement in Memling and a peculiar and very
personal force, but the force comes from within, and is the force of
life lived and understood as well as believed. And so it seems. as if
Memling might simply be called the genius in visual logic, since all of
his forms, lines, and tones are rationalized into one complete and
haunting whole.

The people of Memling's pictures leave no trace of their vul-
garities, and could they have been any more devout than the average
comfortable citizen, and isn't it perhaps in the end the same old
weakness of human nature to want to have its best face put forward,
but as they pass through the alchemical crucible of Memling, they
come out good and pure and kind, and beneficent and that is likely
what they were happy to pay for. It is with Memling in a sense, as if
life flowed by rather as a vision from a clear window than as a

touchable and embraceable thing, the actuality of the reflection upon the glass of the prescribed window being more actual than the object itself would be which is the quality of magical suspense created by the imagination.

That Memling gave nearly all of his sitters praying attitudes is due surely to the fact that he liked hands in this position, for in this position hands may hold counsel in their own right and feel free to keep from the world their impulsive intentions. Memling was certainly one of the greatest and most scientific of observers, and probably no more defective in his power to convey the religious sense, than most of the masters that preceded or followed him.

It is for the portraits alone that I wish to acclaim.

# Mary with the Child—of Leonardo, in the Pinakothek, Munich

*(1939)*

Before me, the photo of the Mary with the child of Leonardo, and having seen this picture several times I am amazed at its aliveness, springing forth at one as waters from the spring, in contrast to the general vacuity and hum-drum of museum emotion.

You get stiff joints in museums as any one knows who attempts to navigate them, and of course I am thinking most of all of the Uffizi, nothing but braziers over which the guard may warm his hands to keep them from freezing and you having not the same privilege and cannot enjoy the same benefits, but you have in another sense the advantage over him, because you may go out into the open air which

no matter how cold it is, is warmer than the congealed and dead air of museum halls.

There are aspects of this picture that confuse since one does not expect to find Leonardo thinking like that, as in the face of the madonna, all other ideas in the picture being typical, and those strange mountains out of the four round-arched windows, the kind of vista out of which little but discomfort can come since one cannot learn exactly where the place is, among whose valleys and crevices flood, tornado, the sudden pressure of glaciers all ominous and foreboding, where the imagination functions stronger than any-where else in the picture, as if to represent the fatigue of the world in the attempt to struggle with the divine idea, that strange austere wisdom which seems always to reside in the appearances of nature, and probably because we ourselves being foolish, all things else in nature look more intelligent than we because they act so, those strange appearances that come to the surface at times as if to terrify the world into a state of recognition.

Is the face of the mother in this case meant to represent nothing else but the state of purity that there should be nothing to testify that she has even been visited by the famed miracle, rather like peasant in some ways she is, dressed lavishly for [an] occasion when everything else in the picture seems so ultra Leonardo—it is difficult to reconcile this empty face to all the rest, and since her eyes are forever downcast or gazing only at the carnation in her hand which the infant seems, infant-like to crave, reaching as it does toward the dark red flower, or was she meant to represent young beauty so com-pletely that human sense is not necessary to be felt, since she can in no way seem to come in contact with the human, touchable world?

We see all her garments flaming as it were with the colours of new wines from the hills, or of substances hidden in the subterranean recesses of the earth where strangely enough this splendour func-tions in the dark, nothing at all to explain as in the case of those bodies that live deep beneath the surface of the sea, nothing to explain why bodies should be made so mystifyingly beautiful, shedding light everywhere as in cathedral windows where the afternoon light seeks so devoutly to break through.

There are the hues of ripened grain in these garments, and of those other wines which seem to imprison the substance of the sun itself and which take on a kind of synchronous cadence as the light falls

through them, drenched with the best and richest notions of special afternoons.

Most disconcerting of all is the gleam in the eyes of the child which have or seem to have taken portions of skies for their inheritance, the light that shines even on worlds forsaken by inestimable armies of little infants all seeking credulity of themselves, all this opposed to the calm wisdom of the centuries as depicted by the mountains in the untouchable distance beyond the head of Mary who perhaps awaits enlightenment more from them than from any other object or symbol.

There are strange starlike flowers in a vase of spun glass in the lower right corner, white and brown leaves and flowers, with a lone, isolated one of blue among them, reaching as it were for its complexion to the mountain peaks whose attenuated pyramids are built of aspiration chiefly.

The child is like any other child of earth, of any earth mother, a child any mother at all would be proud to bear and call her own, it is warm with the new milk of a divine gratuity, its flesh is vibrant with innocence, smiling at the great areas of its first impressions, the fingers of its left hand about to reach for the carnation, and the livingness of the colour of her robes, and those of her right hand are aspiring for familiarity with the great jewel at the bosom of the awakening Mary. This Mary is not one who is ready for her peculiar and sacred burdens for she would not in her present condition understand them, and would be baffled by their simplicity, it is a Mary in a separate world where all is about to be forgiven, and only the best things of a suffering moment remembered.

It is in the hand that you discover the confidence in a world she does not know, a world that will give her great occupations and great surprises and many domestic difficulties while the eyes are waiting for courage to lift themselves and look squarely upon what awful thing there is to face.

Here, Mary is the idea that out of purity in her and the child will come the one real purity, therefore she is not a woman in the ordinary sense, but like the rest of us also, merely an idea, and no emotions are revealed in this countenance of hers, and the coils and folds of her hair are as if chiseled by a goldsmith, and are in reality sharp traceries of the true thing.

As an idea therefore, this Mary is a realized perfection, she is

young, girlish, acutely aware of her innocence and it is as if the crisp mountains in the distance send toward her their glacial recognition.

The scene in the distance is cousin germane to the one behind the head of the Gioconda, of which much too much has been made, save that the river is here but a whisper, there is less turbulence in the water, probably because here there is more natural confidence in a plain world, perhaps even less alarmed since the lady of the case inspires confidence which the other does not.

It is the child that holds the attention in this picture, because of an almost mystical, at least an utterly clairvoyant appearance in the eyes, it seems to know by vision all that it was sent into this world for and is making early preparation for the ordeal, and yet—like all little children it is confused and confident in the same breath, because the new-born spirit knows inevitably the strength of the spirit and of its sacred and tragic ordeal to come, and a kind of beguiling prepared- ness is touchingly in evidence, and the hues of Mary's robes, are the images of divine and abundant fruition.

# George Fuller

*(1937)*

By sheerest good fortune, I had learned that the sole survivor of this gifted American painter George Fuller, could be seen and spoken to, and so by appointment I was received at the door of a large Carnegie studio by two very fine looking ladies who, ordinarily would have been taken for sisters, but proved to be daughter and grandaughter of this outstanding American of Deerfield, Massachusetts.

Great tradition radiates from this daughter of George Fuller, pride of place and station, for the heritage here is outstandingly American at its best, that is to say east[ern] America when it was up on its toes, when Copley was painting his ice cold but fine portraits to go with the mahogany furniture of the period made by the cabinet makers of great name.

And you mustn't make the mistake of thinking that all of this east was centered in Boston, for Deerfield was quite something else and what would be done in Boston would not be done in Deerfield, and to say sweepingly Boston for all that locality is decidedly to malign it, and injure royal pride as well, so in the Fuller case it is distinctly Deerfield.

One walk down the main street of Deerfield with those amazing early American houses on either side, will tell you a lot about George Fuller, for it is just this that comes out of his canvases, a rich full-blooded rush of high grade tradition, there is nothing tawdry in this painting, and I am talking of the painting itself, for the pigment has the appearance of one of those historical dinners served up at a colossal banquet in the earlier times, with pigs and hams and turkeys revolving on spits before a crackling fire, there is no meagreness of substance here, you lived well, you ate well, you slept well, you worked well, and you were somebody in Deerfield and that is the sum and substance of the quality in the painting of George Fuller.

In one of these grand houses George Fuller was born and his five vigorous children after him, he being one of eight himself and an amazingly handsome man in the bargain, giantesque in stature immensely muscular, a sort of centaur out of the beautiful and perfect study in prose of Maurice de Guerin, and there is something of those bacchanalian types in the voluptuous pictures of Jakob Jordaens, too.

At all events you think of autumnal harvests when you look at the photo of George Fuller, and the godlike bust of him in sculpture on the mantel or was it on a pedestal, and was it not by [Henry K.] Brown who was of Fuller's time and teacher of Fuller for he had no teacher for painting, only for drawing and form, and this teacher was one Brown, who was also a great friend, and lived, was it not, in Albany, where other American traditions of a lasting sort began.

This great sweep of quiet opulence in the pictures of this thoroughly American artist is the result of fine ordered background, for Fuller married an exceedingly beautiful woman, one of the

famous Higginson belles who was said to have a natural talent for painting also, there being painting everywhere in the environment of Fuller-Higginson backgrounds, and so it was the best of Deerfield and the best of Cambridge [were] united.

As you hear this Fuller story from his daughter Mrs. Agnes Fuller Tack, it all sounds like one of those deep flowing northern rivers tumbling down over the boulders, told though it was with the simplest and shyest of manners, a great river flanked on both sides by impenetrable black woods where kingfishers dart to and fro and the blue heron might be seen at the glow of evening sweeping like an arrow out of its quiver to some quieter and less haunted waters upstream.

Or more exactly in a local sense, you are aware of great open tracts of land ploughed furrow for furrow with stout horses, and stout males such as Fuller guiding the plow, for he did his own farming, and when there was a lull in farm work, he did his painting, the very best way for any real artist to be living, or so it seems to some of us, and the blade of the plough glistening in the new light of the morning, when the mists have risen and the birds are well about their daily business.

Hawthorne now is telling of marble fauns and scarlet letters, Whittier is telling of village blacksmiths, Longfellow is weaving the legend of Grand Pré[1] and Evangeline, Margaret Fuller is speaking firmly and with original force, Thoreau is looking at lakes and telling their depths by eye measure, being far more entertaining about nature and all its aspects than he is about law and philosophy, and the others in Cambridge are pouring forth riches and you hear the deep full spiritual voice of Emerson quietly mounting and rising upon the air, and there is the sense of fine plain living and spiritual opulence everywhere.

The elegant shyness of Puritan tradition permeates all this scene, you did not make loud noises, you did not speak above the true tone, you acted more like the rain, the wind, and the sunshine did, you had your distinction from these typical virtues, you did not disturb life or nature by unseemly behaviours, everybody did his own work, and so George Fuller was to be found quite naturally behind his plough and not at all according to earlier cheap rumour, for Fuller

---

[1]The Acadian settlement in Longfellow's poem *Evangeline* (1847).

was not poverty stricken, he had five well fed children, he made them all laugh and laughed little himself, and spread paternal and friendly influence over the house and all its inmates, and the animals in the barn as well, everybody housed, warm and happy.

All these terms are given in their fulness by the kind of painting that George Fuller did, it was full-blooded, large hearted, and deep souled—all this richer than in perhaps any other American painter, no trace of struggle toward sublimation appears, for nature had worked everything out according to mathematical plan and there were no left-over neurotic tendencies to care for.

As completely a reverse case as that of Albert Ryder, who was by far the greater actor in the world of the imagination, and if denial is the means by which one arrives, then Ryder did all that could be done about that, but you can go to Fuller's broad sweeps and find repose on the vast bosom of contented nature, and therein lies Fuller's special contribution.

In the far west, the buffalo were still roaming the plains, for 1818 was the era of Fuller's birth, Audubon was hunting his birds, and Whitman was beginning the shocking "Leaves of Grass,"[1] and in these three images alone one gets a picture of masculine vigour and naturalness in the world of art, not too often to be found there.

And imagine just such a gathering of men under a great over-hanging elm in the main street of Deerfield, Emerson across the street perhaps, Thoreau looking out of a cold window, talking, not of poetry certainly or art, but on the ways and means of getting better tobacco crops, and a little girl in a white dress with chestnut hair "like the wine in the glass the guest leaves"—she of the useless little slips of paper that went over the fence to her beloved sister-in-law, otherwise they would have gone in all probability into the kitchen stove—imagine this little girl rushing by as the giants stand talking about tobacco crops, and the surprise coming in here, that tobacco was at so early a period being raised around Deerfield, for it is long since a tobacco center, and to learn that the Fullers were even by then raising their own tobacco, and specializing on a large variety of strawberries, all a very healthy sort of environment for art to spring from.

I asked Mrs. Agnes Fuller Tack why she didn't gather the George

---

[1]Fuller was born in 1822, but Hartley is talking about the period around mid-century. *Leaves of Grass* was begun in 1847 and first published in 1855.

Fuller pictures together and give a restrospective exhibition for the benefit of the present generation, and her only answer was, "I do not wish to show them, I wish to place them in one place," which is of course natural pride of heritage, and the natural place for all this is of course Deerfield itself which attracts the tourists in hundreds because of its general American tradition.

All the pictures in the possession of Mrs. Tack are excellent examples, though in a shyer manner than the outpouring picture of "The Octoroon," and I recall now in passing that Mrs. Tack had said that her father and mother would not wish public demonstration, though I urged the examples of Ryder, Homer, and Eakins of late, to bring before the new young eyes the force of this rich period, which hardly more than now is beginning to be really thought of, painting having gone thin, theatric, and somewhat feeble in this country since that time.

Of course the answer of the new crew will be that early American painting was founded on European tradition, shaming itself to think of names like Titian, Giorgione, Rembrandt and Vermeer, and the only answer to that is, what of it—since tradition has to begin somewhere, and what better ones could have been found than the one that was chosen. There was no other.

One thinks of the George Fuller pictures as fairly early but one does not realize that Fuller died in 1880,[1] which is fifty-seven years ago at this writing, but so it is, good painting travels along, and there is a quality something like timelessness in Fuller just as there is in Ryder, whereas Homer and Eakins remain distinctly dated, and that is their special significance, for it is no smart thing to say that Fuller and Ryder strike a louder note in the American scale, than any other of the American artists, and these pictures will be standing on the walls like epochal sentinels, sad to say, when the Ryders have fallen to the floor, since Ryder was perhaps one of the most careless artists of all of them.

Ryder was thinking of all sorts of qualities outside his imaginative one, and there is no doubt but that he was thinking the rich impastos of Rembrandt as well as the whole-bodied substance that covers great ceramics of the earlier period, and as I have myself seen several of the now famous pictures of Ryder in his studio as I have told

---

[1]Actually Fuller died in 1884.

elsewhere,[1] and of the alarming condition which they were in, for he must have rubbed grime and soot on them from the floor on which there was always plenty. He did not know that there are certain things you cannot do in the process of painting, and what some of these pictures will look like a hundred years hence, it is not possible to say, but some of them have certainly slid down the surface of the canvas, as ripples and ridges show everywhere.

Two great natures, these of Fuller and Ryder, both from the same rich country of the deep voice, both of them understanding their own local degrees of the imaginative revelation, Fuller the lyrical, Ryder the dramatic.

Fuller it seems went to Europe once with a small company of men in his own then youth, and came back saying he had seen old masters but that he did not need to see them again. Being Yankees, they of course gave one good look and what they took with them was probably nearly all of what was there, and a second look would merely prove another world and another life. The single remaining Fuller symbol in the person of his daughter represents completely all this background, she speaks Deerfield and not Boston, because Bostonese is sharp, cynical, and impious, which is most amusing if you like it and I like it, and having a friend for over twenty years now in the person of a distinctly representative woman, I know how entertaining, how sharp, and how funny that sort of thing can be, but Deerfield is a hundred miles away, and that is much better and gives this voice that fine sound of birds coming out of dark woods on quick wing, and the glint of the wings is in the quiet intonation.

If you linger in Deerfield among the amazing houses that fairly push the air with their persistent hominess and the great sense of opulent simplicity, you realize that only that redeeming quality could come to such full expression as in the paintings of George Fuller, and it does, completely.

Marrying for love, living for love, ploughing and painting for natural unspoken love, this is what makes the paintings of George Fuller resound with such depths of morning and evening music, and he was one of the last not only great but utterly handsome men of that epoch, and they were not scarce.

Men are now brittle and nervous, they were round and powerfully

---

[1]See pp. 256-68, "Albert Pinkham Ryder."

organized then, and their muscles sat on them like armor plates, and at sixty-two, the hour of George Fuller's death, you see the tremendous shoulders fairly aching to lay back more earth, to see more and more of the flash of the morning sun upon the plough blades, and what a sight this is in fertile country of fresh smelling earth studded with robins running for early worms. Fifty years of painting and ploughing, fifty years since this painting and ploughing, here are the witnesses to the great richness and full bloodedness of George Fuller, a true American painter.

Melville worshipped Hawthorne and craved affection not given, Fuller craved nothing because all the aspects were right in the beginning, great manly beauty, and the love of the one beautiful and intelligent woman.

Such a deep-lunged sense of life and art comes out of the George Fuller pictures, that I go every now and then to them myself as I would to a spring, where the water is fresh and cold, and has not been touched by alien streams, and the sense of huge hoofs flicking up clods as they saunter heavily down the rows, that too is invigorating, and that is pretty much the whole of Fuller.

# John James Audubon, as Artist

On the stairway of the American Museum of Natural History, you come upon a collection of drawings, engravings, paintings, the steel plates themselves, and other souvenirs of the famous naturalist, one of America's most valuable assets in the world of science and of

culture—John James Audubon. Little attention is probably given to the fact that behind all this vast knowledge of natural history of this indefatigable searcher into the profound secrets of nature, there exists a more than considerable artist.

You come upon a tablet of this man, and it reads—"Audubon and his work were one, he lived his work and in his work he will live forever." And the truth of this statement is so sure that it is worth quoting and thinking about.

An examination of "The Birds of North America," those huge volumes that testify to the incredible labours of observation which are the works of Audubon, you are impressed with the fact that not only was he a highly gifted naturalist, but that he was also quite something of a real artist with a fine gift for stylism which is seldom found in the work of the lesser painters of nature.

This collection on the aforesaid stairway is far too important to be reposing where it is, the great naturalist should be having an alcove to himself, he should be made a feature instead of what he now looks to be, a casual asset to the museum. Taking but one example of this naturalist-painter's work you are so close to it that you can hardly see it properly, the excellent portrait of the American porcupine and an excellent specimen of painted accuracy it is. You have the animal with the sense of its life which is amazing, for Audubon has seen and noted every [one] of its characteristics with the eye of a camera, but plus.

Audubon was not trying to be artistic, he was not trying to be anything but truthful, he was certainly one of the great stylists of naturalist painting, and if he possessed anything like the real artist's talent of a Hondecoeter, or Snyders, or Weenix and others of the Dutch school, not forgetting the gifted Van Aelst, we should have very great works of art in our possession.

If the pheasant picture of Audubon has reached such a height we would have had something more to cherish, but as it is, the pheasants are not flying from the hound, they are static, and they are not possessed of the same passion for naturalistic fact as is contained in some of the other pieces, such as the raccoon or the wolverine drawings, which are in watercolour, giving proof in these last, that Audubon had it in him to become a significant painter, if the quality of art had been more at home with him than it was.

The true pictorial grandeur of the Audubon designs comes out of

course in the famous bird plates—in most cases the actual size of the birds, referring especially to the wild turkey plate and the various heron plates where the element of design comes grandly to the fore.

But, a new agency enters here at this point, for the engraving, printing and colouring were done in the first ten plates by W. H. Lizars, the rest of the volumes being executed by Robert Havell, Jr. There is no question then that Lizars and Havell Jr.—even under the direction of Audubon himself, and they undoubtedly were—take on an artistic strength which does not exist in the same powerful degree in the originals because of the medium alone. The metal of the plates, and they were done on copper and steel, would account for a deal of this remarkable stylism and precision of execution, and doubtless have added a special intensity to the originals made by Audubon himself.

The plates of the wild turkey, white-headed eagle, great blue heron, wood ibis, are the most stupendous and brilliant renderings of bird character and design, and when you come to the plate of the whooping crane pecking indifferently at baby alligators on a mud bank, behind which the curve of a lake or the bend of a wide river is seen, the darkening of the forest beyond the sleek curves of the bird, you are compelled to say that even Hondecoeter did not go farther than this, that is he did not excel this majesty of presentation, but of course Hondecoeter confined himself chiefly to the fowl of the barnyard and with whom else shall Audubon be compared in the world of art in the painting of birds? Collaboration in art often brings superior results, and surely no interpreters have done more for their master than Lizars and Havell, Jr. have done for the great Audubon.

These bird plates as most of you must or should know by now, are all but breath-taking, you even feel the tempestuousness of animal egotism in them, you feel them living out with dramatic ferocity the smart forms that nature has given them and wishes them so to perpetuate.

It has been the fashion for some time to use the Audubon plates as living room decor, just how permanent an idea this will be remains to be seen, but it has only been recently found out that Audubon was quite something of an artist, and a very typical one, as typical as Buffalo Bill and Fenimore Cooper have long since become.

Due credit must therefore be given to Audubon as artist because as you view these enormous tomes of "The Birds of North America"

you realize at once that it was the artist that saw them through, and that he had power of vision, force of imagination, and fine dramatic gifts for presenting his forms, as well as his scientific information. I recall nothing like them outside a large collection of similar designs in the basement of the Uffizi in Florence, by a naturalist of the Renaissance period, whose name for the moment escapes me.

The combined artistry of Audubon and the deep sense of values as appreciated by Lizars and Havell, Jr. present to us admirable works of art that have a life of their own quite outside the naturalist intention of information. Audubon was too true and too simple to affect anything. He had science for an obsession, he had the wish to leave nothing unsaid about his specimens, for he was thinking of the scientific value of his ideas first of all, and he had little thought I am sure of gaining a place in the field of esthetics to which I feel he is eminently entitled. At all events Audubon escapes all casual patronage by bringing sharper eyes to the consideration of him as creditable artist, and his designs take their place in the field of art with quite as much dignity as a design of Blake does. Audubon was all observation and recording, he was a great reporter of the naturalist fact, and he was a creditable artist in the bargain.

The primitive energy that is behind all these drawings allies itself with the forces of a man like Courbet for whom nothing existed but the visible body of the fact, who wasted no time prettifying ideas that were trivial to him, he was masculine to [the] last drop of his blood, and so was Audubon in the same degree of relentlessness, he wanted the truth registered in terms of truth, nature in terms of nature.

Perhaps one of these days the Museum of Natural History will take the hint, and bring these fine designs of Audubon out to the light where the children of this and the next generations may get a square look at the gifts of this significant man, and realize that a painting of life in the natural world may also be a work of art, and lose none of its scientific veracity. Audubon proved mightily, that this may be accomplished.

# Ablution

If I want to wash my eyes out good and clean of all the flotsam imagery of a dark and frantic city and the only one of this sort I know is New York, for all the others seem to have a calming influence on one, I have recourse to two cleansing processes, one is the Egyptian department at the Metropolitan Museum, and the other is the geological department of the Museum of Natural History, and this museum is of far greater importance to one's eyes than most painters would think possible, but as we are all different, we find out satisfactions in different ways.

Pictures are probably fatiguing only to the person that is engaged in making them, and the time comes on him, that is, the moment when he is sure to feel that it is all a sort of nuisance in the scale of human experience, and if we weren't made so constantly to feel the sacredness of art by the art lovers, we might probably be better able to take it as it is, and get more enjoyment out of it, but so few seem to know that art is in no sense a holy matter, no more wonderful than dope-taking or prize-fighting, or whatever.

But the eyes get tired of looking just as the rest of the body gets tired with bucking up against all the other dull obstacles of daily life, and since the eye is the almost sole means by which some of us experience or desire to experience life, these eyes need to go where they can find refreshment. And so it is, I go to the geological department to gain new substance from the wonderful mathematical variations of nature, and among the stones, to speak of them properly, there is enough for great satisfaction.

These stones pick you up, they do not wear you down like the vast stream of faces one sees on a crowded street, all so standardized by virtue of having the same obsessions, which are chiefly of course business obsessions, and they themselves do exactly the same thing, they come out to get a lift from those molasses coloured desks all littered with figures on the subject of heaven knows what offal of the world.

254

We are all alike since we belong to the same order of dull human beings, and if we are to get up out of the grey wash of daily contact, we have to do something about it ourselves, so I do the natural thing for me, I go to the wonders of nature, and if you can beat the unalloyed magic of these specimens of stone from beneath the surface of the earth on which we walk so heavily, it would be nice to hear of it.

Here are shapes that have outdone the architects and the cubist experimenters, here are shapes and colours that make the outer world seem like a cheap maquette for stage purposes, and there is no use asking why all this goes on under the earth where it is never seen, because there "ain't no answer." But take a turn among them, just for the sake of washing the eyes out and the difference will be remarkable.

It will as has been said be of no use to make enquiries, because the scientific cataloguer will get out his ticker tape and run along the edge of all the latinities and give you the prescribed one for the prescribed object, and you are worse off than you were before.

That little harmless shock of pleasure is what the world is after, and the eye brings most of the joy of life anyhow, and the more the eye knows, the more rest the mind may have, because the mind is befogged from morning till night making apologies for bad behaviour and false conceptions, and in the end we are left stranded anyhow as far as mind is concerned. And it is enough to know that the eye when trained to be truly perceptive and receptive, receives all there is, since appearances are everything, and deductions nothing, for in the best sense of the word, seeing is believing.

Peel the eye properly, drop a drop of the right degree of stimulant to curiosity in it, then open it wide and you will be surprised for fair, and as rich as famed Croesus, for nothing can buy this thing, you must teach it to yourself, you must get it by exercise of your own imagination and a true sense of observation, no one can prescribe what you must see, you are your own trick performer, your own magician, and all the baffling wonders will be observed by yourself.

Give the eye three-fourths of a chance in this world, and you will get by a lot of tiresome experiences in a world where only the look of things [is] important, and in general what the common mind says of them, nothing.

# Albert Pinkham Ryder

*(1936)*

One supposes it must be more or less comforting to those who are old fashioned enough, shades of Murger et Cie. to assist them, to entertain the idea, hackneyed enough, that in order to produce good work, the artist must be all but throttled with poverty.

The copious but by no means complete show of Van Gogh at the Modern Museum[1] just closed today, with a gallery mob standing in line after the manner of the queue at the Metropolitan Opera, reminiscences of the amazing spectacle of the same order at the Hispanic Museum in 1909, when cordons of police kept the public in single line as at a baseball game, letting them in one by one to file past the pictures and see them if they could, making no great difference after all as the Sorolla pictures added no whit to art, but were interesting as national documents, as they are now, also with the difference that in the case of the Sorolla holocaust, the artist went home with something like two million dollars, and rationally enough, never came back again, America so grandly gullible as it was then with the perfectly staged exhibitions of that time, and now repeated again in the case of poor Van Gogh who like the Son of Man had not where to lay his head, and by whom the ravens, at least one good raven in the person of his devoted brother, Theo, was fed. What a sad beautiful pair of men these were, and now we have another sob story to weep over if we are to weep, with the terrible story of Vachel Lindsay, perhaps all in all one of the most American poets America has yet had, taking poison to end all his troubles,[2] with a more than faint insinuation that he too might have gone the way of Van Gogh and lost his reason. Well—enough of all this twaddle—except to repeat history cases in the lives of Masaccio, Piero della Francesca, Rembrandt, Modigliani, Marie Delna, one of the greatest vocalists that ever lived, dying in a charity ward, Francis

---

[1]November 4, 1935-Januray 5, 1936.
[2]Lindsay's suicide occurred in 1931.

256

Thompson—saved from further starvation by the Meynells, and taken to the brothers eventually in Stonington, out of which tenderness came "The Hound of Heaven" and the list could be continued ad infinitum.

That poverty is necessary for the production of art, is also finely contradicted and in our time we find that men like Degas [and] Manet, were gentlemen of the haute bourgeoisie, and if Cézanne was of a little lower stock in the matter of class, [he] was inordinately rich, anybody would have been glad of his income, let alone an artist, but the riches of these men made no difference whatever to the natural flow of their talents. On the contrary, they were freed of romantic anxieties, and therefore were able to proceed without having to stoop to regard audience or individual, and while Père Corot was smoking and painting peacefully at Ville d'Avray, Millet was starving on the edge of the fields at Barbizon, Corot was good enough to save Daumier from the law, Monet and Renoir later liv[ed] in huge comfort, while that perhaps best of the impressionists Alfred Sisley was stealing potatoes at night to keep his large brood from hunger. Well, one could fill pages of this sort of thing alone. In W. B. Yeats's memoirs we hear Lady Gregory saying something like this to Yeats as she leaves a twenty pound note behind the clock—"The only immoral act (or crime did she say) is to let anything interfere with one's best work."

As to just how poor Albert Ryder was is for some a matter of conjecture, for there is rumour that there were always checks lying around in odd drawers left uncashed for months, but if the surroundings in which he lived are criterion then Ryder's case was one for social shame and something like heartbreak. You do not have to be a daily visitor to the bread line outside of a soup kitchen, standing for hours at a time freezing to death the few vital energies that are left, [to know that] even a bowl of soup in a room of one's own can be somewhat of a legacy in itself.

Ryder was never in a bread line, but I doubt very much if he ever neglected the privilege of going to his friends the Fitzpatricks who then lived on Seventh Avenue not far below Fourteenth Street, having been there but once myself, [it was] the plain home of a very dear little woman who painted herself, [and] was probably a self-appointed pupil of Ryder, who[se] work was done in the style of Ryder, but was feminine to the last in touch, and of course

completely without the vision. For all that Mrs. Fitzpatrick was not a bad painter by any means, for she had the rich sincerity of the amateur's ideology, and we know plenty of cases where these people painted with great beauty of feeling and touch.

Ryder did not frequent bread lines, because he had thirteen cents a day to live on, he having told an intimate friend from "up town" this, and Ryder was not a liar.

I knew Ryder, and if I knew him but slightly in point of the number of visits, and I have regretted since that they were not more numerous, I feel I can say that I knew Ryder, because a good round five minutes would give the whole bread and wine of his being, and if I had visited him oftener I could have seen merely more of the incredible squalor in which he lived, some of which was doubtless wilful negligence, the rest being utter helplessness, for—as he said to me once, "I do not see all this until someone comes to see me," and it was necessary to put him at his ease at once as regards these matters, carefully of course, for the man was too fine and too clean to insult with any degree of patronage.

I knew Ryder to the extent of receiving one or two of his pencilled lyrics, and while these evaded me in the shuffle of time and the general upheaval of states, and by "states" I mean the artist's states of being, I recall their far away lyrical note, idyllic beauty and lost love being of course the tenor of them, and these were the actual tenor of everything that he did, throwing himself as it were into the vastitudes of oceans, as well as into the arms of the receiving mother of the lost, for he was one of the greatest of the moon's precious citizens.

Ryder had a three room tenement on what I now think was the third floor of an apartment house inhabited by poor working people, just below the corner of Eighth Avenue on Sixteenth Street, the south side of the street, and though I myself lived in rooms in one of the houses of that long row belonging to the Astor estate which were a landmark of their time, it was not until the end of a nine year's room residence in the same house in Fifteenth Street west,[1] or a good full block around the corner, that I came to know that Albert Ryder was

---

[1] Hartley's memory of addresses became a bit confused here, but according to his autobiographical notes, he lived during this nine year period at 351 West Fifteenth Street. Lloyd Goodrich states that for fifteen years (from the mid 1890s) Ryder lived at 308 West Fifteenth Street.

my near neighbor, alas that I didn't break my so rigid rule not to disturb the man from his dreaming, even when he was then becoming something of an alarming fad, [and] was being visited by all sorts of people, usually artists I assume, as whom else could possibly have been aware that Ryder was alive at all, save the kids of the curb who thought of him at worst as an old bum, or at best as a queer old man who must have nothing more than rats in his belfry to make him look and be like he was, to them. But we have long since learned that rats in belfries have sometimes gold collars around their necks, and glints of heaven in their eyes, with special privilege to gnaw at the hinge of the gate of heaven.

Blake had the same kind of belfry and the teeth that gnawed at his garments and at his brain, were also granted special dispensation.

Then it was gas illumination, and the jet barely visible in the darkened halls, with just a little wisp of blue flame to tell you how to further penetrate the dark areas, showed the way to the strangest domicile ever witnessed by the human heart, heart being all eye in such case.

And when the door opened, you were confronted with first an incredible mass of domestic debris, and until you learned how and where to step, you found it exacting to step at all. The north room was blocked to the ceiling with chairs and table mixtures, without doubt the sentimental heritage of family left-overs, and one can even imagine the dear old man thinking that one day when love would really come and abide with him wholly, then there would be furniture of good standing to set up the proposed nest, but the furniture was never called for, for such purposes and remained therefore in the condition of debris gathered to itself as if for its own sentimental needs.

The west-south room was obviously the living room, for it had a very small stove in it, and around the stove, besides the usual overflow of chairs, broken settees, stuffed seating objects, or what-ever, there were numerous piles of ashes, oatmeal boxes, tin cans of whatever sort, and you learned that it had one meal been tomatoes, and another meal corn, and in and out of all this there was a path to the two grimy windows, never having been washed in years probably so that the film on them provided scrim curtains to keep out public gaze, and to the left of this path was a long roll of carpet which had doubtless once covered the Ryder parlor, of course the

parlor of his parents, and by no means his, for after the family establishment was broken up it is not likely that Albert Ryder ever stepped into a family parlor again and he was still young then.

It was on this roll of carpet that Ryder slept, and you remarked the depression of his strong body in the center of it, and the other two ends being therefore raised, provided a pillow at one end, and foot rest at the other.

The rest of the setting you are left to arrange for yourself, and you saw the east-south room in pretty much the same condition, being full of dusty packages, boxes and cases of something or other, furniture upside down, and this has also the air of another store-room, but a little more readily navigated, at least by Ryder himself.

I date this period, or nearly so, by the portrait that was done of him by [Kenneth] Hayes Miller, which eventually became a portrait of a very stately man, but no one that I knew who knew Ryder, could admit that this was the Ryder that they knew, any more than the photograph which Alice Boughton took of him at that time, would be more readily acknowledged, but there is an explanation for all this, and the fault is certainly Ryder's and not that of either Miller or Miss Boughton, for Ryder was in the habit of "dressing up" when he went anywhere above Twenty-third Street, and ordinarily he did this once a year when the day would be taken off from all moon argument, and he would ascend to the fashionable heights to do what he called "looking at the pictures," and it was on one of these august occasions that I chanced upon him in the Macbeth Gallery then at Thirty-ninth Street and Fifth, where he said to me, going up to one of the pictures and pointing to a certain small passage in the lower left of the canvas, "that's nice," and passed on to the next picture, and the picture pointed at was of course a very common one.

What a pity that both Miller and Miss Boughton were not allowed to get Ryder as he was from day to day, as one saw him seldom in the daytime but frequently at night, every night certainly if one were there, for it was the early evening that found him strolling up and down Eighth Avenue, hands behind his back, from—and beyond—Kiel's Bakery where a lot of us were lavishly fed on solid German food for a quarter, and if Ryder lived on thirteen cents a day, then we were of course being nothing less than bondholders spending twenty-five for one meal, including some brown and white mixture called coffee and a cut of pie from the front of the store, or whatever.

There was also opposite us all on the other side of the room a lot of oyster-openers from Virginia, with the mark of their trade on their hands, and a decent lot of men they were, too.

I give the slight vignette of Kiel's Bakery which is much more elaborately given in Alfred Kreymborg's "Troubadour," for Alfy, mandolinist, crack chess player, poet, playwright, and general disturber of the poetic peace, was among the regular feasters at Kiel's or, do I do him too much honour to say that he was as regular as we were, for Alfy lived a hard life then, we all had it hard, but I think Alfy felt the gnaw of the rat's teeth at his heels much too often to be a happy affair with him.

Ryder was a frequenter at Kiel's Bakery, and one could see him there sopping up coffee cake or whatever, and as it was across the street from his place, he was doubtless a daily customer there.

Ryder was so majestic in his grey wools, sweater, skull-cap to match, with a button of wool at the top, and this is the Ryder that we should have had completely recorded. This cap came down to his shaggy eyebrows which were like lichens overhanging rocks of granite, the eyes that they now tell me were brown I thought of course to be blue—thought them blue probably because blue eyes seem always to be looking over desperate horizons, and an intriguing dissertation on the matter of blue eyes is to be found in one of D. H. Lawrence's essays.

There was the heavy mustache, and the long flowing beard, all lichen gray, merging into the grey wool of his clothing, all a matter of protective coloration without doubt, having something to do with Ryder's shyness, as the many veils has to do with that other wonderful American genius, Minne Maddern Fiske, who, so afraid the public would recognize her on the street as she walked to and fro with her coloured maid, in at least good weather, dressed in the shabbiest of green black Alpaca coats, the veils, and were there not four of them, drawn heavily down against the world which had brought her also, great woman that she was, to the point of hurt questioning.

Brown eyes then that seemed blue, skating on the far thin ice of labradorean visions.

Visionaries are nearly always summoned to the centers of revelation, and Ryder, being among the first citizens of the moon, became at once prince and serf of this exacting kingdom. Ryder enclosed

himself in his imagination, and how fortunate he was in this, so utterly impossible now, with the iron tendency for regimentation in all phases of life, and the commercialization of talents, poor tragic, spiritually kingly Vachel Lindsay whose recent death in misery brings all the more to the surface the sad lot of the poor fool who believes that vision is everything and fact to be ignored.

How could a visionary live today and thrive with Franciscan faith and purity, for "where there is God, there is Nothing" and that fine phrase of Whitman's "Nothing, not God, is greater to one than oneself is"—anathemas be poured like lava upon all such impractical nonsense. You will find no visionaries today, you will find them under the white stones, or under no stones at all, wild flowers and grasses by the way have fed on all their substances, and these in turn have fed the free roaming animals, and the air has taken the rest, so it would be hard to find those sad objects of the nineteenth century, for which there is no place in the twentieth, hear again the terrible cry of Lindsay.

Ryder had business with the major premises of a very grandiose order, and his small but majestic product, not more than two hundred canvases in all they say, none of them large, size itself being terrific substance, and that is why and how the small things poured out and still pour out such terrific wealth of vitalizing experience.

Ryder being as he was, inviolably romantic, it is easy to understand that he should fall ill at the sight of Nordica, the O so beautiful Nordica in "Tristan and Isolde," and what is there about this opera that goes so to the very centers, for only two days ago a strong, healthy woman utterly free of neuroses, told me that she had to leave the box where she was guest at a Flagstad performance, overcome with a spell of seasickness.

Romanticism is a dangerous disease apparently and must be watched, and its victims must steel themselves against too much of beauty in a gulp. But there it is, Ryder a man became ill with the sight of Nordica and the sound of Wagner, and anyone will admit that this is not just music, and he was ill for a period of weeks afterward. This is more readily understood in the case of Ryder, for it all had to do with the love image and love denial, he to whom love had been denied and from which he was so ably guarded by his over-zealous friends.

If I am not mistaken, it was at this juncture as told me by the late N. E. Montross, that Ryder was taken abroad, the first edition of

this story being that Ryder got off the boat on to the dock, and waited for the ship to turn around, or did he make two trips?[1]—the second time, having visited Holland, and the Louvre—and that his guiding angels were incensed with his lack of cultural sense by not looking at everything in the Louvre with the eclectic eye, or—as was said, without looking at anything, and this last no one believes for to look at his pictures alone one knows that he looked well, even if at no one else, at Rembrandt, and if he [had] one good look at the "Night Watch" with his sensitive nature, he might have fallen ill again, but for other reasons, for the laws of life are so overwhelming in that picture that it takes a calm nature to look at it at all.

Ryder found the Louvre exhausting, and who hasn't, but there is every evidence from his pictures that he looked with microscopic intensity at something or other, for his entire technique, fautly as it was, was built up on European culture as imbibed from the masters, and [if] it was not from the Venetians, or from the primitives of the Renaissance, it was certainly at Rembrandt that he looked well and hard, for it was there that he would find the inexhaustible floods of humanism that made his own pictures so rich in that element, for even though people as such never entered into his compositions, for they were always ideas of people, he nevertheless painted a world in which people live, and to which the human heart and mind may have recourse if they have the courage to open their eyes upon it, fortunate in so many ways for the millions that cannot or do not, and it is to be quite understood when parents awake of a morning to find a child in the throes of some romantic extasy or other for theirs is a devastating and useless privilege.

Alas for the eternality of pictures, these of Ryder's are so far gone because of their faulty technique, some of them having long since slid down on their surfaces, lying at present in pigmental folds at the mercy of any chemical disturbance, and because they have lasted a small fifty years, is no sign they can live fifty more, though the picture expert will be the best judge of that; I myself saw in Ryder's apartment, along with "Macbeth," "Death on the Racetrack" [i.e. "Death on a Pale Horse"], and the picture called "The Tempest" which I do not see in the books of his life and works.

I was especially arrested by the sight of "The Tempest" because of its most amazing and fatal abrasions in matters of technique, for

---

[1]Actually Ryder made a total of four trips abroad to England, Europe and North Africa.

Ryder had run a hot poker through the thickest part of the sky, and these jags were filled with new paint whitish of course of which he was to build eventually by tonal processes the sense of jags of lightning as it cuts through the dark densities of cloud bodies in a summer storm. The rest of the surface of this picture was all scum, as was the Macbeth and the Racetrack one also, and they were not to [be] recognized after they had been through the hands of the picture restorer, not until after Ryder's death did one learn what was really his first pictorial intention, and the varnish that was applied for protective purposes, gave them a museum finish which was not at all natural to them when they were seen in his own rooms. These scums that were added by dust and abuse, were doubtless part of the process, as if he had reasoned that nature herself must have a hand in it too.

No artist ever used more of the vital energies of the imagination than Ryder, and no one was ever truer to his experience, for there isn't a false movement or tone to be found in the whole range of his works, with the result that one finds his elements so perfectly true, that even the moon herself must recognize them if she had time to look. The moon is in such perfect control of the destiny of his skies and seas, and whatever human incident there may be, associated with the same.

Will the ships ever reach a psychical, let alone a physical haven, do they not seem to be held in perpetuity to the hard business of roaming from one indifferent wave to another, are they not all Fliegender Hollanders, these common vessels, when they have gone over one explicit angle of their horizon, are they at all certain to achieve another? That is the look of the pictures, two small marines, of which I am thinking, having looked this afternoon for probably the hundredth time in the Metropolitan Museum, I see no hope for their ships ever reaching a prescribed safety.

Go to the Courbet marines, especially the fine one presented by Mr. Kelekian, and the difference of concept will be realized at once, for here nothing is fluid. All is the sense of a moment that will break and be something else, and that is the quality of the material world— Courbet was that kind of a man, volatile radical, who paid the price of exile from France for his political ideas, this misery you find depicted with hard, bitter experience in his picture of the Chateau de Chillon in Switzerland, of which he was visual prisoner.

These regal fragments of colossal dream of Ryder now testify that

a great spirit was among us, finding despite the thirteen cents a day, that he could live copiously in that world of greater experience which, if bought by devious and grinding ways can, nevertheless, be done, and that the "only immoral act is not to do one's best work."

Francis Thompson wrote "The Hound of Heaven" out of the garbage cans behind London hotels, and with the eleven pence a day gained by selling matches at stage doors, this gave him after all nine cents a day more than Ryder had, though Ryder did have a bed, his own roll of carpet, and Thompson had a three-pence-a-night flop on the Embankment, or perhaps off it somewhere.

Long residence in this same tenement in Sixteenth Street disturbed no one, probably no one but the stray cats that roam the night with other victims of the moon were in the know as to Ryder's real occupations, and as he doubtless fed them, they were poignantly aware of him, and can't one see them all grimed and soiled, grazing the stout legs of the mystic, before the break of morning?

The poor people who lived in the same building might at least have seen now and then that amazing door open, long enough to let the mystic in or out, but could they have been aware, any more than the street urchin who called him bum, have been conscious of that exceptional mission being performed among them, or understood the meaning of his extravagant plight? No sense of anything probably but the fact that an old man was living alone, and what could he possibly be doing so terribly alone?

There is rumour that Ryder was not utterly poor, that there were checks lying about for months uncashed, but it is hardly likely that any of them were fortunes, merely the monthly installments of patrons, of which there was a small handful, who bought these pictures on time, therefore on easy terms for themselves, and it is very doubtful, Ryder being a Yankee, that he did not know the meaning of money at all, for a Yankee, at least old school style, would be sure that what he had in his hand was a fact, and would not fix false values on promises or hopes. Ryder belonged to the Thoreau period, therefore of the same practical ilk, and we know how grandly Thoreau lived on meagre sources by the labours of his own body, and what a wealth of independence he drew from all that radicalism for which he was so famous among his friends—"I love Henry but I cannot like him" being the very expressive testimony of Mrs. Choate, delicate and true enough, probably.

What inscrutable mathematicians these high visionaries often are,

you need only to look up the available histories of men like Francis of
Assisi, Jacob Boehme, Richard Rolle, who, if they eschewed
poverty as a divine mission, nevertheless drew forth out of the
sacrosanct mercies of nature, whole-sized intuitions if perhaps not
more than half-sized realizations of body welfare.

Ryder knew the meaning of poverty without question, for he was
not selling a picture every week, and because he had some money
stowed away in odd corners, only means that like the squirrels, he
was merely storing up nuts against a hard winter, and maybe a still
harder summer, he knew that life was like what life so often is, hard,
mean, cruel, he knew that the compromise was the costly thing his
soul could not afford, he knew that it is the one sacred thing left to the
innocent and the sincere, sacred as it [is] merciless, and when the
head is among the stars, the feet hardly recognize the rocks that draw
the blood from them.

Albert Pinkham Ryder, with his Job-like physiognomy, stalking
among the Hudson Dusters, who were then performing their
nightly slugging just down the block from him, when even I myself
lived for nine winters and never heard so much as a whisper of them
until long afterward when they had been completely annihilated by
police efficiency—like a hermit thrush that sings the last song into
the mouth of early evening, when the day birds have done too much
of glorifying the day, this was Ryder the dreamer whose dream came
to life when the moon showed its young or old face above a city
horizon, in the throb and throe of Eighth Avenue, amid the deep-
throated clamours of ships sailing for Europe at the end of his street,
and his eyes glued to the dark secrets of his native New England
which held for him all he wished to know of the major premises and
deductions of universal concept.

Ryder had a good mind, else how could he have filled so glorious a
mission, he had much to thank Shakespeare for, and the music of
Wagner added to his wealth of the melodic sense. Shakespearian
sense of lyrical measure, Dantesque sense of profundity, mystic's
simplicity and mystic's belief, and the gift of unmitigated devotion.

How else is the imaginative artist to know the meaning of things,
save by a fine co-ordination of some such elements? What painter's
culture he acquired was essentially European, his private experience
was universal, and what gave him his personal and national power,
was his New England gift of penetration into the abysses of

loneliness. He knew the meaning of being alone with the Alone, he was in constant conversation with it, and for this reason the common babble of inferior minds fell on him like so much rattling of ill-adjusted gears. Therefore the language he acquired was the result of knowing that the Alone is really the only agency with which anyone can really be familiar, every man having equal chance of this, some being brave enough to invite, and most exacting of all, endure it.

Ryder's solid background of fishermen, carpenters, masons and such, gave the natural forces behind all his pictures, and the building them out of the deep substances of himself was the rest, bringing to his pictures their amazing vital strength. There is no need to go into consideration of the individual pictures save to say that those which concern the sea are in truth the deepest because Ryder was closest to the sea by heritage and environment.

The purely legendary pictures such as "Pegasus" are their own witness to the power of his imagination, the true nature of life is always in evidence, the living image of the world in full presence, its august power prevailing in rich, full pressure, the complete realization of the world within in complete comprehension of the world without.

Be humble before the deep purposes of the universe, Ryder would seem to be always saying, always to be thinking, as one looked for the light to come from his eyes out of the dark caverns of his spirit's disasters, out from under the shagged cliffs that were his eyebrows—be humble before the things of deep purpose, tactful omission of self, one of the most convincing proofs for power in living is to be found in all the works of Ryder, from the little yellow canary lying in its sun-colored shroud, to the stupendous and almost frightening "Jonah"—having in their way no rival, and certainly, no equal.

The secrets of life are not given to boasters, and Ryder never could have been convicted of this misdemeanor. He would have been far more likely to have agreed with Montaigne's "What do I know" than with Keyserling's "I know everything." He did not argue that the husk was the corn, the bark the tree, or a flood of psychic travesty the sign of penetrating experience.

This gentle soul, being born a nobleman in the aristocratic country of the imagination, was at once its humble ruler, as well as its loyal servant. He was prepared to perish for his ideas, nature recognized him as one of her most dutiful sons, and accorded him the

honour of full understanding, with the admonition of course that he be always prepared for pain, misery, and even death by strangulation, for that is the way of the foolish who believe.

If the roll of carpet on which he slept, for he had no other bed, was a bed of sleep, then he slept royally, and if the debris that surrounded him represented the sense of home, then he was respectably housed.

He completed a magnificent destiny, and if he kept his patrons waiting for years for their purchases, they got incredible bargains for their mercenary impatience.

If America is to have a great tradition, it will begin with the great and lasting name of Albert Pinkham Ryder.

# And the Nude has Descended the Staircase

*(1937)*

The body of this paper was delivered as a lecture at the Museum of Modern Art, by their invitation.

A pleasing and convenient case history this, that we have before us on the walls of the Museum of Modern Art at the present moment, of the uprise and the descent into its proper place, of the idea of cubism. It is like coming across the family album, poring over old faces, old gestures, old costumes, old modes of conduct. It seems strange as we look at these old faces, to come again upon the qualities and ideas that amazed, confused and delighted us, seeming so nicely settled as they

do now, we having gone through so much since the isms started on their way to various victory, and many of these pictures that are now so nice and old fashioned to us were the cause of so much storm and abuse and disapproval and all but police interference, for novelties always go hard in a conservative condition.

The world of art in Paris was always in a state of cultural turmoil, for the French like that sort of thing, they help in the life or death of ideas with intense energy, and so if art from their point of view is to be fun at all it must be disturbing and must provide heated argument and battles of wit and intellectual fury, and the entrance of cubism brought with it its natural quota, and to appreciate that sort of thing, you must have either seen or been a part of it.

There was a time when impressionism was an affair of sanity or insanity, and then it settled down nicely only to bring forth a new and annoying "Barbare" in the person of Cézanne, and it was a case of too much again, and if Cézanne had not been a rich man he would have perished in the gutter, for the world of art loves a sad story, as perhaps all common worlds do.

Daumier was driven into the streets because he couldn't pay his rent. Corot found this out, decent person that he was, came to his rescue and gave him one of his houses in the country. Van Gogh was driven to madness, even if he was well on his way there anyhow, because he couldn't get recognition for his work, and so he perished, leaving something like eight hundred drawings and paintings in the seven years that were given to him to express his vigorous and perhaps too violent personality, never having sold a nickel's worth during all those years, and but for the deep affection for him of Theodore his brother, and what a rare pair of men they were, would likewise have died of starvation.

I reached Paris in the very vivid period of 1912–13, when so much was in the air at that time, it was electric with the prevailing energy of new ideas, and perhaps too electrified by the undercurrents of what was so soon after to happen, which was of course, the war. Cubism was already the thing, and it was hooted and laughed down, even as Matisse and Derain were, who were not cubists. Matisse was being primitive and Derain was being Gothic, and he was far more interesting than he is now, and has been for some years past, for now his pastey nudes are in every fashionable art shop, and the once fine flesh of earlier masters has become in him common studio clay, the

heart and soul of it all left in the trenches apparently, since rumour has it that after that experience he no longer cared for anything seriously.

Cubism is in front of us on the walls at the present moment, and by no means the best of cubism, and that often happens in museums, through perhaps the fault of no one in particular. This show of cubism is amusing because it takes some of us back to the rise of the movement or nearly so, at least to the great first exhibition of it which brought the movement to its feet and a number of its now celebrities along with it, and this exhibition was the famous one of the Section d'Or, where the exhibition not only excited one, but gave one a feeling that art can always be alive when the painters that practice it are alive.

All pictures go through three stages of existence, that is all innovational pictures—first comes their newness and their possible revolutionary aspects, then they become classical because they are no longer frowned upon, they take on the look of august authority, and thirdly, of a settled kind of humanism, making us feel toward them as part of ourselves, or as sort of second cousins who after all are not so bad, and somehow represent the family stream rather well. With the lapse of time these cubist pictures have accomplished this, and we now think of them as playmates of the past, when they were rough and ready, played the bully, and as they grew older, became the solid companion. We look at cubist pictures with ease because we understand them [just] as we looked at them with surprise when we did not, and it is not in this case the familiarity that breeds contempt, we know them, and we know that they were after all just as respectable then as they are now, only—we are not surprised.

The best of cubism has stood the test of the years with bravery but a lot of these particular pictures here look tired since they have lost the power to shock or to amaze newcomers, and the general attitude today is, anyone can do cubism, and a lot of painters are still doing it, or pictures that depend upon cubistic notions for their strength.

On the further wall is the once so notorious picture called "Nude Descending a Staircase" painted by Marcel Duchamp, and is the picture which was the butt of ridicule for the now so famous Armory show here in New York, and like the other picture that bothered so many people, Paul Chabas' "September Morn" which now of course

no one thinks[1] of, and you may find it in life size form in stained glass in a certain villa in Mexico City in the house of a mestizo of course, and while we are thinking of this, "Nude Descending" would be fine put in stained glass also, and who knows perhaps this will yet happen, as there are always or every now and then, epidemics of something or other. "Nude Descending" is one of the best pieces of cubism ever painted, and we are surprised to find how sensible and tame it is to us now—something has happened to us since there is nothing in a picture that is not put there first by the painter, and afterward by ourselves.

Something had happened, cubism was put in its place as a cultural factor, and if it had a wide swing in painting for a long time and still is on the go, it probably had its most logical expression in the field of architecture where so much has been done with it and is still to be done, and we all know how the stage strengthened its weak spots by the use of the cubistic principle.

The "Nude" was the grand news scoop for the Armory period, but who will look at it now and bother even to ask why it is called nude, why it was called anything, or why in fact it was ever done, but it was done and the world was different. The "Nude" was not negroid in its arrivism, and so it naturally performed its own miracle, it was intelligent, clever, profound, and it was more than that, it was a complete comprehension of what art is all about, and since Duchamp was one of the most intelligent painters of this modern epoch, it is easy to hear of his being dubbed the modern Leonardo.

This notion of settledness is perhaps best expressed by my friend Gertrude Stein during my last visit to her in Paris. I was hoping for a nice evening with American cronies of whom Gertrude was always fond, but instead it turned into an evening of gossip in French, and as I am not interested in gossip in any language, and no one in the room outside of Gertrude and Alice were in the least interesting, the

---

[1]The incident referred to here occurred in 1913 when the Armory Show was exhibited in Chicago. According to Milton Brown's *The Story of the Armory Show*, the arrival in Chicago of this history making collection of modern art was preceded by a series of moral charges by irate citizens, and reported loudly in the press, followed by the removal from a Chicago gallery's window of a reproduction of Paul Chabas' painting *September Morn*. This and the unfavorable press reviews did much to prejudice public opinion against the exhibition.

evening dragged a bit, and after a certain young American, who was supposedly in the "Avant Garde" as far as art was concerned, moved over to the divan where I was sitting and tried to be just homey about plain things, I took the chance of seeming to be odd and got up on my feet to see if perhaps there might be at the street end of the room, some air to breathe, and there was, and with that as it sometimes says in the stories, "and his eyes fell to the ground," my eyes fell on the pictures, since they didn't want to fall on the ground, and so naturally the process was, since I knew every one of them well from the years past, what do they look like now, with their pieces of newspaper insertion, of cloth, and other odd bits of things, and the answer to myself was, they look so settled, and soon Gertrude followed me, and seeing I was looking, asked, how do they look to you now, and the only answer was, they look so settled, and Gertrude's reply was, that is the trouble with them.

I had often been in previous years in the famous room, for Gertrude and I were always good friends and are still, and I think it a mark of great friendship really that she should speak of me in five clipped words, "we liked him very much," where óf my friend Rönnebeck whom I had taken there she found much more cause for excitement, because she knew he was a German (he is an American now) and she detested Germans, and wanted in all probability to detest this one, but couldn't seem to find any way, and so ended by saying that for a German he was interesting—all this in "The Autobiography of Alice B. Toklas." And I was thankful that I had caused Gertrude no more trouble than that because I did not antagonize her, as I have little to do with people's ideas and like them for themselves which is a nice old-fashioned touch I suspect, anyhow I didn't have to take it as Hemingway did, who is now booked as a ninety-five percent rotarian and begged to be allowed to be an eighty-five percenter.

And so when I looked at straight cubism and all those "collage" variations I felt as I do now about them—nice old things, sort of, wild in their day, but after all good old things, and shall have their warm place by the fire, etc.

Cubism is at least a muscular affair, it had its league boots on, and it strided the dull spaces with nearly as much of the same magic as formerly, but with the appearance of Freudianism in painting, we have another dish of poison to swallow, that of surrealism which is

now closing its history, and [it] remains to be seen if it is to identify itself and be of as much value as the other isms have been, but there is that feeling however, that since its substance is of a local and personal character, will it carry as far and be as pleasingly domestic as the other movements have been?

There is a strange sense of the hallucination which is being experienced by objects living too near each other, and in the small picture of Salvador Dali called "Persistence of Memory" you see the singular melting of the watches that have been telling the time with such gentlemanly fortitude, they are hanging or falling, from branches without leaves, about to fall in a glutinous heap, and in one instance, one of the watches, and the gold one strangely enough, a terrible revolution is taking place, there is an army of ants devouring it, or is it merely the minutes they are after and so they are attempting to bore down through the crystal, and the cutting is hard. If you want to know what terrifying devastation can be accomplished in animal life, read Maeterlinck's "Story of the White Ant," unbelievable in their voracity, and their murderous gift for organization and destruction, eating the foundations from wooden houses without being seen, until the house falls upon its occupants, in which social scale sluggards are killed and eaten, and labourers are killed from excess of labour, where the farmer in Africa rises to hitch his wagon to the horses, only to find nothing left but the iron work.

Well, cubism in relation to all this hallucination stuff was completely livable and ordered, it built up something, it showed the lax painter how to build up something better, it set up a world of possibility over against a world of impossibility, which is now being analyzed so well by Dr. Hooton[1]—the noted anthropologist of Harvard, who remarks that the biological danger to man is more imminent than ever, since having exhausted or all but exhausted his powers of invention to eliminate the need of private gesture, man has weakened more than ever, [and] is no better able to do something about himself than he was before, and is therefore, according to Dr. Hooton's belief, no better off about himself than he was in the gorilla stage.

Surrealism is a strange field for painting to have wandered in and it will naturally be on the verge of split-personality or something like

---

[1]Cf. Earnest Albert Hooton in *Up from the Apes*, 1931.

that if it continues that way, but it won't since it is the habit of human nature to go far for the sake of excitement, but it runs home eventually to comfortable conditions and statuses.

The best Freudian painting, and by the best I mean that which is the most natural, is the painting of the insane, where consciousness is supplanted by innocence, and as they do not "know" what they do, they follow their state of innocence, and these pictures have the look of having been completely lived if not having been "known" while lived. It is all too far "in" for art, and since this new work is all done by miniaturists, something can be dug up out of that too, but what is the use, for painting is never in the world meant to be a pathological chart, and that is about all a surrealist painting can be, and the art that is in it, is usually in a state of indifference when it comes to the support of everyday emotions.

The intellect we have been told by Bergson is by no means the all of experience, and there is another problem involved. Fact is, the Nude has descended the staircase and most gracefully, and she may now parade the halls and foyers of common experience without the least fear of insolent interference. She gave the misunderstanding ones a great deal of excitement and has put the understanding ones to sleep with her obvious regularity.

# Georges (Dumesnil) de la Tour

*(1936)*

It is safe to say that one of the most important exhibitions that [was] ever given in this country was this one of Georges Dumesnil de la Tour in conjunction with the three brothers Le Nain, in the Knoedler Galleries in 1936.

Hardly a single art connoisseur I fancy but has long since been made aware of the Le Nain brothers and their singular realism as imbibed from the Dutch school, and the strongest of these painters was obviously Louis Le Nain. The "Peasant's Meal" is a remarkable picture and a remarkable rendering of a common fact, and yet I personally did not linger so long for a far greater magnet drew me to the rear room to the pitch almost of hypnosis in the pictures of the amazing Georges de la Tour.

The French dealers and connoisseurs have a delightful and very intelligent way of bringing forgotten talents to the surface, and while of course it is with them a pre-eminently commercial affair always, there is at the same time a gratifying sense of taste accompanying these adventures, and George de la Tour is a great and lasting adventure for our ever craving eyes.

Georges de la Tour was no common artist, and because his work gives every evidence that he was first of all pleasing himself, it is hardly likely to be the truth that he was pleasing many others beside himself, for there isn't a trace anywhere that this artist was catering to prevailing modes, or to the dictates of the epochal Maecenas.

In the peculiar privacy of their esthetic experience, these pictures, though they are nothing at all like them, make me feel the same as the pictures of the magnificent Piero della Francesca, they are meant to appeal chiefly to one's notion of logic in visual experience.

A peculiar sort of architectural sense of the spirit rises out of the de la Tour pictures for me, and at the same time, a gratifying quality of humanism, for all of his types are such natural human beings as to make one feel immediately at home with them. In all the range of painting of the sacred infant has ever any artist so completely and

thoroughly given the sense that this divine visitation could happen to any recognizable infant such as we are aware of, has ever a child been made to sleep in the strange absent world of infancy as these infants of de la Tour? I think of no child in the whole range of art which gives forth that sense of the possibility of daily miracle as is so deftly described here, they are the recognizable infants of our common material world always, for the humanity in them is hypnotic.

These pictures then as I want to say, breathe forth first and last the breath of plain animals and of devout spirits who pause for whatever sublime or ordinary reason.

It is easy of course to go to Rembrandt, to Ribera, or Caravaggio and perhaps most of all to Zurbarán in these pictures, but that is the natural prerogative of every searching artist, and the thing which makes them significant is the same quality of originality which stamps all works of significance.

The relation as to the peculiar sustained tone typical of the pictures of de la Tour of course, take one immediately to Zurbarán. Who in all the schools of painting [has] given more completely that exceptional sense of deep and sustained tone, outside of the Venetians of course, and of just that sort of thing there is none in the pictures, since they are primarily the work of an intellectual ascetic.

A kind of mystic smouldering covers all of the sacred objects. They are obsessed by the reality of their own intimations, and alive with sacred obligation, and they are never extravagant with ornamental idolatry. In the "New-born" for example, the relation of the mother to the child in sleep is so natural and moving that you expect her to sigh almost with the revelation of the child's sudden presence in a world completely unknown to it, looking pitifully weak and pitifully trustful, and the hands of the mother hold the wrapped body of the child as if it were a new instrument and she herself were about to play upon it some as yet unheard song. The child will waken and it will fall asleep again, it will be alarmingly aware of the world to which it has so recently made itself known, and it will retire into that strange solitude of infants which is in the power of no one to interpret, to that country of unshaped emotions, thoughts and feelings, it will remain serene for it will not yet have learned the terrors of being alive, it will know only the poetical substance of being accompanied by sudden afterthought of flowers that have performed their geometry with consummate grace and are not ashamed to leave with the world their minute messages.

How does one begin telling of the amazing picture, "Saint Sebastian mourned by Saint Irene"? Probably no picture breathes more fitfully with the tense and timed energies of suspense, the action of the spiritual substance is immediately here. Sebastian has been mortally wounded, death ensues, the body of Sebastian, which is warm, sensuous, muscular, and voluptuous too, lies still upon the dark floor, the huge single candle flame lighting up the expanse of suffering around it, lighting up also the expansive breast measured fully with throbbing gleams, the glow that covers all areas with a speechless glimmer, the pose is speakingly human, these figures of the women above it consumed with anguish without proscribed gestures, anguish which is properly beneath the surface and registers little outwardly, only enough to make the surrounding world aware that grave things have happened, for which there is no certain relief.

With de la Tour's natural comprehension and love for solid form, all these are rendered in architectural sequence, so that the whole builds up new and powerful effects of illuminated shapes and forms which are not familiar to the light of day, when the world of candle light becomes quite another world, a world where great shadows are real actors and the darkness becomes alive with living possibilities, the place from whence the dark world of thought receives those spectres of the imagination which destroy the plain peace of ordinary mortals.

"The Adoration of the Shepherds" brings one again to the mother notion of this favorite theme, it might however be a group of friends gathered together to welcome a common child into their midst, and by the transmutation of pure thought among them, the child becomes to itself, holy. It is the child that absorbs the thought here, for de la Tour had an uncommon genius for understanding the magic of birth, he invests it with all the archangelical glamour that is attributed to it, every child immaculate, until the terrible moment comes when commonplace images begin to crowd around its creche, the ridiculous humans with their grandiose notions of importance, have learned that they themselves are twice as ignorant, this being probably why all elders are pitied sooner or later by their children. The lamb comes near in this picture to sniff at infanthood of another sort than its own, to learn if possible just how much they may have in common, the lamb being not at all sure.

There is a rich gamut of emotions in Georges de la Tour, chiefly two, and these are nearly always allied, the religious and the

sensuous. The peculiar oblique intellectuality of de la Tour makes it difficult to say which he cared for most, yet it is in the religious mood that he has most to say by far, and since he is not an idle character by nature, is sparing of his words and of common extravagances—he gives, nevertheless, never more than he feels, since measure is the means itself by which he lives. His ardours lift him up, but they do not suspend him beyond his own human reach, perhaps there is a phlegmatism now and then in the faces, and the postures, one never can quite make out what the people may be thinking, and perhaps they are sensibly and intelligently thinking nothing at all, which is probably the great moment of experience, perhaps the greatest of all, unless it be that great moment when one has found the way to think one thing at a time.

There is no small technical problem in this candle illumination as any painter will allow, it is above all that rare loftiness of spirit which is the passionate assertion of the "Presence" among things that distinguishes the work of Georges de la Tour, another tempo entirely, another augmentation by means of the imagination, this it is that makes these pictures burn and glow with a something which is to be found nowhere else in the world of pictures.

# The Drawings of Carl Sprinchorn

*(c. 1937)*

It is quite likely that the drawings of Carl Sprinchorn are all but totally unknown to what must now be called this generation and it is for these that I wish to speak here. These drawings, for which thousands of preliminary notes have been made, and this is strictly literal, in order that the final drawing itself shall reveal the single idea, belong as much to the great tradition in their way, since they are sensibly derived from it, as do those of the masters, and those others that know too well that a drawing may easily be a complete work of art, and in a sense more difficult to perform, since in painting one may be excessive and generous, whereas in a drawing, economy and directness are the first and most important notions.

Drawings like those of the old masters were full of information as that is what they were done for, they were complete as works of art, even though their makers may have thought of them as preliminaries to something greater, but they represent the completeness of a single experience in nature or from the imagination, and in many respects a fine drawing makes one think of a fine sonnet, since both are built solidly out of certain rules.

Perhaps Rembrandt went as far as anyone has in this feeling for completeness in a few strokes, but we have others to verify the same idea in great draughtsmen like Lautrec, Degas, and some others, and there are those amazingly complete designs of Constantin Guys which are in the end complete pictures, giving a vivid sense of the action of the moment, and the sudden sense of arrestation of life.

All artists invent their own line, if they incline toward the extra gift of draughtsmanship, and some of course do not, but in the case of Carl Sprinchorn, all the energies of a natural painter have gone into the making of these complete works of art, and they are in themselves as a result, demonstrations of true refinement of taste and of swift powers of observation. Sprinchorn is of an essentially romantic nature, and at the time when Robert Henri figured so greatly as a teacher, when most of his pupils were out for direct and

muscular realism, there were two of his male students who were directly of the reverse tendency, and these were the late so gifted and certainly lamented Rex Slinkard, and the present Carl Sprinchorn, both of whom Henri thought a great deal, and from whom he expected much, and with whom he was in no sense disappointed, and if this particular quality of romanticism is to be sensed, then one must think of George Bellows as at the opposite pole, for the two artists I speak of were of the same period and in the same classes.

Sprinchorn is a great lover of appearances and of the various styles and habits of human beings and the singular, unconscious movements, and [he] notes that everyone is the natural actor of his own imaginative processes, and that every gesture is a kind of fingerprint of the mind or of the spirit, everyone behaves differently, there is variety, vanity and egotism in everyone, and the sense of elemental and gentle comedy that emanates from everyone borders slightly on the comic, but since he is never the satirist he never resorts to exaggeration, does not seize too violently upon the uniqueness of a movement, for he knows that behaviour, when it is vivid and genuine, satirizes itself.

Sprinchorn is three things in his drawings, he is idolator of perfection of feeling, lover of romantic extravagance, and observer of objective projections. There is no difference in beauty for him, for whatever is natural is likely to be correct.

It takes a quick eye to see the pictorial meaning of a pose, to seize upon this or that one as the outstanding portrait of emotion or character, and everyone around us including ourselves is making his picture on the surface of life as he walks, laughs, scowls, or is silent. There is bound to be movement of some sort in all living beings, whether they themselves are conscious of "making" them or not, we act, and the action is registered, and it is the highly sensitive artist that sees this telling difference between one movement and another. Some have this understanding early, and since I have known Sprinchorn over a space of twenty-five years, there has never been a time when he was not making his usual vigorous and vivid notations of common life.

The friendship between Rex Slinkard and Sprinchorn was a classical one, they were of the same idealistic trend of mind, and knew the meaning of beauty as real men can know it, they were indefatigable in their search of and their belief in it, and if Rex had

lived, it is assured from his earlier work that he would have had a great career for he had the perfect foundation for it, cut short by death in the service of war.

Sprinchorn, very much alive at this hour, has not changed an iota in his determined interests in behalf of beauty, and since the experience of beauty is a natural thing and never dies, but goes on like life in spite of all the ups and downs of what is called progress, the devotional process of the artist in favour of the permanent and the abiding is a matter which calls for praise.

Fashions in art die out easily, and unless some vestige remains of the underlying classical quality of experience, it is likely to disappear and that is quite as it will be and probably should be. Popularity is not the best sign of good work, and much good work gets itself sidetracked into grooves of obscurity because it does not shout aloud of its virtues, and so it is that some of the best things get snowed under for a time.

There is no exaggeration in placing these drawings among the best works of art in America, since they register and take account of the finest and truest emotions in the world of art. Sprinchorn has recorded the graces and foibles of one period and has pinned them on to another which is that of the present, for the real artist is never dated in the essential meaning of his ideas. There will be found qualities and characteristics in these drawings that are to be found nowhere else, and that is enough to fix the originality of any artist.

I have known these drawings for many years, I know them as I know a person, I know them as I know their author, and because I know them and him so completely, I am able to step aside and take the directly impersonal point of view, and I never tire of their charms, of their distinction, and of their essential refinement as performance in the field of true creation.

# Thinking of Gaston Lachaise

*(c. 1937)*

In the summer evenings I sometimes sit on the veranda of the studio of Gaston Lachaise which overhangs the tidal river at Robin Hood Cove in Georgetown, Maine. Across the road is a little white house with green blinds, and the fine old sign posts point to three pleasing destinations, with the names of Five Islands, Little River and Indian Point. This house is in the typical style of the period of the middle seventies, it has the usual two room length front and a long ell to the eastward providing room after room, which is the comfortable summer residence of the Lachaise family. The sea people that built these little homes knew the meaning of the word home, it was for them a place to come and find peace, protection and comfort within.

In the middle dormer window on the front, above the curved trellis which is buried in pink ramblers of several hues in the summer, and the usual conch shells at the side of the front door, there is a seagull in alabaster, with its head turned back between its wings, in the position of tranquil if momentary sleep. It is the still relative of those that fly up and down the cove from sunrise until nightfall, and these birds are sitting in everybody's seayard at all hours of the day, and in and out among them the blue herons are weaving their long movements silently up and down, as the fish-hawk circles above. This gull of alabaster is a warm glowing white, letting the meaning of light if not quite the light itself pass softly through it. There is a dryad up under the slender birches of a shaded terrace, and the clustering roses and innumerable carpets of all hues, speak of the fine old symbol of peace and contentment, and a belief in the simplest things of life.

Lachaise belonged to the faun style of male, being as his earliest photos show, the dreamer in the hills, he was the wanderer in bright fields, he might have tended herds on the slopes of Greece, he might have even been the human image of the very centaur of Maurice de Guerin for it was merely necessary to unite the double image of man and hoofed animal, to feel that kind of reality in Lachaise.

282

Lachaise was that singular being of today and of yesterday, the worshipper of beauty, he thought of nothing else, beauty was his meat and bread, it was his breath and his music, it was the image that traversed his dreams, and troubled his sleep, it was his vital and immortal energy.

Lachaise was unquestionably the true artist, he was the sculptor of the joyous moment, there are at least not in the major portion of Lachaise's production, no dark and ponderous images in the work of this man, and since for him the dream was a magnificent "affaire du coeur," he believed first and last in the efficacy of it, and the proud substance of beauty as a force in itself.

He never was ashamed of using this word for he was a natural male, therefore his notion of the meaning of this element was normal and robust, it was in fact a kind of pontifical high mass for Lachaise, since he was always the consistent and ardent worshipper, he was always at work day and night, sleeping when the body could no longer hold out and above all this ritualist solemnity rises the figure of the indomitable pagan who saw the entire universe in the form of woman.

The woman who was to supply the completeness of this image was Isabel Dutaud of Cambridge, Mass., born of French parentage, and from the moment of meeting before some amazing object or other thirty years ago in the Musée de Cluny in Paris, these two persons perfectly ordained for each other were joined forever and from this moment on were never to be separated, thirty years of unalloyed happiness and devotion, and so it was that when Gaston Lachaise found Isabel Dutaud he proceeded to love her, work for her, idolize her, glorify her, resting completely immersed in the enveloping warmth of her abundant nature, and from the first moment onward therefore had no thought for or interest in any other single individual.

Two things therefore engrossed Lachaise, the one supplied the strength for the other, and these were love and labour, he was indefatigable in his ardour for both these ideas, and fulfilled them to the last. And because Lachaise worked too terrifically and with unreasoning violence there is every reasonable notion to believe that he destroyed all of his recuperative energies, for at the early age of fifty-two, much too early indeed, Lachaise had ceased to function.

Lachaise believed in the grandeur of self-expression above all

things and would have agreed with Eva Gauthier who said to me one day when we were talking of the artist's lot, that after all the artist is better off than those who cannot express themselves, and as a sculptor he was much like Maillol and like Renoir too, reserving for his special adoration the female form and the symbol of woman in relation to man.

Lachaise was a big man, of better than medium height, dark eyes, dark flowing hair, and an elemental animalistic burning in him like flames on the hilltop of a burning city, you felt the tumult of his ardours and his idealistic ideas in every look and movement of him, he was alive with passion for art and the pure expression of it, he was inordinately simple as well, like a child yet in no way childish, he believed in his pesonal star and to him it was the most radiant of all, and he left the world outside himself to its own ridiculous or sublime devices, and it mattered not at all which it was.

Lachaise was enclosed in the microcosm of his vision, and was one of the happiest of men, since nothing but joy and the idealist's fervour of living shines out of his work. He was never victim of that awful impulse in sculptors to symbolize the philosophical depth of things, he could never have done a huge hulk of a male figure with hands on chin and called it "Penseur," never in the world of art, or in any other world, for he would not be thinking like that.

Maillol is perhaps Lachaise's happiest relation in the world of sculpture, they felt so intensely the same sort of idea about woman, just as Renoir was at his best in painting the forms of woman, it is the flesh itself that seems to dynamize such men to idealistic action, and they were all natural males.

Lachaise was more the lyrical histrionist in a way, since nearly all of his female figures assert if not quite dramatize many moods in the same woman, all of his figures are the expression of the immediacy of emotion and of mood, his line is as brilliant as that of Raphael in so many instances and is less hampered by the desire for classical imitation.

He was somewhat also the jeweler in the fashion of Cellini, and if he did not build up his ideas by extraneous ornamentation, he gave them the pressure of swift movement according to the direct states of assertion, and for this reason if for no other the sculpture of Lachaise is always alive and pulsating with life, for the simplest of reason that he himself was always so.

The recent exhibition of the drawings of Lachaise with small sculptures at the Whitney Museum of American Art was a revelation in point of this sureness of style, and was as such one of the finest exhibitions that have been given in New York for a long time.

Lachaise followed his esthetic demon like a true artist and this demon was perfection, ideality, the reality of ideal experience in life first of all, and through this principle, in his work.

The complete lack of introversion in Lachaise's sculpture, gave his work that freshness which is rare especially in sculpture, when the tendency so often is to symbolize and dramatize. Lachaise hated obliqueness and opacity in matters of art, he was esthetically speaking, a devout rebel and was emphatically against all that interfered with pure experience, all that partook of the element of pastiche was poison to his eye and spirit.

Whitman speaks somewhere of universal and eternal rondures, and this was the subconscious belief of Lachaise also, he was a romantic poet besides, a kind of lyric architect of the human form.

Art, ideality, love, these are the vouched-for agencies both mechanical and metaphysical of good work and with the addition of romanticism and poetry. There is the unified sense of complete experience, and this was evidenced at a very early period in Lachaise's history, for it is many years now since he did that remarkable figure of a woman rising on her slim feet as if to represent the going of night and the coming of morning. He lived out the knowledge of such symbols to every circumference and diameter, and would because of this have done still greater things, but the life was abbreviated with much too sudden violence.

I can see Lachaise sitting on the other bench on this studio veranda above the tidal river, the dark cliffs above it making deep shadows within the waters, his chest out and it was an expansive one, his strong hands splayed upon his knees, his slightly longish hair floating carelessly over his temples in the evening breeze, and the marked likeness comes to me of that very living portrait of Dr. Bertin by Ingres, which, if it is pure photography and little else, is alive with objective reality, and Lachaise would later in life have looked still more like Dr. Bertin, and of course he would have looked most of all, like Lachaise.

America's inheritance of Lachaise's gifts was due to his desire to escape military pressure I believe, and so what was to be inevitably

France's loss is America's gain—he became an American citizen, and figured as such until death overtook him.

Lachaise was a true artist, a unique and original personality, his knowledge of life was expansive, he was adjusted to all laws and all wisdom, he was completely conversant with the meaning of things, and it is in these degrees of immortality that he resides.

# The Element of Absolutism in Leonardo's Drawings

Straying among the books with a newly purchased copy of W. B. Yeats' "The Herne's Egg"[1] in one hand, my eyes chanced to rest upon some attractive monographs of the painters of the past, the revealing ones of Memling and Leonardo, very unlike in many ways and yet bound by the logic of vision together, the one the revealer of life by means of the myopic vision, the other interpreter of life by means of universal and scientific knowledge.

That amazing face of St. Anne[2] for example in front of me now, shaming the Gioconda into dullness for the great revelation of that most inexplicable of all human demonstrations, namely the smile. Look at the first smile of an infant and then ponder upon the smile of a face from which all the rest of life has departed, and you know what I mean, that most pathetic of all compliments, to smile in memory at

---

[1] One of two plays by Yeats published in 1936-37.

[2] The cartoon for *Madonna and Child with Saint Anne* in the National Gallery, London.

what has past and to face the unknowable with the same delicate weapon.

This drawing of Leonardo is a much more unified affair than the painting is, chiefly of course because it is the unfoldment of the first great inspiration. There is music in it of an undying nature, all the poise and unity of the world-soul is fixed in it, whereas, like nearly all of Leonardo's painting, it [the painting] shows the excess labour of the years, and the rhythms of the painting are dry in comparison with those of the drawing. We do not pause for long in the presence of the "Bacchus" in the Louvre because it is neither convincing [n]or beautiful, and the femininity involved compels us to go to Leonardo's women for that conception. This painting is however described as "Ecole" and who knows, [Giacomo] Salai or any other pupil may have had a heavy hand in it, and it could probably be decided that Salai offered more feminine charm than we can explain here.

My vision of the original Leonardo drawing for Saint Anne was in that great Italian exhibition at Burlington House in London in 1929, and what a breath-taking event that was, a profoundly impressive example of what these great exhibitions have been, alas the only one of them that I was able to see though every one of them worth crossing any ocean for, and there is something about these great art events that revives the bloom of art itself, they seem, all these great pictures, to breathe forth new life by being round from their fixed museum places.

It was most typical of the English that there should be crowds elbowing each other in front of the "Venus" of Botticelli, mostly women of course with rough masculine faces, who were in no sense Venuses, though England every now and then produces a startling Venus-ism of beauty in its young women, and sometimes its young men, as so often in Mexico it is the faces of young men that produce an idealism not warrantable with the rest of the person, and there the madonna is the image. There was almost no one but myself in front of the row of magnificently rich Giorgiones, no one but myself in front of that strangely haunting picture of a Madonna by Piero della Francesca,[1] almost completely agnostic in quality, yet very handsome in a peculiar poetical way, save that the child, a solid little man,

---

[1]Hartley probably refers to *Madonna and Blessing Child with Two Angels* (from Singallia) in the Galleria Nazionale delle Marche in Urbino.

does not sit in the arms of the young mother, it sits by itself on them, and the relation of the two is strained thereby, though like all the infants of Leonardo, he has that disarming look of wisdom in the eyes, and one never quite escapes the masculine look of Piero's women, always as if young men had posed for them, because probably female models were not to be had, just as with Cézanne in Aix, it was not possible for him to have had women models pose nude for him, as the scandal would have been too great, and it is too well known how destructive small-town minds are.

There were no eyes at all upon the delicate and original drawings of Pisanello, elegant almost to a fault, yet pulsing with a singular sensuous beauty which is not quite human enough to attach to a vulgar, visible world, but Pisanello was decidedly a poet, and so the poetic principle intervenes, and if his animals do not rage and paw the ground as do those amazing drawings of buffalo in the caves of Altamira and the Dordogne, they do at least present a Virgilian kind of serenity.

I had the "St. Anne" to myself then, as I have now "en brochure" and a great piece of harmonic unity and visionary perfection it is, for it reminds one at best of a Bach-like precision of emotion.

These religious pictures of the Renaissance however, never convince one of their utter religiosity, and there is a reason, as outside Fra Angelico and Giotto of course, none of them were religious, they were essentially hedonistic according to the voluptuous tendencies of the day when sex lusts were at their height and the pictures were no doubt commissions given by the donors named for the remission of sins as well as for the aggrandizement of these persons.

Leonardo was the greatest harmonist in the world of painting of all time because his sense of absolutism was perfect, he had arranged his intellectual and spiritual relativities in order in the manner of the logician, as was the case with every thing else he did, for to him to understand was to know and if it was easy for him to be universal, it was simply a natural language with him.

He wasted no time on frivolities for absolute wisdom and knowledge were neither of these things, he did not trust the intellect more than the intuition, he did not indulge in debaucheries of the body or the heart, he used his eye as the sextant by which he determined all directions, all latitudes and longitudes of sense and sensibility, he was the see-er supreme.

"In life beauty perishes, in art it does not" is Leonardo's own terse and correct statement, and no one knew this secret with greater understanding than did Leonardo, and in all probability too he was aware that "solitude is beatitude and creates its own warmth" as Mary Colum says in her book "From these Roots,"[1] a delicate remark concerning Thoreau, a much smaller but nevertheless a true and exact spirit.

The Italian genius is essentially speaking, over sweet, setting aside the sardonic quality of Mantegna, the bitter fierceness of Pollaiuolo, the essential agnosticism of the work of one of the greatest of them all, Piero della Francesca, to whom I always turn with final reverence, because he satisfies the mind, and was one of the profoundest logicians in the world of art. The cloying sweetness of Botticelli is at all times in evidence as there is a sweetness in all of Leonardo's faces, and the love of saccharine ornamentation is likewise in evidence in much Renaissance painting, and for the modern eye at least used to streamline severity and elimination, these cloy upon the eye as too much melody cloys upon the ear, also one of the great faults of Italian music.

The idyllic impersonations of Leonardo are never quite human because the divine idea itself is not, and the nearer the approach to that idea, the less likely is humanism to be the prevailing note, because pure knowledge like pure wisdom, is above the human demonstration, and therefore it is this absolutism of Leonardo that makes him greater than the humanists like Rubens and Rembrandt, because they saw the world first in terms of themselves, but Leonardo was not strictly speaking the painter that these men were, because Italian painting in texture is not of that overwhelming physical abundance. Leonardo was the greatest master of all of linear opulence, he saw his linear harmonies through to their logical conclusion, because he was a very different kind of a man and so he was a different kind of an artist, he was above his subject and that was rare.

What the "Adoration of the Magi" in the Uffizi, majestic as it is, to be compared only to the "Night Watch" of Rembrandt for the orchestral distinction that is in it, would have been like if it had been

---

[1]*From these Roots; The Ideas that Have Made Modern Literature* (New York: Charles Scribner's Sons, 1938). This publication date helps determine when Hartley wrote this article.

finished is of no consequence to us, since it contains as high a sense of the laws of harmony as has ever been achieved in the realm of pure art, "emotion remembered in tranquillity" to a perfect degree comes to the eye in both these great pictures, the one all fire and fanfare, the other like passages out of the Bible for serenity.

Leonardo was the great revealer of the overtone in life, the "quelque chose d'autre" which is the vital essence of all things and from which only the real sense of life springs, he knew that true emotion is experienced after all preliminary emotionalism has been dissected and discarded.

And because Leonardo was first and last a scholar, he was out of joint necessarily with his time, making of him in some eyes a strange fantasy, in others, a kind of social menace, a dangerous alchemist, a diabolic revealer of occult secrets, and he could not have walked beside the Arno or over the Ponte Vecchio without exciting attention and suspicion, because if you have greater wisdom you are likely to have greater discomfort. And all because of his mystery-evoking appearance, for to know too much is to be superior, and to be superior is to be socially difficult.

Leonardo was a complete man, he was a scientist and a mathematician and in a sense, painting and drawing were for him a rest from his other labours.

The anatomical drawings of Leonardo are another matter, and are entirely of a scientific nature, pronounced by surgeons of today as faultless in their knowledge of the human body, and because the meaning of them was not idealistic, they have little or no esthetic beauty of which his other drawings are so full.

In the creative aspects of Leonardo's imagination, he was pre-eminently a psychologist, he never confounded male and female sensibility, he knew perfectly when he crossed over from one field to the other, and he knew that feminine beauty is often found in alien countries of the human concept, and so none of these aspects are disembodied as in the case of many artists. And if his own feminine sensibility was now and then in evidence he knew how to counteract it by some other phase of knowledge and so, because he knew, he was never weak in knowledge. He gets at the root first and is therefore happier in his sense of the flower, his botanical details are always accurate and convincing because he did not confuse genuses in this world either, so that every casual accessory of detail is added

merely as enrichment of idea and not for the sake of mere ornamentation.

His creatures are of the flesh, but the flesh does not dictate their existence in his vision, he sees them all as ideas, as symbolic representations of the whole thing, as the absolutist consummation of one thing.

One gets a clearer sense of the magnitude of Leonardo's personality in that brilliant essay of Paul Valéry's, written in his early twenties as a kind of university thesis probably, called "Introduction to the Method of Leonardo." Valéry thinks of Leonardo as the equal of Socrates, of Shakespeare in his knowledge of the all and everything of things, which, simply said, is his kind of achieved absolutism.

In matters of art the Chinese knew this, they knew the meaning of the one and only line that separates all planes, yet unites them in complete relationship, they knew that this line is the personal element of life itself, and that the single one and not two will clarify this matter of unity. And because Leonardo was not concerned with trivial success or any other concept of success save realization, he was never the public idol because he was never the trivial virtuoso, he was not like Raphael, the idol of a fashionable motley.

Bach knew what Leonardo knew as regards mathematical exactness—only two days ago I was listening to a Bach partita played on the harpsichord by an expert, and the thought came, how could it have been otherwise, so completely and loftily impersonal as all great art is, no weeping for confused love as in the case of Tchaikowsky.

Great emotions are always impersonal and no one knew this better than the mind and spirit of Leonardo, and if he was not the complete man psychologically, he was the complete man intellectually, and so saved himself from petty personalisms. It is obvious that there is nothing new to say in the case of Leonardo, but it comforts the artist at least to know that knowledge is either a relative or an absolute affair, and the more one knows the more one is able to put into a picture, a fuller, richer sense of things.

The world of art has never seen a greater man than Leonardo, and it will never see another, he knew all, understood all, and for proof of this turn to that amazing drawing of himself at the close of life, the eyes flooded with the tragedy of seeing through, the brow knotted

with the mystery of it, the heavy eyebrows serving as shade from too much blinding light of pure experience, the mouth resigned to the thought that passion for its own sake is not worth troubling about, and all in all, a cheap form of entertainment.

In every line of Leonardo, there exists that wisdom and knowledge, the true sense of absolutism in human experience.

# Source Notes

Unless otherwise noted, all MSS by Hartley are in the Yale Collection of American Literature, Beinecke Rare Book and Manuscript Library, Hartley/Berger Archive.

## PART I

*1914 Catalogue Statement, 291*

First published as the catalogue foreword for an exhibition of Hartley's paintings at 291 (January 12–February 5, 1914). Reprinted in *Camera Work* (no. 45, dated January 1914, published June 1915, pp. 16–18). No extant MS; the *Camera Work* text is used here. The statement was accompanied by an excerpt from Gertrude Stein's play *IIIIIIIIIII* that included an abstract word portrait of Hartley; and a statement by Mabel Dodge (Luhan) in appreciation of Hartley as a painter.

*What is 291?*

First published in *Camera Work* (no. 47, dated July 1914, published January 1915, pp. 35–36). No extant MS; the *Camera Work* text is used here. In response to the many inquiries about his unprecedented effort on behalf of new art, Stieglitz decided to publish a special issue of *Camera Work* devoted to the question, "What is 291?" The resulting issue is a compendium of essays, poems, and brief statements by nearly all the artists, photographers, writers and appreciators who had any contact with the gallery. Hartley, in constant correspondence with Stieglitz from Europe, sent his contribution from Berlin.

*A Word*

First published in the exhibition catalogue for the "Forum Exhibition of Modern American Painters" at the Anderson Galleries, New York (March 13–25, 1916). Hartley's statement was a revision of one in German that accompanied an exhibition of his work in October 1915, held at the house of Max Liebermann in Berlin and sponsored by Otto Haas-Haye, a German designer who supported the new modernist artists. The statement was subsequently reprinted in English in *The New York Times* December 19, 1915, sec. 6, p. 3). After returning from abroad, Hartley rewrote the piece in February 1916, while visiting Mabel Dodge's Finney Farm in Croton-

on-Hudson, New York (the MS in the YCAL Stieglitz Archive, is written on stationary from Finney Farm). The "Forum" text has been used here from the Arno Press reprint, 1968.

### 1916 Catalogue Statement, 291

First published as a brief note accompanying his exhibition at 291 (April 4–May 22, 1916). Reprinted in *Camera Work* (no. 48, October 1916, p. 12). No extant MS; the *Camera Work* text is used here.

### Dissertation on Modern Painting

First published in *The Nation* (vol. 112, February 9, 1921, pp. 235–36). No extant MS; *The Nation* text is used here. For a related piece written about the same time, see volume II, "The Business of Poetry," first published in *Poetry* (vol. 15, December 1919, pp. 152–58).

### Art—and the Personal Life

First published in *Creative Art* (vol. 8, June 1928, pp. 31–34). No extant MS; the *Creative Art* text is used here. One of Hartley's best known pieces of prose, this article has been excerpted or reprinted in numerous catalogues and anthologies.

### The MOUNTAIN and the RECONSTRUCTION

First published in the catalogue for an exhibition of his paintings and watercolors at The Arts Club of Chicago (February 28–March 13, 1928). No extant MS; the catalogue text, which is used here, was signed and dated "New York, February 12, 1928." After attending the show Hartley went on to Denver to visit his friend Arnold Rönnebeck, Director of the Denver Art Museum, and to give "a reading of an essay" (as he called it), entitled "The Original Research of Cézanne." For the only record of that essay see the lengthy account in *The Rocky Mountain News* (Denver, March 25, 1928, p. 4).

### The Recent Paintings of John Marin

First published in the catalogue of an exhibition of Marin's work at the Intimate Gallery (November–December, 1928). No extant MS; the catalogue text is used here. Hartley wrote two other pieces on Marin: "As to John Marin and His Ideas" published in *John Marin Watercolors, Oil Paintings, Etchings* (New York: The Museum of Modern Art, 1936; reprinted by Arno Press, 1966, pp. 15–18); and a poem in free verse, "A Satire for John Marin," 1936 (unpublished MS, YCAL, Stieglitz Archive).

### 291—and the Brass Bowl

First published in *America and Alfred Stieglitz: A Collective Portrait*, edited by Waldo Frank, Lewis Mumford, Dorothy Norman, Paul Rosenfeld and Harold Rugg. (New York: Doubleday Doran & Co., Inc., 1934, pp. 236–42). Reprinted by Aperture, 1979. No extant MS; the 1934 text is used here.

*George Grosz at An American Place*
First published as a catalogue foreword for an exhibition of Grosz's work at Stieglitz's An American Place (March 17–April 14, 1935). No extant MS; the catalogue text is used here. Earlier, while still in Europe, Hartley had written another piece on Grosz, included in the *Varied Patterns* MS.

*Farewell, Charles*
First published in *The New Caravan*, ed. Alfred Kreymborg, Lewis Mumford, Paul Rosenfeld. (New York: W. W. Norton & Co., Inc., 1936, pp. 552–62) with the essay on Ryder (see *The Spangle of Existence*). The subtitle "A Number of Deaths" refers to his intention to include this piece in a series on friends who had died: Edwin Arlington Robinson, Hart Crane and Gaston Lachaise, to be titled "Four Deaths." A eulogy on Crane, "Hart Crane, the Life of a Poet" was submitted to *The New Caravan* with this one on Demuth, but was rejected. Hartley later included them both in *The Spangle of Existence* MS, along with one written a year later on Lachaise (see pp. 282-86). *The Spangle of Existence* typescript has been used, noting some variations from the published version.

*Georgia O'Keeffe*
First published in the catalogue of an exhibition of her painting at An American Place (January 7–February 27, 1936). No extant MS; the catalogue text is used here. Hartley had written an earlier piece on O'Keeffe included in *Adventures in the Arts*, in "Some Women Artists," pp. 116–119.

*An Outline in Portraiture of Self*
First published as the catalogue foreword for an exhibition of Hartley's painting at An American Place (March 22–April 14, 1936). No extant MS; the catalogue text is used here. Also included was his poem "This portrait of a seadove—dead" (see volume III).

*On the Subject of Nativeness—A Tribute to Maine*
First published as the catalogue foreword for an exhibition of his work of An American Place (April 20–May 17, 1937). No extant MS; the catalogue text is used here. Also included was his poem "Signing Family Papers." An important related poem, "Return of the Native" had appeared a few years earlier in *Contact* (N.S. 1, no. 2, May 19, 1932, p. 28).

*Pictures*
First published as the catalogue text for an exhibition Hartley shared with Stuart Davis at the Modern Art Society, Cincinnati, Ohio (October 24–November 24, 1941). There is a handwritten preliminary draft in the YCAL; the printed version obviously underwent considerable revision, is a smoother text, and has been followed here.

## PART II

Since none of the essays from *Varied Patterns* were published, the texts here follow the YCAL MSS. With the exception of the pieces on Toulouse-Lautrec and Ingres, the typescripts were done by Hartley's friend, Rebecca Strand. She might have changed Hartley's paragraphing to some degree, because the Ingres and Toulouse-Lautrec MSS—obviously typed in Hartley's inimitable way—revert to the characteristic short paragraphs and singlespaced typing.

### Arezzo and Piero

In the fall of 1923 Hartley left Berlin where he had been living for two years and set out for Vienna, Florence, Arezzo, Rome and Naples, and thence back to the United States. He wanted to see his favorite Italian masters, especially Masaccio, Fra Angelico, and Piero della Francesca "in the flesh." His impressions of these encounters, written during or shortly after seeing the frescoes, became the basis for "European Art Notes." Since he was unable to publish *Varied Patterns*, he later rewrote some of the pieces, such as "Some Words on Piero and Masaccio" included in Part III.

### Max Ernst

Doubtless his wittiest and sharpest indictment of surrealism, this was Hartley's response to a Max Ernst exhibition at the Galerie Georges Bernheim (Paris, December 1–15, 1928) entitled, *Max Ernst, Ses Oiseaux, Ses Fleurs Nouvelles, Ses Forêts Volantes, Ses Malédictions, Ses Satans*, with the catalogue essay by René Crevel.

### Paul Klee

The exhibition of Klee's work to which Hartley refers was held at the Galerie Georges Bernheim (Paris, February 1–15, 1929) with a catalogue essay by René Crevel, "Merci Paul Klee." Hartley's account of his early encounter with Klee in 1915 is one of few occasions in his writing where he discusses his association with the artists of the Blaue Reiter.

### Picabia—Arch Esthete

This essay probably refers to a one-man exhibition of Picabia's painting held at the Galerie Théophil Briant (Paris, November 12–December 7, 1929), and to one at the Intimate Gallery (New York, April 19–May 11, 1928).

### Impressions of Provence

Hartley lived in several locations in Provence from July 1925 to December 1929—except for brief visits back to the United States, and to Paris, Hamburg, Berlin, and London. This essay demonstrates how deeply

affected he was by the natural elements peculiar to this area of Southern France—its light, rugged mountains, and the quality of the air. He also wrote a book of poems titled *Provençal Preludes* (see volume III).

*Toulouse-Lautrec at Albi* and *The Ingres Museum at Montauban*
    In November 1929 en route from Provence to London to visit friends over the Christmas holidays, Hartley stopped at Albi to see the Toulouse-Lautrec collection, and at Montauban for the Ingres Museum. The two artists represent the contrasting poles of his esthetic preferences.

*St. Thérèse of Lisieux*
    Hartley read St. Thérèse's *L'Histoire d'une Ame* in 1925, the year of her cannonization, and probably began writing the essay in 1929. After returning to New York in 1931 he rewrote it with plans to submit it to *Commonweal*.

# PART III

*Eakins, Homer, Ryder*
    Previously unpublished; the holograph MS, which is followed here, is dated 1930. He refers to an exhibition that year at the Museum of Modern Art: *Sixth Loan Exhibition: Winslow Homer, Albert Pinkham Ryder, Thomas Eakins*.

*Copley's Americanism*
    Previously unpublished; the text follows the original typescript. Hartley wrote another essay on Copley, "John Singleton Copley," in 1937 after seeing a commemorative exhibition of his work at the Metropolitan Museum of Art in New York. The later MS deals chiefly with Copley's English period.

*Wm. M. Harnett, Painter of Realism*
    Previously unpublished; the text follows the holograph MS. Hartley wrote another piece, "William M. Harnett, American Realist in Painting," similar to this one but not close enough to be another version. Writing about Harnett was doubtless prompted by the historic exhibition of his work, *Nature-Vivre*, at the Downtown Gallery in New York from April 18 to May 6, 1939. Among Hartley's personal effects in the memorial collection at the Treat Gallery, Bates College, are several photographs of Harnett's paintings, including the one reproduced here, *Music and Good Luck*, now called *Still Life—Violin and Music*, (fig. 5).

*Mark Tobey*
    Previously unpublished; the text follows the typescript MS. Hartley refers to two exhibitions: *Painting and Sculpture by Living Americans* at the

Museum of Modern Art (December 2, 1930–January 20, 1931) in which Tobey was represented by three paintings, *American Landscape* (1928), *Portrait of a Poet* (1928), and *Victory* (1928); and a one-man exhibition at the Contemporary Arts Club of New York, March 1931. Hartley and Tobey did not see each other often but remained friends over a long period of time and when together would engage in intense discussions on art, mysticism and music. Hartley once described their relationship as "a rare spirit and understanding of the 4th dimensional sense of plain experience" (letter to Adelaide Kuntz, October 24, 1939, AAA).

*American Primitives*
    Previously unpublished; the text follows the typescript MS. Hartley writes about an exhibition of this title at the Newark Museum (November 1930–February 1931), with a catalogue by Holger Cahill.

*John Kane of Pittsburgh*
    Previously unpublished; the text follows the typescript MS. The memorial show of Kane's work mentioned in the essay was held at the Valentine Gallery (New York, January 1935).

*Is There an American Art?*
    Previously unpublished; the text follows the holograph MS. The mention of Vinal Haven would date this piece in the summer of 1938, when Hartley spent several months there at the suggestion of poet Harold Vinal.

*On the Persistence of the Imagination*
    Previously unpublished; the text follows the typescript MS. Between Hartley and Milton Avery there existed a mutual respect which, as has been suggested by Clement Greenberg (*Art and Culture*, Boston: Beacon Press, 1961, p. 199) occasionally slipped over into actual influence. Hartley sat for a portrait by Avery just before his death (fig. 6)—a sensitive likeness that captures an inner vitality beneath the faded debonair exterior. This essay places Avery in direct lineage with the American imaginative tradition of Homer Martin, George Fuller, and Ryder, written about elsewhere by Hartley.

*Salutations for the Pictures of Leon Hartl*
    Previously unpublished; the text follows the holograph MS. Mentioned in the preceeding text was the simultaneous showing of Hartl's painting at the Brummer Gallery (New York, February 14–March 31, 1938).

*Gauguin—for the Last Time*
    Previously unpublished; the text follows the holograph MS. Mention of Pola Gauguin's book about his father, published in 1937, indicates a probable date for this article.

*Georges Rouault*

Previously unpublished; the text follows the holograph MS. From evidence in Hartley's letters, the exhibition referred to in the text was a one-man show in 1937 at the Pierre Matisse Gallery. The possible connections between his own and Rouault's painting are also suggested here. Referring to the masculinity of Piero's female figures, Hartley comments that to Rouault, male and female are "ideas, and not merely material facts." This immediately brings to mind Hartley's powerful female figures in the 1938–39 "archaic portraits" of *Marie St. Esprit* and *The Lost Felice* (fig. 11) in which women who embody the *idea* of strength, are depicted with as much vigor as the men in the related portraits, *Adelard, Drowned Master of the Phantom* and *Cleophas, Master of the Gilda Gray.*

*Jacob Epstein's Adam*

Previously unpublished; the text follows the holograph MS. Hartley first met Epstein during his initial trip to Paris in 1912, and, upon invitation from the sculptor, visited London in December of that year where he also met the Camden Town artists, Augustus John, Wyndham Lewis, and poet Ezra Pound. This piece was written after Hartley saw the exhibition of Epstein's *Adam* at the Fine Arts Galleries in New York in May 1940, a year after it was completed and exhibited in London.

*Roger de la Fresnaye*

Previously unpublished; the text follows the holograph MS. Mention of José Garcia Villa's volume of poetry, *Have Come, Am Here* New York: Viking Press, 1942), dates this essay from the last year of Hartley's life and as one of his last pieces of prose. The inspiration for it sprang from a portfolio of facsimile gouaches by de la Fresnaye which Hartley owned (now in the memorial collection at the Treat Gallery). This portfolio, published in Paris in 1928 by Waldemar Georges, contains many casual gouache figure drawings—mostly males—done in a limpid, lyrical style.

*Some Words on Piero and Masaccio*

Previously unpublished; the text follows the holograph MS. Though Hartley is recounting a subject from *Varied Patterns*, and the piece is not dated, its tone and the underlying theme of humanism and the artist as divine "see-er" relate it to other late essays and paintings.

*Posing for Lipchitz*

Previously unpublished; the text follows the holograph MS. Hartley, like Gertrude Stein, consistently used the original spelling "Lipschitz." The "s" had been dropped in a clerical error made in 1909 when Lipchitz registered on first entering Paris. The common spelling has been used here.

The essay may be added to accounts by Gertrude Stein and Jean Cocteau

of posing for a portrait by Lipchitz. Stein's description appears in *The Autobiography of Alice B. Toklas*, 1933 (New York: Random House, Vintage Press edition, 1960, pp. 202–03). Cocteau's version, "Jacques Lipchitz and my Portrait Bust," was published in *Broom* (Rome, vol. 2, no. 3, June 1922, pp. 207–09).

Though Hartley had written about Lipchitz's work in 1935 after seeing an exhibition at the Brummer Gallery, they did not actually meet until 1941, and, as in Stein's case, their meeting was only by chance. Lipchitz had just settled in New York after fleeing Nazi-occupied France, and, needing to earn a living, was on the watch for good portrait subjects. At a gallery opening he glimpsed the head of a man (Hartley) whose sculptural features intrigued him. When introduced and asked if he would sit for a portrait by the sculptor, Hartley was delighted and flattered. He professed not to like most sculpture, but since seeing the 1935 show, he regarded Lipchitz's work as an exception. In fact, he had just purchased a small drawing from the *Rape of Europa* series mentioned in the text.

Three heads resulted from the twenty-eight sittings: a terra cotta (now in the Metropolitan Museum of Art); a bronze version in seven issues (fig. 8); and a terra cotta of Hartley assuming the pose of the sleeping man (posthumously cast in bronze). Lipchitz was pleased with the portraits, commenting later in an interview that Hartley had a "marvelous" head for sculpture, ". . . a very fine head and at the same time childish); he had something strong and something very, very sweet and almost feminine in his face" (interview with Lipchitz by Elizabeth McCausland and Mary Barltett Cowdrey, February 20, 1960, AAA).

In addition to her account of posing for Lipchitz related in *The Autobiography of Alice B. Toklas*, Gertrude Stein also wrote a word portrait of him published in 1927 in *Ray* magazine. Though it is not known if Hartley was aware of this piece, he *had* read *The Autobiography*. Nevertheless, his essay also includes a verbal portrait of the sculptor, which, unlike Stein's terse, cubistic characterization, is a kind of psychological study, a poetic penetration into the depths of Lipchitz's nature.

## PART IV

Hartley's original typescripts (rather than the typescript version at the Museum of Modern Art or a published version) have been used for the texts of these selections from *The Spangle of Existence*.

*Memling Portraits* and *Mary with the Child—of Leonardo*
    First published with "Thinking of Gaston Lachaise" in *Twice a Year* (nos. 3–4, 1939–40, pp. 253–263).

*George Fuller*
Previously unpublished. Hartley mistakenly notes Fuller's death date as 1880 and then speaks of the fifty-seven years since his death. Calculating from 1880, we would thus date the essay in 1937. He had previously written about Fuller in "Our Imaginatives," and "American Values in Painting" in *Adventures in the Arts*, pp. 50–58; 65–73.

*John James Audubon, as Artist*
Previously unpublished. As a young man Hartley had collected and studied butterflies and wild flowers and was proud of his scientific knowledge and rendition of the various species. Himself a frequent visitor to New York's Museum of Natural History, he once advised a friend who was worried because her daughter seemed to be immersed in fantasy, that a visit to the Museum of Natural History would "put something solid in her delicate little psychic stomach," and that contrary to what one might expect to hear from an artist, art museums are "not always the best formative sources" (letter to Adelaide Kuntz, April 4, 1932, AAA). The forms of nature served for him a kind of therapeutic purpose, purging away the surfeit of intellectualism and theatricality he found rampant in so much modern art.

*Ablution*
Previously unpublished.

*Albert Pinkham Ryder*
First published in *The New Caravan*, 1936, pp. 541–552. This essay is one of the most extreme cases of editorial revision in a printed version. *The New Caravan* version contains numerous changes of style, grammar, punctuation and syntax. But in compiling *The Spangle of Existence* manuscript, Hartley chose to include his original typescript rather than the printed text. This choice may have been simply for convenience (a typescript being more readily available than a printed copy), but the fact that he made no effort to incorporate any of the revisions indicates his attitude towards such editorial advice. He might accept such emendations initially in order to insure acceptance of the piece but would later revert to the original. The same is true in the case of less heavily edited pieces as "Farewell, Charles," and the three in *Twice a Year*.

The importance of Ryder as a force in Hartley's career can hardly be overestimated. From 1908 when he saw his first Ryder painting and on through the years, Ryder was a guiding spirit in his experience and the subject of two major essays (this one and the one published in 1917 and reprinted in *Adventures in the Arts*, pp. 37–41), two minor unpublished pieces and a fragment MS, as well as the poem, "Albert Ryder, Moonlightist" (volume III), and the portrait painted from memory (fig. 10).

*And the Nude has Descended the Staircase*

Previously unpublished. Hartley delivered this piece as a lecture at the Museum of Modern Art in 1936 around the time of the historic exhibition, "Cubism and Abstract Art" (March 2–April 19). After seeing the show, he wrote to a friend, "how tired and sleepy the pictures all look now—too much cerebration—no human warmth, without which nothing can last" (letter to Rebecca Strand, March 7, 1936 from New York City, AAA). Surrealism is also discussed in the lecture, and in December, 1936, the Museum of Modern Art mounted the important exhibition "Fantastic Art, Dadaism, and Surrealism" which Hartley also saw.

*Georges (Dumesnil) de la Tour*

Previously unpublished. In November–December 1936 (the same season during which he saw the cubist and surrealist shows), the Knoedler Galleries in New York exhibited paintings by the 17th century French masters the Le Nain brothers and Georges de la Tour. This essay was inspired by that exhibition. De la Tour's paintings offered, in Hartley's view, precisely the warmth and humanism lacking in cubism with its abstract "cerebration" and surrealism with its charting of personal pathologies.

*The Drawings of Carl Sprinchorn*

Previously unpublished. Sprinchorn was perhaps Hartley's closest friend. They knew each other over a lifetime, shared a love for Maine—its people and its landscape, particularly Mt. Katahdin—and had a long correspondence (as yet unavailable to the public). When Hartley had gained a small measure of success in his later years, he made several efforts to promote Sprinchorn's career through his writing. He wrote this essay around 1937, though, from existing evidence, it appears not to have been published, and another in 1942 for an exhibition of Sprinchorn's work at the American-Swedish Historical Museum in Philadelphia. When that show traveled to the Macbeth Gallery in New York later in the year, Hartley submitted another version of the catalogue statement, entitled "The New Paintings of Carl Sprinchorn of the Maine Woods" to *Magazine of the Arts* as a review, but it was not accepted. It was published in 1978 in *Eight Poems and One Essay* (Lewiston, Maine: Treat Gallery of Art).

*Thinking of Gaston Lachaise*

Previously published in *Twice a Year*, pp. 260–263. Reprinted in *The Sculpture of Gaston Lachaise*, ed. Hilton Kramer (New York: Eakins Press Publishers, 1965, pp. 27–29). The two printed versions omit the first three paragraphs and the reference to the Lachaise exhibition at the Whitney Museum. In the Kramer version, the last five paragraphs are also deleted.

The essay was probably written in 1937, two years after Lachaise's death, when Hartley spent some time with his widow, Mme. Lachaise, at Georgetown, Maine.

### The Element of Absolutism in Leonardo's Drawings

Previously unpublished. Hartley seldom mentioned Leonardo in his early writing, but he is the subject of two essays here in *The Spangle of Existence* and mentioned in several other late manuscripts. Hartley also wrote about Valéry in a MS titled "Some Considerations of Paul Valéry, French Thinker and Poet."

# Bibliography

This bibliography contains first a complete checklist of Hartley's published writings arranged chronologically with reviews indented after the item reviewed. The second part is an alphabetical listing of books, articles and poems about Hartley as a writer, as well as related material referred to in the commentaries and notes of this volume. For a thorough bibliography on Hartley as a painter, see Barbara Haskell's exhibition catalogue, *Marsden Hartley* (1980, pp. 194-208).

*Published writings by Marsden Hartley*

## 1914

"Foreword" to *Paintings by Marsden Hartley*. New York: Photo-Secession Galleries. Reprinted in *Camera Work*, no. 45(dated January 1914, published June 1914): 16-18 [exhibition catalogue with forewords also by Mabel Dodge (Luhan) and Gertrude Stein].

## 1915

"What is 291?" *Camera Work*, no. 47(dated July 1914, published January 1915): 35-36 [special issue on the Photo-Secession Galleries with contributions by many artists, photographers and others].

"Foreword" to exhibition catalogue sponsored by the Münchener Graphik-Verlag, Berlin. Reprinted in "American Artist Astounds Germans." *The New York Times*, 9 December 1915, sec. 6, p. 3.

## 1916

"A Word." *The Forum Exhibition of Modern American Painters*. New York: Anderson Galleries): 53 [group exhibition catalogue with statements by the artists]. Facsimile reprint New York: Arno Press, 1968; also reprinted in *Readings in American Art Since 1900*, ed. Barbara Rose. New York: Frederick A. Praeger, 1968, pp. 63-64.

"Foreword" to *Paintings by Marsden Hartley*. New York: Photo-Secession Galleries. Reprinted in *Camera Work*, no. 48 (October 1916): 12[exhibition catalogue].

"Epitaph for Alfred Steiglitz." *Camera Work*, no. 48(October 1916): 70.

*1917*

"Twilight of the Acrobat." *Seven Arts* 1(January 1917): 287-91. Reprinted in
   *Adventures of the Arts* (1921), pp. 155-61.
"Odilon Redon." *The New Republic* 9(January 20, 1917): 321-23. Reprinted
   in *Adventures in the Arts* (1921), pp. 126-33.
"Albert Pinkham Ryder." *Seven Arts* 2(May 1917): 93-96. Reprinted in
   *Adventures in the Arts* (1921), pp. 37-41.
"A Painter's Faith." *Seven Arts* 2(August 1917): 502-06. Reprinted in
   *Adventures in the Arts* (1921) under the title, "The Dearth of Critics," pp.
   238-43.

*1918*

"John Barrymore's Ibbetson." *The Dial* 64(March 14, 1918): 227-29.
   Reprinted in *Adventures in the Arts* (1921) under the title "John Barrymore
   in Peter Ibbetson," pp. 182-88.
"Kaleidoscope" (four poems: "In the Frail Wood," "Spinsters," "Her
   Daughter," "After Battle"). *Poetry* 12(July 1918): 195-201.
"Emily Dickinson." *The Dial* 65(August 15, 1918): 95-97. Reprinted in
   *Adventures in the Arts* (1921), pp. 198-206.
"The Reader Critic; Divagations." *The Little Review* 5(September 1918):
   59-62. [In this and the following article Hartley criticizes excessive
   erudition in the poetry of T. S. Eliot, Ezra Pound and others.]
"The Reader Critic; Breakfast Résumé." *The Little Review* 5(November
   1918): 46-50.
"Tribal Esthetics." *The Dial* 65(November 16, 1918): 399-401.
"Tribute to Joyce Kilmer: As Friend of an Earlier Time." *Poetry* 13(December 1918): 149-54.
"Poetic Pieces" (two poems: "The Ivory Woman," "Sunbather"). *The Little
   Review* 5(December 1918): 26-28.
"Aesthetic Sincerity." *El Palacio* 5(December 9, 1918): 332-33.

*1919*

"Local Boys and Girls Small Town Stuff," "Evening Quandary," "Fish-
   monger," "The Flatterers," Salutations to a Mouse," "Synthesized Per-
   fumes and Essences" (six poems). *Others for 1919: An Anthology of the New
   Verse*, ed. Alfred Kreymborg. New York: Nicholas L. Brown, pp. 61-68.
   "Local Boys and Girls Small Town Stuff" reprinted in *Twenty-five Poems*
   (1923), p. 11 [title erroneously not capitalized].
"Two Lily Satires" (two poems: "Pernicious Celibates," "The Very Wise
   Virgins"). *Playboy: Magazine of Art and Satire*, no. 3 (1919): 11.
"The Dowager's Distress" (poem). *Playboy: Magazine of Art and Satire*, nos.
   4-5(1919): 23.
"Scaramouche" (poem). *Others* 5(February 1919): 16.
"Swallows" (poem). *Others* 5(March 1919): 14.

"Rex Slinkard: Ranchman and Poet Painter." *Memorial Exhibition: Rex Slinkard 1887-1918*. Los Angeles: Museum of History, Science and Art [exhibition catalogue, variants of which appeared in catalogues of similar memorial exhibitions at:
The Palace of Fine Arts, San Francisco, 1919; M. Knoedler & Co., New York, 1920; The Los Angeles Museum of History, Science and Art, 1929; and in *Adventures in the Arts* (1921), pp. 87-95, under the title "Rex Slinkard"].

"The Beautiful Neglected Arts: Satire and Seriousness." *The Little Review* 5(June 1919): 59-64.

"The Poet of Maine." *The Little Review* 5(July 1919): 51-55 [a defense of Hartley's poet/friend, Wallace Gould, followed by editorial comment by Margaret Anderson and samples of Gould's poetry].

"Art and Wallace Gould." *The Little Review* 6(October 1919): 24-29 [final retort to the previous exchange].

"The Business of Poetry." *Poetry* 15(December 1919): 152-58.

*1920*

"Red Man Ceremonials: An American Plea for American Esthetics." *Art and Archeology* 9(January 1920): 7-14. Reprinted in *Adventures in the Arts* (1921) under the title "The Red Man," pp. 13-29.

"The Poetry of Arthur B. Davies' Art." *Touchstone* 6(February 1920): 277-84. Reprinted in *Adventures in the Arts* (1921) under the title "Arthur B. Davies." pp. 80-86.

"Vaudeville." *The Dial* 68(March 1920): 335-42. Reprinted in *Adventures in the Arts* (1921), pp. 162-74.

"Sunlight Persuasions" (seven poems: "The Festival of the Corn," "Español," "Girl with the Camelia Smile," "The Topaz of the Sixties," "The Asses' Out-House," "To C—," "Saturday") *Poetry* 16(May 1920): 59-70.

"The Festival of the Corn" reprinted in *The Turquoise Trial*, ed. Alice Corbin Henderson. Boston: Houghton Mifflin Co., 1928, pp. 44-51.

"Aperatifs [sic]," and "A Portrait" (two poems). *Contact*, no. 1(December 1920): 8-9. "A Portrait" reprinted in *Twenty-five Poems* (1923), under the title "Rapture" among a series of "Boston Portrait Projections," pp. 33-34.

"Concerning Fairy Tales." *Touchstone* 8(December 1920): 172-79. Reprinted in *Adventures in the Arts* as the Foreword under the title "Concerning Fairy Tales and Me," pp. 3-10.

*1921*

*Adventures in the Arts: Informal Chapters on Painters, Vaudeville and Poets*. New York: Boni & Liveright. Facsimile reprint, New York: Hacker Books, 1972.

*Reviews:*

Unsigned. "The Importance of Being 'Dada.' " *The International Studio* 74(November 1921): 1xiii.

Unsigned. *"Adventures in the Arts." Outlook* 129(November 2, 1921): 356.

Unsighed. "New Books: *Adventures in the Arts." Cartholic World* 114(January 1922): 542.

[L.C.M.]. *"Adventures in the Arts." Freeman* 4(December 21, 1921): 358.

Brodzky, Horace. "Marsden Hartley's 'Adventures.' " *Art Review* (January 1922): 24, 26.

McBride, Henry. "An Adventurer in the Arts." *The Dial 71*(December 1921): 704-06.

Pearson, E. L. *"Adventures in the Arts." The Independent and Weekly Review* 107(October 29, 1921): 106.

Rosenfeld, Paul. "Paint and Circuses," *Bookman* 54(December 1921): 385-88.

"Canticle for October" (poem). *Contact*, no. 3(1921): 11-12.

"Dissertation on Modern Painting." *The Nation* 112(February 1921): 235-36.

"The Crucifixion of Noël" (poem). *The Dial* 70(April 1921): 378-80. Reprinted in *Twenty-five Poems* (1923), pp. 2-5; and *Lyric America: An Anthology of American Poetry 1630-1930*, ed. Alfred Kreymborg. New York: Coward-McCann, Inc., 1930, pp. 460-62; revised edition with supplement 1930-35, New York: Tudor Publishing Co., 1935, pp. 460-462.

"Yours with Devotion; trumpets and drums" (unsigned poem). *New York Dada Globe* (April 1921): [4]. Reprinted in *Twenty-five Poems* (1923), pp. 51-54.

*1922*

"The Scientific Esthetic of the Redman." Part I, "The Great Corn Ceremony at Santo Domingo." *Art and Archeology* 13(March 1922): 113-19; part II, "The Fiesta of San Geronimo at Taos." *Art and Archeology* 14(September 1922): 137-39.

"Marie Laurencin." *Der Querschnitt* 2(Summer 1922): 102-03 [reprinted excerpt from "Some Women Artists in Modern Painting" from *Adventures in the Arts* (1921), pp. 114-16.

"A Propos du Dôme, etc." *Der Querschnitt* 2(Christmas 1922): 235-38.

*1923*

*Twenty-five Poems.* Paris: Contact Publishing Co.

*Review:*

Monroe, Harriet. *"Twenty-five Poems." Poetry* 23(November 1923): 105-07.

"Georgia O'Keeffe." *Alfred Stieglitz Presents One Hundred Pictures Oil, Water-Colors, Pastels, Drawings by Georgia O'Keeffe American.* New York: The Anderson Galleries [exhibition catalogue essay, reprinted excerpt from "Some Women Painters in Modern Painting" from *Adventures in the Arts* (1921), pp. 116-19].

*1924*
"The Greatest Show on Earth: An Appreciation of the Circus from One of its Grown-up Admirers." *Vanity Fair* 22(August 1924): 33, 88.

*1925*
"The Woman distorts, with hunger" (poem). *Contact Collection of Contemporary Writers,* ed. Robert McAlmon. Paris: Three Mountain Press, 1925, pp. 87-90.

*1928*
"Recent Paintings by John Marin." New York: Intimate Gallery [exhibition catalogue].
"The MOUNTAIN and the RECONSTRUCTION" (poem). *Paintings and Watercolors by Marsden Hartley.* Chicago: The Arts Club of Chicago [exhibition catalogue].
"Art—and the Personal Life." *Creative Art* 2(June 1928): xxxi-xxxvi.

*1931*
"Four Poems" ("From a Paris window—high," "The beautiful rush." "Life ahead, life behind," "—Corniche, Marseilles"). *American Caravan IV,* eds. Alfred Kreymborg, Lewis Mumford, Paul Rosenfeld. New York: The Macaulay Company, pp. 445-47.
"New England on the Trapeze." *Creative Art* 8(February 1931): 57-58. "The Paintings of Florine Stettheimer." *Creative Art* 9(July 1931): 18-23.

*1932*
"Scenes" (two poems: "Brautigam," and "Window-Washer, Avenue C"). *Poetry* 40(April 1932): 22-23.
"Return of the Native" (poem). *Contact* 1(May 19, 1932): [28]. Reprinted in *Pictures of New England by a New Englander; Exhibition of Recent Paintings of Dogtown, Cape Ann, Massachusetts.* New York: The Downtown Gallery (exhibition catalogue, 1932); *Androscoggin* (1940), p. 3; and *Selected Poems* (1945), p. 3.

*1934*
"291—and the Brass Bowl." *America and Alfred Stieglitz; A Collective Portrait,* eds. Waldo Frank, Lewis Mumford, Dorothy Norman, Paul Rosenfeld, and Harold Rugg. New York: Doubleday Doran & Co., Inc., pp. 236-42. Reprinted New York: Aperture, Inc. 1979), pp. 119-21.

*1935*

"George Grosz at An American Place." *George Grosz: Exhibition of Water Colors (1933-1934)*. New York: An American Place. [exhibition catalogue].

*1936*

"Albert Pinkham Ryder." *The New Caravan*, ed. Alfred Kreymborg, Lewis Mumford, Paul Rosenfeld. New York: W. W. Norton & Co., Inc., pp. 540-51.
"Farewell, Charles." *The New Caravan*, pp. 552-62.

  *Review:*
  Jack, Peter Munroe. *"The New American Caravan," The New York Times Book Review*, January 17, 1937, p. 16.

"As To John Marin and His Ideas." *John Marin: Watercolors, Oil Paintings, Etchings*. New York: Museum of Modern Art, pp. 15-18 [exhibition catalogue]. Facsimile reprint New York: Arno Press, 1966.
"Georgia O'Keeffe: A Second Outline in Portraiture." *Georgia O'Keeffe: Exhibition of Paintings, 1935*. New York: An American Place [exhibition catalogue].
"An Outline in Portraiture of Self: From Letters Never Sent," "This portrait of a seadove—dead (poem). *Marsden Hartley: First Exhibition in Four Years*. New York: An American Place [exhibition catalogue]. "This portrait of a seadove—dead" reprinted in *Androscoggin* (1940), pp. 32-33; and *Selected Poems* (1945), pp. 34-35.

*1937*

"Signing Family Papers" (poem)', and "On the Subject of Nativeness. A Tribute to Maine." *Marsden Hartley: Exhibition of Recent Paintings, 1936*. New York: An American Place [exhibition catalogue]. "Signing Family Papers" reprinted in *Androscoggin* (1940), pp. 35-36.
"Concerning the Work of Richard G." *Exhibition of Paintings by Richard Guggenheimer*. New York: Lilienfeld Galleries [exhibition catalogue].
"Seeing the Shows: The Paintings of Harry Watrous." *Magazine of Art* 30(March 1937): 176.
"The Six Greatest New England Painters." *Yankee* 3(August 1937): 14-16.

*1938*

"The Berry House," "She Went Without Telling" (two poems). *The Triad Anthology of New England Verse*, ed. Louise Hall Littlefield. Portland, Maine: Falmouth Book House, pp. 32-33; 48-50. "The Berry House" reprinted in *Androscoggin* (1940), pp. 49-50; and *Selected Poems* (1945), pp. 88-89.

*1939*

"Three Notes: Mary with the Child—of Leonardo in the Pinakotek, Munich; Memling Portraits; Thinking of Gaston Lachaise." *Twice a Year*, nos. 3-4(1939-40): 253-263. Excerpt from "Thinking of Gaston Lachaise" reprinted in *The Sculpture of Gaston Lachaise*, ed. Hilton Kramer. New York: Easkins Press, 1965, pp. 27-29.

*1940*

*Androscoggin* (poetry). Portland, Maine: Falmouth Publishing House.

Reviews:

Campbell, Kathleen. "*Androscoggin.*" *Poetry* 59(December 1941): 168.
Mellquist, Jerome. "*Androscoggin.*" *Kenyon Review* 3(Autumn 1941): 521-24.
Rosenfeld, Paul. "*Androscoggin.*" *New York Herald Tribune Books*, 13 April 1941, p. 26.

*1941*

*Sea Burial* (poetry). Portland, Maine: Leon Tebbetts, Editions.

Review

Unsigned. "Marsden Hartley has New Book of Poems," *Lewiston Journal*, 24 January 1942, Sec. III, p. 4.
Jack, Peter Munro. "The New Books of Poetry." *The New York Times Book Review*, 15 March 1942, p. 9.

"Commentary." *Paintings by John Bloomshield*. New York: James St. L. O'Toole Galleries [exhibition catalogue].
"Spring, 1941." *Story* 19(September-October 1941): 97-99 [essay contribution to special memorial issue on Sherwood Anderson].
"Pictures." *Marsden Hartley/Stuary Davis*. Cincinnati, Ohio, Cincinnati Modern Art Society, 1941, pp. 4-6 [exhibition catalogue].

*1942*

"Sprinchorn Today." *Exhibition by Carl Sprinchorn*. Philadelphia: America Swedish Historical Museum [exhibition catalogue].

*1945*

*Feininger/Hartley*. New York: Museum of Modern Art [exhibition catalogue with selection of excerpts from Hartley's writings and letters].
*Selected Poems*, ed. Henry W. Wells. New York: The Viking Press.

Reviews:

Unsigned. "Books Briefly Noted: *Selected Poems* by Marsden Hartley." *The New Yorker* 21(December 29, 1945): 68.

Unsigned. *"Selected Poems." Booklist* 42(December 1, 1945): 106.

Benet, William Rose. "Poems of a Painter." *Saturday Review of Literature* 29(January 19, 1946): 39.

Flanner, Hildegarde, "Poems of a Painter." *Poetry* 68(July 1946): 220-22.

Morris, Lloyd. *"Selected Poems." New York Herald Tribune Weekly Book Review*, 23 December 1945, p. 3.

Reed, Judith K. "Poems of Hartley." *Art Digest* 20(January 1, 1946): 24.

*1948*

"Letter to Jacques Lipchitz." *Lipchitz: Early Stone Carvings and Recent Bronzes*. New York: Buchholz Gallery, 1948, pp. 1-5 [exhibition catalogue].

*1976*

*Eight Poems and One Essay* (poems: "The Royal Love Child," "To a Syrian Lute," "Nature," "Light of Night," "The End," "To A Friend, A Musician," "Summer Evening," "Song for Eilleen"; essay: "The New Paintings of Carl Sprinchorn of the Maine Woods"). Lewiston, Maine: Bates College.

*1977*

"The Drawings of Nijinksy." *Nijinsky, Pavlova, Duncan: Three in Dance*, ed. Paul Magriel. New York: Da Capo Press, pp. 68-73.

*Secondary sources*

Barnett, Vivian Endicott. "Marsden Hartley's Return to Maine." *Arts Magazine* 54(October 1979): 172-76.

Biddle, George. *An American Artist's Story*. Boston: Little, Brown, & Co., 1939.

Brown, Milton W. *American Painting from the Armory Show to the Depression*. Princeton: Princeton University Press, 1955.

———. *The Story of The Armory Show*. New York: The Joseph H. Hirshhorn Foundation, 1963.

Brown, Robert. Interview with Norma Berger, June 28, 1973. Hartley Archive, Yale Collection of American Literature, Beinecke Rare Book and Manuscript Library, Yale Univeristy.

Bulingame, Robert. "Marsden Hartley: A Study of His Life and Creative Achievement." Ph.D. Dissertation, Brown University, 1953.

———. "Marsden Hartley's *Androscoggin*: Return to Place." *The New England Quarterly* 31(December 1958): 447-62.

———."Marsden Hartley" (poem). *Northwest Review* 47(Winter 1962): 28.

———. "Marsden Hartley 1877-1943" (poem). *Newport Review* 1(Winter 1980): 39.

Crane, Hart. *The Collected Poems of Hart Crane*, ed. Waldo Frank. New York: Liveright Publishing Co., 1933.

Craven, Thomas. *Modern Art*. New York: Simon and Schuster, 1934.

Dahlberg, Edward. *Do These Bones Live?* New York: Harcourt, Brace, and Co., 1941.

————. *Epitaphs of Our Times: The Letters of Edward Dahlberg*. New York: George Braziller, 1967.

Dijkstra, Bram. *The Hieroglyphics of a New Speech*. Princeton, N.J.: Princeton University Press, 1969.

Ford, Hugh. *Published in Paris; American and British Writers, Printers, and Publishers in Paris, 1920-1939*. New York: Macmillan, 1975.

Frank, Waldo. *The Rediscovery of America*. New York: Charles Scribner's Sons, 1929.

Gallup, Donald. "The Weaving of a Pattern." *Magazine of Art* 41(November 1948): 256-61.

————,ed. *The Flowers of Friendship*. New York: Alfred A. Knopf, 1953.

Gillespie, Gary H. "A Collateral Study of Selected Paintings and Poems from Marsden Hartley's Maine Period." Ph.D. Dissertation, Ohio University, 1974.

Greenberg, Clement. *Art and Culture*. Boston: Beacon Press, 1961.

Haskell, Barbara. *Marsden Hartley*. New York: New York University Press and The Whitney Museum of American Art, 1980.

Hoffman, Frederick J., Charles Allen, Carolyn F. Ulrich. *The Little Magazine: A History and Bibliography*. Princeton, N.J.: Princeton University Press, 1947.

Homer, William Innes. *Alfred Stieglitz and the American Avant-Garde*. Boston: New York Graphic Society, 1977.

Jaffe, Irma B. "Cubist Elements in the Painting of Marsden Hartley." *Art International* 14(April 1970): 33-38.

James, Henry. "Preface," *The American*. New York: Charles Scribner's Sons, 1907.

————. "Preface," *Portrait of a Lady*. New York: Charles Scribner's Sons, 1908.

James, William. *Essays in Radical Empiricism* and *A Pluralistic Universe*. New York: E. P. Dutton and Co., Inc., 1971.

J[ewell], A. E[dward]. "What is Imagination?—Doubts Surge Forward as Marsden Hartley Frames New Credo." *The New York Times*, 17 June 1928, p. 19.

Josephson, Matthew. "Open Letter to Mr. Ezra Pound and Other Exiles." *transition* 13(Summer 1928): 100-02.

————. *Life Among the Surrealists*. New York: Holt, Rinehardt & Winston, 1962.

Knoll, Robert. *Robert McAlmon*. Lincoln, Neb.: University of Nebraska Press, 1957.

Kreymborg, Alfred. *Troubadour: An Autobiography*. New York: Liveright Inc., Publishers, 1925.

Levin, Gail. "Hidden Symbolism in Marsden Hartley's Military Pictures." *Arts Magazine* 54(October 1979): 154-58.

Luhan, Mabel Dodge. *Movers and Shakers*, vol. 3 of *Intimate Memories*. New York: Harcourt, Brace and Co., 1936.

McAlmon, Robert. *Being Geniuses Together*. London: Secker and Warburg, 1938.

————.*Distinguished Air (Grim Fairy Tales)*. Paris: Contact Editions, Three Mountains Press, 1925.

McCausland, Elizabeth. *Marsden Hartley*. Minneapolis, Minn.: University of Minnesota Press, 1952.

————. "Tradition and Marsden Hartley." *Texas Quarterly* 5(Winter, 1962): 193-99.

————. "The Return of the Native." *Art in America* 40(Spring 1952): 55-79.

————. and Mary Bartlett Cowdrey. Interview with Jacques Lipchitz, February 20, 1960. Archives of American Art, New York.

Mellquist, Jerome. *The Emergence of an American Art*. New York: Charles Scribner's Sons, 1942.

————. "Marsden Hartley." *Perspectives U.S.A.* no. 4(Summer 1953): 62-77.

Novak, Barbara, *American Painting of the Nineteenth Century*. New York: Praeger Publishers, 1969.

Pemberton, Murdock. "Soul Exposures." *Creative Art* 4(January 1929): xlvii-xlix.

Rexroth, Kenneth. *An Autobiographical Novel*. Garden City, N.Y.: Double-day & Co., Inc., 1966.

Rönnebeck, Arnold. "Hartley Gives Talk on 'The Original Research of Cézanne' " *The Rocky Mountain News* (Denver) 25 March 1928, p. 4.

Rosenfeld, Paul. *Port of New York*. New York: Harcourt, Brace & Co., 1924; reprinted with an introduction by Sherman Paul. Urbanna, Ill.: University of Illinois Press, 1966.

————. *Men Seen: Twenty-four Modern Authors*. New York: Dial Press, 1925.

————. "Marsden Hartley." *The Nation* 157(September 18, 1943): 326-27.

Scott, Gail R. "The Surface of His Dignities," *The Christian Science Monitor*, 10 February 1977, p. 28.

————. "Marsden Hartley at Dogtown Common." *Arts Magazine* 54(October 1979): 159-65.

Smoller, Sanford J. *Adrift Among Geniuses: Robert McAlmon Writer and Publisher of the Twenties*. University Park: Pa.: Pennsylvania State University Press, 1975.

Stein, Gertrude. "11111111111," in *Geography and Plays*. New York: Haskell House Publishers, 1967.

————. *The Autobiography of Alice B. Toklas*, 1933. New York: Vintage Books, 1960.

Stevens, Wallace. "The Relations Between Poetry and Painting" in *The Necessary Angel*. New York: Vintage Books, 1942, 1951.

Tashjian, Dickran. *Skyscraper Primitives: Dada and the American Avant-Garde: 1910-1925*. Middletown, Conn.: Wesleyan University Press [1975].

————.*William Carlos Williams and The American Scene*. Berkeley, Calif.: University of California Press, and New York: Whitney Museum of American Art, 1978.

Unterrecker, John. *Voyager. A Life of Hart Crane*. New York: Farrar, Straus, Giroux, 1969.

Van Vechten, Carl. *Peter Whiffle: His Life and Works*. New York: Alfred A. Knopf, 1922.

Walsh, Ernst. "A New Book by Robert McAlmon." *This Quarter* 1(1925): 330-34 [review of *Distinguished Air*].

Wells, Henry W. "The Poetry of Marsden Hartley." *Quarterly Review of Literature* 1(Winter 1944): 100-06.

————. "The Pictures and Poems of Marsden Hartley." *Magazine of Art* 38(January 1945): 26-30, 32.

Wickes, George. *Americans in Paris*. Garden City, N.Y.: Doubleday & Co., Inc., 1969.

Williams, William Carlos. "Marsden Hartley: 1940" "Beginnings: Marsden Hartley: 1948" and "Marsden Hartley: 1956" in *A Recognizable Image: William Carlos Williams on Art and Artists*, ed. with an introduction by Bram Dijkstra. New York: New Directions, 1978, pp. 149-156.

————.*The Autobiography of William Carlos Williams*. New York: New Directions, 1951.

# Index